PENGUIN BOOKS

PAINTING, POWER AND P.

Bram Kempers studied sociology and art history at the University of Amsterdam in The Netherlands. For some time he worked as a painter, illustrator, copywriter and researcher for the Ministry of Cultural Affairs.

Since 1989 Dr Kempers has been Professor of the Sociology of Art at the University of Amsterdam.

BRAM KEMPERS

———————

PAINTING, POWER AND PATRONAGE

THE RISE OF THE PROFESSIONAL ARTIST IN THE ITALIAN RENAISSANCE

TRANSLATED FROM THE DUTCH BY
BEVERLEY JACKSON

PENGUIN BOOKS

PENGUIN BOOKS

Published by the Penguin Group
Penguin Books Ltd, 27 Wrights Lane, London W8 5TZ, England
Penguin Books USA Inc., 375 Hudson Street, New York, New York 10014, USA
Penguin Books Australia Ltd, Ringwood, Victoria, Australia
Penguin Books Canada Ltd, 10 Alcorn Avenue, Toronto, Ontario, Canada M4V 3B2
Penguin Books (NZ) Ltd, 182–190 Wairau Road, Auckland 10, New Zealand

Penguin Books Ltd, Registered Offices: Harmondsworth, Middlesex, England

First published in Dutch, under the title *Kunst, macht en mecenaat*, 1987
This English translation first published in English by Allen Lane 1993
Published in Penguin Books 1994
1 3 5 7 9 10 8 6 4 2

Printed in England by Clays Ltd, St Ives plc

CONTENTS

Part II The Republic of Sienna

Part III Florentine Families

Part IV The Courts of Urbino, Rome and Florence

Part V Social Contexts to the Present Day

LIST OF ILLUSTRATIONS

FOREWORD

═══

When I worked as a painter and illustrator I gained a little first-hand experience of the blessings and blights of the artist's profession in the twentieth century. Whilst delighting in painting itself as a source of inspiration, my dependence on buyers and official guardians of subsidy purse-strings was forcibly brought home to me. Later, studying sociology at the University of Amsterdam, I became interested in the history of painting as a profession and the significance of patronage. What particularly intrigued me was the question of how it was possible that for a period spanning more than three hundred years, painters in Italy had produced innovative and high-quality work when working for clients who saw art primarily as a means of glorifying themselves and the power they possessed.

The contrast between that age and our own impressed itself upon me all the more forcibly when I was undertaking research for the Netherlands Ministry of Welfare, Health and Cultural Affairs. In the Netherlands there is a comprehensive arts policy with objectives unheard of during the Renaissance: the promotion of quality and innovation as well as the greater accessibility of art for the public at large. It was my desire to explore the symbiosis that once joined painting, power and patronage together that provided the initial impetus to conduct the present study. This book was first published in Dutch as a doctoral dissertation at the University of Amsterdam; for the German and English editions I have revised and corrected the text.

Painting, Power and Patronage is a study in sociological history. The theoretical and methodological tools adopted do not derive from any one discipline or school of thought. I have proceeded empirically, seeking to define a synthesis that would respond to the challenges posed by sociology and cultural history in all their well-nigh unmanageable breadth. I should add that the course of my research was not moved by scholarly requirements alone, but also a great love for the landscape, cities and art of Italy.

I am greatly indebted to the ideas of my colleagues and friends: S. de Blaauw, H. Belting, E. Borsook, E. H. Cassee, C. L. Frommel, J. Gardner,

R. H. Goldthwaite, B. van Heerikhuizen, I. Herklotz, I. Hueck, J. de Jong,
K. Krüger, B. W. Meijer, H. Miedema, A. Nesselrath, B. Ridderbos, R. W.
Scheller, C. Schmidt, P. Seiler, J. Shearman, H. van Veen, W. H. Vroom,
N. Wilterdink and M. Winner, and especially J. Goudsblom and H. W. van
Os. I am also most grateful to the Netherlands Institute of Florence, the
Archivio di Stato in Sienna, the Biblioteca Hertziana and the Biblioteca
Apostolica Vaticana in Rome, the Netherlands Research Organization, the
Ministry of Education and that of Welfare, Health and Cultural Affairs and
the universities of Amsterdam and Groningen. I should like to extend a
word of thanks to the English translator, Beverley Jackson, for her dedicated
and imaginative work.

I remember and record with gratitude the loving attention with which my
mother and father first kindled my interest in art. This book is dedicated
to Hannie and Marcus.

Bram Kempers
Amsterdam, January 1991

INTRODUCTION

═══

THE RENAISSANCE ACCORDING TO VASARI

Travelling the road from Florence to Bologna in around 1275 the wealthy painter Cimabue saw a poor peasant boy who, whilst tending a flock of sheep in a pasture, was engrossed in drawing one of the animals on a stone. The renowned artist was so impressed that he inquired the young shepherd's name, and shortly afterwards asked the boy's father if he might be allowed to take over the upbringing of his remarkably gifted son. As years went by this pupil, whose name was Giotto, came to surpass even the excellence of his master.

The successful painter and architect Vasari worked this anecdote into his *Lives of the Most Excellent Painters, Sculptors and Architects*, which first appeared in 1550, a revised and expanded edition following in 1568[1]. Vasari's seminal survey of the achievements of Italian artists between 1250 and 1550 credited Cimabue and Giotto with having initiated the revival of the art of painting after it had slumbered for almost a thousand years[2]. For centuries, according to Vasari, painters had been working in a crude style little touched by elegance, without ever improving upon their abilities. The two men from Tuscany developed new skills, laying the foundation for an art that required study – an art that would be varied, elegant and faithful to life.

Vasari saw this artistic rebirth as moving through three phases, each with its own distinctive features. The outstanding achievements of the first period, 1251–1420, were the great works of Cimabue, Giotto and a number of painters from Sienna: Duccio, Simone Martini and the Lorenzetti brothers. In this first renaissance the tone was set by the two generations of artists active between 1280 and 1350. We learn from Vasari's *Lives* that many of their commissions were for mendicant orders, that some worked regularly for the commune of Sienna and a few were attached to courts.

After 1420 the innovations accelerated once more. Florence became the focal point, as Masaccio began to apply the mathematical rules of perspective, discovering how to place figures within a large space so realistically that his

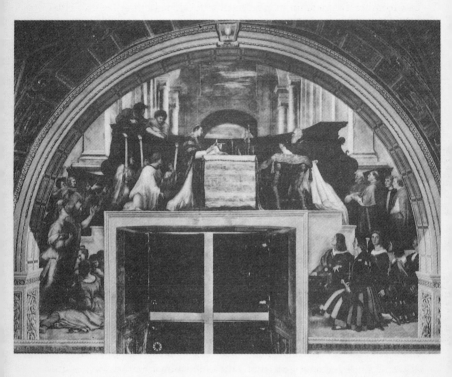

1. Raphael, *Julius II at Prayer*, Stanza d'Eliodoro, Vatican Palace, 1511
(photograph Vatican Museum)

paintings seemed actually to possess a third dimension[3]. The generation of artists that succeeded him – Fra Angelico, Botticelli and Ghirlandaio – refined the details, achieving greater verisimilitude still. These painters also took to using the medium of oil, recently developed in the Flemish cities of Bruges and Ghent[4]. This second age was dominated by commissions issued by the great merchant families of Florence, who wanted paintings to decorate their chapels. But at the same time mendicant orders and communes continued to play a role, and courts gradually became more conspicuous patrons.

Vasari called the third period, beginning in 1500, the 'modern age', describing it as an era in which painters came to possess solutions to every problem with which their art confronted them[5]. To the skills already acquired they now added a thorough knowledge of classical art, which enabled them to represent the most complicated of observations with a perfect composition in an elegant design. Artists such as Raphael and Michelangelo exhibited an impressive mastery of painterly techniques, perspective, draughtsmanship, composition and design, and at the same time showed themselves to be highly knowledgeable about each subject depicted. Vasari saw these artists as moving beyond the ancients into a stage of perfection. He attributed these achievements partly to the masters whose precepts they followed and to the spirit of competition among contemporaries, but he also recognized the impetus provided by the demanding, prestigious commissions that were now largely emanating from princes, popes and their courtiers.

Vasari did, it is true, comment on the various relationships that existed among artists and between artists and patrons, but there is no doubt as to where he places greatest emphasis: on the individual contribution of the 'most excellent painters'. Vasari focused above all on the praise meted out to painters by renowned men of letters and the honours bestowed upon them by their grand patrons. By quoting from admiring descriptions and epitaphs he gave an added air of distinction to the art that he practised himself[6].

The source for the anecdote about Cimabue and Giotto, as retailed by Vasari, was the Florentine goldsmith Ghiberti's *Commentaries*, written in about 1450. Ghiberti praised the superior accomplishments painters had been developing since 1250[7]. Compared to Vasari, Ghiberti paid more attention to the painters of Sienna; together with those of Florence, they left the roughness of Greek painters behind them and went on to evolve a new kind of art.

The increased skills being displayed by artists had already attracted comment in the fourteenth century from Dante, Boccaccio, Villani and Petrarch[8]. These writers articulated the notion of a cultural revival and linked it to the art of painting in Italy. In trecento Italy individual artists received growing acclaim and the concept of progress in art came of age. The idea of an autonomous artist, who sets his own standards and acts as an independent innovator, took a firm hold on Western culture from this time onwards[9].

The humanists writing in the fifteenth century modelled themselves more closely and more directly than preceding generations on classical writers, with their great admiration for the visual arts and their eloquent tributes to individual artists. Alberti, Fazio and others laid the foundation for a theory of art and a view of history that centred on autonomy, individuality, innovation and excellence. Such were the terms used in these writers' discussions of particular artists and the distinctive merits of their work[10].

In his efforts to improve the status and prosperity of his fellow painters, Vasari emphasized that eminently desirable concept, the autonomy of the artist. In his letters, discourses and biographical writings he developed an ideal that, though it was relevant to those who gained the most prestigious commissions, was far removed from the working conditions of the average painter. Autonomy, in other words, was in fact a very scarce commodity.

Without detracting from the qualities possessed by individual artists, it is possible to take a view of their work that is informed by a more sociological perspective; they can be seen as belonging to a group working for those who issued artistic commissions and who were in their turn dependent on others[11]. The very awareness of natural ability, as expressed in the anecdote about Cimabue and Giotto, is socially acquired. Artists have cultivated this emphasis on personal qualities, and precisely for this reason such a perspective should be questioned rather than taken for granted. We cannot detach the abilities of painters from the circumstances in which they worked – in particular, from the relationships among those involved in issuing and executing commissions, and neither can artistic patronage be made intelligible in isolation from its broader social context. When art is considered in relation to power, with patronage as the vital link, each can illuminate the other; social context can provide insight into paintings, which in their turn shed light on social history[12].

PATRONAGE AND CULTURAL HISTORY

Taking artistic commissions as the focal point of the inquiry has the advantage of providing certain constraints, reducing the risk of entering into the speculative realm of generalizations about relations between art and society. On the other hand, however, it is an emphasis that places heavy demands on our empirical knowledge[13]. We are fairly well-informed about the network of artistic patronage: that is to say, the whole machinery of relationships that existed between clients, advisers and the public and that formed the context in which painters did their work – there was hardly ever a single patron making decisions on his own. It should be noted here that this book will not distinguish between the terms 'client' and 'patron'; the difference is scarcely relevant for the period under discussion where painting is concerned. The characteristic feature of patronage is the dominant role of the client who issues a commission, in marked contrast to a situation in which art is produced for the market or with a view to gaining a subsidy.

On some occasions one particular project was defined, on others painters were employed for many years to execute various works. In both cases, specific instructions on what to depict were very common, as was an imposed and fixed date of completion. The notion that has come down to us of a disinterested promotion of the arts grew up largely as part of what may be called the myth of artistic patronage. Factual information on artistic commissions can be found on the one hand in monographs dealing with artists or particular paintings, and on the other in full-length works on patronage as such[14]. In this connection Burckhardt and Huizinga's studies of cultural history, though they scarcely dwell on the issue of art and patronage, are a permanent source of inspiration[15].

A good deal has been written on the relationships that existed between painters and their clients, on the basis of direct sources such as contracts, letters, payments and various descriptions[16]. Such sources make it clear that the many functions of painted images for those who commissioned them included elements remote from artistic appreciation. There are also numerous historical publications containing information on the lives of many patrons, which, though not generally focusing on culture, are enlightening on the subject of their subjects' relationship with the arts.

Patronage thus forges links between academic disciplines that have traditionally been pursued separately and that often still are today. This illustrates a more general phenomenon, that problems impinging only

marginally on one discipline are at the heart of another. In other words, one researcher's footnotes are another researcher's chapter headings. Such connections cannot be ignored; the temptation to separate disciplines, however great, should be resisted.

Rejecting a vision of art that would proclaim its autonomy and that would view each work as a discrete entity, we can find in paintings much to help us understand the ideas and customs of those for whom they were made. Their usefulness as historical sources remains limited, however. Much as they fire our imagination, the world they evoke is chiefly made up of the idealized achievements crowning the public lives of, in the main, elderly, rich and well-educated men. There are many things about which the images that form the subject of this book are virtually silent: not only oppression, despair and hunger are passed over, but so also are the generally unexciting features of everyday life.

These considerations and reservations lead to the main issues to be explored in this study: the development of the art of painting in Italy between 1200 and 1600 as a process of professionalization; the links between this process and trends in patronage; and finally the connections between changes within art and patronage and the shifting balance of power.

A SOCIOLOGICAL APPROACH TO ART HISTORY

It is striking how little attention sociologists have paid to art. It is as if they, too, have thought artists immune to the forces operating in society[17]. The sociology of art has thus far not matured as an independent discipline; it has as yet scarcely developed any systematic terms of reference that would be of direct relevance to the questions posed here[18]. Partly because of this vacuum, it is useful to consult classical sociologists such as Durkheim, Marx, Weber, Mauss and Elias. Their work has led me to focus on three concepts – professionalization, state formation and the process of civilization – all of which refer to relationships as well as to processes. It is not a question of adopting a ready-made theoretical framework, but of utilizing terms that have derived their meanings from empirical usage and that have proved useful, in the course of the research, in structuring the material.

'Professionalization' is a term coined by modern sociologists that, despite its initial application to doctors working in the nineteenth and twentieth centuries, can help illuminate the remarkable maturation of Italian painting from the thirteenth century to the sixteenth century[19]. Characteristically,

the professionalization of painters can be seen as having unfolded in a number of successive stages. Specialist skills were passed on from master to apprentice, gradually broadening in range as a result of work executed on commission or sold on the market. Those practising the same profession banded together in organizations that aimed to supervise training, the practices in workshops, quality assessment, modes of conduct and participation in collective rituals. After several generations, writings started to appear that discussed the skills acquired and went on to formulate certain generalizations or theories[20]. A few successful individuals recorded the history of their profession, emphasizing their renowned predecessors. Such writers laid down rules for the relationships that existed among artists and between artists and patrons in an attempt to establish a monopoly on practising their profession. From these ideals a sense of solidarity was called into being, and the scope for autonomous action within the bounds of dependency on patrons was stretched to a maximum.

It is the professionalization of painters that is central in this book, but we can point to a similar process in connection with goldsmiths, mosaic workers, sculptors and architects. We can go further and discern parallel developments among those who issued commissions. Clergymen, for example, though they did not form professional organizations, did evolve specific skills, theories and historical perspectives. In contrast, merchants and bankers were less active theorists, but did set up guilds. Thus the concept of professionalization does not merely refer to the medium-term changes affecting one particular group, but to the long-term economic differentiation that takes shape within a broader social context[21].

This broader social context, however, exhibits a diversity of political and cultural features that cannot, of course, be done justice by the single term 'professionalization'. The work of Norbert Elias and Max Weber provides useful concepts for discussing precisely these aspects of social change. Both sociologists attach great significance to the notion of a 'state', and where Elias is concerned, to 'state formation', which he describes as a form of political integration with certain distinctive features[22].

States lay claim to a monopoly control of taxes, ensuring that all other bodies are excluded from raising taxes independently[23]. The income deriving from taxes enables states to control the use of force. Conversely, the state claims a monopoly on military force that consolidates its hold on taxation. Thus the two monopolies – of taxation and of physical force – are inextricably linked together[24]. The third characteristic of a state is the existence of fixed frontiers that define the limits within which the

monopolies hold good. Territories are protected and defended by armed forces financed from tax money. The following step is that the need to organize the army and tax collection makes administrative bodies indispensable, and diplomatic functionaries, too, become part of this apparatus[25]. A body of legislation steadily accumulates, which is to an increasing degree used as the basis for political-decision making[26]. Finally, administrators extrapolate these laws into an ideal vision of the state and its history that privileges the values of unity, peace, liberty and justice[27].

In the early Renaissance period ecclesiastical institutions shared many of these features with states. They, too, developed their own administrative machinery and laid down laws. As far as expounding and disseminating their ideals they naturally tended to go further than states. Their tracts took great care to demarcate sacred from profane spheres of influence[28]. At the same time they noted that even those not directly subject to sacred authority had obligations such as regularly giving to the Church and duly participating in religious rituals[29]. This situation gradually changed. Churches lost to the state the right to impose taxes. As far as military force was concerned, though ecclesiastics urged peaceful conduct upon the people in the name of their sacred beliefs, they became greatly dependent on the protection of state armies. The land owned by the Church diminished everywhere except for the Papal State itself, which actually expanded during the fifteenth and sixteenth centuries.

Both professional groups and states evolved codes of conduct. These are ideals such as come to be expressed in moral precepts, laws, religion and art; in short, this is a process by which 'culture' develops, and can also be termed a 'civilizing' process[30]. That the process of state formation is related to that of 'civilization' has been demonstrated by Elias, who explored the links between the two in connection with France, his study focusing on the period between 1500 and 1800[31].

The 'civilizing' process has both an internal and an external aspect; it refers both to the developmental stages through which a child acquires the reactions expected of him or her in adulthood and to changing practices in upbringing and education[32]. These interlaced processes both require further study. It was not only the sanction of punishment that ensured that standards of behaviour were upheld; conformity to a particular mode of living was increasingly a form of learnt behaviour – that is to say, an internalized cultural response. More and more often, attitudes that held altruism, learning and industry, for instance, to be unquestionable virtues would be communicated from one generation to the next. Violations of such codes of

conduct would then give rise to feelings of shame if one's own behaviour was concerned and embarrassment where someone else was at fault[33]. Virtues were described in treatises, depicted, elaborated and systematized. Ever larger groups of people endeavoured to live up to them in a balanced and consistent fashion, not only with equals but increasingly also among inferiors[34]. Processes of civilization, in short, are multiple developments that encompass not only the codes of conduct themselves, but also the reach of a given set of values as it is disseminated in upbringing, schooling and social control[35].

For his analysis of the civilizing process Elias drew chiefly on written sources, in particular etiquette books[36]. A major objective of my own study is to investigate the extent to which paintings can be used as sources of information in the study of the kindred developments of state formation and civilization in Italy. For the developments described by Elias in relation to France can also be observed in Italy, although there are marked differences between the two: in Italy there was, in particular, no leading cultural centre, such as the royal court in France, to which religious orders, city councils and merchant families were subordinate. Such distinctions will give rise to different accents being placed, and different developmental stages being discerned, in the course of this study.

BLANKS IN HISTORY

Compounding the theoretical problems involved in establishing the characteristic features of the three processes referred to above – professionalization, state formation and civilization – and in tracing relationships between them, there are crucial gaps in our historical knowledge. Where a broad-based study with a theoretical dimension would, ideally, be able to draw on a repository of scholarship in which the empirical problems had already been solved by others, this is not the case in the present study. Again and again it proves to be necessary to reconstruct the original situation as we try to understand, for instance, the circumstances in which a particular painting was commissioned. Existing hypotheses often prove useful, but sometimes even long-accepted views have to be reconsidered. A margin of uncertainty always remains, as many of the data on which a historical reconstruction would be based have been lost. And even what remains is not infrequently hard to interpret, material not having been written – or painted! – with a view to facilitating future historical research.

That there are so many gaps in our knowledge is a particular encumbrance to a study that does not take the reconstruction of the original situation as its ultimate objective. Rarely are we able to say with certainty where a painting was originally situated, when and by whom it was ordered; neither can we pronounce confidently on what a particular image conveyed, nor which section of the community most often looked upon it.

The marked patchiness in the available facts clouds, for instance, a balanced interpretation of the professionalization of painters. Florence has received more scholarly attention than Sienna, and our knowledge of painters' lives largely concerns the illustrious few – an emphasis to which writers such as Ghiberti and Vasari contributed in no small measure. The Siennese painters of the thirteenth and fourteenth centuries owe their reputation in the main to the nineteenth-century enthusiasm for 'primitives', as expressed notably by the pre-Raphaelites. These factors combine to distort the picture we have of the development of the art of painting in Sienna: it is misleading to take the Siennese school as merely derivative in relation to its more famous neighbour, and ill-conceived to admire its art in terms only of 'primitivism'.

To focus here on the city of Sienna, the subject of the second chapter, will help to illumine the wider problem of historical reconstruction. Tourists visiting present-day Sienna are initially struck by its medieval aspect; it seems so well conserved. Monumental mendicant churches surround the city centre with its cathedral and Palazzo Pubblico, the town hall – and from the latter, now at the very heart of Sienna, rises the Torre del Mangia, the highest point in the city's skyline. Inside the Palazzo Pubblico the famous frescoes by Simone Martini and Ambrogio Lorenzetti attract visitors from all parts of the world.

Where once the town hall was the hub of Siennese government, however, it has now been turned into a museum. The councillors debating wartime exigencies or peacetime anxieties have been replaced by tourists admiring the works of art on the walls. Most of the chapels and meeting-halls have had their contents removed. Those records, laws and annual reports that still survive have been transferred to the State Archives in the Palazzo Piccolomini. Many paintings have been lost, moved or drastically restored. There have been so many renovations that it is hard to retrieve an accurate picture of the decoration as it existed in the fourteenth century. Twice a year the traditional festival of the *Palio delle Contrade* is still celebrated in the scallop-shaped square in front of the Palazzo Pubblico, its chief attraction being a horse race around the square in which the competitors are decked

out in medieval dress. But at the *Palio*, too, an increasing proportion of the spectators are tourists. The Siennese look upon them as intruders: to them it is a sacred ceremony, recalling the medieval lines of demarcation between the different quarters of the city and between the people in the square and the élite standing on the balconies of their palaces.

In the thirteenth century, before the Palazzo Pubblico had been built, Sienna was still a small town, and the black and white marble edifice of the cathedral, built on a slight elevation, formed its true centre. The Duomo has now been somewhat displaced from that position. Facing it is a high wall which ends at a false façade; together they enclose a parking lot. Against this wall is the museum of the Duomo, where the panel paintings, manuscripts and other items originally housed in the cathedral are now on exhibition. They are placed there to be admired as works of art in an arrangement in which no regard has been paid to their original functions. Duccio's *Maestà*, for instance, a work painted on both sides, which on its completion in 1311 had been installed at the high altar, has been sawn in half. Each half is hung on a separate partition with two lines of chairs in between. The panels that were in the predella originally have been detached and are displayed as separate paintings on the long wall. Most of the altarpieces have been removed from the cathedral; some panels have been lost, and others are exhibited as monuments to Western civilization in the museums of Florence, London, Frankfurt, Paris, Copenhagen and the American city of Williamstown. Some panels have remained in Sienna. But it is obvious that a mode of exhibition in which they are hung as paintings on blank walls obscures their original role. These altarpieces were once surrounded by screens, baldachins, flying angels and suspended ostrich eggs, candles and lamps, missals, and the altar slab with its fine overhanging cloth. The images used to be covered by cloths, shutters or a tabernacle, except on festive occasions. Where now we have silent and drably-attired custodians, there were once singing and preaching priests with their precious vestments, copes and chalices. And the paintings now explained by art historians to a lay public that is increasingly outside the Christian religion once had the function of elucidating the faith. In every respect modern forms of presenting the art of this time tend to veil the function it used to have, and fail to bring out the specific features of the sense of beauty that prevailed when these works were executed: a sense dominated by an admiration for intricacy, monumentality and the use of precious materials.

The interior of the cathedral as we see it today is the end-product of a vast number of changes made from the early thirteenth century onwards,

hard to disentangle if we wish to reconstruct an image of the original arrangement. The present church is larger and higher than it was around 1350. Not only have most of the altarpieces disappeared, but so have the frescoes; and the monumental pulpit made by Pisano was taken down and moved elsewhere. The choir in the nave was also removed in 1506. The paving was put in between 1360 and 1530, and the church below the Cathedral has been closed, though part of it has been converted into a museum. All in all, medieval as Sienna might appear to us on first sight, reconstructing the original situation requires a complex series of deductions, and the readiness to weigh against each other the plausibility of the rival constructions that present themselves at each step.

A HISTORICAL SURVEY

If we return to Vasari's division of the Renaissance into three periods, we can see that these successive ages were also characterized by different trends in patronage. The first was dominated by the mendicant orders and city communes, the second by merchant families, and the third was the great age of princely courts. Thus the emphasis passed gradually from commissions for mendicant churches, town halls and cathedrals to family chapels and palaces.

The construction of those buildings for which paintings were commissioned took place at a greatly accelerated rate from the thirteenth to the sixteenth centuries. In this book architecture will prove to be a particularly valuable source of information. Dimensions and costs are factors amenable to measurement, which can also be traced in their historical sequence[37]. A monumental building requires not only a vast quantity of basic materials and labour, but also a high level of organization and technical expertise. Moreover, taken together with the decorations of a given building and the rituals performed there, architecture has a symbolic value. The class constituting the élite reinforced its claims to power both by means of the buildings themselves and of recognizable images displayed in public buildings.

The proliferation of new buildings during this period is in marked contrast to the previous centuries. Many large-scale projects, it is true, were carried out before the thirteenth century: some indeed, such as St Peter's and St John Lateran in Rome, as early as the rule of Emperor Constantine, on whose initiative the first churches on these sites had been built. There

was also Charlemagne's palace and mausoleum at Aix-la-Chapelle, not to mention numerous cathedrals and abbeys whose construction had been initiated by bishops or by abbots and princes[38]. But on the whole major projects were undertaken only sporadically, and the pace of building was relatively slow. During the critical four centuries that we are considering here, however, buildings sprang up at an unprecedented rate and the entire approach to architecture exhibited a greater cohesiveness and continuity than ever before.

The historical features of art and architecture and the links with the development of patronage are embedded in a broader historical movement in which all kinds of clients, whether mendicant orders or city communes, merchant families or princely courts, came to have a place in a more diversified and yet integrated social unit – the State. Cities expanded rapidly, from a population of, say, 5,000, to in some cases as many as 100,000, and this growth had two crucial consequences: it augmented the income from taxes and increased centralized controls on physical force[39]. As territories expanded the balance of power was tipped further in favour of the cities, which acquired bigger and more effective armies. Whilst within the new states people lived increasingly in greater security, wars undertaken between the most powerful states were all the more fiercely fought[40]. By the sixteenth century Europe would be dominated by the states ruled by the kings of England, France and Spain, but the persistent impulse towards state formation had found its first monumental and widespread expression in Italy[41].

A prominent role was played in the expanding cities by the mendicant orders; the friars attracted an ever greater following[42]. At first they took over numerous little churches or chapels dotted about the outskirts of what were still small towns, but within a hundred years' time these were to be rebuilt as immense churches with large convents that stood firmly within the new, greatly extended city walls.

As cities grew more secure and prosperous city councils became more wealthy and influential, and they too came to play a vital role in enabling art and architecture to flourish; they funded the building of town halls, mendicant churches and cathedrals. This prominence of the commune as patron was best exemplified in Sienna and Florence, reaching a peak in the years between 1250 and 1350. The Italian courts had not yet become frequent patrons in this period, and when they did issue commissions they depended largely on artists from Sienna and Florence to fulfil them. Of the two Tuscan republics, it was Sienna whose commune commissioned more works of art over a longer period of time[43].

In Sienna even the bishop was dependent on the civic authorities. As a direct result of the surge in growth in industry, trade and banking the influence of bishops and canons, as well as that of feudal noblemen, was undermined[44]. Farms and land depreciated in value as new capital came to be concentrated in the hands of the merchant families. The proud citizens of Sienna commissioned artists to embellish their cathedral and town hall with images representing the social attributes that they cherished: peace, security, prosperity, justice, wisdom and unity.

Around the mid-fourteenth century life in Sienna began to be disrupted more and more frequently by internal strife and the threat of war from outside. The government of the city lost control over the city-state from causes as diverse as factional disharmony and bankruptcies, outbreaks of the plague and acts of violence such as rebellion, crime and war[45]. Whilst the central authority lost its cohesiveness smaller units such as families, confraternities and smaller towns came to be more influential in their immediate surroundings. At length the city was governed by changing coalitions that formed ties with powerful figures such as the duke of Milan, the Holy Roman Emperor and the pope, as well as the rulers of the Florentine republic.

The story of Florence was very different. Whereas Sienna had been arrested in its growth and suffered a concomitant stagnation in the three-processes whose development we are following – state formation, civilization and professionalization – Florence survived onslaughts of the plague and the general decline in wealth within Europe, remaining a prosperous and relatively secure city. For a number of reasons Florentine merchants amassed greater fortunes than their counterparts in Sienna; partly because the city was richer in raw materials and partly because it developed a highly active textile industry. The success of Florence also had much to do with its geographical location; whereas Sienna had always been troubled by a lack of water, Florence lay on the River Arno. Moreover, once they had subjugated Pisa, the Florentines had access to a seaport. They traded with successive kings of Naples, with popes and with the dukes of Burgundy and supplied the most important bankers in Europe, who conducted their business in Rome, Geneva, Bruges and London[46]. Though economic development in Florence gained momentum later than it did in Amalfi, Pisa, Lucca and Sienna, it carried on far longer than in these other cities in which the initial thrust had been checked[47]. It was the Florentines who gained the most enduring control of trade, banking and industry, and it became a matter of course to conduct one's transactions in the 'florin'. In

Florence itself the increasing cohesiveness of the city-state filled the coffers of individual families[48]. Kinship assumed renewed prominence in this climate; the council came to be dominated by groups of families that formed factions, from which the house of Medici emerged supreme[49].

Merchants ordering works of art generally did so as the heads of families at this stage, where previously they had acted on behalf of a church or civic institution. Accordingly the commissions for family chapels outnumbered the projects of mendicant orders and the commune. Noblemen's towers were dismantled to make room for merchants' palaces that could be accommodated within the expanded perimeter of the city walls, and villas were built outside the town; ties with princes tended to increase the emphasis on such activity. These wealthy families also played an important role in ensuring the security of Florence through their alliances with nobles as well as contracts they entered into with *condottieri*, paying them and their armies for protection. By this time states were of a size to foster enduring diplomatic relationships; the Medici, for instance, had good contacts with successive popes, dukes of Burgundy and the princes of Urbino and Mantua. Such connections, combined with their banking activities, consolidated the pre-eminence of the Medici, who shared power with a number of merchant families that shrank steadily owing to blows struck by bankruptcies, rebellions and epidemics. However, unlike developments in most other Italian cities, neither the Medici nor any other family was able to establish an enduring signory in Florence until the sixteenth century[50].

Now merchants turned into courtiers, as knights had done before them. The entire complex of ideals of civilization to which mendicant orders, communes and merchant families had all contributed became absorbed into a courtly culture. It was a culture that set more store by ostentatious display and elegant socializing with diplomats and foreign rulers than it did by frugality or industry. This was a gradual reorientation of values that arose partly within cities and partly through the increasing influence of surrounding courts. Florence became a courtly society and came to resemble courts elsewhere in Italy that had developed earlier[51].

To a significant extent courts developed because nobles whose sovereignty only covered a small area were experiencing ever greater difficulty in maintaining their position. By entering into alliances with cities or by going into battle under the command of more powerful princes they were able to improve that position. The fees paid to those who had served in these amalgamated armies enabled the descendants of feudal lords and certain highly capable generals to establish themselves as *signori* in small

towns, and later in the large cities. The kind of courtiers that would tend to gravitate to such lords would generally be from the lower aristocracy.

The Count of Urbino, Federico da Montefeltro, was supremely successful as a military commander. He amassed a vast fortune by taking his troops into battle in alliances of changing composition and by accepting substantial sums of money in exchange for not engaging in military action. Shrewd and able general as he was, he made his fortune by selling himself to the highest bidder. His capture of Volterra for the Florentines established Federico's martial reputation, and two years later he was appointed commander-in-chief for Pope Sixtus IV, who further conferred on him the title of Duke in 1474[52].

The Court of Urbino was one of the more prominent in what was, by the second half of the fifteenth century, a network of courts in which patronage was now concentrated. Federico emulated and surpassed the artistic commissions he saw being issued by other rulers; in the palace and cathedral of Urbino princes, diplomats, scholars and artists were all received with great courtesy and lavish attention. Lords whose ancestors had been mortal enemies as knights in armour now formed cordial alliances, discoursing at leisure in Urbino and other luxurious palaces. The development of such courts prompted and nurtured the growth of a civilization with high intellectual and artistic aspirations, as each prince would be eager to display his power to the people and, even more, to the courtly élite, in ways that would be found tasteful and stylish.

Soon, however, this wave of activity in Urbino was checked in its turn by the expansion of the Papal State. By 1500 the lesser independent princes had lost their sovereignty, and finally the dukes of Montefeltro also succumbed to the power of the papacy. The only way for them to maintain their position to a certain extent was by serving the popes. So it was that Julius II, a nephew of Sixtus IV, and then Leo X, a scion of the house of Medici, gave their official sanction to the annexation of Urbino as a part of the Papal State.

Pope Julius II was not only a great general but emerged as an energetic patron of the arts. Directing that the old St Peter's be demolished, he commissioned the construction of a completely new church. He also had the Vatican palace expanded, building a monumental gallery between the thirteenth-century palace and the villa that had been completed shortly before 1500. He commissioned new decorations for the halls and chambers of the old palace and also for its main chapel. On the other side of the Tiber Julius had a straight road built that would lead past the new palaces that he

was planning for the Halls of Justice and treasury, ending at the bridge which Sixtus IV had had built over the Tiber. As statesman and as patron of the arts, Julius II had a greater impact than his predecessors and successors alike, including Leo X and Clement VII of the House of Medici.

After a period characterized by vicissitudes of fortune, the Medici were finally restored to supremacy in Florence, now with a hereditary dukedom over a state which, after 1555, included Sienna. On the façade of the town hall of Sienna and on the city gates the arms of the Medici were blazoned, complete with the new ducal crown. In Florence Cosimo I ordered restoration work to be carried out in the mendicant churches, and he also commissioned paintings for the Palazzo Vecchio, which was incorporated into the Duke's new palace. A long covered gallery was constructed over the Ponte Vecchio, linking the palace that had once belonged to the Pitti family to the newly built Uffizi. And in San Lorenzo, which had been the parish church of the Medici, Cosimo's descendants built a mausoleum with a dome worthy of a cathedral.

Towards the end of the period we are considering the Italian states were overshadowed politically by a Europe frequently racked by war. The great rulers – emperor, pope, the kings of France, England and Spain – grouped and regrouped in military alliances, but none had been able to realize the ideal of hegemony over a unified European state. Though most Italian states were unable to sustain a role of political and economic dominance in this climate, the popes and the dukes of Florence were suffered to continue exercising sovereignty, as no European power had proved capable of bringing their territories under lasting dominion.

Italy gained a different kind of dominance now, however; it had come to stand for cultural excellence. Italian writers, sculptors and architects moved into the international arena. Castiglione's *Il Cortegiano* became the standard work on courtly civilization, and Machiavelli and Guicciardini were leading commentators on the state and its history. But the greatest renown was won in the visual arts: the work of Raphael, Leonardo, Titian and Michelangelo was held in the highest regard throughout Europe. A visit to Italy came to be seen as the finishing touch to the education of the European élite. The art of painting as it flourished in Italy from the twelfth to the late sixteenth century attracted universal admiration as constituting one of the finest chapters in the history of civilization, and that verdict has stood the test of time.

PART I

MENDICANT ORDERS

1. POPES, CARDINALS AND FRIARS

THE FUNCTION OF IMAGES IN CHURCHES

'It is one thing to worship a picture, but it is another thing to be taught by the story conveyed in the picture what to worship. For words teach those who can read; pictures show the same to those who cannot read, but only see, so that even the ignorant can learn from pictures whom they should follow; pictures enable the illiterate to read'[1]. These were the words used by Pope Gregory the Great (590–604) to define the role of pictorial representations in churches.

Who should choose the subject to be depicted was a matter of great concern to the clergy, who wished to secure for the Church of Rome what amounted to a monopoly on communication in word and image. They took a keen interest in the relationships between clients, advisers and artists – the machinery, in effect, of patronage – and urged that his or her subject-matter was not for the painter to choose but that the prime basis for such decisions must be the morality and beliefs of the Church[2]. This insistence reached a pitch in the trials conducted by the Inquisition; a notable case was that of Paolo Veronese, called to account in 1574 for introducing worldly pleasures into paintings of sacred subjects[3]. Between the years 1200 and 1600 prelates reiterated, expanded and in places adjusted their view of pictorial images as a means of disseminating religious beliefs; it was a theme upon which a great many variations were played[4].

Learned friars emphasized that church paintings should set an example in terms of morality and conduct. They claimed that images had a civilizing role to play, particularly where the laity who did not possess the textual knowledge familiar to clerics were concerned[5]. From their perspective the purpose of paintings was to draw the people's attention to virtues and standards of behaviour, demonstrating, for instance, the occasions on which it was appropriate to feel shame or embarrassment. Rooted in these views of the function of art was a complex and differentiated network along which commissions were issued for churches, mendicant churches in particular.

The mendicant orders grew with striking rapidity in the thirteenth century: the first had yet to be founded at the dawning of the century, but by 1316 there were 1,400 churches belonging to the Franciscan order alone[6]. They were more concerned with the laity than either the secular clergy or the older regular orders[7]. Their role in patronage also expanded swiftly, and by the fourteenth century there were murals and panel paintings to be seen in hundreds of new mendicant churches. The mendicant orders – or 'begging' friars – constituted a reform movement; the older orders also honoured the rule of individual poverty, but the friars' asceticism was more stringent. Their rule also embraced collective poverty; as possessions were not allowed, begging was the only permissible means of acquiring any income. They were very successful fundraisers – the mendicant orders were anything but poor. The fact that begging was their only source of income particularly strengthened the mendicants' ties with the lay citizenry, on whom they were financially dependent, and served to underscore the purity of their way of life. In issuing commissions the friars' main priority was to provide models of ideal conduct. Their belief that art and architecture should serve this end played a major role in their decision-making: furnishings and decorations should manifest no excess that might distract the people's attention from the essential point[8].

The Introduction suggested that interrelationships can be shown to exist between the following three processes: the professionalization of painters, dominant trends in patronage and the shifting balance of power. Within this general context the present chapter will focus on commissions for mendicant churches. The discussion will start by examining the development of the friars' commissions for frescoes from older traditions of ecclesiastical patronage, and it will go on to deal with the system of panel paintings that evolved in the interplay between friars and laity. The final issue to be examined is the role played by the mendicant orders in the far-flung network of patrons that arose in Italy between 1200 and 1350.

THE PATRONAGE OF THE PAPAL COURT

Of all the manifold traditions of patronage that grew up between the fall of the Roman Empire and the thirteenth century, each in its turn interrupted or superseded, none was as consistent or as enduring as that of the papal court in Rome. Between 1225 and 1280 popes and cardinals provided incidental support for the building and decoration of the friars' churches,

and from 1250 to 1320 indulgences and privileges were granted that further increased the indirect support provided by the papal court. More directly, members of the *Curia* began to issue commissions for churches belonging to the mendicants[9]. The *Curia*'s main emphasis, as far as its artistic patronage, which had a tradition reaching back to the fifth century, was concerned was focussed on the four patriarchal basilicas. First and foremost were the church and palace of St John Lateran, the cathedral church of Rome; the other basilicas were the new bishop's church of S. Maria Maggiore, subordinate to the Lateran but situated more centrally, S. Paolo fuori le Mura and finally St Peter's in the Vatican, the pilgrim church housing St Peter's memorial tomb[10]. In addition to these there were numerous smaller churches clustered about Rome for which popes and cardinals ordered decorations, furnishings and burial places ranging from simple slabs in the floor to elaborate funerary monuments.

The popes had consolidated their position as territorial rulers in central Italy since the twelfth century; the Papal State had been expanded and papal government had developed an increasingly elaborate machinery of administration[11]. The popes laid claim not only to a greater sacred authority than that possessed by secular rulers, but also to territorial power and the right to levy taxes, like emperors and princes[12]. Laws and glosses on existing statutes were formulated by canonists, the legal advisers to the papal court[13]. In historical justification for the secular authority exercised by the pope the canonists cited the Donation of Constantine, a document (later shown to have been forged) in which Constantine, in gratitude for being healed, gave the authority over Rome to Pope Sylvester and transferred the seat of his empire to the newly founded city of Constantinople in AD 324.

Popes ensured that their superiority to secular princes was brought out unambiguously in pictorial images[14]. For the Lateran palace, Calixtus II (1119–24) and Innocent II (1130–43) commissioned paintings that depicted the papal claims to power over the emperor[15]. In content the Lateran frescoes produced in the 1120s were highly topical, with their emphasis on the authority of the contemporary papacy as against the emperor and the antipopes, who were pictured in the frescoes again and again trodden underfoot by a pontifex ensconced in a far larger throne. Later popes introduced images with comparable messages into the four large basilicas and into several other churches in Rome, though these were less overtly political in theme. They took the form of murals and monuments, sometimes linked as parts of a single design[16].

In the first instance the popes modelled their approach to art on imperial

precedent, following first the Roman emperors and later those of the Holy Roman Empire, who claimed to be their legitimate successors. It was common practice for emperors to lend force to their own sovereignty in the works they patronized by having themselves portrayed enthroned, equipped with the symbols of rule and surrounded by courtiers and per-sonifications of virtues[17]. The popes drew on such traditional images and forms of decoration, a case in point being the frescoes painted (around 1246) in the chamber used temporarily as a reception-room for the pope's distinguished visitors, the Sylvester chapel of the S. Quattro Coronati convent. These show Sylvester healing the Emperor Constantine; the emperor has been presented with a portable icon bearing portraits of Peter and Paul, Sylvester receiving in turn the temporal authority over Rome as symbolized by the papal crown, *ombrellino* and white horse. While the Pope is mounted on his splendid horse, the emperor leads him into Rome on foot.

The balance of power between the papal see and the various monastic orders was likewise translated into visual images by the popes. Innocent III (1198–1216) commissioned a work to depict the relationships between the papacy and the Benedictine order for the pilgrim convent of Sacro Speco, outside Subiaco, where Benedict had sought seclusion as a hermit: in addition to portraits of the founder, the abbott and himself, Innocent also had the text of his bull conferring privileges on the Benedictines included. Most of the popes who acted as patrons of art had their own portraits included in the programme of decorations; Gregory IX (1227–41) had his portrait made whilst still a cardinal, also adding Gregory the Great and St Francis to the cycle[18].

In the great basilicas of Rome decorations were restored and additions made in the course of the thirteenth century. The popes validated their divine authority by including images of St Peter as he received from the figure of Christ the keys symbolizing this authority. Shortly before 1280 Cavallini painted a vast sequence of paintings for the nave of S. Paolo; he rendered scenes from the Old Testament between a higher row of forty-four standing saints and a lower row of medallions with portraits of popes. Those who had commissioned the work also appeared on the walls: they included two abbots, John VI and Bartholomew, Cardinal Gian Gaetano Orsini, who was Deacon of S. Paolo, and the sexton Arnolfo[19]. The apse mosaic had a portrait of Honorius III (1216–27), a member of the wealthy Savelli family at prayer[20].

The feudal family that played a pivotal role in the consolidation of

patronage in Rome, its blossoming in Assisi and its spread to other cities was the house of Orsini. Gian Gaetano Orsini was pope (taking the name of Nicholas III) from 1277 until his death in 1280. He had portraits of himself painted on a memorial in St Peter's and on the walls of the Nicholas chapel in the Lateran palace[21]. A nephew of the pope's, Matteo Rosso, became Cardinal Protector of the Franciscan order in 1288, and was also the archpriest of St Peter's; he was succeeded in both these functions by Napoleone Orsini. The Orsini thus played a prominent part in the patronage associated with St Peter's and within the Franciscan order[22]. Other members of the family rose to acquire such titles as Roman senator and *rettore* of Romagna[23]. The Orsini arms were included in the painting of the Capitoline palace in S. Francesco, thus forging a direct visual link between Assisi and Rome[24].

Various factions struggled for ascendancy in Rome and the surrounding area, of which the Orsini was only one. The rival Colonna family was also to take a leading role in the patronage of the period, for instance through Jerome of Ascoli, a supporter of the Colonna rather than the Orsini faction, who became Pope Nicholas IV. Jerome succeeded Bonaventure as Minister General of the Franciscan order; he became cardinal in 1278 and pope in 1288 – the first Franciscan to reach the Apostolic See[25]. As pope he played an important part in patronage on the interface between his order and the *Curia*, his decisions tending to favour the existing churches of Rome[26]. In the apse mosaic of S. Maria Maggiore Nicholas IV was portrayed in prayer with Cardinal Jacopo Colonna. He ordered restorations to be made in this church, which encompassed the building of a transept, a new apse and the construction of funerary monuments. In St John Lateran, too, he had a portrait of himself in prayer included in the apse decorations; in the course of the renovating work he also secured places in the apse mosaic for the founder of his order, St Francis of Assisi, as well as an important follower of Francis, Antony of Padua[27]. The inclusion of two Franciscan saints was later frowned upon by Boniface VIII. He decided to have the offending portraits removed, but Franciscan legend has it that an accident prevented him from doing so[28].

The Franciscans acquired two large churches in Rome, both decorated by Pietro Cavallini. In S. Maria in Aracoeli, in the lunette above the recumbent statue of Matthew of Acquasparta, Cavallini painted the cardinal praying to the Virgin, with St Francis presenting him[29]. This commission for the memorial to Matthew, who had died in 1302, was but one part of an extensive series that also included the construction of a monks' choir in

the nave surrounded by walls and two raised pulpits, and the building of memorial chapels for members of the wealthy Savelli family[30].

Churches in the area surrounding Rome also benefited from the upsurge in *Curia* patronage[31]. Paintings of Franciscan saints were introduced into church decorations by members of the order who had risen to the office of bishop, cardinal or pope. Where such patrons had a large share in the construction and decoration of order churches, Franciscan saints came to be the very focus of the visual images displayed.

Most monumental decorations in the thirteenth century, however, adhered to established tradition. Time-honoured customs were followed respecting the way commissions were issued, the role accorded to artists and the images to be represented. Neither painters nor monastic orders were of great importance here. But the friars discovered that the papal tradition offered scope for innovations; they took advantage of this, infusing new energy into the workings of patronage, and their commissions had a major impact upon art. This happened especially in towns at some distance from Rome, towns with less entrenched and less celebrated traditions to uphold. The regeneration that would eventually spread throughout Italy received a decisive impulse in the town of Assisi.

CURIA AND FRANCISCANS IN ASSISI

In 1253, two months after the consecration of S. Francesco in Assisi, Innocent IV (1243–54) issued a bull enabling the friars to finance the building and decoration of their church. For twenty-five years the Franciscans were to be permitted to spend the alms and donations they received on commissions to artists. Existing privileges were thus formalized, clearing the way for the friars to patronize art and architecture on a grand scale[32].

The attention Nicholas IV paid to S. Francesco in Assisi was second only to his concern for the Roman basilicas. He renewed the indulgence that had been granted in 1253; in 1288 he decreed that S. Francesco and S. Maria de Portiuncula in Assisi should be maintained, enlarged and decorated using gifts of money received by the order, wishing to enable them to 'manifest excellence in architecture, and a preference for sumptuous decoration'[33]. With this aim in mind he donated all the items necessary for the papal altar in the Upper Church: vestments, an adornment for the front of the altar, money for the liturgy and a precious chalice bearing portraits of Franciscan saints – and of himself[34].

Nicholas IV's actions served to consolidate the ties that had been growing since 1210 between the *Curia* and the mendicant orders. The popes recognized the friars as full priests and placed them directly under papal authority, without the mediation of bishops. A series of papal bulls extended to friars the right to celebrate Mass, to administer the other sacraments, to preach in church and to ring church bells; moreover, something of particular importance from a financial viewpoint, they were empowered to grant indulgences and to use the gifts of money they received in return to fund artistic commissions.

The commune of Assisi also contributed to the growing magnificence of the town's church and convent. Endorsing the papal decrees, the commune took measures to initiate the building of a large square[35] and, at the same time, citizens, princes and prelates began to donate sums of money to S. Francesco. These diverse initiatives combined to produce, in a little over a hundred years, a church that lacked nothing in the way of furnishings, equipment and decoration, and whose aspect formed an impressive whole[36].

Shortly after 1260 Bonaventure had been entrusted with the task of writing a new life of St Francis; the resulting *Legenda Maior* and *Legenda Minor* portrayed St Francis's life as modelled on that of Christ. Bonaventure's material was the story of an ambitious youth's uncompromising behaviour and his decision to forgo both the adventurousness of the life of a knight and the riches of a merchant and to opt instead for the life of a monk. Bonaventure worked this material in such a way as to reconcile the story of a revolutionary individualist, intractable though elements of it were, with the conservative principles of government advocated by the papal court. Bonaventure also wrote a treatise in which he drew up tables of theological and cardinal virtues, providing a systematic basis for the ideals of civilized conduct[37].

St Francis's life, his relationship with the *Curia*, the miracles ascribed to him and the virtues he represented, were depicted on the walls of the Lower Church. Opposite the images of Francis, painted in about 1260, appeared similar scenes from the life of Christ. The Lower Church functioned not only as a monks' choir and a centre of pilgrimage, but also as the Franciscan burial church; countless tombstones commemorating confrères came to be inserted in its floor. Between 1290 and 1315 certain highly placed Franciscans wishing to be buried close to the most sacred part of the church founded their own burial chapel; for this purpose, holes were hacked in the wall, and in about 1300 the choir wall was taken down, enlarging the choir and providing material to be used in the construction of the new chapels[38].

Because of these operations it was decided to commission a similar, but more elaborate, cycle of frescoes for the Upper Church, the new focus of pilgrimage. The paintings would honour St Francis and Christ, and they would also bear witness to the shared glory of the *Curia* and of the Franciscan order.

UPPER CHURCH: THE HISTORY OF THE ORDER

In 1272, when his presence had been required in S. Maria Maggiore to witness the signing of an official document, the Florentine painter Cimabue had seen depictions of the beheading of Paul and the crucifixion of Peter; afterwards he came across similar historical representations in other Roman churches[39]. In about 1285 he decorated the papal choir established in the nave and transept of the Upper Church of S. Francesco with images of these scenes, also painting representations of the Virgin Mary and St Michael, to whom altars in the church were dedicated.

The commissions issued to Cimabue emerged from decisions taken in Assisi by the general chapter of the Franciscan order in 1279[40]. At this assembly, convened to discuss the order's general policy, the rules governing church decorations had once again been restated; the friars affirmed their adherence to the Cistercian principles by which it was deemed undesirable to include any decorations in the form of windows, statues, paintings or books that manifested excess – either in terms of content or in terms of sheer size[41]. During this period, which extended from about 1250 to 1320, the borderline between usefulness and redundancy was hotly debated; meanwhile it remained possible to spend large sums of money on artistic commissions. The Franciscans' rule of poverty and their statutes prohibiting undue luxury had enabled their order to flourish and by no means presented an obstacle to the building and lavish decoration of churches. On the contrary, the statutes tended to encourage donations with which art could be financed.

In the nave of the Upper Church, which was frequented by large numbers of lay people as well as friars, twenty-eight images were painted in illustration of St Francis's deeds and moral principles, each one bearing an explanatory quotation from Bonaventure's *Legenda Maior*. Francis was born in Assisi in 1182, the son of a prosperous merchant. He developed an aversion to the culture of his own family and of their circle, however; he felt no affinity with those who were eager to take up arms or to make their

fortune. It was at the age of twenty-five, according to legend, that Francis entered upon a simple life which would chiefly be marked by poverty and devoutness.

The frescoes bring out various facets of historical and contemporary social life. The cycle opens with the story of Francis's conversion. A man of the people kneels in the main square of Assisi before the wealthy youth, who proceeds to renounce his possessions, including his rich clothes. In the fifth scene the Bishop of Assisi is seen taking the young man into his protection, shielding him from his indignant father. After this Innocent III dreams that Francis supports the Lateran church as it starts to collapse, and he is received at the Lateran palace. During a public consistory, held in 1210, the pope sanctions the code of conduct devised by Francis for his followers. Innocent III tells Francis that those who follow him should be tonsured, so that they may preach the word of God as religious men. Surrounded by cardinals clad in lavish robes, the enthroned pope blesses Francis, the latter now appearing with the status of the leader of a new monastic order with its own distinctive attire: a coarse woollen habit encircled by a cord.

Francis's efforts to achieve social harmony are illustrated by a scene that shows him, after his visit to Rome, driving the demons from Arezzo, or in the words of the accompanying text: 'The demons disappeared, and peace was once more.' The fresco cycle goes on to show Francis preaching to the sultan, to the birds in the vicinity of Assisi and then once again in Rome, to Honorius III, who had passed the formal edict approving the Franciscan rule in 1223, after certain modifications had been made.

Some of the scenes painted serve to enhance the parallel drawn between the life of St Francis and that of Christ, such as those showing him receiving the stigmata and those depicting his ascension. There is an image of an unbelieving nobleman assuring himself of the authenticity of the stigmata, whilst St Clare laments the death of her confrère. After his canonization in 1228, Francis appears to Gregory IX. Following the usual custom, the fresco cycle concluded by depicting a number of miracles ascribed to the new saint.

It is clear that in devising these images historical accuracy was subordinated to the wishes of an élite within the order who had close ties with the *Curia* and wished these ties to be accentuated. The story of Francis's life is played out against a background of church buildings with richly decorated façades and interiors boasting marble structures – in short, a setting more appropriate to the *Curia* of 1300 than to the Franciscans of the

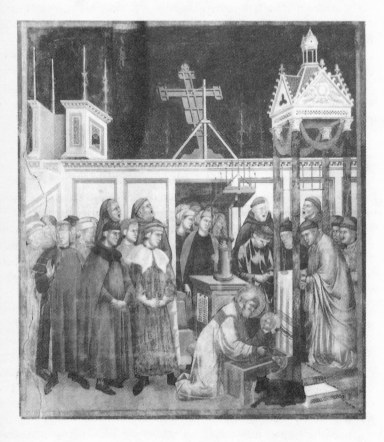

2. Giotto, *St Francis at Christmas celebrations in Greccio*; Upper Church of S. Francesco in Assisi, 1295–1300 (photograph Alinari)

period depicted, that is to say the early thirteenth century (see fig. 2). The judicial and ceremonial requirements of what had become an established ecclesiastical organization superseded the oral and literary tradition that told of a fraternity that had actually opposed the establishment in the years from 1210 to 1250. Francis is depicted as the founder of an order approved by papal edict, who is himself received at palaces and whose followers have monumental church buildings at their disposal. The unifying theme of the fresco cycle in the Upper Church of S. Francesco in Assisi, then, is the integration of the new Franciscan order with the *Curia* and the fast growing communes, as it pleased the papacy to contemplate it towards the close of the thirteenth century.

LOWER CHURCH: PATRONS AND SAINTS

Various individual members of the *Curia* ordered decorations for chapels in the Lower Church, as their predecessors had done in the churches of Rome. In thematic terms such images integrated traditional religious doctrine with the new Franciscan ideals and elements that simply served to enhance their own self-image. The clerics who ordered the construction of burial chapels in the Lower Church included Napoleone Orsini, Teobaldo Pontano – the Franciscan Bishop of Assisi – and Cardinal Gentile Partino da Montefiore, all three of whom were of wealthy families whose estates lay between Rome and Assisi. In the chapel built in the eastern transept Napoleone and Gian Gaetano Orsini commissioned portraits showing themselves worshipping St Nicholas, to whom this chapel was dedicated. In an early version the paintings included a larger group of prelates belonging to the influential Orsini family[42]. Cardinal Napoleone Orsini also founded a burial chapel dedicated to St John, but its decoration was left unfinished at his departure for Avignon, and he was buried in St Peter's.

Immediately upon the completion of the St Nicholas chapel, around 1308, frescoes were painted in the Magdalene chapel, the commission having been given by Pontano, previously Bishop of Terracina. This see lay in the kingdom of Naples, then ruled by Robert of Anjou, whose artistic patronage extended as far as Assisi. Pontano is depicted praying to St Mary Magdalene and to St Rufino, the patron saint of Assisi[43].

The chapel founded by Cardinal Gentile Partino, a Franciscan from Montefiore, drew more heavily on the available funds than any other. Cardinal Gentile had served the court of Anjou as a diplomat in Hungary,

and on his return he was charged with overseeing the transport of the papal treasures, temporarily stored in the burial church of S. Francesco, to Avignon. In the course of this journey he passed through Sienna and then met with an untimely death at Lucca. A memorial to him was erected at Montefiore, and two chapels were founded by him in S. Francesco. The life of St Martin, the patron saint of the church to which Gentile owed his cardinal's title, was painted by Simone Martini, who also portrayed a number of Franciscan saints, including Louis of Anjou – the elder brother of the King of Naples. Louis had died in 1297 and been canonized twenty years later. Another of the artist's works showed his patron at prayer, in a portrait embellished with Gentile's coat of arms[44].

Another Siennese artist, Pietro Lorenzetti, covered the arches and walls of the transept with scenes from the life of Jesus, depicting his youth on the western side and the Passion on the eastern side. When these were completed, pupils of Giotto set to painting the vaults in the crossing[45]. Scenes illustrating the Franciscan virtues of poverty, chastity and obedience are situated above the choir altar, culminating in Francis himself crowned in heavenly glory. The scene depicting obedience shows representatives of the three different branches of the order – Franciscans, Poor Clares and members of the third order, sometimes referred to as the lay brothers.

The choir frescoes as a whole further elaborated and updated the theme of the revolutionary order that had been accepted by the ecclesiastical establishment[46]. In the vault we see a figure beside a kneeling cardinal (presumably Napoleone Orsini, though Jacopo Stefaneschi is another candidate); both figures are affirming their adherence to the ideals depicted in these scenes[47]. The standing figure may be Robert of Anjou, under whose auspices a chapter meeting of the order was held in 1316. This meeting proved to be of great significance for the order and for patronage in Assisi; a new general of the order was elected, and John XXII (1316–34) decided to revise the statutes, specifically the rules relating to the friars' habit, church construction and the fiercely debated Franciscan rules – in particular those relating to chastity, poverty and obedience. The new pope instructed a committee to investigate the controversial order but a temporary compromise was reached, the Pope even issuing a proclamation in which he specifically praised the three Franciscan ideals[48]. For a short time there was a spirit of reconciliation between the Pope and the order – and also between Spirituals and Conventuals, that is, the stricter and the more moderate sections of the order. This spirit of compromise was reflected in the themes elaborated in the paintings above St Francis's tomb: they

focus the friars' attention on the Franciscan ideals of poverty, chastity and obedience as shared – for a few years at any rate – by Franciscans and *Curia* alike.

In the summer of 1319 the generous flow of funds patronizing the art of painting in Assisi came to an abrupt halt. Various works begun in the Lower Church were left unfinished, and painters moved on to take employment elsewhere. September saw a Ghibelline uprising during which the treasure belonging to the church was stolen; the bishop was forced to flee, and the order fell prey to deepening internal divisions[49]. At this point John XXII made the papal disapproval of the Franciscan order more explicit, drawing up statutes in 1336 in which some of the controversial Franciscan ideals that the pope had left intact in 1317 had vanished[50].

Once situated in Avignon, the *Curia* was unable to maintain its ties with Assisi. After a period of over seventy years in which an alliance between the *Curia*, the mendicant orders, the rising communes and a few powerful feudal houses had sustained a grand network of artistic patronage, this alliance lost its authority over Latium and Umbria, and the fertile stream dried up. It was decades before any system of patronage would be revived, and the innovative example provided in these years would never be re-covered. The effect achieved, however, was already very great: the painting commissions given in Assisi had made an impact on work done in churches throughout Italy.

MENDICANT CHURCHES AND THE DISSEMINATION OF IMAGES

In the first four decades of the fourteenth century the life of Francis, modelled on the paintings in Assisi, came to grace the walls of dozens of Italian churches. Such paintings generally appeared in the apse, referred to as the *cappella maggiore*[51]. In almost every city elaborate historical sequences could be seen, portraying not only the life of Francis but frequently also those of Clare of Assisi, Antony of Padua and Louis of Anjou[52]. In Sienna, for instance, a painting showed a public consistory that had been dignified by the presence of the King of Naples; the focus of attention was on the Franciscan Louis of Anjou, as he was being received in his new exalted position of Bishop of Toulouse by Pope Boniface VIII.

It was not unusual in the thirteenth and fourteenth centuries for historical scenes portraying Franciscan saints to be accompanied by parallel scenes

from the lives of Jesus, St John the Evangelist, the Virgin Mary or early Christian saints. In addition to such narrative cycles there were countless full-length pictures of saints of a particular order, often with the individual who had commissioned the work included in the painting kneeling in devotion[53].

The decisions that led to paintings being commissioned for a church were not taken in isolation. Many friars at different levels within the order's hierarchy had frequent contact with the *Curia*. This was a particular responsibility of the cardinal protector, one of the two highest offices in the order, and there were other members of the order who could communicate freely with the *Curia* by virtue of their position, having risen to the rank of bishop, cardinal or even pope. Furthermore, Franciscan guardians and their equivalents among the Dominicans – priors and subpriors – were supervised by provincial ministers. Such a structure assured the *Curia* of a measure of influence in determining the nature of artistic commissions.

The mendicant orders were indeed characterized by a far more tightly-knit organization than were the older orders, and at the same time the friars were a good deal more mobile. There were regular opportunities for the exchange of ideas, such as visitations, diplomatic missions, consistories, conclaves and chapter meetings, and once the main business of the day had been concluded artistic commissions would rank high on the agenda of matters pertaining to the order. The interlocking lines of communication between friars at various levels within the order provided the dynamics of a system of patronage that reached out in all directions.

Once Franciscans had begun to celebrate their saints in church paintings, Dominicans, Carmelites, Servites and Augustinians took to following their example. These orders only ventured into monumental narrative murals on a less grandiose scale; in this area the Franciscans remained pre-eminent. These other orders, especially the Dominicans, tended rather to concentrate on commissioning diverse panel paintings for their churches.

It is a difficult enough task to unearth the original circumstances in which frescoes were commissioned, but where panel paintings are concerned the problems are multiplied many times over. The remarks made in the Introduction concerning gaps in our knowledge are acutely relevant here. This is not only because many works have been lost and almost all those that have been preserved have been moved and their constituent parts separated. These problems are compounded by the fact that the interiors of the original churches have been refurnished and rearranged, and the rituals common at the time have been largely superseded. The written sources of

information are fragmentary, but sometimes, when they are taken together with sources that have become available more recently, such documentation runs entirely counter to prevailing schools of thought[54]. At the present stage of scholarly endeavour it has become essential to split up the general issue of the connection between power and art into a number of distinct points. In so doing we will find that some of the key questions to be explored are virtually archaeological in kind. We need to know how the interiors of mendicant churches were arranged. We need to discover the subject, size and proportions of the panel paintings themselves and where they were situated in these churches. In this context we shall try to discover who gave commissions or advised on them, what sections of society actually looked at the pictures and what functions the paintings fulfilled. In answering these questions we shall come closer to understanding the dynamics of a patronage that enabled the art of panel painting to flourish and diversify.

2. A NEW SYSTEM OF PANEL PAINTINGS

══════

FROM SACRED TO PROFANE: A SPATIAL HIERARCHY

'And there are three parts to the church: first there is the monks' choir or oratory, which is closed off so as to be separated from the laity; then there is the choir for the laity, in the second part of the church; and thirdly there is the foremost part, which is called the women's church and in which four altars were erected and stalls made for the pious women who come to services'[55]. This was how the Dominican prior of S. Marco in Florence sketched the broad interior divisions of his church, and it is a description that would have applied equally well in the case of the main Dominican church in Florence, S. Maria Novella[56]. At right angles to the nave of S. Maria Novella was a rood screen (*tramezzo* or *ponte*): a monumental structure with a gallery running along the top, the whole formed by arches built against a stone wall and supported by pillars[57]. To reach the gallery one ascended a flight of steps by the convent door, beneath the organ. This construction had pulpits to accommodate preaching and singing, and it could also be used for religious plays: puppets or actors might be seen flying from strings there on the Feast of the Annunciation or Ascension Day. There were chapels on the gallery, as well as underneath it: little rooms with altars, each maintained and used by a fraternity or a family.

Doors in the *tramezzo* led to the laymen's choir, behind which the monks' choir nestled, enclosed by walls about two metres high[58]. Inside these walls there were places on each side of the choir door for the prior and subprior, the choir stalls extending square to them, and two lecterns: one for Mass and antiphons and the other for readings from the Bible, from the lives of saints, or from the martyrology – a book recording the deaths of monks and of the order's benefactors. At the boundary between the choir in the nave and the rectangular *cappella maggiore* stood a large stone pulpit from which the monks and the *conversi*, who were not ordained, would be addressed[59]. The *cappella maggiore*, containing the high altar, was where the monks celebrated Mass; there were other Masses in adjacent chapels, the

most important of which was the one closest to the high altar. Thus the church was divided by numerous partitions into sections reflecting progressive stages from the church door leading from the profane world outside to the most sacred place of all (see fig. 3).

The monks' choir in the nave – like the canons' choir, to which we shall return in due course – had three functions. First and foremost, it was the place where the religious community assembled up to seven times a day for prayer and song. Divine office was held at intervals from early morning to late evening, the monks sitting or standing in rows facing each other. Second, Mass was celebrated daily at the high altar, involving both the monks' choir and the *cappella maggiore*: this took place with particular ceremony on holy days. And third, memorial services were held for the departed members of the order: monks would pray for their rest and remember their role in the convent. These services would usually take the form of Masses celebrated on behalf of a particular foundation, and would include readings from the martyrology. All the arrangements of the choir – its stalls, lecterns and altar, and also the larger structure of dividing walls, gates and openings – were designed to accommodate these three different kinds of ceremonies held regularly by and for the priests of the convent[60].

There were shrines at various places between laymen's nave and monks' choir. For instance, by the wall between the 'women's church' and the laymen's choir, in S. Maria Novella, rose the memorial to the blessed Giovanni di Salerno, founder of the convent, flanked by a large number of votive offerings[61]. Further into the church, by the choir wall, was another place of worship, in honour of the Dominican saint Peter of Verona; miraculous powers were ascribed to his image, which was housed within a tabernacle[62]. He had been attacked and killed in the forest on the way to Milan in 1252 and had been canonized a year after his death. At a later date a third monument was erected, to another Dominican saint, Vincent Ferrer.

The positioning of shrines and images is of great importance. When we are speaking of the interior space of a mendicant church we are in fact dealing with a number of different spaces, which also constituted different situations from the point of view of artistic commissions. There was always a laymen's section or 'women's church', an element quite absent from the older convent churches, containing altars with relics of saints of the order for the people to worship. There was often a middle section, used primarily as a laymen's choir and bounded either by a simple wall with one or two pulpits or by a full *tramezzo*. Finally, enclosed within a space often known as the *chiesa di sopra*, there was the monks' choir and, facing it, the *cappella*

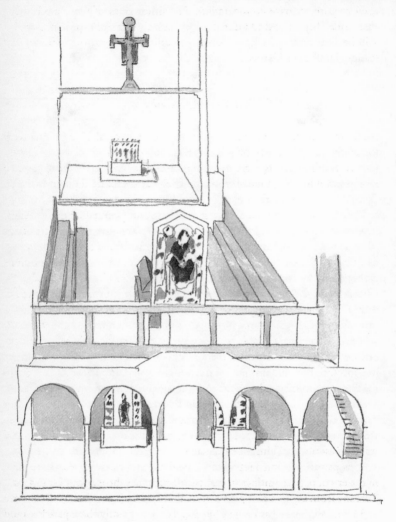

3. A system of panel paintings from profane to sacred in a mendicant church, *c.* 1320 (drawing Bram Kempers)

maggiore. The lay altar with relics, the laymen's choir and the monks' choir each require separate consideration. The other areas of the church – the many side chapels, and additional spaces such as chapter house and sacristy – will be dealt with in a later chapter in connection with the patronage of leading families in Florence.

THE PEOPLE'S SAINTS

Saints were traditionally buried in a crypt under the altar[63]. Alternatively the coffin might be raised on pillars in the choir or overhung by a baldachin. But as the mendicants increased the number of shrines, they also devised new ways of housing them outside the choir, thus making them more easily accessible to the laity than those located in the crypt or choir.

This may be illustrated by the situation in the Lower Church at Assisi. Within the monks' choir of this church, under the altar – which paintings show as having been overspread by a monumental canopy – lay the tomb of St Francis[64]. Laymen were admitted to the shrine only in exceptional cases, the doors in the *tramezzo* usually remaining closed. What the lay churchgoers saw was a wall rising to more than two metres, the upper storey of which bore an altar, a painted cross, an organ and a stone pulpit[65]. We know of an incident occurring in 1253, in which one of the stones in the pulpit came loose and fell into the congregation during a sermon, seriously wounding a woman. Bonaventure records that she was saved from death by the miraculous intervention of the church's patron saint[66]. From the description of this legend and from the information we have of other churches, we can deduce that the lay population was able to see an altar dedicated to Francis – an altar accompanied by a panel painting, with a full-length depiction of St Francis at its centre and episodes from his life and miracles ascribed to him on either side.

This pattern – saint, biographical incidents and miracles – was repeated in dozens of panel paintings in Franciscan churches throughout Umbria and Tuscany from about 1228, portraying other saints of the order, such as Clare and Dominic, as well as Francis (see fig. 4)[67]. Frequently these panels would be high rather than wide (unlike the one mentioned in the previous paragraph), often more than two metres high and a little over one metre in breadth, coming to a point at the top. Whatever its shape, this was a type of panel frequently commissioned for a reliquary, and it was sometimes fitted with locks and doors if it was actually part of the reliquary[68].

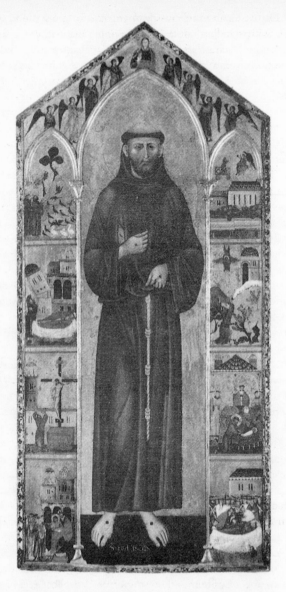

4. *St Francis with scenes from his life, c.* 1300; Pinacoteca Nazionale, Sienna (photograph Grassi)

Sienna provides an excellent starting-point for a discussion of this type of panel, with standing saints in the middle and narrative scenes round about. Mendicant churches also served as parish churches, and the people of Sienna came to the choir partition to worship as saints some of the more exemplary – and consequently beatified – of their departed fellow citizens[69]. A special place was assigned within S. Domenico, for instance, for the people to pray to Andrea Gallerani, who was a banker's son and lay brother. He had died in 1251, and about twenty years later a statue was added above his grave, with painted shutters: the outside depicts the new saint, bearing the name 'S. Andreas', accompanied by four faithful Christians, one a pilgrim. The inside shows Gallerani distributing gifts among his needy fellow citizens and worshipping the crucified Christ. Painted above are older saints of the order: the blessed Reginald, St Dominic and St Francis[70]. The importance of this shrine was emphasized by the fact that an indulgence was granted to its visitors in 1274 and corroborated by the attention paid to its renovation in around 1330 – work that included the painting of a large new panel of Gallerani and the miracles ascribed to him[71].

Other churches in Sienna also made provision for the worship of such local saints: S. Maria dei Servi had one such monument to the Siennese citizen Giovacchino Piccolomini, which bore representations of episodes from his life and miracles he was thought to have performed[72]. In S. Francesco there was a memorial to Pier Pettinaio, a comb-maker and member of the third order who was mentioned by Dante; in 1296 the commune donated forty candles to be used at memorial services to this illustrious townsman[73].

The Siennese church of S. Agostino commands our especial attention, being the only church for which we have explicit documentation for the location of a saint's altarpiece; it contained the tomb of Agostino Novello and an altar erected in his name[74]. His festival was apparently celebrated at least as early as 1324, as there are records of some of the revenue collected by city tax officers being used to fund it in that year[75]. The monuments were situated in the usual place, in the 'women's church' by the choir wall. Between 1324 and 1329, on both sides of the opening in the coffin, Simone Martini painted scenes from the life of the 'New Augustine', showing him successively turning his back on political life, taking his religious vows to the Augustinians and being ordained[76]. The altarpiece had depictions of miracles wrought posthumously by Agostino Novello, beside a full-length portrait of the man – a pensive figure at whose ear an angel hovers, whispering his news of those in need of help (see fig. 5). It would appear

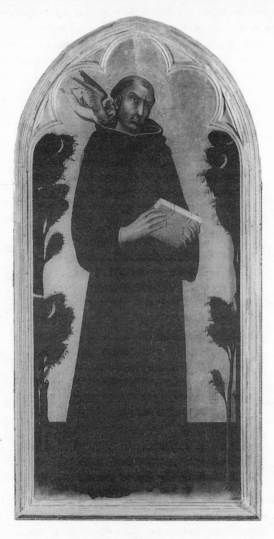

5. Detail from Simone Martini, *Agostino Novello with scenes from his life*, *c.* 1329; Museo dell'Opera del Duomo, Sienna (photograph Grassi)

from the accompanying scenes that the saint was famed for springing to the aid of groups as diverse as children and knights in armour: he assists the desperate mother of a child that has already been bitten badly by a snarling dog despite her efforts to fend the animal off with a stick; a second scene shows the saint rescuing a child who has fallen from a rickety wooden structure to the ground below, and again there are grateful parents embracing their son and praying to Agostino. The first of the scenes painted on the right of the saint depicts him coming to the aid of a knight who has been thrown from his horse in the mountains to the south of Sienna, and the final scene again concerns a child. This time it is a baby in its bed whose injuries are healed, the family showing their gratitude by determining that the child will enter the Augustinian order[77].

What these examples show is the function fulfilled by the miracles of these new saints in expressing what was beyond human powers, or even beyond comprehension. The doctors at the infirmaries often proving inadequate, the sick and their relatives ascribed special powers to those now deceased whose lives had been exemplary. There was an immediacy about the way their memories of these virtuous citizens played through people's lives, colouring their experience of illness, accidents and death. Such saints played the same role as the Virgin Mary, their worship supplying a vehicle for the expression of hopes and fears, and they were entrusted with the solution of problems to which the people had no answer, as it was believed that they possessed the power to reverse fortune[78]. The miracles ascribed to saints filled the gap between a keenly felt need for care and attention and the limited extent to which people were able to fulfil this need for each other. Thus where there was a shortage of competent doctors the belief would take root that cures could be effected miraculously, and where the army was thought to be weak, the conviction prevailed that it could be made mightier by the force of prayer.

The worship of exalted citizens like Agostino Novello was not just a matter for the order – it involved a large part of the community as well. When the Augustinians requested money to help finance the festivities held in the saint's honour the city council granted the requisite support, justifying their decision by pointing to the great beneficence of Agostino, who in his saintliness and affection for Sienna had done so much for the town; his interventions in heaven had contributed to the peace of Sienna. Such was the pragmatic drift of the commune's reasoning, and in consequence the city's representatives saw fit to promote the worship of the Virgin Mary and a number of established saints as well as five new saints[79].

The worship of saints thus played a key role in the life of civic communities – Sienna is of course only one example. Shrines installed for such worship, each with an altar, an image of the saint, scenes from his or her life and posthumously performed miracles – usually shown on a painted altarpiece – frequently accompanied by a coffin or reliquary as well, became a widespread feature of mendicant churches. These memorials were sometimes located at the choir wall and sometimes at the *tramezzo*, and there were churches with several monuments to saints, for instance one on either side of the door to the presbytery[80]. Such altars played a considerable role in stimulating donations to augment the funds of the order, finance festivals and purchase more items for the church, such as images of saints[81]. The friars reaped the returns of their investments as well as their principles: their standards of individual and collective poverty facilitated their acquisition of gifts and offerings, but so did their dedication to lay forms of worship[82]. On religious festival days priests would carry portable reliquaries around the streets to encourage the laity in their churchgoing, as well as to prompt them to make extra donations[83]. The friars could put all this income to good use, expanding in turn the services provided to the laity, whilst at the same time consolidating their own position.

As far as the panel paintings with one central saint are concerned, it is clear that these were primarily functional rather than decorative and were not intended for the choir altar[84]. They played a major part in lay worship, both within the local community and as focuses for pilgrimage. The latter was of particular significance in the case of pilgrim churches such as S. Francesco in Assisi and also in the case of churches pilgrims passed on their way. The local people would come to face the saintly images on diverse occasions: here they would fulfil their vows of penance or pray that a disease might be cured; here they earned indulgences and brought their offerings. The mendicant orders played a crucial role in these practices: the friars were responsible for the large-scale introduction of new saints that were originally from the urban parishes, and also for ensuring that the laity worshipping at their churches came into contact with more and more religious paintings.

MONUMENTAL PANEL PAINTINGS FOR THE LAYMEN'S CHOIR

The demarcation point between monks' choir and laymen's choir was a location *par excellence* for images on which the people could focus their

attention. It seems highly likely, indeed, that other, larger panel paintings were also situated at this point. In fact, the evidence suggests that this was the position originally occupied by works such as Duccio's panel of the Virgin Mary, known as the *Rucellai Madonna* (see fig. 6).

This famous painting was commissioned by the members of a Florentine choral confraternity. On 15 April 1285 the officers of this society, 'in their capacity as rector and clerk of works for the aforesaid Society, assigned to Duccio di Buoninsegna, the painter of Sienna, for painting with the most beautiful picture a certain large panel ordered to be made for the aforesaid Society in honour of the blessed and glorious Virgin Mary . . .'[85].

The religious status of the members of this confraternity dedicated to Mary was between those of ordinary laymen and monks. They were neither priests nor *conversi*, but many were tertiaries, that is, members of the 'third order', a lay community whose members lived outside the convent. They had a regular share in the life of the church, and they could avail themselves of the gallery of the *tramezzo* for choral or dramatic presentations. In the lay choir it was they who were responsible for singing praises to Mary, earning them the nickname of *Laudesi*[86].

Attending Mass, confession and communion with greater regularity than the general lay congregation, members of the confraternity would offer candles at the high altar in addition to bread and wine. They laboured to acquire such heavenly virtues as humility and patience, and they performed acts of charity. Within the church, in addition to their use of the lay choir and gallery, they had a chapel of their own[87].

The lay confraternity financed the illumination of their panel paintings with a legacy left them by a certain Ricchuccio Pucci, a wealthy resident of the parish of S. Maria Novella and a member of the *Laudesi*. His will, drawn up in 1312, instructed the rector of the confraternity to provide oil to the sexton for 'the lamp of the Crucifix [. . .] painted by the excellent master Giotto' and 'for the lamp of the large panel on which is painted the figure of the Blessed Virgin Mary'[88]. Pucci also left gifts for Masses to be said for him and his family as well as donations to other mendicant churches, and he bequeathed a *Crucifix* painted by Giotto, together with a sum of money, to the Dominicans in Prato[89]. The records of the confraternity include references to the oil purchased, in accordance with Pucci's wishes, and three lamps in S. Maria Novella are mentioned: one is for the *Madonna*, one is for the *Crucifix*, and the third is for the high altar[90]. The records make it clear that the *Madonna*, *Crucifix* and high altar were three distinct focal points within the church.

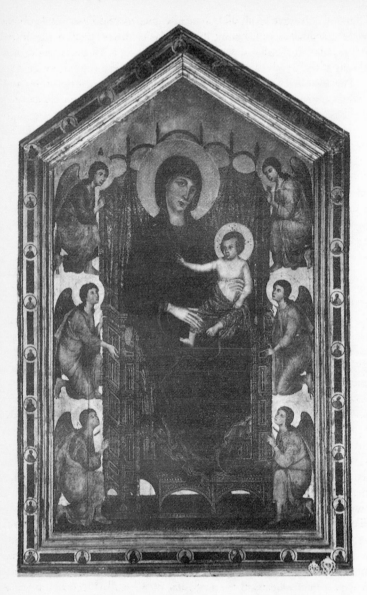

6. Duccio, *Rucellai Madonna*, 1285; Galleria degli Uffizi, Florence
(photograph Alinari)

There is a further piece of evidence to suggest that Duccio's *Madonna* was not intended as a retable for the choir altar: the contract in which the work was commissioned describes the painting as a '*tabula*', without the addition of the words '*super altare*' or '*altaris*' that were commonly used to designate altarpieces. Moreover, features such as the size, proportions and representation do not fit well into the development of panels painted for the altar of the choir, as will become clear. Its sheer size – 4.5 metres high and 1.9 metres wide – disqualifies it from consideration as part of the decorations for a side altar. In short, the evidence relating to the circumstances in which the work was commissioned and the context in which it was to be displayed, added to the spatial implications of the payments made for the lamps, exclude the possibility that Duccio's *Madonna* adorned the high altar and make it extremely unlikely that the work hung or stood in a side chapel[91].

We can learn much about the original location of paintings such as Duccio's *Madonna*, or Giotto's *Crucifix*, by studying the late thirteenth-century frescoes in the Upper Church of S. Francesco in Assisi, which include representations of church interiors. The scene of the verification of the stigmata shows a church with a large transverse beam in the nave to which three panel paintings are attached: an enthroned Madonna resembling that of Duccio, a Crucifix which has a base in the form of a trapezium, as does Giotto's *Crucifix* in S. Maria Novella, and a panel showing St Michael (see fig. 7). Each painting is lit by an oil lamp hanging before it, precisely corresponding to the entries in the records of the *Laudesi*. Another scene of the frescoes, *St Francis at Christmas celebrations in Greccio*, shows a choir altar with a baldachin, behind which is a lectern, and the pulpit at the back against the wall; above the door, the wall bears a Crucifix (see fig. 2). Thirdly, the scene of St Francis in S. Damiano shows the saint worshipping before an altar above which hangs a Crucifix[92]. Thus these frescoes document three arrangements: a hanging Crucifix, a Crucifix on a wall and a row of panel paintings attached to a beam.

There was indeed such a beam in the Upper Church, and until the seventeenth century it bore a Crucifix[93]. Other churches also possessed such beams with panel paintings affixed to them. Coppo di Marcovaldo and his son Salerno painted a *Crucifixion* and a representation of St John the Evangelist for the beam in the cathedral of Pistoia[94]. We can also see a decorated beam, crossing the church and supported by brackets, in the fresco in Todi depicting the death of St Francis[95]. A further example is

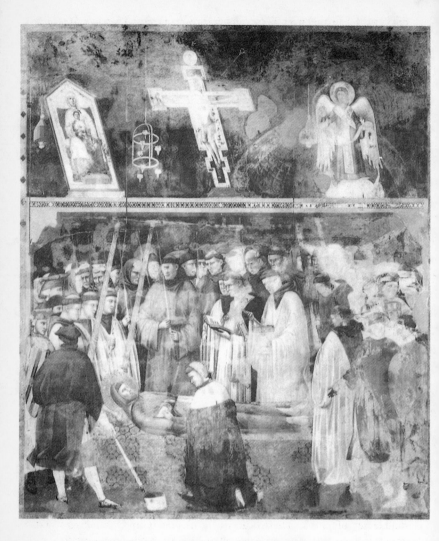

7. Giotto, *Examination of the stigmata of St Francis*, 1295–1300; Upper Church of S. Francesco in Assisi (photograph Alinari)

provided by a panel from Orte, which shows a beam with a painting of St Francis[96].

Giotto's *Madonna* in the Florentine church of Ognissanti was located by the *tramezzo*, as is clear from a document of 1417 granting a citizen the right to an altar. His altar is described as being 'by the noble panel painted by the renowned master Giotto of days past, which is placed in view of all, beside the entrance to the choir, to the right when entering from the street and proceeding to the choir'[97]. A further piece of evidence is provided by Ghiberti, who gave an overview of Giotto's work in the Ognissanti in about 1450[98]. He explicitly distinguished between altarpieces, panel paintings of Our Lady, and a Crucifix[99]. The scheme of the Ognissanti, and also of S. Giorgio in Florence and S. Maria sopra Minerva in Rome, each point in turn to the existence of large panel paintings at the choir partition[100]. The large panels depicting an enthroned Madonna and the stigmatization of St Francis in S. Francesco in Pisa also fit this pattern (see fig. 8)[101].

It was apparently customary to arrange various images – including a Crucifix and a Madonna – on beams ranged one behind the other from the *tramezzo* almost up to the high altar. That this was common is confirmed by traditional arrangements in Rome. When directions were issued for the interior of churches, explicit mention would be made of structures to which images, cloths and candlesticks could be attached. On the nave side of the high altar in St John Lateran, Constantine ordered that free-standing columns should be erected with a tympanum to bear a series of images on both sides[102]. This triumphal arch, known as a *fastigium*, stood at the end of a central aisle, which was enclosed by two low walls and was used for processions to the presbytery with the altar and cathedra. These elements – closed aisle, *fastigium*, high altar and bishop's throne – were the Christian innovations introduced by Constantine to a basic structure deriving from imperial tradition. In St Peter's the long aisle was replaced by a choir that was shorter and broader, and there were several transverse connections with images, including a *pergula*, modelled on the Lateran *fastigium* but with a double set of pillars. There was also a smaller beam with images and, connecting up to a large beam, a walking gallery that led through the nave and that was used, among other things, to exhibit relics. Silver images were ordered for the beams, including portrayals of St Peter and the Redeemer together with St Michael, the Angel Gabriel and the Virgin Mary with the apostles St Andrew and St John. A third example that should be mentioned here is S. Paolo fuori le Mura, another Roman church of great significance,

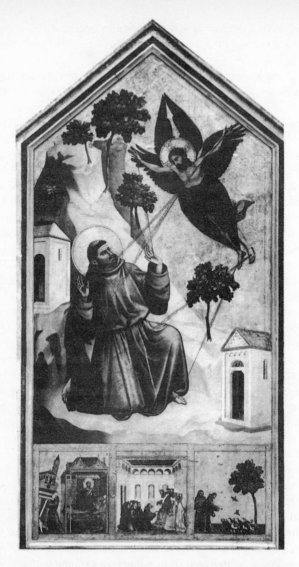

8. Giotto, *Stigmatization of St Francis*; below: St Francis supporting the Lateran; the Rule approved by Honorius III; St Francis preaching to the birds, *c.* 1300 (photograph Louvre, Paris)

which had both a *pergula* and a triumphal beam: each bore pictorial images, and these included a painting of Christ that had movable wing panels[103].

Although the available sources are limited and not always unambiguous in their implications, they suffice to indicate the various standard arrangements of panel paintings in mendicant churches; moreover, the documentation we do have relates to churches that were of particular significance. Particularly large and heavy works would be on the wall, on an architrave resting on pillars or perhaps on a beam supported by brackets; smaller panels would be placed on lighter constructions. Usually there would be a Crucifix in the centre, sometimes a Crucifix beside a Madonna and another panel. Large churches would have an elaborate display, with two or three rows of paintings on constructions spanning the nave, one behind the other. A hanging Crucifix was a variant frequently employed near the high altar. The large mendicant churches with transepts, side aisles, a monumental *tramezzo* and a choir wall clearly had a variety of elevated and prominent locations for different kinds of panel paintings to be displayed (see fig. 3).

The panel paintings alluded to here, like the saints with scenes from their lives and posthumous miracles, were primarily for the benefit of the laity. It was a laity that was increasingly 'clericalized', that is to say that the people were ever more involved in religious matters, often to the extent of affiliating themselves to monastic communities. This tendency was a spur to the friars' artistic patronage, which in its turn played a major civilizing role among ecclesiastics as well as among the various categories of laymen. The cumulative effect between 1250 and 1330 was the development of a far-flung and influential network of patrons, advisers and large sections of the population, with the friars at the focal point.

Commissions might proceed from lay brothers, tertiaries or ordinary citizens. In the case of panels such as the *Rucellai Madonna*, the *Laudesi* were in a sense at both ends of the transaction, ordering a panel that would be a fitting attribute to their song. Illuminated by the large oil lamp and by candles, the Madonna appeared during the services at night seated on her throne, high above the worshippers. From the gallery of S. Maria Novella in Florence the lay brothers sent their harmonious tribute to the Queen of Heaven, where she was seated amidst a host of singing angels; and the wealthy Florentine confraternity could not have ordered a panel more suited to such a context than the massive enthroned *Madonna* painted for them by Duccio of Sienna.

9. Duccio, *The Virgin Mary with St Augustine, St Paul, St Peter and St Dominic, c.* 1310; Pinacoteca Nazionale, Sienna (photograph Grassi)

10. Deodato di Orlandi, *The Virgin Mary with St Dominic, St James, St Peter and St Paul, c.* 1300; Museo Nazionale di San Matteo, Pisa (photograph Alinari)

ALTARPIECES FOR THE MONKS' CHOIR

The paintings of saints depicting episodes from their lives and miracles ascribed to them were variations on existing pictorial themes, and the same is true of the panels at the choir partitions. This is in stark contrast to the painted retable for the high altar, which was an innovation brought about mainly by the mendicants. This altarpiece in the choir also differed from the other images to be found in the church in that it was not intended for a lay public. The decorations for the choir altar were for the contemplation of the priests and assumed a higher level of learning and sophistication in their viewers.

The Master of St Francis painted an early altarpiece for S. Francesco in Perugia, around 1270, which, like the Assisi frescoes, depicted the saint as a Christ figure[104]. It was a broad, low retable, constructed from several panels and painted on both sides. After this date, from Pisa to Perugia and from Sienna to Bologna, paintings of roughly the same size would be found depicting saints of orders on the high altars of mendicant churches (see figs. 9 and 10)[105]. More elaborate was the 'panel for an altar' commissioned from Cimabue in Pisa in 1302, which had separate levels of representation: the panels were separated by small columns, and below the main subject was a predella with a strip of narrative scenes[106].

The tendency for altarpieces to become larger and more intricate was particularly marked from about 1320 onwards, so much so that simple pieces were sometimes replaced. Commissions might be in the hands of the sacristan, such as the energetic Fra Pietro of S. Caterina in Pisa, who ordered a costly new retable for the high altar of his Dominican church in 1319[107]. This sacristan had issued many other commissions, including numerous liturgical vestments and cloths. Not long after ordering the new altarpiece he died in Bologna on his way to order a large crystal Crucifix in Venice.

The polyptych Pietro commissioned from Simone Martini became a landmark in the development of the altarpiece. It consisted of four horizontal and seven vertical rows, spanning a total breadth of three and a half metres. The central vertical row, from the top figure of the Saviour to the figure of Thomas Aquinas at the bottom, gives a visual exposition of the central tenets of Christian theology[108]. The top row is devoted to the predictions of the Old Testament: four prophets stand holding scrolls that bear the initial words of their prophecies, whilst Christ's role as the King is clarified by the figures of David and Moses at his side. The intermediate rows show apostles and saints, including St Dominic and Peter of Verona, and the

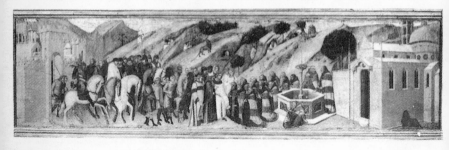

11. Pietro Lorenzetti, *The Patriarch Albert gives the Carmelites their Rule*; below: Honorius III approves the Rule, Honorius IV gives the Carmelites their white habits; Pinacoteca Nazionale, Sienna (photograph Grassi)

bottom row shows Church fathers and later Christian scholars, with Aquinas at the centre. The arrangement of the figures in the entire altarpiece corresponds to the order designated by the Dominicans in theological tracts, which they also taught at their schools and repeated at Mass[109].

The necrology of another Dominican church, S. Maria Novella in Florence, records the death in 1324 of Fra Baro, a scion of the wealthy Sassetti merchant family, a priest and confessor who had been held in high esteem and had risen to the position of subprior of the convent. The entry notes that he – like Fra Pietro in Pisa – had provided the sacristy with a double series of vestments and an altarpiece and had donated altar cloths and liturgical garments for the use of priest, deacon and subdeacon[110]. The altarpiece was accompanied by a *paliotto*, an altarcloth with precious stones and embroidered images that embellished the front of the altar slab on the major feast-days[111]. The altar and the tabernacle themselves had been donated by the Ricci family, whose arms adorned the walls of the main chapel. Yet another family, the Tornaquinci, financed the frescoes painted in the *cappella maggiore* in about 1348[112].

Franciscans as well as Dominicans were involved in commissions that produced a rich store of elaborate ornamentation for their altars. In 1322 the Franciscans of S. Croce in Florence arranged for a polyptych to be made for their church, the work being paid for by the Alemanni family. Executed by the painter Ugolino da Siena, this altarpiece was conceived on the same massive scale as those in the Dominican churches, being more than four metres wide. Rather than depicting isolated figures in the predella, Ugolino painted narrative scenes of the Passion, with the Crucifixion at the centre. The theological import was clarified in the central vertical row of panels by a Madonna and Child, and at the top the pelican that wounds herself to feed her young. Franciscans were conspicuous among the larger paintings of saints, which included St Antony of Padua and St Louis of Anjou as well as St Francis[113].

The new impulses were also felt among the Carmelites in Sienna, who ordered an equally large altarpiece for their presbytery in 1324. They directed that the scenes in the predella, by way of celebration, should depict a condensed history of their order, a history retold in the new Carmelite statutes of that year (see fig. 11). The first scene shows the father of the prophet Elijah, who dreams – as we are given to understand by the text of the hovering angel at his side – of men in white habits greeting each other; then there is a gathering of monks at Elijah's fountain on Mount Carmel; then the hermits receive from Albert, the patriarch of Jerusalem, the rule

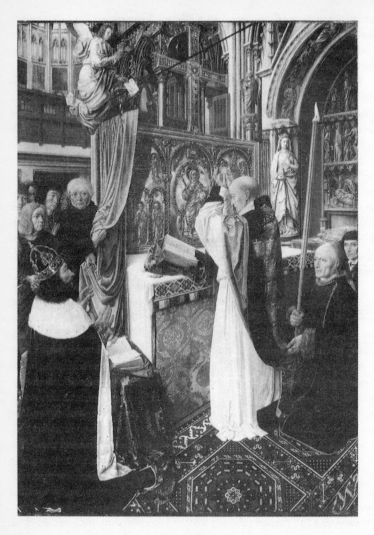

12. *St Giles Mass*, *c.* 1480 (photograph National Gallery, London)

that signifies their recognition as an order; the next episode depicted is Albert leaving the city in 1209 and travelling to the monks, who have by now built a large church, which resembles the cathedral of Sienna; shortly after this, Honorius III receives the Carmelites at a consistory meeting, confirming their rule, and above the enthroned pontiff hovering popes are seen, holding texts that make it clear that this is no new rule, but rather a confirmation of earlier statutes; finally, Honorius IV is shown giving the Carmelites their white habits, and the prophecy of the first scene is thus fulfilled[114].

The Carmelites of Sienna, with the commune's support, also worshipped S. Niccolò, the patron saint of their church[115]. They further paid tribute to the founding prophets Elijah and Elisha, thus emphasizing that their order was of longer standing than that of the Franciscans or the Dominicans. They alluded to this venerable tradition in their statutes, and likewise strove to express it visually – not only, as we have already seen, in the predella, but also in the larger panels of the altarpiece. The central panel has a Madonna and Child with angels, Elijah and S. Niccolò, the whole flanked by full-length renderings of Elisha and St John. Thus the ancient hermits of Palestine were cast in the role of the direct precursors of the oldest urban mendicant order in Italy.

The items used in the liturgy celebrated before these altarpieces can be gleaned from panel paintings and inventories, as well as from miniatures in statute-books and choirbooks (which were large manuscripts full of music and texts that were place on a lectern for the use of the choir). For instance, the painting the St Giles Mass shows a priest in a richly embellished chasuble, his face to the altar as he raises the consecrated Host (see fig. 12). Cloths hang over the altar slab, the foremost a *Paliotto*, on the altar lies a missal, and at the back an altarpiece can be seen, with curtains at the side[116]. This situation corresponds to the choir Mass; it was customary for the priest to stand facing the altar, with his back to the monks in the *cappella maggiore*.

Inventories and church chronicles list the various components that played a part in the friars' worship. Crucifix, chalice and candlesticks were the chief requisites for the altar, as well as a tabernacle or storage place for the Host and an assortment of altar cloths for different feast-days. Then the sacristy would contain vestments for the priest, deacon, subdeacon and acolytes, and vessels in which to burn incense. Within the choir reliquaries were also to be found, as well as smaller icons of the Virgin or of saints,

which would be carried high in ceremonious processions on feast-days, and then set near or even upon the altar whilst Mass was celebrated[117].

Whereas some of these objects had traditionally figured in monastic churches, changes were also being introduced in the familiar furnishings. Such changes had much to do with the priest's position when celebrating Mass – as already noted, he stood in the rectangular apse with his back to the monks. Certain decorations that had found favour in the past, such as marble, baldachins and silver or gold frontals, now fell into disuse. On the other hand, the fixed altarpiece, scarcely seen before 1250, began to dominate the presbytery.

At the choir altar the monks wanted the theological tenets and history of their order, as expressed in bulky treatises and countless sermons in the late thirteenth and early fourteenth centuries, to be rendered in pictorial form[118]. The altarpieces were intended for the priests and *conversi*, who were well versed in the complexities of doctrines such as transubstantiation and incarnation. Advisers on artistic commissions were also drawn from this élite; quite often they issued commissions themselves. The learned friars saw the altarpieces as a synopsis of their liturgical precepts, historical teachings and theological dogmas, also expressed in antiphonaries and missals that were frequently illustrated with pictures of the same saints and historical scenes.

Choices as to the theological concepts, historical episodes and figures to be given visual form were made on the basis of the three different liturgical functions that the friars had to perform. First, there was the annual cycle of commemorative rituals in honour of Christ and the Virgin Mary; these two figures generally featured in the central vertical row of panels, often accompanied by prophets and Apostles and sometimes by a predella with scenes from the Passion. Second, the friars celebrated the calendar of saints' feast-days. Each order and each church had its own catalogue of notable saints, and newly canonized members of the order were accorded key positions, being rapidly incorporated into altarpieces and surrounding frescoes. The friars' liturgy played an important part in the rearrangement and simplification of the calendar of saints. This role was of great moment for the choice of representations in altar decorations, and it also provided the impetus for ordering new decorations for the church. Third, the use of the *cappella maggiore* and choir for special memorial services and readings also found visual expression in the form of images of patron saints and portraits. Portraits would generally grace tombstones or funerary monuments, or they might take the form of devotional figures in an altarpiece,

as in the case of Trasmundo Monaldeschi[119]. In short, the three functions of the services held in the choir and the *cappella maggiore* led to the development of three distinct but interlaced iconographic agendas for the polyptych at the high altar.

The way in which the liturgy was conducted in basilicas in Rome, and in cathedrals and parish churches in other towns, differed from that in mendicant churches in an essential particular. These churches lacked the crucial feature that has been linked above to the introduction of altarpieces; for in their liturgies the priest *faced* the choir and the congregation. This provides the key to understanding why the altarpiece, which rapidly gained such a prominent position in the choirs of the mendicants, made such a hesitant entrance into other types of churches.

A NEW SAINT IN THE CANONS' CHOIR OF ST PETER'S

The Stefaneschi altarpiece, formerly in St Peter's in Rome, has been the subject of much debate (see figs. 13 and 14). The very fact of an altarpiece being introduced into a secular church – especially this, the most important of secular churches – is striking in itself[120]. But conflicting views on its dating, attribution and subject-matter have tended to command most attention, so that problems of its original location and function, and the circumstances in which it was commissioned, have receded into the background[121]. Like other altarpieces we have considered, there is a combination in this polyptych of a new saint and a portrait: Cardinal Jacopo Stefaneschi was painted together with the recently canonized pope, Celestine V. The 'hermit pope' – founder of the Celestine order – had been enthroned in the pontificate in 1294, but resigned this office shortly afterwards and retreated to live as a hermit in the mountains by Sulmona, where he died two years later[122].

Cardinal Stefaneschi frequently paid homage to Celestine, also after the latter had been succeeded by Boniface VIII. The cardinal had a number of miniatures made that depicted Celestine, and shortly after the hermit's death Stefaneschi started to write his life. He later added a biographical tribute to Boniface; together these came to be referred to as his *Opus Metricum*. This tribute, the second volume of Stefaneschi's poetical works, describes the various stages in Boniface's assumption of the papal office: election, consecration, enthronement and *possessio*, i.e., the ceremonious acceptance of the pontificate, in the form of a solemn procession from St Peter's to the

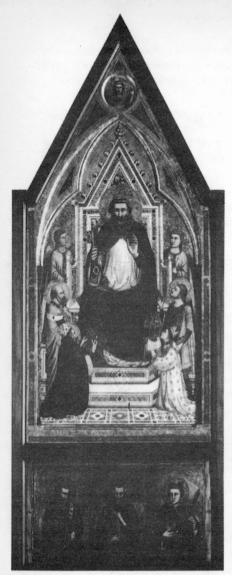

13. Centre panel of *Stefaneschi altarpiece* with Cardinal Stefaneschi and Celestine V before the throne of St Peter, 1330–40 (photograph Vatican Museum)

14. Detail of *Stefaneschi altarpiece*

Lateran. Stefaneschi presented Boniface with an illuminated manuscript of this second volume; one small medallion shows the cardinal kneeling before Boniface; another, a little larger, depicts the pope with his symbolic attributes of *ombrellino* and tiara before the portal of St Peter's atrium, on his way to the Lateran[123]. A third miniature, in contrast, portrays Stefaneschi at a desk by the rock where Celestine has made his abode[124]. The hermit himself is shown with thick grey hair and beard and clad in a simple habit, with none of the papal insignia that so ostentatiously accompany the portraits of Boniface.

Boniface himself was a great patron of art; his commissions were so imposing as to dwarf the early endeavours of the young Stefaneschi[125]. His assumption of the papal office was commemorated in monumental style in a fresco painted in the Lateran. To the left of the pope stands Cardinal Matteo Rosso Orsini, and to the right Stefaneschi as a young man, beside Celestine, whose beard and habit are emblematic of his abdication from the papacy. The group stands on the balcony of the Lateran palace, whilst a huge crowd has gathered in the square below[126]. Both this fresco and the monument erected for Boniface's tomb in St Peter's underscore the grandeur that marked Boniface's patronage.

The years between Boniface's death in 1303 and the move of the papal court to Avignon in 1308 saw drastic changes in the balance of political power. Despite Boniface's attempts to bolster up the pontificate by issuing treatises on papal authority and above all his *Unam Sanctum*, a bull summarizing the traditional tenets of theocracy, it now proved impossible to curb the growing influence of the French court[127].

The major elements of the conflict between French and Italian prelates were the French tendency to glorify Celestine and their attacks on the validity of Boniface's succession. They claimed that Celestine had been forced to resign, and charged Boniface with avarice and the improper use of indulgences and donations in St Peter's. A compromise was finally reached at the Council of Vienne (1311–12) (see fig. 15); the accusations against Boniface were withdrawn, and a document was prepared that provided for the canonization of Celestine, albeit in somewhat restrained terms. The three stages of the canonization procedure commenced with the bull proclaimed by Pope Clement V, formerly Archbishop of Bordeaux, recommending Celestine for saintdom; then his life and the miracles ascribed to him were subjected to scrutiny, and finally canonization was formalized. Celestine was thus officially admitted to the canon of saints in 1313.

Now that the French were in the ascendancy and the Italians losing

15. *General Council with Pope, c.* 1350 (photograph Biblioteca Apostolica Vaticana, Vaticanum latinum 1398 fol. 3v)

power, Cardinal Stefaneschi made certain strategic changes to his *Opus Metricum*, deleting some passages criticizing pro-French cardinals, such as Matthew of Acquasparta and members of the Colonna family. He also added a third volume in which Celestine V was again the main figure, but now in his capacity as a new saint[128]. In 1319 Stefaneschi sent the manuscript of the third volume, which dealt with Celestine's miracles and his canonization, to the abbot of the Celestine mother convent in Sulmona. There was an accompanying note in which the author acknowledged the defects of his text, but wrote that it should nevertheless be added to the official hagiography.

In the 1330s Jacopo Stefaneschi commissioned a magnificent illuminated missal. It included hymns, prayers and a life of St George, the patron saint of S. Giorgio in Velabro and hence also of Stefaneschi himself; S. Giorgio had been designated his titular church when he was created a cardinal. The Master of the St George Codex executed miniatures showing St George and the dragon, St George's decapitation and the translation of his head to S. Giorgio in Rome. There is also a depiction of the cardinal himself praying to St George, and another showing Stefaneschi writing about the saint at his desk, with his books, his cardinal's hat and his family arms all in view behind him. The missal was not solely devoted to St George, however; Celestine receives a special tribute in a miniature that shows Stefaneschi presenting the hermit pope with the *Opus Metricum*. Celestine is enthroned and clad in a monk's habit, a halo indicating his recent canonization. Behind the cardinal, ten followers are seen kneeling in devotion to the saint, including five Celestine monks and a hermit (see fig. 16)[129].

There were many different facets to Jacopo Stefaneschi: he was a scion of a well-respected family and acquired a reputation as a gifted poet; he was also a cardinal and known to be an authority on saints and the liturgy. All these characteristics were reflected in his commissions – not only of the missal, with its text and its miniatures, but also in the altarpiece he donated to St Peter's. In the central panel of this retable we see St Peter enthroned; St George presents to him Cardinal Stefaneschi, who kneels before the throne, offering his altarpiece to the prince of the Apostles. On the other side of the throne, opposite the cardinal, kneels the saint about whom he had written at such length; Celestine V holds the dedication copy of the *Opus Metricum*. Possibly the figure at Celestine's side, presenting him to St Peter, is Clement I (97–102), an oblique reference to Clement V, who had initiated his canonization (see figs. 13 and 17). In brief, compressed into this group of figures is on the one hand a visual rendering of Stefaneschi's

16. Master of the St George Codex, *Cardinal Stefaneschi presents his*
Opus Metricum to Celestine, c. 1330 (photograph Biblioteca Apostolica
Vaticana, Chapter Archives C 129 fol. 123r)

own role as cardinal, as a patron of the arts and as a hagiographer, and on the other hand a depiction of the continuity of papal authority in Rome[130].

In 1361 Stefaneschi's nephew, Cardinal Francesco Tebaldeschi, set to describing his uncle's commissions in the book of donors' necrologies for St Peter's. His donations had included a painted panel worth eighty gold florins and a mosaic valued at two hundred florins. Also mentioned are boxes of vestments, intended to cover the costs of three memorial Masses in Stefaneschi's burial chapel, which was situated by the northern column of the triumphal arch and was dedicated to St George and St Lawrence[131]. We know that the list of donations is not complete, as it peters out at one stage into a vague allusion to 'a great many other things, too many to mention'. It seems likely that Stefaneschi also presented the church with the liturgical accoutrements he had bought from the estate of the deceased Cardinal Fieschi in 1336[132].

Stefaneschi had begun making arrangements in 1329 with a view to his death; he made provisions for his burial chapel in a codicil to the will he had already made in 1308[133]. We also know that the chapter and members of the papal court were involved in restoration work conducted in St Peter's shortly afterwards in the 1330s[134]. Thus the contextual evidence would indicate that the altarpiece dates from that period. The missal was probably also among the donations made to the chapter of St Peter's in the 1330s, for the same figures adorned both missal and altarpiece; they may well have been intended for the same liturgy.

There is no doubt that the altarpiece, painted on both sides, was intended for a free-standing altar in a prominent place within St Peter's, but it is less obvious which altar this was[135]. As far as the high altar was concerned, celebration could only be from the apse side by either the pope himself, or in exceptional cases by a cardinal representing him, who would always face the congregation. He would stand between the papal throne and the altar, which was overhung by a monumental baldachin or ciborium. Immediately below the high altar was St Peter's tomb, which could be reached from the circular crypt and was provided with a viewing window in front (see fig. 18). The altar was covered on the nave side by a frontal, before which there was a narrow ledge and a 1.4 metre drop to the nave. In the nave stood a double row of twisted columns supporting an architrave six metres high, with candlesticks, cloths, incense-holders and pictorial images attached to it. The singers' choir was enclosed within low walls in which two pulpits were incorporated, each accessible by way of its own steps – a construction that prefigured the *tramezzo* and fulfilled the same function[136]. So whereas

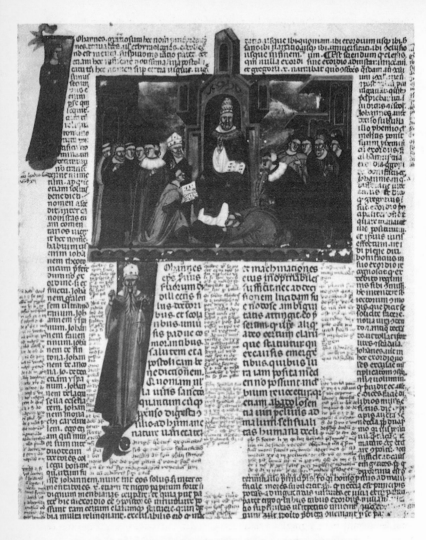

17. *Clement V proclaims new Decretals after the Council of Vienne (1311–
12), c.* 1330 (photograph University Library, Leiden, d'Amblaing 14,
fol. 1r)

the singers were in the nave, the pope and cardinals had their seats on the raised platform of the apse, with the papal throne in the centre. The semicircular apse wall had been decorated with frescoes, as directed by Stefaneschi, and above the windows a vast mosaic spread across the calotte of the apse[137]. The arrangements described here do not accord with any monumental panel painting on the high altar. And indeed, no mention is made of any altarpiece in the ceremonial compiled during Stefaneschi's lifetime. This manuscript does, in point of fact, state that 'the pope stands in the centre before the altar [...] facing the people', which excludes the possibility of there having been a polyptych on the high altar[138].

The Stefaneschi altarpiece, then, was not intended for the high altar. Nor was it destined for the free-standing altar on the north side of the apse platform, which was dedicated to the apostles. This is clear from the fact that this altar was later restored and provided with a retable by Francesco Tebaldeschi between 1368 and 1378. The new polyptych was most probably intended by Stefaneschi to dignify the canons' presbytery. The cardinal himself was one of those who gathered for divine office, Mass and memorial services in this separate area, which was situated by the southern column of the triumphal arch, between the transept and the centrally placed choir for the pope's singers. The canons' choir and its adjacent chapel with its altar were part of a chain of points visited by the pope in the rite of distributing incense, and were seen collectively as a subsidiary of the high altar: 'The pope ascended to the high altar, distributing incense there. He then descended to the choir, following the aisle on the Vatican side, to supply the altar there with incense. Returning on the opposite side to the altar where the relics of the apostles had been weighed and identified, he provided this altar with incense'[139].

There is a direct source indicating that Stefaneschi's altarpiece was intended for the canons' altar in addition to the contextual evidence thus far presented. This is a description of offerings that were made between 1343 and 1348 at 'an image of Christ behind the choir of the canons'[140]. This reference serves at the same time as an additional indication that the retable should be assigned a relatively late date. As the canons conducted Mass their eyes were directed towards the image of Christ, shown worshipped by Stefaneschi and flanked by representations of the martyrdoms of Peter and Paul reminiscent of Cimabue's paintings in the Upper Church of S. Francesco in Assisi mentioned at the beginning of this chapter (see fig. 19). The other side of the polyptych could be seen by the officiating canons, the pilgrims who passed the choir and by the members of the papal court on their way to the platform of the apse: the candlelight illumined for them

18. Interior of the old St Peter's, *c.* 1340 (drawing Bram Kempers and
S. de Blaauw)

19. *Stefaneschi altarpiece*, with Christ enthroned and Cardinal Stefaneschi at prayer, (photograph Vatican Museum)

the enthroned figure of Peter, on one side the order-saint Celestine, and on the other, Stefaneschi presenting a model of the altarpiece, a type of panel painting entirely new to St Peter's.

3. A FAR-FLUNG AND DIVERSIFIED
NETWORK OF PATRONS

COURTS

Jacopo Stefaneschi was one member of a courtly network of patrons who had ties with mendicant orders, cities and merchant families. He came from a wealthy family that had included cardinals and senators, and his confessor was a Franciscan friar. Stefaneschi played a role in determining the pope's stance concerning the mendicant orders and he was personally involved in promoting the worship of Celestine. His links with the papal court were especially close, partly because of his family connections with the Orsini, who held key positions in the mendicant orders and in the *Curia*. The success of the new mendicant orders in central Italy first consolidated the position of the feudal élite to which Jacopo Stefaneschi belonged[141].

From the late thirteenth century onwards rulers and courtiers lent their support to the mendicant orders within their territory[142]. They did, of course, ensure that their aristocratic patronage brought forth permanent tributes to themselves, but they also paid homage to the new saints. We may take the King of Naples as an example: on the one hand he founded S. Chiara, a huge convent, having it equipped so that it might also serve as the royal mausoleum. On the other hand his courtiers were encouraged to be active patrons in aid of the Franciscans. The result of the latter activity, particularly marked after 1325 but already noticeable ten years earlier, was a proliferation of painted images depicting Franciscan saints in and around Naples[143].

The flourishing of the art of painting and the revival of patronage had both spread primarily from Rome. In the thirteenth century popes and cardinals had provided the initial impetus that would lead to a fresh wave of enthusiasm in granting artistic commissions. As activity developed the mendicant friars maintained contacts with the *Curia*, with various courts, with merchant families and with the cities, which now began to accumulate

vast riches, thus forging the most important link between these diverse centres of power and wealth.

CITY COMMUNES

A glance at the history of mendicant church-building shows how heavily it was subsidized by city communes. In the first place the very space needed for a square would be given in the form of a donation by the city council; in the second place the commune provided building materials such as wood and stone. Sienna also gave money and candles to be used in the worship of saints[144]. But the communes also supported the friars' efforts in other ways: they endorsed edicts issued by popes and cardinals, they granted subsidies for the worship of city saints and occasionally they went so far as to issue commissions themselves, perhaps for a tomb, an altar, a chapel or an altarpiece, or some combination of these. An example of the way the assistance of a commune might be enlisted is provided by the history of a petition that the Carmelites of Sienna presented to the General Council on 14 April 1329. They were requesting support for the worship of S. Niccolò, the patron saint of their church, and they further asked to be given a subsidy in order to complete their altarpiece. The Carmelites' petition was granted on 26 October, the tax collectors were instructed on 19 November to make the necessary payments, and on 20 December the money was given into the hands of Pietro Lorenzetti. The authorization of payment instructions issued to the tax collectors made reference to the council's decisions and stated emphatically that the polyptych for the choir altar bearing an image of S. Niccolò – which was finally completed by this time – had been executed beautifully and with all due reverence[145].

MERCHANT FAMILIES

Through the Orsini family Stefaneschi was related to Enrico Scrovegni, the wealthiest merchant in Padua and the son of Dante's spokesman for usurers in his *Inferno*[146]. Around 1304 Enrico ordered a fresco cycle and a monumental cross from Giotto, both to adorn the chapel next to the spacious palace he had built in Padua, and later he added a tomb with a portrait statue[147]. He also had a portrait of himself painted for his chapel, like the

Orsini and Stefaneschi families in Rome and Assisi. For a merchant, though, Enrico Scrovegni was an unusually extravagant patron; merchants generally gave more modestly, sharing in commissions issued by mendicant convents to which they belonged or founding a chapel within one of the friars' churches.

As wealthy *conversi* swelled the ranks of the orders and merchants living in parishes took to donating from their fortunes, after about 1310 the friars were able to afford to order larger and more lavish decorations. Sacristans were generally entrusted with issuing commissions and paying out the necessary funds on behalf of the convent. Once a merchant had joined an order he would often encourage other members of his family to support the church by making donations; gradually a tradition developed whereby the family would lend its support to complete sections of the church, founding a chapel or even a sacristy or chapter house. The Bardi, Peruzzi and Baroncelli families, for instance, all issued commissions to Giotto and his assistants, ordering altarpieces as well as frescoes for their chapels in S. Croce.

The wealthiest families would found large chapels by the *tramezzo* and in the transepts next to the *cappella maggiore*[148]. In this manner the church space – already divided along its central axis – was further differentiated by the many chapels according to the structural principle of gradations from sacred to profane: a spacious chapel behind the *tramezzo*, clearly, was infinitely to be preferred to an alcove by the church door. This segmentation of the church thus paralleled the social hierarchy in a given neighbourhood, in the city as a whole and in the relations between cities. These aspects of social differences within mendicant churches are further elaborated on pp. 74–5.

It was not only the wealthiest section of the community that entered into the artistic patronage stimulated by the friars; also monks, *conversi*, lay brothers or other devout citizens gave within their means. Initially, owning paintings was a privilege reserved for high prelates, but after 1300 it became accepted practice for private citizens, even those of modest means, to make such acquisitions; many did so for their private devotion, purchasing images of saints of the order, the Virgin Mary as Our Lady of Humility or Christ as the Man of Sorrows[149]. Ecclesiastics advocated the ownership of sacred images as having a salutary effect on the upbringing of children[150]. With this popularization the range of commissions expanded; in addition to the more prestigious commissions there was now a great demand for simple, inexpensive paintings with representations of civilized behaviour and those

who had led exemplary lives. Those people who could not afford to order paintings independently joined the ranks of the devout churchgoers for whom the friars developed forms of popular worship that had a wide appeal; the congregation of the laymen's church was no élite, unlike the group of friars behind the walls.

Viewing the rise of the mendicant orders as a whole, we see that its main effect was to bring all the diverse layers of prosperous civic communities into contact with religious images. The number of churches increased greatly, each in turn also being gradually expanded. Each church was subdivided according to the scale from sacred to profane – and from élite to the common people. And yet one achievement of the mendicant orders, in a sense, was the democratization of religion. In the thirteenth century far more people became involved in the life of the church than had been before. There was an enormous increase in the number of popular sermons and in the intensity of lay worship in general. The friars' ideals of poverty gave them a particular appeal; their criticism of excessive extravagance accorded well with the shrewd leanings of shopkeepers and merchants. Within the context of luxurious church decorations a more sober tendency developed, wood, brick and paintings taking the place of marble, mosaics and precious metals.

The combination of mendicant friars on the one hand and merchant families on the other gave rise to a movement of artistic patronage that was both widespread and enduring. Within existing patterns an increasing number of variations was essayed, and so in comparison with the images to be seen in secular churches the images that accumulated in mendicant churches had a broader social range altogether.

MENDICANT ORDERS

The patronage associated with the mendicant orders was not rooted in a few cases of commissions issued simply and directly by a small group of individuals. Rather, it was the end-product of numerous decisions made in the context of an extensive network of social relationships during the course of several decades. Although it is true to say that the various relationships involved might well be different from one case to the next, commissions were not issued in isolation and neither were they based on more or less incidental initiatives as they had been for some thousand years. The friars'

patronage was characterized by an unprecedented social diversity among those who issued commissions and those who viewed the resulting works of art and by the extremely widespread, lasting and intense involvement felt by all sections of the population in the kind of social ideals that the mendicant orders championed.

With this growing level of involvement came an increase in the numbers of frescoes and panel paintings ordered, no church wanting to seem to lag behind another. Between 1250 and 1310 countless panel paintings were ordered, the initial simplicity of which gradually gave way to larger and more expensive works. The shared view of civilized life taken by the friars, together with the differences of emphasis from one commission to the next, generated a unique vitality in the friars' whole machinery of patronage.

The élite of the mendicant orders could experiment, by virtue of their key positions, in developing new variations on traditional forms of representation. The friars plucked the fruits of the long-established patronage associated with the papal seat in Rome, combined with the results of the *Curia* patronage that had received a fresh impetus in Latium and Umbria since the twelfth century. They also derived elements from the interiors of abbeys, such as the rectangular apse of the Cistercians.

Where morality was concerned, the ideals laid down in the friars' statutes, which discouraged excess and stressed the importance of functionality, played an important role in the decisions on patronage that were made. The mendicants were far more concerned than the older orders – which rarely admitted the laity to services – to disseminate their ideals among the townspeople. Thus they were able to combine a reputation for purity and restraint with the visual effects produced by paintings readily available for a price that a broad section of the population could afford.

Through the exertions of the friars, it became possible, from the middle of the thirteenth century onwards, for laymen to focus their divine worship on saints with whom they felt a social and emotional affinity. From these mendicant saints emanated a kind of spirituality that found a ready response in the moral sensibilities of the lay population of the expanding cities. The newly beatified and canonized figures derived their reputations largely from images depicting the exemplary lives they had led and the welcome miracles ascribed to them, and the more convincing such images were, the more the laity would strive to emulate the saints' standards of conduct, and the more sacrifices they would be willing to make in the form of gifts to the church. It is in this context that we should place the friars' encouragement of commissions for decorations for the people to see, to be placed at the

barriers separating monks' choir from laymen's church; this was a direct result of the friars' intense involvement in promoting lay forms of worship.

Functioning as mediators between various social groups that were accumulating ever-greater power and wealth, the friars were well placed to promote a competitive form of patronage. They both inspired competition and fell victim to it; mendicant churches were also rivals for ascendancy in terms of income and status. Such rivalry characterized patronage in general, and a constant shift of emphasis became desirable in the commissions given, so that painters were forced again and again to seek new answers to the challenges they faced. As a result of such impulses, the entire structure of power and authority was in constant flux.

The changes in relationships between different social groups took place within a political framework of states, such as the Papal State and the republics of Sienna and Florence, that was settling into greater stability. The emerging states provided a strong stimulus to the economic revival, and the wealth amassed between 1100 and 1250 made it financially possible to patronize the arts. It happened that a substantial portion of the money was used to purchase relatively cheap art forms, of which painting was to prove the most important. What this means is that there is no direct link between the economic climate on the one hand, and patronage and the pro-fessionalization of artists on the other; in the expanding towns there had been enough capital to give commissions to painters since the late twelfth century. There is a closer connection, however, between the formation of states and the professionalization of painters, which will be explored at length in Part II in relation to the city-state of Sienna. Commissions were issued by communes as part of a lasting expansion in patronage, which was intimately bound up with the role played by mendicant orders in the community.

Between 1200 and 1350 a network of artistic commissions with manifold ramifications grew out of the tradition of *Curia* patronage, fostered by the mendicant orders. This network played a crucial role in many major artistic developments: the widespread popularity of monumental fresco cycles filled with figures, buildings and landscapes; the incidental use of icons carried high in processions; the introduction and refinement of the painted polyptych on the high altar; the rise of panel paintings of new mendicant saints on lay altars near the *tramezzo* or choir wall; the increased size and more frequent use of crucifixes and panel paintings showing the Virgin Mary or saints on transverse beams above the choir; and also the gradual perfecting of these paintings – only the icons carried in processions proving immune to change –

and their appearance in churches throughout Italy. In every commission that the friars issued they recognized the importance of fine craftsmanship. Their objective was to acquire images that would disseminate their views of ideal conduct as effectively as possible; and they were well aware that each painter who was to produce such images must be paid not only for the amount of work done, but also for the quality of the painting that eventually emerged from the artist's workshop[151].

PART II

THE REPUBLIC
OF SIENNA

1. THE FORMATION AND STRUCTURE OF
A CITY-STATE

═══

LEGISLATION

Anyone wishing to understand the social background of the art of painting in Sienna should first peruse the statute-books. Profane and sacred art alike were entwined with the political life that centred on the town hall. The proud and prosperous citizens who constituted the ruling oligarchy of Sienna were responsible for issuing most major commissions, and to a large extent the paintings that they ordered served to consolidate their political position (see fig. 20). It is therefore revealing to consider the images with which they surrounded themselves in the light of the statutes that explicitly legitimized their exercise of power.

The process of 'state formation', as defined in the Introduction, was under way by the late twelfth century, but it was the hundred years from 1250 to 1350 that witnessed its greatest acceleration. As Sienna expanded, an élite formed among its citizens that took control of the city's trade, administration and patronage. In 1262 the merchants first took stock of the burgeoning city-state, collecting the regulations that had been drawn up since the latter part of the twelfth century into a five-volume constitution[1]. The first pages contained predominantly new regulations on the cathedral, the hospital facing it, which was run by the canons, the mendicant churches and the abbeys in the *contado* – those lands directly under Siennese jurisdiction[2]. They were laws by means of which the merchants and bankers further curbed the influence of the older ruling classes: the nobles and the bishop and canons, largely recruited from the nobility[3]. The economic upturn in the city meant a shift of political power towards the townsmen and away from the secular clergy and the feudal nobles, who were dependent on income from their land. Soon, indeed, the latter groups were to be excluded from administrative posts in the city's new institutions.

In 1287 the new balance of power was formalized in a number of new

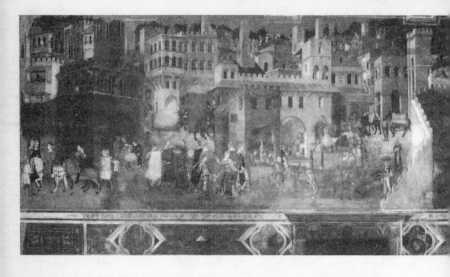

20. Ambrogio Lorenzetti, *The City of Sienna under the Good Government of the Nine*, 1338; Palazzo Pubblico, Sienna (photograph Grassi)

rubrics added to the constitution. The city was henceforth to be governed by 'the Nine Governors and Defenders of the Commune and the People of Sienna'[4]. They were to be elected bimonthly. One section defined quite explicitly the class of citizens from which the Nine would be recruited: they 'are and must be of the merchants of the City of Sienna . . . or, indeed, of the middle classes of the people'[5]. Those ineligible for office, however, included shopkeepers, craftsmen, notaries, doctors, nobles and clergymen; the members of the Nine were only, in fact, to be drawn from the ranks of the well-to-do merchants and bankers.

Besides the Nine, the Signory of Sienna included specialist officials from the Biccherna and Gabella, which administered taxes, as well as the consuls of the merchant guild, whose court of law played an important part in resolving disputes, and the three captains of the Guelf party[6]. There were also several leading magistrates, chief among whom was the 'podestà'. The podestà had previously exercised supreme authority in the administration of justice, but gradually lost this supremacy with the expansion of the civic state. The maintenance of highways, bridges and roads was one of the many areas of competence of a different magistrate, the 'maggior sindaco', whereas maintaining law and order was the province of the 'capitano del popolo'. Finally there was a general captain of war. Never from Sienna, all such men were hired from other parts of the peninsula and appointed to their positions for a fixed period of time[7].

Legislation was controlled by the more broadly based General Council, or 'Council of the Bell', so named after the bell in the tower of the town hall that summoned councillors to business. According to the 1262 constitution this General Council, which had existed in some form since 1176, had 300 members; an amendment in 1309 had the effect of adding 60 more. These people's representatives, who came from the same circles as those who served in the Nine, debated the decisions made by the Signory and made proposals of their own, a quorum being mandatory when important issues were to be decided. Extant records of the Council's business show that its members held direct consultations with Signory officials. Both Signory and Council were subject to strict regulations that had been framed to prevent power from becoming concentrated in the hands of only a few individuals or families[8]. Clearly, the government of Sienna was both more democratic and more constitutional than were, say, the courts of principalities or the Papal State.

This said, it is beyond dispute that the greatest powers resided with the Nine. For instance, a constitutional rubric of 1287 gave the Nine the

authority to determine how a law should be interpreted in the event of any dispute[9]. Another, also of 1287, exempted them from control by a third party when disbursing tax monies. A passage affirmed that these funds would be used 'to maintain and conserve the peace and for the honours and rights of the commune and of the people, and for the conservation and increase of the commune and of the people of Sienna and of the *contado* and jurisdiction of Sienna, and for the destruction and depopulation of the enemies, rebels and traitors of the people of Sienna and of others who would disturb and with force destroy the peace and the good peaceable state . . .'[10].

The link between raising taxes and controlling the threat of violence was made explicit in the first few statutes drawn up by the tax office, the Gabella. The taxes are staunchly defended there in the following passage, dating from about 1300: 'First, it is manifest to all, both of the *contado* and city of Sienna, established by experience and diverse reasons, that the Gabella of the commune of Sienna is the light and the support of the pacific and tranquil state of the Siennese city and *contado*; because of which all who desire that peaceable state and the well-being of the city ought to defend that Gabella as they would themselves'[11].

Regulations continued to proliferate, and towards 1309 it was recognized that a more systematic structure would have to be introduced; better co-ordination was needed between the many authorities involved in administering the city and the *contado*. In consequence, laws were introduced to strengthen central controls and to improve practical procedures, and the political ideals guiding those in power were made more explicit. The legislators made a greater effort than before to formulate clear and consistent codes of conduct that could be properly enforced and that applied to all citizens alike. Furthermore, they showed that their insistence upon the public nature of their administration was no mere rhetoric by drawing up the new statutes in the vernacular rather than in Latin, thus making them accessible to a larger section of the population. Moreover, the Nine placed several statute books in the town hall to be freely consulted by anyone. They insisted that these copies must be written by people with a good command of the language, and directed that a copy made for the people should be written 'in large, well-formed letters' and bound in 'good quality sheepskin'[12].

The rulers devoted themselves in diverse ways to achieving coherence in government and enhancing the image of the civilized state over which they presided. Their struggle against the continuing accumulation of documents to achieve clarity for themselves and for the Siennese citizens

was an uphill task. Not only did the number of regulations pertaining to the city itself increase inexorably, but a great number of treaties with towns and churches in the *contado* had also been signed in the first half of the fourteenth century. A committee of wise citizens, each experienced in administrative affairs, was charged with the task of having new copies made of all these agreements, and arranging them systematically. The second collection of treatises or *Capitoli* (ordered in 1331) has been exceptionally well preserved – the republic's rulers stipulated that it should be issued in a fine edition like that of the statutes passed in 1309 and 1310 – and is an important historical document (see fig. 31). In effect, the *Capitoli*, which took years to complete, allows us to trace the territorial expansion of Sienna from 813 until 1336[13].

To start at the latter end of this expansion, the most recent annexations to the state had been several castles – focal points of feudal society – situated by the two high mountains at the boundary between Sienna and the Papal State. The first of these victories resulted from a series of military actions that had initially gone against Sienna: in 1325 a large army that included the Siennese force suffered an unexpected defeat at the hands of Castruccio Castracani, Lord of Lucca and the commander of a Ghibelline army that had augmented his power considerably in the region between Pisa and Florence. But Sienna recovered from this blow, largely owing to the efforts of its general, Guidoriccio da Fogliano; the strategically situated castle of Sassoforte was devastated in 1328. In the same year the Castle of Montemassi was taken, after a long and costly siege[14]. The nobles of the nearby Arcidosso and Castel del Piano on Mount Amiata were forced to sell these castles towards the end of 1331; they did so under the threat of war and for a low price that was supposed to serve as compensation for damage suffered in the previous actions[15]. With the taking of Montemassi and these two forced purchases Sienna had finally subjected the last remaining independent noblemen, scions of a house that had wielded great power well into the middle ages, the counts of Santa Fiora of the feudal line of the Aldo-brandeschi.

Another area of interest in the *Capitoli* concerns the agreements con-cluded with the regions of Massa Marittima and Grosseto[16]. The area around Massa was important for two reasons: it contained valuable minerals, and it provided access to the port of Talamone, which Sienna had purchased in 1305. But the city's dogged efforts to turn Talamone into a major Mediterranean seaport would prompt Dante to call the Siennese 'people in folly bred/Who trust in Talamone'; according to the poet of Florence, this

project was a still greater fiasco than attempts to seek an underground stream in Sienna itself, which was always troubled by a shortage of water[17].

Despite the failure of the Talamone project, Sienna's sphere of influence continued to expand steadily. The ensuing organizational measures were recorded not only in the new *Capitoli*, but also in the third edition of the constitution, drawn up between 1337 and 1339[18]. Another addition to the constitution, smaller but noteworthy, appeared in the section containing the administrative guidelines for the Nine: it was an oath of office, with an affirmation in brief compass of the political and cultural ideals cherished by the city-state of Sienna[19].

The statute-books document not only the process by which Sienna was formed as a state, but also the interdependency of its economy, politics and culture. On the one hand, the workings of the state were financed by tax money, and on the other hand, it was the organized protection that such a state could offer against theft, pillage and fraud that made it possible for industry and trade to flourish, and for the profits of Sienna's citizenry to continue to grow[20].

The development of diverse professional groups took place within a context of numerous guilds, each with its own regulations[21]. Like the laws of the city-state, these regulations referred to the connection between the raising of taxes and the maintenance of law and order, both of which promoted the exchange of goods and services. After all, no single group – whether of craftsmen, shopkeepers or bankers – would have been able to ensure, say, that stocks of salt or grain were properly supervised, that taxes were duly administered and trade routes safeguarded. The link made in laws and statutes between the dual monopolies claimed by the state – of taxation and of the exercise of physical force – was of crucial importance in preventing major disturbances in the economy.

Guild regulations prescribed professional conduct in what amounted to their own laws. For instance, butchers were obliged to sell fresh meat, to refrain from fraudulent practices and to observe the proper rules of hygiene[22]. Leather workers were obliged to ensure that their activities did not constitute a nuisance to others[23]. The work of bricklayers, carpenters, notaries, jurists, teachers and painters was all subject to the constraints of such regulations, as were the textile industry and grain suppliers. In brief, the Siennese economy was to a great extent a state-led process.

The great wealth of the citizens who ran this state brought about a dramatic change in the social landscape. They had the means not only to buy land but also to purchase military services and expensive defences such

as high walls and fortified city gates, and, as we have already seen, they sent their army to lay siege to castles or used military coercion to ensure a sale. Meanwhile, within the city itself, fortified towers were demolished. In this new social order, nobles were either eclipsed altogether or sought new standing as knights-in-armour serving the state. Added to its army and police force, Sienna could afford a system of law courts and prisons, all of which boosted the republic's power still further[24]. The merchants had the financial and organizational means to increase their own security, enabling industry, shopkeeping, trade and banking to thrive unhampered. The old alliance of feudal aristocrats and secular clergy that had been supreme for centuries was quite overthrown by the energetic money-makers who now led the city-state of Sienna.

A VIRTUOUS STATE AND ITS CULTURE

The state was a good deal more than a system for collecting money in return for security. From its political and economic roots grew and flourished an urban civilization, which found expression in the city's paintings and architecture as well as in events ranging from holy festivals in honour of the Virgin Mary or locally revered saints to horse races around the main square (see fig. 21). In this area too, the plethora of rules had a great impact. Anyone planning to construct anything from a fountain to a new wall would have to take note of regulations, subsidies and penalties for offences. There were rules governing the use of everything from lakes to granaries[25].

As befits a highly regulated state, provisions were made to tend the sick and the poor, thus deepening citizens' sense of allegiance to their state[26]. Anyone with a relative lying in hospital would obviously be grateful for the care provided there; moreover, the conscience of the wealthy was assuaged by the knowledge that the needy would be provided for, and those on the receiving end of alms could not but feel well-disposed towards the state that watched over them. Such solicitude was mixed with pragmatism, as those benefiting from the state's care would remain available to take employment at a later stage. So provisions in the nature of charity benefited the economy as it strengthened the people's sense of solidarity with the commune.

Social control was another function that the state took upon itself. Punishment was no longer the direct action of one person against another but was mediated by the state. Just as those who kept the law could feel confident that murderers and rebels would not go free, the virtuous came

21. *Map of Sienna* from the *Chronicle of Malavolti*, Sienna 1599
(photograph Archivio di Stato, Sienna)

to trust, in their dealings with customers, business associates, suppliers, or indeed the city's administrators, that there were standards of honesty and fairness that would be maintained, or rather, that could not be transgressed with impunity. The law had its sanctions against violations of the civilized code of conduct with which all Siennese citizens were by now imbued from early childhood.

The state actively concerned itself with young people's upbringing and education. This was the sphere in which the norms of virtuous conduct were transmitted and in which future citizens were equipped to perform administrative functions, to conduct themselves well in business affairs and to be good parents in their turn. The Siennese authorities arranged for teachers from outside the city to be taken on; jurists from Bologna, grammar instructors and other lecturers came to teach Sienna's youth at its new civic university[27].

The civilized inhabitants of Sienna exalted their state as their most prized possession, placing it above personal achievements, their families and their businesses. The preamble to the constitution links their commune to two of the longest-established legal systems – that of the emperor and that of the pope. It emphasizes the importance of the worship of the Virgin Mary and the Christian faith and of loyalty to the pope[28]. Then follows a section in which the concepts of a 'commune' and '*civitas*' are further elaborated. This touches on various objectives that are to guide those governing the city-state; most frequently mentioned are the preservation of peace and the administration of justice, territorial expansion and the promotion of sound physical planning. Besides such concrete aims, the statutes allude to numerous virtues that should be cultivated, including charity, generosity, circumspection, wisdom and unity, specifically urging that the citizens should band together in combating crime, rebellion and foreign interference. What emerges is a programmatic division into on the one hand the civic virtues, and on the other the feudal vices of intemperance and dishonesty, and specifically those of war, pillage, rioting, robbery, rape and murder[29].

However, the administrators of Sienna were not to any great extent abstract theorists. Scarcely any theological, political or lyrical reflections on life were written by these men, whose major concern was to solve the practical problems of trade and administration. We glean the standards they upheld from repetitions and enumerations of certain words and phrases scattered throughout the statutes and the records of their dealings rather than from any systematic and comprehensive dissertation. Nevertheless, we

do find a verse treatise on morality and a supplement to the city chronicle, both written between 1335 and 1350 by influential men of Sienna, which both express the same moral preoccupations. Taken together, they illuminate the ideals shared by their class. They help us penetrate the impersonality of communally drafted legislation to glimpse the personal perceptions and feelings of the lawmakers.

Bindo Bonichi's verses dwell on various sections of Siennese society in turn. There is a steady insistence on the importance of living a virtuous life – on conduct that is peaceful, prudent, temperate and commonsensical. Bindo evinces no small degree of complacency as to the virtuousness of his own social class and a certain missionary zeal towards other classes. He warns the nobles and those who have dealings with them:

> Though the knights may swear to the friars
> Not to harm others, and to live pure lives,
> Woe to him who puts his trust in old soldiers[30].

Another of the vices Bonichi condemns is the dissatisfaction that arises from a situation – the advantages of which he readily acknowledges – in which there is a division of labour and mobility among professions:

> The shoemaker makes a barber of his son
> So the barber makes his son in turn a shoemaker.
> The merchant turns his son into a notary
> So the notary's son is bred to be a tailor.
> . . .
> Each thinks he earns his bread with only a spoon
> Whilst others seem to come with bushel baskets.
> A man does not always have what he seeks . . .

In other passages Bindo rails at those lacking in virtue in all the different groups of society, focusing his abuse particularly on self-interest, hypocrisy and the abuse of power:

> Merchants are the asses of this world . . .
> Those who rule at court are barking dogs.
> The men of cloth . . . are evil swine
> And the wolves are our bad shepherds.
> Hypocrites give us counsel . . .
> Each man baits his hook to deceive.
> He does most harm who has most learning.

Bindo Bonichi's main concern was not to remind his readers of divine or temporal retribution, however, but to appeal to an ideal of civilization that

he felt should be embraced by all. In a passage in which he addresses the issue of 'How to conduct oneself in relation to one's inferiors', he urges his readers always to be honest, to pass on the education they have acquired to others, and, however powerful they are, always to keep to the law. In Bindo's moral universe the values most appreciated are self-control and discriminating powers of judgement:

> Be neither hard nor mild . . .
> The wise man is hard or mild as the occasion demands . . .
> Let him live a prudent, temperate and just life
> And may he have strength in adversity.

Bindo goes on to speak of Prudence, Justice, Fortitude and Temperance; the four cardinal virtues must be at the heart of civic self-control, he maintains. The poet exhorts his readers to develop a sense of responsibility for their actions. He urges those in power not to fall prey to the vices he has so vehemently condemned, but to set an example to others. Their gaze should not be fixed upon self-important ostentation or on immediate profits to be gained. Having a position of power, Bindo warns, should not lead one to forget oneself in relation to one's inferiors or to indulge in aristocratic self-aggrandizement.

The impression we gain from Bindo Bonichi's verses is confirmed by other writings, in particular those of Agnolo di Tura del Grasso, who wrote a supplement (covering the period up to the mid-fourteenth century) to the city chronicle. He clearly comes from the same social group as Bindo, and represents the same political vantage-point[31]. He too exalts – though in the more sober prose of the chronicler – the ruling élite of wealthy citizens that had established a virtuous state without allowing themselves to be seduced into a desire for personal ostentation.

CIVIC PATRONAGE

The same rules of conduct as those referred to in the statutes and described by Bindo Bonichi and Agnolo di Tura came to be expressed in paintings. Civic culture in Sienna emphasized clarity, explicitness and order in a code of behaviour that was held to apply to a broad section of the city's population. For those ordering paintings a historical event, a moral precept or a piece of legislation might serve as the basis for their commission, to structure and disseminate the city-state's ideals as visualized inside public buildings.

Sienna's rulers took the physical planning of their city very seriously. Much of this concern focused on the role played in the economy by roads and bridges over which grain would be transported, and walls that would give the city protection, but there was also a lively interest in the aesthetic function that buildings fulfilled; the city's architecture symbolized its civic pride. A well-planned city with splendid buildings was seen as a testament to the harmony and unity of the society that had brought it into being[32].

Social ideals could be made more visible in paintings than in buildings alone. This was a form of instruction long exploited by the Church, which had a centuries-old tradition of using images to convey exemplary behaviour. Contained in the preamble to the statutes of the painters' guild of Sienna is a passage stating that its members have a professional obligation to disseminate Christian ideals by means of the images they produce[33]. This was not only for the benefit of the illiterate; paintings were also a means of influencing the grandees and diplomats who were received at the town hall and in the cathedral[34].

A vigorous approach to patronage was advantageous to the city's administration. Moreover, the city's rulers could afford to pursue such an approach; from the immense wealth accumulated since the twelfth century a substantial budget could be allocated to artistic commissions. Nor was there any shortage of expertise; Sienna had diverse groups of craftsmen each with its own guild. The Nine were in a position to perform a co-ordinating function for the commissions issued, and did so from their broader vantage-point; for them, artistic patronage was but one responsibility in a whole range of administrative tasks embracing such complexities as city planning and military control.

Agnolo di Tura's chronicle illustrates the pride with which Siennese citizens looked upon their civilization. Side by side with descriptions of decisive battles he records great artistic works ordered by and for the commune. Tura describes the placing of Duccio's *Maestà* at the high altar of the cathedral in great detail, noting that it was larger and more beautiful than the older decorations. He also praises Duccio's pupils and calls the master himself the best painter of the age. He does not neglect to mention the price of the altarpiece, which was three thousand florins[35]. Such passages make clear the great extent to which economics, politics and culture were interwoven. In a subsequent section Tura discusses the painting of conquered castles in relation to the sieges that had led to their fall; in detailed descriptions of military actions he includes references to the Nine's

commissions of paintings for the meeting hall of the General Council, depicting the conquered castles[36].

Tura elucidates in retrospect the link between politics and culture that played a role from the moment at which a commission on behalf of the city was under consideration. When a work was being ordered for the town hall, the Nine implemented decisions made by the Council or took initiatives of their own, and payment would be made by one of the two tax services. In other cases decisions were arrived at by way of a more complicated procedure. For instance, the bishop, a mendicant convent or a civic body might put in a request for financial support. Any such request would first have to be deliberated in the General Council before recommendations would be put before the Nine, who would then decide if the proposed project should be subsidized.

SIENNA WITHIN EUROPE

Civic patronage in Sienna was a very different matter from the courtly patronage of, for instance, Naples, Rome, Milan or Avignon. Where the latter was indeed characterized by pomp and circumstance magnifying the glory of the rulers under whose personal control artistic commissions were issued, the citizens of Sienna rather took self-restraint to be their norm. Despite this distinction, the buildings and paintings for which these townsmen were responsible bear very favourable comparison with courtly ostentation.

It was the particular way in which the Siennese state was formed and its civilization defined that enabled an unusual type of artistic patronage to flourish there. Other cities, in which social differentiation and civic cohesiveness had often developed earlier than in Sienna, also witnessed an earlier stagnation or degeneration of these processes during the latter part of the thirteenth century. The groups of citizens that established themselves in Sienna around 1300 were wealthier than those of Pisa, Lucca, Arezzo, Perugia and most communes of northern Italy. Almost everywhere else a handful of families took power, and their rule usually had a negative influence upon industry and trade. What this meant was, for instance, that the formation of these other states was a more fitful process, and artistic patronage more of an incidental activity, separate projects playing a larger role than was the case in Sienna. Civic patronage did indeed exist elsewhere – in Florence, Genoa and Venice, for example – but around 1300 it

was on a more modest scale than in Sienna. As for smaller towns, which had public buildings of more modest dimensions and decorated them simply, such communes played no great role in ordering works of art[37].

The processes of state formation and civilization that occurred in both Sienna and Florence were more enduring than they were in centres of population dominated by courts. However vast the territory controlled by the king of Naples or the pope, or indeed the kings of France and England, neither industry nor commerce prospered in their lands as they did in the two republics of Tuscany. The state apparatus was more unstable in administrative centres of such large regions. Even those courts that sometimes witnessed particularly vigorous thrusts towards a more cohesive state did not build up either systems of law or administrative bodies that proved to be as stable as those of republican Sienna and Florence.

The stagnation of state formation at the great courts, including the *Curia*, allowed the rise of the Tuscan city-states to be consolidated. One factor that helped them maintain their sovereignty despite threats of imminent violence was their geographical situation – south of the Alps and the Appenines. No prince or general had the power to lay Sienna and Florence under permanent tribute. The two republics both had the financial resources to defend themselves, and by this time they were astute enough not to squander these resources in waging unprofitable wars over territory.

Such battles had, it is true, been fought in the course of the thirteenth century as the two expanding states of Florence and Sienna contested each other's boundaries. Ascendancy veered towards one side or the other, and diplomatic negotiations were conducted, the end result being a mutual acknowledgment that neither could be subjected; in the fourteenth century a *détente* was agreed upon[38]. Whereas Sienna continued its expansion towards the south-west, Florence expanded in a quarter-moon around Sienna to the west, east and north. As far as other powers were concerned, little threat was posed by the Papal State in central Italy, the removal of the popes to Avignon having weakened it, and the Neapolitan court was likewise regularly in southern France. The formation of such a strong state in Sienna was thus made possible by its scope for expansion within the prevailing balance of power in Italy and in Europe as a whole.

Various factors combined to call a halt to this expansion around the mid-fourteenth century. Many leading families had suffered bankruptcies, several costly wars had taken their toll, and in 1348 the plague struck a devastating blow. By the fifteenth century Sienna was in a different position in relation to other states. Courts were continuing to form stronger states and to evolve

more tightly organized units of civilization, and Florence was now clearly in the ascendant in relation to its Tuscan neighbour. Meanwhile, other centres of population also struggled towards a collectivization of responsibilities along the route that had characterized Sienna, struggle being the operative word for a transition that was laboriously achieved in each state anew. The flourishing states gradually structured the administration of justice, the army, industry and trade, making provisions for the poor and sick and attending to education, and exerting themselves in the realm of physical planning. They also became active in artistic patronage.

2. THE CATHEDRAL

BISHOP AND CANONS: POWER AND LITURGY

In Italy there were 275 bishoprics, compared to 130 in France, forty-six in Germany and twenty-one in England. In total Europe possessed around 700 cathedrals in the late medieval period, one of which was the Duomo of Sienna[39]. The twelfth and thirteenth centuries had seen a proliferation of chapters, that is, groups of canons who served a particular church, not only assisting the bishop with the rituals but also contributing to the administration of the cathedral[40]. Bishops would frequently have to cede part of their authority over the rights and properties of the cathedral to the chapter, a situation that would erupt in all manner of conflicts between the two parties[41]. The influence of the chapters on the use and interior arrangement of the cathedral will be explored in the next section, and then the changes that were introduced later by the commune of Sienna will be noted. For though the city council acquired great influence in all spheres of life including the cathedral, it had no such role in the early twelfth century. At this stage the secular clergy had absolute authority over the cathedral and enjoyed a privileged position in the uncomplicated small town life.

Around the year 1200 Sienna had no mendicant churches nor yet a town hall, and the cathedral – though a smaller and shorter edifice than it was to become in the fourteenth century – stood firmly at its centre[42]. The church did not deviate from the customary pattern: with a choir in the nave and the high altar in a semi-circular apse[43]. Beneath a raised area in the apse holding the high altar lay a crypt which followed the contours of the apse[44]. The third element of the Duomo was the nave with its steps leading up to the apse and down to the crypt.

Sienna's Duomo was one of the many churches for which an office book was written in the thirteenth century for the canons' liturgy: the *Ordo officiorum ecclesie Senensis*, compiled by Canon Oderic around 1215. At that time the canons had to observe an immense quantity of rules, which indeed

far outnumbered the laws of the city. Canon Oderic describes all the ceremonies that the canons conducted annually, and his book is of particular interest for the references to the various parts of the cathedral concerned[45]. The choir and crypt figure most prominently in his descriptions, but he also mentions the altars in the nave and processions held outside the church. Oderic based his schedule of rituals – including the offices, Masses, prayers and hymns, sermons and processions – partly on his own experience and partly on precepts and customs in the Roman liturgy with which he had become familiar during his recent attendance at the fourth Lateran council at Rome[46].

Being an office book produced by one canon for the benefit of his chapter, all of whose members were well acquainted with both church and liturgy, Oderic's work passes over things that would have been obvious to the canons, his elucidation focusing on theological aspects of the ceremonies described. One consequence of this is that a present-day reader cannot always tell what part of the church he is referring to. 'Before the altar' usually refers to the antechoir, that is, the enclosed area in the nave immediately in front of the apse, as in the Roman churches whose liturgy and spatial arrangements Oderic well knew (see fig. 18)[47].

Oderic tells us of numerous relics possessed by the cathedral: those of Crescenzio, Victor and Ansanus as well as the apostle Bartholomew[48]. Ansanus's evangelism had eventually led him to martyrdom by the River Arbia, where he was decapitated in the year 303, and he was originally buried in a chapel there. In 1107, however, his remains had been transferred to the Duomo of Sienna, where his festival was added to the calendar of saints' feast-days[49]. The festival of St Victor, who had been martyred in Egypt in AD 198, was also added at about this time. In the middle of the crypt was the altar to Crescenzio containing his relics; he was decapitated near Rome. Oderic proudly describes the splendour that the presence of the relics had conferred upon this martyr's festival, and he mentions a panel painting that had recently been added on or above the altar[50].

Oderic's text makes no mention of an altarpiece on the high altar. As was customary, however, the choir was furnished with numerous attributes such as the lecterns on which the canons rested their books at Mass, prayer and song[51]; two raised pulpits were placed to the left and right of the antechoir, which were used for reading and singing and, occasionally, for preaching[52]. Other items naturally appearing in the cathedral's inventory were candle-sticks, a silver cross, chalice, missal and bishop's throne[53]. On the lower level of the nave a system of walls – with a beam above – separated the

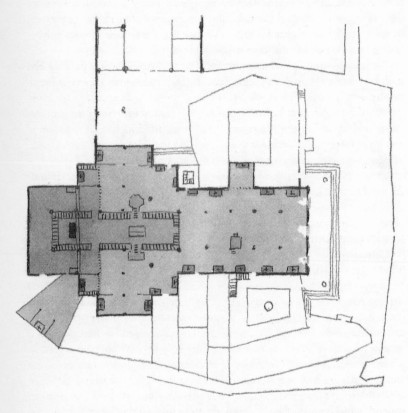

22. Side altars, choir with pulpits and choir around the high altar in Sienna Cathedral, *c.* 1480 (drawing Bram Kempers)

antechoir from the laymen's church, and there were also two altars on this lower level.

Part song, blending voices from both sides of the high altar, was the main feature of the choral service[54]. Once the procession of canons had entered the church, they donned their liturgical garments either in the sacristy or by the altar[55]. They formed into two groups that faced each other, a soloist taking his place on the opposite side of the altar.

The large stone pulpit sometimes used during choral song was particularly useful when there was a larger congregation, such as during Mass celebrated for the laity[56]. The pulpit rose up at the juncture of choir and nave, and the lay worshippers would incline towards it to hear song or sermon, to see relics held up to impress them, or to exchange the kiss of peace. Laymen also frequented the church for all manner of other reasons: for confession, to make offerings or to worship at shrines dedicated to saints.

The church itself comprised but one element of a larger whole. To aid them in performing their liturgical duties the canons had their own library; there they could consult missal or antiphonary or such books as Oderic's *Ordo*. To the north of the church were the canons' houses, walled off from their surroundings, whilst to the south lay the bishop's palace[57]. And opposite the church stood the hospital run by the canons, called S. Maria della Scala – 'of the steps' – after the steps of the cathedral (see fig. 22).

These buildings had a monumental architectural presence that reflected the unique position occupied by the canons and bishops. The supremacy of the secular clergy was not only cultural but also economic, based on ownership of property within the city and extensive lands dotted with farmsteads and villages, some fifteen kilometres to the south of Sienna[58]. Their possessions were continually being augmented by donations, offerings and legacies. Part of the income deriving from the cathedral's assets was allocated to the canons; each received a substantial prebend, or annual stipend, which reverted to the cathedral upon his death[59]. Everything about the church, including the buildings attached to it and the splendid liturgy celebrated within, gave the position of canon an added lustre.

The celebration of religious services fulfilled a variety of functions that went far beyond the source of income it represented for the canons. The cathedral community's sense of internal cohesiveness was enhanced by the communal gatherings to recite Hours throughout the day. The liturgy, which was at the heart of the priests' sense of identity, bound them together and distinguished them from the laity. It was precisely this special position that qualified the clergy uniquely to pass on scriptural knowledge and moral

values to the laity. Both the rituals enacted and the structural divisions within the church were responsible, in particular, for creating an awareness that the laity could share of the distinction between the realm of the sacred and that of the profane. The citizens of Sienna, clergy and laity alike, derived their civic identity from the cathedral; they built it to be the focal point of their urban community.

The secular clergy had a distinct advantage over their fellow townsmen in matters of organization and education. This was because in addition to observing the Hours and celebrating Mass the canons regularly gathered for meetings and periods of instruction. Around 1200 the lay population could scarcely draw on a distinct code of conduct, and neither did they have their own rituals or fund of knowledge. It was the secular clergy who played the dominant role in the city's culture; in their eyes the citizens were illiterate. Oderic draws a distinction between the literate and the ignorant: the distinction amounts to that between the priests and the laity, for whom separate readings were given[60]. It was the responsibility of the learned priests, maintained Oderic, to educate the illiterate. He is at pains to differentiate groups from each other, remarking, for instance, on the particular place within the church that is assigned to women, and he refers to them as a distinct section of the congregation[61]. Within the clergy, too, he carefully distinguishes each rank from the other, from bishop and canons to *conversi* and sextons, giving the separate tasks to be divided up even among members of a particular group[62]. This amounted to a virtual stratification of the clergy, a form of differentiation expressed firstly in terms of different liturgical functions and in a more final sense in the places where those of each group were eventually buried within the Duomo.

ALTERATIONS TO THE CATHEDRAL (1250–1350)

In the course of the thirteenth century the cathedral chapter was edged out of its dominant role in Siennese affairs by a more active citizenry, who were now also setting up their own organizations and evolving regulations for them, as well as taking a more active role in education and developing greater interest in forms of display. The resulting changes in social stratification within the city were reflected in changes made to the cathedral. Between 1250 and 1350 a series of modifications – stemming from a consistent body of decisions presided over by the city authorities – transformed both the Duomo's interior and the way the building was used.

The citizens had been expressing a desire for the cathedral to be enlarged at least since 1245, a date referred to by Bishop Malavolti in his historical treatise on Sienna, published in 1599. They held that the Duomo was far too small for high days, during which the entire population would converge on the cathedral in ritual procession, finally to assemble in the nave facing the high altar[63]. It was in 1259, according to the records of two Council meetings, that a concrete proposal for expansion was at length submitted by a minority of three members of the advisory committee – composed of nine 'good men' – that the Council had appointed to make recommendations on the reconstruction[64]. The proposal was far-reaching, including the following interrelated changes: the high altar was to be moved to a position beneath a new dome; either the tribune should be made accessible from all sides or the entire church floor should be levelled to the height of the nave; and the outer doors were to be adapted and a new wall built. All the elements of the proposal furthered two crucial objectives: that the church should be rebuilt on an altogether grander scale and that there should be better access to the high altar from the nave. It was the lay citizenry that would chiefly benefit from both these aims when festivals brought them to the church *en masse*. Clearly, a space that was perfectly adequate for the needs of the regular processions of canons could no longer accommodate the greatly expanded civic community.

In 1260 a somewhat less drastic proposal was approved. Among the architectural features to be enlarged were both vaulting and apse; 'three more vaults similar to those newly constructed between two adjacent pillars' were planned. The proposal also included a plan for still more vaults as well as a new door and a flight of steps, which would necessitate demolishing several houses[65]. How much of this was actually done remains unclear, but certainly a larger, rectangular crypt was built beneath the downward slope which was also accessible from outside the church. Around 1280, frescoes were painted in this crypt, and on top of the structure an extension to the apse was added.

The entire series of changes – architectural, functional and liturgical – which took much more than a hundred years to complete, can be broadly defined as a transition from a Romanesque to a Gothic cathedral. With the construction of the rectangular apse, the new dome and transepts, and especially with the decoration of the magnificent new façade, the citizens had created a superb approach to the cathedral that they looked upon with proprietorial pride. They also commissioned a new campanile, and they turned their attention to the interior, ordering a cathedra, choir stalls and

lectern, a high altar, pulpits, marble walls and iron gates, windows and altarpieces[66]. Every aspect of the church was thus transformed.

CIVIC PROCESSIONS AND THE BATTLE OF MONTAPERTI

It was 3 September 1260. As Siennese troops gathered by Montaperti, north-east of Sienna, preparing to do battle once more with neighbouring Florence, all the people of Sienna gathered in the Duomo. The city chronicles record the efforts of the citizenry to resolve their internal differences in the face of imminent war[67]. The bishop, 'the city's spiritual father', called the canons and monks to the Duomo, and urged them in a brief sermon to entreat God, Mary and the saints to preserve Sienna from evil and to keep it from falling into Florentine hands.

Buonaguida Lucari, a layman of the nobility with an unblemished reputation, played a leading role in these proceedings. From S. Cristoforo, the church in which the city Council generally met, Lucari came to the Duomo at the head of a huge crowd of citizens. Clergy and laity converged upon the high altar, led by the Bishop and Lucari respectively, and Lucari knelt 'at the foot of the choir' in prayer before the image of the Virgin Mary, that, together with a Crucifix, had been raised high in procession beneath a canopy, and that was now placed by the high altar. Bare-headed and in tears, Lucari prayed: 'To You, Glorious Virgin, Queen of Heaven and Mother of sinners, wretched sinner that I am, I give and dedicate the city and lands of Sienna. In token whereof I now place the keys to the gates on the altar of the City of Sienna.' Lucari then entreated the Madonna to accept this offering and beseeched her to 'watch over our city, defend it and let it not be taken by our enemies the Florentines, nor by any who have evil designs upon us, who would make us fearful and wreak destruction upon us'[68]. The supplication concluded, the bishop again mounted the great pulpit to deliver a sermon urging brotherly love, unity and forgiveness. He exhorted all citizens to join in prayer, confession and communion. Descending once more, he then led the people in a devotional procession through the streets of their city.

WORKS OF ART IN THE CATHEDRAL

The painted panel before which Lucari knelt was produced some thirty years before, and depicted an enthroned Virgin adored by angels. The work is now known – as a result of confusion between this painting and the later *Madonna of Thanks* – as the *Madonna of the bulging eyes*; it should rightly be referred to as the *Madonna of the Vow*, alluding to the solemn pledge of 1260[69]. This Madonna was referred to as the *Madonna in Relief*; several references can be found to it, in connection with this pledge, describing it as *di mezzo rilievo*, and locating it by the south transept entrance, the *porta del perdono*[70]. The *Madonna of Thanks* was referred to as *The Madonna of the bulging eyes*, according to the inventories and chronicles of the fifteenth century. The oldest Madonna performed a dual function, in accordance with a pattern that had been common with such paintings for hundreds of years[71]. As a rule laymen could see it in a tabernacle by the church door, but on special festivals the panel was removed, to be borne aloft during processions and accorded a temporary place of honour near the high altar once the procession had reached the Duomo. There was also a panel depicting Christ that had a similar dual function, being placed by the high altar at Easter[72].

The Siennese emerged triumphant from the Battle of Montaperti; they likened the 'Florentine curs' from whom they were liberated to the dragon St George had slain to free the princess, and so fixed on the festival of St George as a fitting day on which to celebrate their liberation[73]. The 'City of the Virgin' also celebrated the successful outcome of the battle in a burst of new artistic commissions. In 1262 the Signory announced that a new chapel was to be built in the Duomo to commemorate the (unexpected) triumph in the war against Florence[74]. In this chapel both the sacred vow and the military victory were commemorated at once, and it was provided with an altarpiece appropriately named the *Madonna of Thanks*, painted by Guido da Siena around 1261[75]. Besides the patroness of the city, saints were also originally depicted on this altarpiece, including Sienna's patron saints. Mary's close connection with the city was emphasized by her silver crown and silver votive offerings, some in the form of eyes.

An illustration evocative of this ritual ceremony of dedication and grati-tude, in which the keys of the city are presented to Mary, appears over 200 years later on the cover of the Gabella's annual report for 1483 – a year after the Siennese had once again achieved an unexpected victory in battle and decided to dedicate their city once more to the Virgin (see fig. 28). In

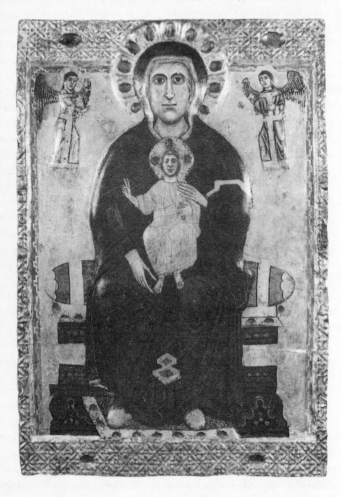

23. *Madonna of the Vow, c.* 1230; Museo dell'Opera del Duomo, Sienna
(photograph Grassi)

this image the ceremony is enacted in the third chapel of the southern aisle of the nave. It is led by the then cardinal-bishop of Sienna; a lay congregation is shown kneeling in worship before a Madonna while clerics cluster in song. A citizen places the keys upon the altar, which is decorated with the city arms. The interior as represented in this image does not, of course, correspond to the situation in 1260, as this chapel was built around 1262 and renovated during the fifteenth century. It is shown as it was when the artistic works ordered after the victory had all been completed, and matches the new inventory that had just been made in 1482 (see fig. 22)[76]. By then all the chapels in the nave had acquired altarpieces, which stood out against frescoes in the recesses behind. A large pulpit stood at the choir partition, covered with a cloth that proudly displayed the city arms. On the tribune behind this, the high altar boasted an enormous altarpiece, and the light streaming in through a round window illuminated the choir.

The new pulpit, which had been ordered from Nicola Pisano in 1266, rested on columns whose base was formed by lions. Scenes from the lives of Mary and Christ embellished its octagonal enclosure. Rising at the screen between choir and nave, this pulpit commandingly enhanced the unity between these two areas of the church[77].

There is ample documentation for the increasing influence of the civic authorities in the life of the cathedral in the latter part of the thirteenth century. For instance, in 1277 we find the bishop requesting a subsidy. He writes that the construction of his new palace and the bishop's chapel cannot be completed without the 'aid, support and good will' of the commune[78]. And in 1287, the year in which the Nine took office, the city's rulers went a step further, deciding that the 'large round window behind the high altar of the Holy Virgin Mary in the main church must be glazed at the expense of the commune of Sienna'[79].

The inclusion of the town's patron saints in the figures portrayed in the round window – which was five and a half metres in diameter – is also indicative of the active role citizens now played in cathedral affairs. Beside the central section, which depicted the death, ascension and coronation of the Virgin Mary, were images of the apostle Bartholomew and patron saints Ansanus, Savino (the first bishop of Sienna) and Crescenzio, all of whose relics were housed within the cathedral.

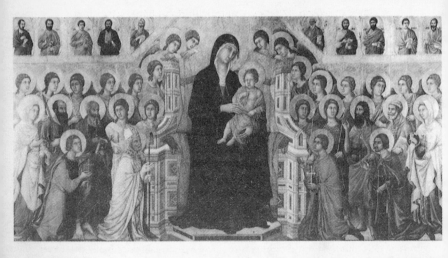

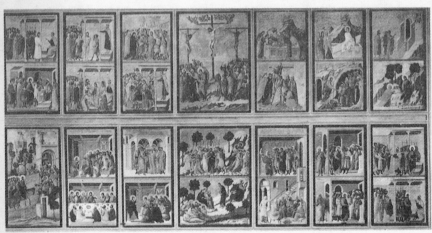

24. Duccio, *Maestà, with St Ansanus, St Savino, St Crescenzio and St Victor*, 1308–31; Museo dell'Opera del Duomo, Sienna (photograph Grassi)

25. *Maestà*, with scenes from the Life and Passion of Christ

DUCCIO'S *MAESTÀ*: SIENNA'S SACRED EMBLEM

Siena's ruling Nine maintained a high profile during ritualistic ceremonies such as processions leading to the nave and the offering of the keys to the Virgin in the 'chapel of thanks'. As patrons of the church they had come to be collectively entitled to influence religious observance. Within the basic liturgy as recorded by Canon Oderic the authorities were able to effect a shift of emphasis, increasing the role played by the Virgin and her four attending saints, Ansanus, Savino, Crescenzio and Victor (the latter gradually supplanting St Bartholomew).

The commune authorities had a selective approach to theological and liturgical conventions, gravitating towards those elements that best accorded with their aims. From Cistercian and Dominican dogma they chose to accentuate the worship of the Virgin Mary, in such a way as to transmute the Madonna into the most sacred emblem of the Siennese state.

On 9 November 1308 a contract was concluded between the master of the cathedral works and the painter Duccio, both described as citizens of Sienna, for 'the painting of a certain panel to be placed on the high altar of the main church of the Blessed Virgin Mary of Sienna' (see fig. 24)[80]. On 20 December Duccio recorded that he had received a sum of money from a man of the cathedral works[81]. A later document gives a cost-estimate for the work and materials required for the paintings covering the back of the altarpiece: for each of the thirty-four images the painter had been paid two and a half florins for 'all the work of wielding the paintbrush, the sexton providing the colours and everything else required'. Duccio had received fifty florins in advance (see fig. 25)[82]. Such an elaborate painting for the back of the altarpiece had not, incidentally, been decided upon during the Council meeting in October 1308; it was the side facing the nave which took priority for those commissioning the work.

On 28 November 1310 the Nine met to discuss the artistic works to be ordered for the cathedral. Affirming their concern for the Duomo, they made a point of wanting to keep the cathedral works under closer supervision. With a view to the commune's income, assets and expenditure, the rulers wished to make a considered cost-benefit analysis. They wanted the altarpiece to be completed as soon as possible, but economized by relieving several officials of their functions at the cathedral works[83].

In the main panel Duccio painted the Virgin seated upon a monumental marble throne with inlays. Beside her, from left to right, kneel Ansanus, Savino, Crescenzio and Victor, the four Siennese saints, their prominence

mediating, in a visual sense, between the city of God and the citizens of Sienna. Behind these four stand angels and a number of figures, including John the Baptist, the patron saint of Florence, and Peter and Paul, the patron saints of Rome. Above the Virgin Duccio painted smaller images showing scenes from her life, culminating in her death, Assumption and coronation in heaven. Bartholomew and other apostles are ranged together, reminding those who gaze upon the painting that the worship of Mary, as well as that of Jesus, was promulgated in their teachings. The predella beneath the *Maestà* depicts Mary and scenes from Jesus's childhood, interspersed with images of the prophets who had foretold his coming[84]. On the back of the altarpiece Duccio painted miracles performed by Jesus, as well as his trial, crucifixion, resurrection and ascension – all of which, of course, were solemnly commemorated in the canons' liturgy.

June 1311 saw the jubilant installation of the great altarpiece, which was almost five by five metres in size. The tax service paid four musicians to enliven the ceremony with trumpet, horn and castagnettes[85]. The chronicler Agnolo di Tura excitedly recorded the great cost, enormous size, the beauty and rich decoration of the altarpiece that had been commissioned by the Siennese and made by 'Master Duccio di Niccolò, a Siennese painter, who was one of the greatest painters to be found in these lands in his time.' From the master's workshop a solemn procession moved through the streets, carrying the altarpiece to its final destination. The bishop and all the Siennese clergy, the Nine, the city magistrates and a great number of citizens, flaming torches in their hands, converged upon their Duomo. On this day the shops were shut, the bells pealed in acknowledgement of the event, and the poor were given alms. The whole community prayed to the Virgin Mary, 'patroness of the city', beseeching her to give them succour on earth and to intervene on their behalf in heaven[86].

Altarpiece and window together constituted a visual unit from the standpoint of the citizens gathered in the nave, for whose eyes they were especially intended. Through the processions and the worship of the four new city saints, through the total effect of tribune and throne, Mary took on the aspect of the civic emblem of Sienna. This is but the most salient instance of a practice by which the citizens of Sienna singled out religious images and symbols of sovereignty commonly associated with princes and popes to build up and project an image of their new society. In the early fourteenth century there was no tradition to speak of that would have furnished suitable images for a republican state. The Siennese wanted to build up a sacred vocabulary of images that would be unerringly identified

with their sovereign state and that would bring out the fact that power did not reside with any one individual ruler. Concentrating civic acts of devotion on the Virgin Mary and the four patron saints suited both these purposes admirably.

It was the citizenry, not the cathedral chapter, that had been so eager to install the great altarpiece. True, the small images on the back portraying scenes from the life of Christ illustrated elements of the liturgy celebrated by the canons, but the main element of the commission was the *Maestà*, which to the civic community massed in the nave on the eve of Assumption Day was to be an awe-inspiring image to which all eyes were drawn.

Around the time the painting was ordered the Nine were engaged in drafting new legislation to extend and tighten up regulations governing the Opera, or body managing the cathedral works. Between 1290 and 1297 Opera expenditure was subjected to restrictions: in particular, less must be spent on marble and on animals used for bearing loads – and their hay. The Nine were empowered to check that the new rules were adhered to. The new provisions also prohibited the use of Opera monies for certain extraneous activities: no more wine was to be drunk at the Opera's expense, nor were its funds to be drawn on for the purchase of a house[87]. Of particular interest here is that the new statutes included a long rubric inaugurating a major civic festival to centre on the Duomo and to take place annually on Assumption Day[88]. The Nine explicitly referred to this statute when recording the decisions made in connection with Duccio's *Maestà*[89].

On the eve of Assumption Day the entire populace – not only the inhabitants of the city itself, but also those owning castles or representing towns that had been subjected and thus came under the jurisdiction of Sienna – was to pay its respects by coming to the Duomo. The climactic ceremony in these proceedings was that in which each member of the congregation in turn approached the high altar, offering wax candles according to his or her means, the commune itself donating a gigantic foliated candle. Nobles were also obliged to give silks. In conclusion the councillors dined inside the Duomo whilst the populace outside, in high spirits and decked out in their finest clothes, celebrated the festival joyfully with wine and dancing[90].

One element of the festivities was to become particularly popular: the *palio* (meaning 'banner'), a spectacular horse race around the main piazza of the city, still celebrated to this day. Indeed it is this event that gave the square its name – Piazza del Campo, or 'arena'. On 17 June 1310 the Council of the Bell authorized the use of funds allocated to the chief festival

honouring God and the Virgin for the races, the winner of which was to
receive a banner. The Nine were to supervise the implementation of this
decree and to incorporate it into the new statutes, 'that it might be observed
in perpetuity in honour of the Glorious Virgin' – a sentiment that echoed
the words of the lengthy decree of May 1309 inaugurating the Festival of
the Assumption. All the inhabitants of the city-state were obliged to join
in devotion to the Virgin on this holy day of August 15. Shops and places
of work were closed by decree, and trade – barring the sale of candles –
was prohibited, fines being imposed on any offenders[91].

The commission that the Nine issued to Duccio was part and parcel of
their general policy. Patronage and legislation both served the interests of
good administration, and the same group of citizens was involved in both.
As the new laws were entered in the statute-book, and Duccio's altarpiece
set down in its place of honour in the Duomo, Sienna gained a more
pronounced identity than it had had before.

The city chronicles further consolidated the *Maestà*'s sacred significance
to the populace; again it becomes clear how words and images together
worked to achieve this effect. The vocabulary used by the chronicler Tura
to describe the Virgin is in the same idiom as the ordinances, statutes, and
indeed of Duccio's commission. He speaks of her share in preserving and
extending the state of peace and prosperity in the city and her realm. She
was their sovereign, advocate and protectress who shielded not only orphans
and widows but the whole city from peril and evil.

The importance of Assumption Day as a civic festival was enhanced by
the fact that apart from this occasion the Nine were only present at festivals
honouring the four Siennese saints, who were thought of as the Virgin's
attendants. (The Nine were barred, in fact, from participating in other
public celebrations outside the limits of the town hall during their term of
office[92].) Other expressions of Sienna's corporate identity were to be seen
in the painted cart of the Florentines, which had been captured in the Battle
of Montaperti and now formed part of the Assumption Day procession,
and the hundred-odd flags to be seen among the icons, each borne by a
representative of a town or castle that had been subjected by the proud
republic[93].

Facing their common symbol on the day of the great civic festival the
citizens arranged themselves each according to his or her place in the
hierarchy. For those who represented annexed towns the ceremony served
as a reminder of the ritual of surrender that they had once been obliged to
undergo; year after year they had to kneel to this, the symbol of Sienna,

adding to the lustre of the *Maestà* with the candles they placed before it[94]. For the authorities it was a ceremony that presented them with an opportunity to take stock of their state, and for the populace it was a day of devotion, feasting and games.

Church and commune were locked into a new interdependency, and there was a blurring of the distinctions between their respective incomes. Thus the statutory obligation to offer wax candles in the Duomo provided one ready source of disputation concerning the proportion of the offerings due to each, and the city arms blazoned on the collection boxes in the cathedral made another. Canon law and local custom empowered the Bishop and the cathedral chapter to disburse the money donated in these ways, but in Sienna civic regulations were introduced that superseded this privilege. This was but one further consequence of the shift in the real balance of power. The altered structure had repercussions on the use of the Duomo and the layout of its interior, this edifice now being pre-eminently the scene of civic ceremonies.

The enormous gathering of the people to gaze at the *Maestà* was a spectacular event. The procession of citizens and clerics that had wound its way through the dark, narrow streets of the city, passing row upon row of simple dwellings, now entered the magnificent lofty cathedral. On the way to the altar the procession passed the city chapel with Guido da Siena's *Madonna of Thanks* and Pisano's pulpit. Those who had carried the *Madonna of the Vow* in the procession – the panel that normally hung beside the transept entrance – placed it for this day before the high altar near the pulpit. At the end of the nave the huge painting of the Virgin, set on a golden background, confronted the people, lit by a multitude of candles and oil lamps and set off against the large round window behind. During the services at night the Queen of Heaven was unveiled; she was illuminated by a large oil lamp and an apparatus of candles. At dawn and at sunset Mary and the Saints were lit by the large windows in the apse and above the main door. The control of light and darkness was an essential element in the visual arrangement of the church. On either side of the altarpiece hung ostrich eggs and hovering angels[95]. The painted figures were enclosed within a gold-coloured construction with a base, pillars, ornaments and a baldachin at the top. The *Maestà* was from the moment of its installation the cynosure – indeed the focal point – during the grand civic ritual.

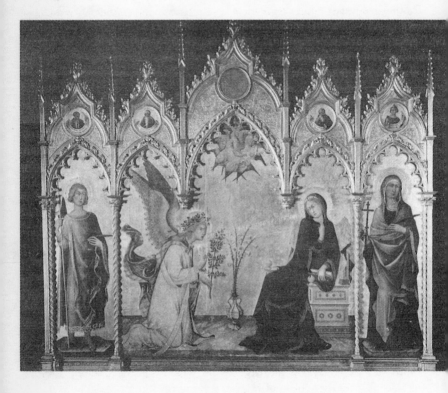

26. Simone Martini, *Annunciation with St Ansanus and St Massima*, 1333;
Galleria degli Uffizi, Florence (photograph Alinari)

SIDE ALTARS AND CITY SAINTS

The installation of the great altarpiece, combined with successive civic decrees, brought about a further change in the way the cathedral was used. The presbytery was now effectively divided in two, which made it difficult to retain all the elements of the liturgy as described by Canon Oderic a hundred years before. Where the high altar had once been above all the focus of the canons' daily services and the occasional contribution of the bishop, it now played a major role in the life of the city, looming imposingly at the end of the nave. Because of the importance of the cathedral in civic processions, Sienna's ruling oligarchy now took to ordering more and more works of art to adorn the church.

In the 1320s the city council decided that a new, much larger church should be built at right angles to the existing one[96]. After the enlargement of the apse in 1260 and plans for a further enlargement, made possible by the construction of the baptistry, the direction and scale of the plans changed radically. It was felt appropriate that since Sienna had acquired a new civic centre, in the form of the Palazzo Pubblico at the Piazza del Campo, it should also have a new cathedral, which would better meet the needs of the city in terms of size, location, and interior lay-out. It was to be the most splendid cathedral in the world. The foundation stone of the Duomo Nuovo was laid in 1339, and an imposing façade was erected, facing south rather than west. One of the designs for this ambitious project has a spacious choir before the high altar, which is further surrounded by a ring of chapels. The dimensions of nave and ambulatory were calculated so as to make it easier for a large congregation to be led past the side altars to the high altar; and these side altars, as the notes to the design make clear, would be dedicated to the four patron saints of Sienna[97].

Work commenced on the four paintings. From 1330 until 1350 Simone Martini, Pietro and Ambrogio Lorenzetti and Bartolommeo Bulgarini were engaged in painting altarpieces each of which measured around three by three metres (see figs. 26, 27 and 37)[98]. Each depicted at its centre one of the key events in the life of the Virgin Mary, the images akin to the small scenes in Duccio's *Maestà*. On either side of this image were saints: on the left invariably one of the patron saints and on the right another saint honoured in the cathedral, such as, from left to right, Bartholomew, Massima, Corona, the wife of Victor (see fig. 27) and finally the archangel Michael. The predellas portrayed the life and martyrdom of Sienna's saints[99]. The new cathedral towards which their toils were directed was never

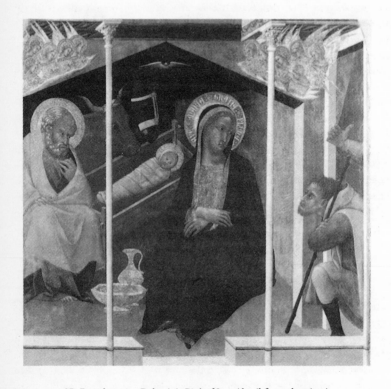

27. Bartolommeo Bulgarini, *Birth of Jesus* (detail from altarpiece), *c.* 1350 (photograph Fogg Art Museum, Cambridge, Mass.)

completed, but the four altarpieces came to adorn side altars in the expanded old church.

The citizens explored every avenue to exalt the devotion of their saints. For instance in 1335 they paid 'Cieco, master of grammar' to help Pietro Lorenzetti by 'translating the life of Savino into the vernacular that it might be illustrated on a panel'[100]. The number of historical images was greatly increased, with many more panel paintings and statues appearing and frescoes being painted in the niches behind the altarpieces, as can be seen on the Gabella panel which shows the interior of the Duomo as it was in 1483 (see fig. 28)[101].

The altarpieces were arranged so that the citizens could follow the events in the Virgin's life in chronological order as the procession moved on. Passing in turn the chapels dedicated to Savino, Ansanus, Victor and Crescenzio they saw depicted the Birth of Mary, the Annunciation, the Adoration of the Shepherds and Candlemas. At about the same time as the altarpieces for the chapels were being planned, artists were painting similar scenes on the façade of the hospital facing the Duomo[102]. Thus outside the church too, important elements of the lore surrounding the Virgin Mary were visualized for the benefit of all.

IMAGES SACRED AND SECULAR

The bishop and canons of Sienna lacked sufficient funds to take responsibility for the expansion and refurbishment of the cathedral. This is not to suggest that they were averse to the changes being made. Although they had no major stake in the alterations to the nave – these were largely for the benefit of civic processions – the expansion of the presbytery was decidedly to their advantage. Moreover, the embellishment of the cathedral as a whole consolidated their pre-eminence in respect of other churches in the city. As for the commune, the main point was to ensure that the Duomo equalled or if possible surpassed the magnificence of cathedrals elsewhere. Thus from the mid-thirteenth century onwards, the expansion and decoration of the cathedral was regarded as a collective responsibility. The extent to which the secular clergy were obliged to rely on the citizenry, however – for money, craftsmanship, organizational skill and the power to introduce legislation – increased from year to year.

The position adopted by the civic authorities *vis-à-vis* the secular and regular clergy came to be dominated by a policy of divide and rule. Subsidies,

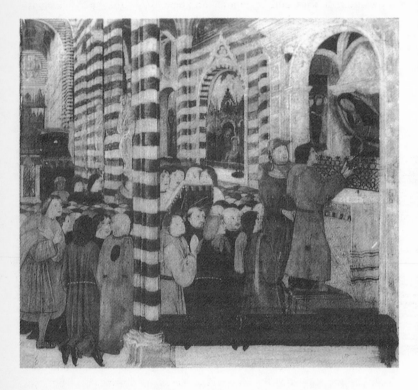

28. *The transfer of the keys to the Virgin Mary in the chapel of thanks,* Gabella
1483 (photograph Grassi)

building materials and protective measures would be granted more readily to whichever party was favoured at a given time. During this period of rapid growth the commune's rulers were increasingly involved in the distribution of alms and in church construction[103]; they gave financial support, and expected in return to be allowed to monitor the allocation of monies and goods more closely. In fact we can say that the age of the great cathedrals was at once the age in which secularization first set in – not in the sense of apostasy, but simply in respect of the increasing influence which the laity now wielded over churches.

The Opera was the body that managed the cathedral and administered its capital, and in Sienna this body was accountable to the civic authorities. The Opera's statutes – starting with the regulations on the use of marble and beasts of burden – were gradually absorbed into the constitution, a process virtually complete by 1309[104]. Other cathedral affairs were also brought within the compass of legislation: for instance, a 1262 statute decreed that the main altar and the cart of Montaperti were to be permanently lit, a new chapel built and benches installed for the benefit of meetings[105]. In 1309, on the basis of regulations passed in the previous two decades, the supervisory powers of the city's rulers over the Opera were tightened up. The administrators of the Duomo had two masters now: they had to bow both to the ecclesiastical authorities and to the state; they were bound not only by canon law but also by secular law. The expansion and reorganization of the Opera was, in effect, but one element in the wider process by which Sienna consolidated itself as a state.

A number of abbeys had come under Siennese rule. The monks of S. Galgano, south-west of Sienna, played a special role in Siennese affairs during the stage in which power was gradually passing from the secular clergy to the citizenry[106]. From 1230 onwards Cistercians from the S. Galgano abbey were prominent in the management of the Duomo as well as in the civic tax services, gaining so much respect as Opera functionaries that the citizens decided to recruit the master of the works henceforth from the abbey rather than the chapter. Their influence was in evidence in the rectangular apse of the Duomo, which was modelled on that of the abbey.

Civic documents show monks and laity collaborating in the administration of the city. One frontispiece to a statute-book shows a monk at the head of a line of four tax officials in the left margin, with the podestà pictured on the right[107]. The miniature at the top of the 1298 Biccherna statutes shows the tax officials in assembly, presided over by the treasurer,

Jnnomine dñi amï. Jnfrasepta siir capli cõsti
tun seiï. que ptinet ad offitiï camerary ẓ uïïẓ
prouisoz cõis seiï. put inferius continet. Jpmus.

29. *Meeting of tax officials*, 1298 (photograph Archivio di Stato di Siena, Statuti Biccherna I, fol. 1r)

30. *Fra Rinaldo as a tax official*, 1280; Archivio di Stato di Siena, Biccherna Annual Report (photograph Grassi)

a monk in a white habit; the four lay officials are deliberating whilst a notary records the proceedings (see fig. 29)[108]. Other monks populate the pages of the city regulations: one, adorning the rubric '*De Fide catholica*', is depicted with a book in his hand, and another is seen addressing a civic administrator. Secular and sacred images alternate: the 1337 constitution has a Christ as the Redeemer for its frontispiece, and a lay citizen portrayed at the top of the regulations concerning the Nine[109]. Numerous pictures of monks – usually seated at a table with piles of money – also appeared on the covers of the tax service's annual accounts. In 1280 the subject of this illustration was a certain Rinaldo; he has coins in front of him and a purse in his hand (see fig. 30). The function of treasurer was sometimes fulfilled by members of the Humiliati order; one such was Don Magino, portrayed in the Gabella counting house in 1307[110].

Verbal allusions to the faith pervade civic documents – statutes and records alike all had their obligatory references to God, the Virgin Mary and the city's saints. Sacred images also abound. For instance, the political significance of Assumption Day was clarified in a miniature by Niccolò di Ser Sozzo of 1334, the frontispiece to the second *Capitoli* – that is, the collection of treaties with annexed towns. At the centre Niccolò depicted the Virgin crowned as the Queen of Heaven, with angels paying their musical tribute to the glory of her Assumption. At the four corners of the miniature appear the patron saints of Sienna (see fig. 31).

Cover illustrations of the tax service's annual reports and paintings commissioned for their offices again exhibit a mix of sacred and secular images[111]. The four ubiquitous saints, needless to say, figure prominently. In 1334 Bulgarini painted a Madonna shown with Ansanus and Galgano for the townhall[112]. In 1343 a treasurer, a tax collector and a secretary collectively commissioned an Annunciation from Ambrogio Lorenzetti; the image was taken from one of the Duomo's altarpieces[113]. The three patrons forged a link between themselves and the sacred image by having their names added beneath the painting. The following year the same three men took an image by Lorenzetti for the cover of the annual report – and again appended their names. This time, however, rather than the Virgin it was the secular symbol of the city-state with which they sought to identify themselves – an enthroned lord, taken from the painting Lorenzetti had executed in the meeting-hall of the Nine six years before[114].

The 1364 report shows the tribute; nobles and citizens pay their tribute to an enthroned lord, who holds a sceptre and a globe bearing the arms of Sienna: they proffer castles, keys, their swords, money, documents, palm

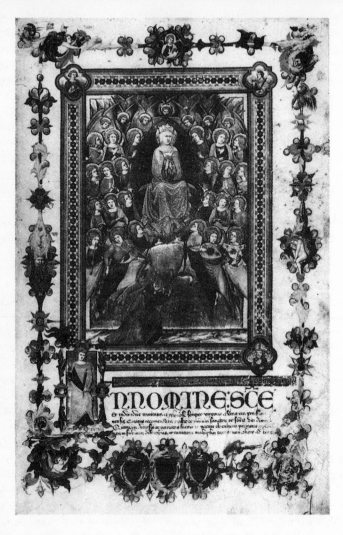

31. Niccolò di Ser Sozzo, *Assumption of the Virgin Mary with angels and Sienna's four patron saints*, 1334 (photograph Capitoli 2, fol. 1r, Archivio di Stato di Siena)

leaves, banners and candles. The cover of 1385 shows the citizens standing before a lord, their common bond represented by a cord which all are holding on to. The occurrence of secular and sacred images in the same context leads to the conclusion that they played the same role; in other words the Siennese looked upon the Holy Virgin and the secular lord, in their capacity of emblems of the state, as interchangeable.

THE CITY AND THE FRIARS

The role played by the Cistercian monks in the period leading up to the secularization of power has already been noted. They may be viewed as having cleared the way for the mendicants, who also began to fulfil administrative functions in the city. Those involved were generally *conversi*, that is, those in lower orders; their tasks would often include the material aspects of religious life, such as taking care of church buildings, the precious paraments, and all the items belonging to the sacristy and the altars. They were also responsible for bell-ringing and seeing that the doors were closed[115].

Successive phases of clericalization and secularization in the thirteenth century, despite the seeming paradox, are two aspects of the process of state formation. In its early years the republic had a good deal to gain from the clergy's learning and administrative expertise. This meant that the churchmen could augment their funds by placing their services at the city's disposal and thus encouraging people to donate to the Church. To an increasing extent such gifts – made possible by the trade and industry of the town – financed their rituals and their costly buildings. Ecclesiastical institutions, in other words, thrived on the consolidation of the city-state. Those mendicants whose orders were established in the city did particularly well, since their rule of individual and collective poverty made them more attractive to the citizens as partners in the administration of the state.

The citizens of Sienna saw religion as one more area requiring proper administration and effective facilities, from land and building materials to subsidies for festivals and altarpieces. When the need arose, consultations would be held, ensuing in abiding organizational structures, regular flows of funds and statutory agreements. Long entries in the statute-book regulated not only the cathedral festivals but the worship, for instance, of the recently beatified Ambrogio Sansedoni, a Dominican friar who had participated in several Church Councils and had played a role in the diplomatic ties maintained between Sienna and the pope. In 1306 the commune decided

that his festival should also be honoured with a horse-racing event financed from the city's coffers, and a decree to that effect passed on to the statute-book three years later [116].

In Sienna the friars had their own saints, or rather '*beati*', members of the order who had lived during the previous hundred years and were renowned for abstinence, wisdom or charitable deeds [117]. People felt the older saints to be more remote, connected as they were to other cities and usually to an unfamiliar world. So beatification was a ground on which friars and the commune readily found themselves in agreement. The friars aimed to foster the dignity of their own order by such means whereas the citizens were happy to worship saints who came from their own city. Papal co-operation was not forthcoming – citizens beatified in Sienna were not granted official canonization – but the Siennese venerated them as saints.

From about 1290 onwards, the commune spent large sums on festivals, monuments and altars for their new saints [118]. In 1328 the support was under extreme pressure, partly because funds had been tremendously depleted by the Battle of Montemassi. In 1329 a decree was passed to lower the subsidies to the mendicant orders, provoking fierce protest from the friars, who saw the worship of their new saints jeopardized. The issue was debated at a number of meetings of the Council of the Bell, culminating in the pronouncement that the saints were of great importance to the community. As noted in the petitions that had been presented by the friars, these departed had indeed intervened on the city's behalf in heaven, causing many disasters and evils to be averted. Once the citizens had confirmed that the worship of the Siennese saints was in the public interest, the planned cuts were abandoned [119].

CHURCH AND STATE: A WIDER VIEW

Civic control of ecclesiastical affairs was taken to unusual lengths in Sienna. Nowhere else were bishop and canons so dependent on city funds and statutes. Similar trends did become visible in other cities with powerful groups of merchants and bankers, but on a more modest scale. In Florence, for instance, the cathedral Opera became primarily a civic institution, and civic processions played a dominant role in the use of the Duomo [120].

The cathedral Opera can be regarded as a precursor of present-day departments of public works. Its swift development in Sienna – it was a flourishing institution there long before its equivalent in Florence – and the

exceptionally great influence of the civic authorities were responsible for its ambitious schemes. We are reminded of the most grandiose of all, the Duomo Nuovo, that was to have been, in terms of size, second only to St Peter's in Rome [121].

In Florence, alterations to the Duomo in 1296 were still being carried out under the shared supervision of two representatives of the bishop and two of the commune. But by 1321 management of these affairs had passed into the hands of the guilds, and by 1331 this meant exclusively the wool guild. Control could mean strangulation: we find the following observation in the city chronicles for 1331: 'No money was forthcoming from the commune of Florence; therefore work ceased for a long time, and nothing was built'[122]. In Bologna the city authorities were also influential in determining the course of church building, as witnessed, for instance, by a decree passed there in 1390: Milanese ascendancy had been warded off, and the commune proposed that victory should be celebrated by donating a sum of money to the cathedral [123].

Major civic intervention in matters relating to the cathedral was the exception, not the rule, in Italy; it was not found in Rome, Naples, Spoleto, Orvieto, Pisa, Arezzo, Lucca or Urbino. In Rome, of course, all ecclesiastical affairs were dominated by the pope. In Arezzo sacred and secular power alike were vested in the bishop. Elsewhere, decision-making was in the hands of either the cathedral chapter or the ruling prince.

North of the Alps, city authorities concentrated their support on parish or collegiate churches, which had the dimensions of cathedrals but not the same ecclesiastical status [124]. The cathedrals themselves were seldom subject to any substantial civic authority; exceptions to this rule were Strasbourg and Lübeck, both cities with bustling trade [125]. As far as the relations between citizens and regular clergy were concerned, Benedictines and Cistercians did not take the same active role in civic affairs in these regions as in Italy. Beyond the Alps, Cistercians were chiefly concerned to promote agriculture and took no part in civic life. Accordingly, mendicant churches tended to be smaller than in Italy, whereas abbeys – situated in rural areas – were larger and more numerous.

Whatever the prevailing power structure, the funding, organization and use of churches all depended on it and could only function within it. In Sienna it is clear that diverse sections of the community collaborated more closely to achieve the same objectives than was the case in other Italian cities, the contrast with cities north of the Alps being more marked still. Large-scale building construction, predictably, followed on a period of

economic growth and in turn consolidated the economy [126]. The building and decoration of churches provided a great boost to trade and industry. Bricklayers, carpenters, sculptors and painters would all be involved in work on churches, and all would in turn stimulate other sectors of the economy such as clothing and food supplies with the income they had to spend. In short, building and decoration were crucial to the economy from the thirteenth to sixteenth centuries. It was obviously in the interests of a city-state to grant its major commissions to local craftsmen, because then there would be no exit of funds, and the people would be all the more able to enjoy and display their civic pride.

3. THE TOWN HALL: SEAT OF POWER, SEAT OF PATRONAGE

THE FIRST COMMISSIONS

Pericles' Athens enjoyed a shorter period of political stability and artistic excellence than did the Sienna of the Nine. In the first half of the fourteenth century Sienna's cathedral and town hall were quite unrivalled.

Before 1280 the councillors had held their meetings in the church of S. Cristoforo. They stored their archives in the Dominicans' sacristy and announced meetings by ringing the bells of the Duomo[127]. As their power grew, however, so did the need to have their own premises – a space in which to store records and hold assemblies and communal prayers, and that would also stand as a monument to their authority. Over the space of thirty years there arose on a site which in 1280 had held a store-house, two small churches and several houses a gigantic town hall. When its clock tower was completed in 1348 it was the highest on the peninsula[128].

The basement of the vast edifice could accommodate dungeons and storage-rooms for weapons and salt. On the ground floor, the tax officers of the Biccherna and the Gabella conducted their business. The first floor, completed around 1310, housed the great assembly hall of the General Council and the meeting chamber of the Nine. A separate wing contained the podestà's hall, and rooms for him and those serving him to live in[129]. From 1289 to 1306 the rulers ordered a series of decorations for the first rooms of their new building; later followed many more, the great commissions for the first floor stretching from 1310 to 1345. What the Nine achieved with the building of their Palazzo Pubblico and the square before it, the grand Piazza del Campo, was the visual embodiment of their function as the rulers and protectors of the commune of Sienna.

Around 1289 the Nine began to arrange the decorations for their chapel. An enthroned Virgin surrounded by angels was an essential element, of course; indeed, throughout the rule of the Nine their eyes met these figures

at every step, whether here, in the Council Hall or in the Duomo. On 28 July 1289 the Biccherna paid for the chapel's wooden seats and a glazed window[130].

Other commissions followed thick and fast. On 12 August 1289 'Master Mino' received his wages for the *Maestà* he had painted in the Council Hall[131]. The goldsmith Guccio di Mannaia was paid for the new seal produced for the Nine in 1291, and he subsequently made several others[132]. In 1293 and 1294 'Mino' and 'Jacopo' were paid for paintings executed for the podestà's wing; in 1295 'Guido' received payment for the *Maestà* painted in the meeting chamber of the Nine. 'Bindo' was paid in 1296 for a fresco depicting St Christopher, described as being 'for the house of the commune of Sienna, in the meeting chamber of the Nine', and Mino portrayed this saint in 1303 for the 'hall of the commune'[133]. In 1302, for the chapel of the Nine, Duccio painted 'a panel, or in fact a *Maestà* [. . .] and a predella, to be placed upon the altar in the house of the Nine in the section known as the office'[134]. Also executed for the chapel in this period was a Crucifix for the altar, painted by Massarello, who was paid for it in 1306[135].

A second spate of artistic activity stretched from 1314 to 1338. In 1319 Segna di Bonaventura was paid for a Madonna[136]. In 1321 Simone Martini received twenty florins for a *Crucifixion* painted on the wall behind the altar in the Nine's chapel; in the same year he carried out restoration work on the *Maestà* in the hall of the General Council[137]. Some years later, in 1329, Martini added to the chapel's polyptych a number of painted angels holding candles[138]. The programme of decorations also included panel paintings depicting towns of the *contado* such as the seaboard town of Talamone and nearby Ansidonia as well as the lakeside fortress of Selva del Lago[139]. In successive stages, decorations multiplied within the town hall. To Simone Martini was to come lasting wealth and fame, but to the Jacopos and the Minos, too, the commissions brought a certain status in society, and there was a high level of employment for all concerned.

The representations of Mary seated in majesty known as *Maestà* primarily stemmed from commissions given by the civic authorities. The *Maestà* in the Duomo had been a crucial addition to the sacred/civic symbolic repertoire, a tradition continued by the *Maestà* that Simone Martini executed for the new Council Hall. A specifically Siennese Madonna tradition developed under the regime of the Nine: the enthroned Virgin, 'sovereign, patroness and advocate of the commune', flanked by four saints only worshipped as a group in Sienna. Other innovations in painted images

appeared in the second phase of the town hall decoration, also following directly from the process of state formation that was being consolidated in Sienna.

THE TERRITORY: THE GLOBE ROOM

The Council Hall is still known as the Sala del Mappamondo, or Globe Room, in reference to the globe painted by Ambrogio Lorenzetti and attached to its west wall around 1344. The circles and the iron pivot beneath the equestrian portrait by Simone Martini are all that remain of the rotating orb that won the praise of Ghiberti and Vasari[140]. The general depicted on horseback is the *condottiere* Guidoriccio di Niccolò da Fogliano, from Reggio. Below this portrait, beside the pivot and circles, the patron saints Ansanus and Victor are depicted: they were painted by Sodoma almost two centuries later, in 1529 (see fig. 32)[141]. Until 1980 a depiction of the Madonna hung between the two saints; then restoration work was conducted which revealed a fresco showing a castle and two male figures[142].

The east wall bears the image of the enthroned Madonna. The wall looking out upon the lands to the south of the city has been repainted several times since the fourteenth century, so its original appearance can no longer be ascertained. As for the long north wall opposite the windows, the patron saints and battles that can be seen there were all painted after 1350.

This, then, was the assembly hall for the General Council. Here they deliberated, the records tell us, on matters such as the worship of the Virgin Mary and the city's patron saints, territorial expansion, agreements concluded with *condottieri*, the annexation of towns and the way to put down rebels. Clearly, the images on the walls sprang from the items on the councillors' agenda.

Some paintings functioned as actual documentation. One instance of this practice arose when the little town of Giuncarico was once more forced to yield its sovereignty when subjected to Siennese rule in 1314. The town's representatives each had to place a hand on the Bible and pronounce a solemn oath of allegiance to Sienna. The treaty, given force of law by notarial authorization, obliged the inhabitants of the annexed town to obey Siennese law, to support Sienna in times of peace and in war, joining its allies and opposing its foes. Like all other subjected towns, Giuncarico

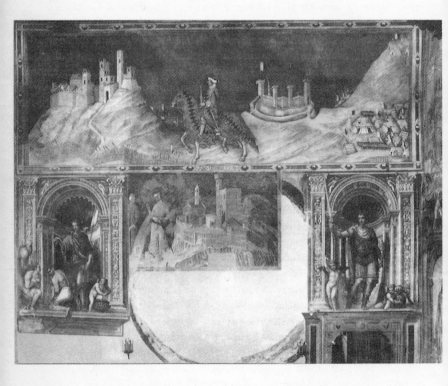

32. Simone Martini, *Guidoriccio da Fogliano at the Taking of Montemassi*
1330; below: *the Annexation of a Castle, c.* 1314; remains of the globe
by Ambrogio Lorenzetti; and *St Ansanus* and *St Victor* by Sodoma,
1529; Palazzo Pubblico, Sienna (photograph Grassi)

would be required to send representatives to the Festival of the Assumption in the Duomo, who would offer the obligatory wax candles and silk. The treaty also prescribed the taxes to be paid and contributions that would be exacted for the upkeep of bridges and roads. The podestà of Giuncarico would now have to bear the arms of Sienna, and all the town's previous privileges would be annulled[143].

The day after this treaty had been drawn up the subjection of Giuncarico was discussed in a meeting of the General Council. It was decreed that in order to consolidate the written agreement in a more public way, the transfer of power was to be depicted in a painting. Whilst the treaty itself was consigned to the city archives, the annexation of Giuncarico was immortalized in a form visible to anyone entering the hall. This was by no means a unique case; a series of castles subjected by Sienna already graced the walls[144]. Thus it would frequently happen that when territory was won and the Siennese sphere of influence expanded, two things would happen at once: a treaty would be drawn up and a commission directly corresponding to it would be issued for a painting.

In 1315 Simone Martini was entrusted with the task of painting the sacred emblem of the state on the east wall of the Council Hall (see fig. 33)[145]. Directly above and behind the seat of the podestà, who presided over these assemblies, the *Maestà* with the four patron saints appeared on the wall. Martini emphasized the fact that he had taken Duccio's altarpiece as his example by painting into his work the baldachin overhanging the altarpiece in the Duomo. But he painted the Virgin's throne differently; instead of being fashioned in Roman marble it bore something of a resemblance to a 'Gothic' polyptych such as had been developed in Sienna[146].

Martini's *Maestà* has a number of significant added details, such as the crown worn by the Virgin and the painted border, in addition to the baldachin. Images on the latter refer to the political situation: the mare in black and white and the white lion on a red ground, the arms of the city and the people of Sienna, are included, together with the fleurs-de-lis of Robert of Anjou, King of Naples – leader of the Guelf alliance to which Sienna now belonged.

The border around the *Maestà* contains portraits of prophets, Evangelists and Church Fathers. The central figure at the top is Christ the Saviour conferring his benediction. The corresponding image at the bottom is of especial interest: it is of a two-headed woman, portrayed with the Old and the New Testament. Her octagonal aureole contains inscriptions reminding administrators of virtues to which they should aspire. The heavenly

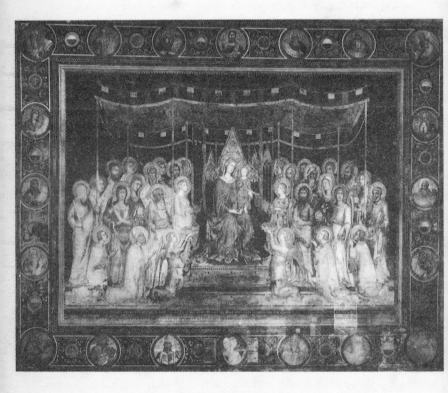

33. Simone Martini, *Maestà*, 1315–21; east wall of the Council Hall, Palazzo Pubblico, Sienna (photograph Grassi)

company is linked to the city-state of Sienna more explicitly by way of the two sides of the Siennese coin depicted beside the Old and New Testament, which bear the inscriptions: *Sena Vetus Civitas Virginis* (Old Sienna, City of the Virgin) and *Alfa et Omega Principuum et Finis* (Alpha and Omega, the First and the Last). Also shown in the border is the seal of the captain of the people, a further reference to the link between Sienna and the religious themes depicted in the painting.

The Christ child held by Mary has a parchment roll which says 'Pursue Justice, ye who judge on earth'. On the steps leading up to the throne two rhymed verses exhort the councillors and rulers of the city to ensure that justice, peace and prosperity triumph over injustice, war, treachery, theft and murder – poetic variations on themes to be found in the records of Council meetings and in the text of statutes resulting from those meetings[147]. These lines in effect amplify on inscriptions presented in the painting as the utterances of the Virgin, her first words being 'Not angelic flowers nor the roses and lilies adorning the heavenly pastures please me more than does good counsel'. Beside her throne kneel two angels, holding flowers.

From 1328 to 1332 much of the Council's business was dominated by the annexation of fortresses to the south of Sienna: Montemassi, Sassoforte, Arcidosso and Castel del Piano. In 1328 the war captain, at the time the best paid official in Sienna, embarked on what proved to be a lengthy siege of Montemassi. The Aldobrandeschi family finally surrendered and were therefore also compelled to sell Arcidosso and Castel del Piano in 1331, the resulting treaties being added to the revised edition of the *Capitoli* referred to above. At the same time, just as in the case of Giuncarico, the treaties were soon followed up by painting commissions.

In September 1331 Simone Martini was given expenses for himself and a page to proceed on horseback to the annexed towns, his brother Donato, incidentally, also being paid to make several drawings of houses in the area. By 14 December Simone's task was complete and he collected his salary: the paintings of Arcidosso and Castel del Piano had been added to the Hall[148]. These are no longer visible, and the painting of the destruction of Sassoforte that Tura says was painted in 1330 has also disappeared[149]. It seems likely that the images made to record the treaties of Sassoforte, Arcidosso and Castel del Piano are hidden beneath the battles painted at a later date on the long north wall.

In 1330 Simone Martini added the 1328 siege of Montemassi to the west wall (see fig. 32)[150]. The fresco visible below Montemassi is a fragment of the pact concluded with feudal lords during the first campaign, around

1314. The figures and buildings of the first and second campaigns are painted on the same scale and against the same dark blue background that is used for the entire Hall[151]. The castle of Scanzano, which the Aldobrandeschi counts were permitted to keep on condition that they would not fortify it and that the annual wax tribute would be paid, was drawn but not painted on the wall[152].

The paintings made by Simone Martini and his assistants of the Aldo-brandeschi's towns and castles served as a pictorial sequel to the defeat of that other great feudal family, the Pannocchieschi, counts of Elci, whose subject towns had once included Giuncarico. Much of the work has been obscured by later decorations, however, notwithstanding the intention expressed at the time to keep the subjected castles on permanent display[153].

The row of saints and *beati* of the city, beneath the images of annexed towns, tells the same tale of additions and alterations. The programme of images may well originally date from 1329, when the General Council decided to maintain the funds needed for the worship of local saints, but Catherine and Bernardine of Sienna, for instance, were added much later, in the fifteenth century[154].

As counterparts to the patron saints, portraits of rebel noblemen with their castles, known as *pitture infamante*, were painted on the north, west and probably also on the south wall of the great assembly hall. Images of those disgraced were also included on the Palazzo façade. With these two extremes – the city's patron saints on the one hand and the feudal rebels with their former estates on the other – the theme of peace versus war, or Good and Bad Government, was introduced, which was to be elaborated in the adjoining chamber[155].

In sum, the decorations to be seen in the Hall provided the citizens with a comprehensive picture of the city-state of Sienna in general and the decision-making of the Council in particular, covering subjects as diverse as the worship of saints and the waging of war. The unifying element was the republic's symbol, the *Maestà* resplendent on the east wall. As the process of state formation was further consolidated, each step was paralleled by images on the wall that recorded the expansion of Sienna's territory. Siennese symbolism thus comprised two distinct elements: the state was represented on the one hand by the Virgin seated in majesty, its constant single image, and on the other by a shifting agglomerate of castles, towns, nobles and the officials that represented the republic[156]. The picture was completed with rebels, shown overthrown and disgraced, and the patron

saints, on whose support the Siennese relied in their continuing struggle to protect and promote the interests of their state.

GOOD AND BAD GOVERNMENT: THE PEACE ROOM

The Nine were alive to the dignity of republican statesmanship. As they fashioned their policies on preserving peace or waging war the example of the Republic of Rome guided them, and indeed they felt themselves to be the heirs to those ancient rulers. Commissions were issued evoking this tradition, such as a representation of the exemplary patriot Marcus Regulus, ordered from Simone Martini in 1330 to be painted in fresco next to the Council Hall[157]. Other scenes from Roman antiquity were painted several years later by Ambrogio Lorenzetti[158].

The theme chosen in 1338 for the Nine's meeting chamber was contemporary rather than historical. Many more or less arcane theories have been developed to explain the sources of Ambrogio Lorenzetti's fresco, known as the Allegory of Good and Bad Government. In fact it was directly related to recent legislation.

Three walls covered with frescoes are lit by the windows of the chamber (see fig. 34). The north wall opposite the window has a representation of a tribune with a number of figures, the painting known as *Good Government*, and the fresco on the west wall, originally known as *War*, shows another group around a tribune, to the left of which the city and countryside are seen to be in the grip of military action. Finally, the entire east wall – the connecting wall with the Council Hall that has the equestrian figure of General Guidoriccio on the other side – is taken up with a serene depiction of peacetime in Sienna and its *contado*. It is the last-mentioned painting that has given the chamber its present name, 'Sala della Pace' or Peace Room.

In framing legislation the Nine were always concerned to achieve clarity and to ensure that the laws were properly publicized. A series of statutes was drawn up in 1337 and 1339. In this time of peace and prosperity, commented the chronicler Tura, the chief aim of the Nine was to avoid any ambiguities and to ensure that people lived under a just rule[159]. The new statutes contained various supplementary regulations and the whole was more systematic and formulated with greater clarity than before. Although this new constitution was once more written in Latin, only the version of 1309 having appeared in the vernacular, the citizens could now

34. Ambrogio Lorenzetti, *The Good Government of the Nine in the City and Contado of Sienna*, 1338; Meeting Chamber of the Nine, Palazzo Pubblico, Sienna (photograph Grassi)

more readily consult legal experts to clarify a point, as scores of jurists had fled from Bologna in 1338, many of whom settled in Sienna[160].

An apt complement to the revised statutes would be a pictorial overview of the regulations that made up the foundation of the sovereign state of Sienna, as ruled and defended by the Nine. In executing the frescoes that would become known as *Peace*, *War* and *Good Government* for the chamber walls (1338–9) Ambrogio Lorenzetti performed this task[161]. The paintings specifically relate to the city-state of Sienna. They are not based directly on texts written by mendicants or by courtiers; such cultures and that of the Tuscan republic were worlds apart[162].

The painter, too, could consult the 1309 statutes, and if he desired clarification on the Latin text of 1337–9 he could also enlist the expert advice of the Bolognese refugees. Moreover, these jurists were quite familiar with the practice of rendering verbalized ideas into pictorial images. The miniaturists of Bologna had developed their own constitutional repertory of images to illuminate collections of papal and imperial decrees. Each such collection would have a miniature as its frontispiece, depicting the transfer of the symbols of authority from a divine figure to a mortal ruler. An enthroned majesty – God, Christ, St Peter or God depicted as the Trinity – would be shown handing the insignia of authority – whether a book, a sword, a sceptre or a crown – to the pope, emperor or king, depicted with his retinue[163]. In his commentary on the papal laws in 1338 the prominent jurist Giovanni d'Andrea emphasized the importance of good government. When the treatise was published, it bore a frontispiece displaying the virtues he referred to in pictorial form[164].

Other such illustrations were also at hand. In the Duomo one could consult illuminated versions of Gratian's *Decretum* and other statute books[165]. One of these contained a miniature that showed an enthroned Christ presenting a book and a sword to the pope and emperor respectively. Many issues with a bearing on government were dealt with in such images, for example, the administering of justice and execution of sentences, but none focused specifically on the situation of a republic. Lorenzetti could certainly have found suggestions in the simple miniatures illuminating the Siennese statute books that could be elaborated into a symbolic repertory tailored to a republican state, but he was obliged to create the overall design himself.

The short wall facing the window shows a tribune with personifications identified by means of clear inscriptions, attributes and raiment (see fig. 34). The largest is an enthroned ruler, the letters CSCV circling his head,

standing for *Comune Senarum Civitas Virginis*, or Commune of Sienna, City of the Virgin. In his left hand he holds the golden seal of Sienna with an image of the enthroned Madonna. His cloak has the white and black of the state escutcheon worked into it, his fur cap the red and white of the popular arms. The sceptre in his right hand is the symbol of this figure's sovereign authority. The two infants at his feet, suckled by a she-wolf – also depicted on the façade and on columns in front of the Duomo – refer to Romulus and Remus and thus to the city's Roman heritage[166]. Here once again the citizens of Sienna presented themselves as legitimate heirs to the Roman republic.

Attached to the sceptre is a braided cord that leads all the way through the men in front of the tribune to a woman seated on the left. Like the ruler, she is viewed squarely from the front; she is dressed in red, with gold trim. Behind her, we read the same text as that which accompanies Simone Martini's *Maestà* in the adjacent hall: 'Pursue justice, ye who judge on earth'. The woman's gaze is directed upwards to the scales of justice being held out by a winged woman, and she is identified, by an inscription over her head, as Wisdom. She is a source of inspiration to justice, guiding the scales, and also has the statute book, which provides the basis for judgement. On the left, we see an angel marked *Distributiva*, referring to the notion of distributive justice – the angel beheads a wrongdoer with one hand and crowns a kneeling figure with the other. The latter represents Robert of Anjou, who bears a palm branch rather than a sword in token of his pacific attitude to the city-state – he has relinquished his sword, his military might, to the angel. The angel on the right, *Comutativa*, represents commutative justice, which ensures that a proper balance is maintained by preventing fraud and enforcing the payment of debts, here pictured by the two figures being forced to exchange a stick and a chest. On the far right of the fresco is a figure identified as Justice herself, with a sword and the head of a decapitated miscreant in her right hand and a crown in her left hand. This is a clear indication of the retributive justice or criminal law of Sienna, which was unflinching in the case of rebellious nobles and warring princes.

Seated beside Justice are Temperance, holding an hourglass, and Magnanimity, with a dish of coins and a crown she is giving to the ruler, on whose other side we see Prudence, Fortitude – equipped with a general's staff, shield and armour – and Peace[167]. Peace holds an olive branch in one hand and wears a crown of laurels; tucked away under her cushion is a coat of mail. She is conspicuously defenceless. Flying above the great ruler and

the cardinal virtues are the three theological virtues, Faith, Hope and Charity.

Taken together the figures represent the objectives pursued by the Nine in their rule over Sienna, laid down in the constitution and in their oath of office. Chief among these aims were peace and justice, and reference was also made to magnanimity and charity, in a general sense as well as in specific decrees ordering the provision of alms or allocating funds for church building. The virtues of wisdom and prudence were repeatedly cited as characteristics sought in men to serve on the committees of wise men to whom administrative tasks were often delegated.

There are further allusions to the statutes in the figures standing in front of the tribune. On the left a woman is seated with a plane, a tool symbolizing civilization. She is identified as Concord, a term always mentioned in the records of the Nine's meetings in connection with decision-making. She takes the two cords leading from the scales bearing the angels of punishment and reward, and twines them together, giving the resulting emblem of concord to one of the small male figures depicted in the lower section – two rows of twelve men, representing the Signory of Sienna.

The first six men at the front of this assembly are presumably the chief officials[168]. We may distinguish the podestà, the 'maggior sindaco', the 'capitano del popolo' and three consuls of the merchant guild, their seniority suggested by the fact that they wear fur caps, as depicted in miniatures, whereas the others do not[169]. Behind them appear the ruling Nine and a second row of nine figures consisting of executive officials – four Biccherna functionaries, three collectors of the Gabella and the two 'camerarii' or keepers of the city's communal weapons. Together they make up the wise and learned rulers of Sienna.

The procession of dignitaries would have put contemporary viewers in mind of the procession held on the eve of Assumption Day. Two nobles in chain mail kneel before the citizens, one offering them a castle and the other pointing to the miscreants and rebels bound behind him[170]. They represent the nobles now loyal to the commune, such as the counts of Santa Fiora, the feudal line of Aldobrandeschi and the counts of Elci of the line of Pannocchieschi. The tribune is defended not by feudal nobles but by the state army[171]. The Siennese armed forces were defenders of the sovereignty of the commune in wartime and upholders of the law in times of peace.

Depicted on the west wall is the antithesis of peace and good government (see fig. 35). At the centre of the group of figures on the tribune is Tyranny enthroned, flanked by sins. Justice lies shackled on the ground. As a

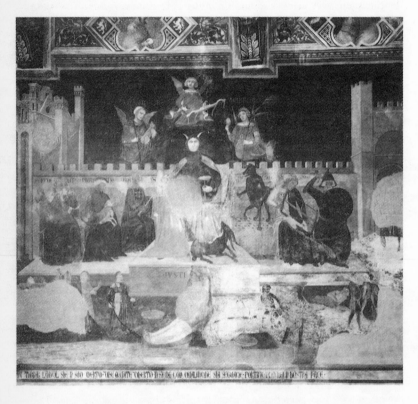

35. Ambrogio Lorenzetti, *The Rule of Tyranny*, 1338; Palazzo Pubblico, Sienna (photograph Grassi)

counterpart to the suckling she-wolf there is a black goat at Tyranny's feet, and as a counterpart to Concord with her plane we see here Discord with a saw. Above the unsavoury company on the tribune other vices hover in the air, such as Avarice, shown clutching closed money-bags. The yoke which has come loose refers to conduct lacking in restraint, and Vanity is evoked by a mirror. In front of the platform murder, rape and robbery are all in progress, in other words all the things prohibited by criminal law[172].

The city seen to the side of the tribune is in a state of decay. Balconies are crumbling, walls cracking, windows are broken, the streets are full of rubble and the shops are bare. Armed thugs have taken over the public highways, threatening children, attacking men and raping women. The figure of Fear dominates this life and the economy of the land has been utterly disrupted. There is no sign of trade or industry – in fact no-one is working at all. Villages are burning, farms being plundered, bridges are falling down and anything fit to eat is being stolen[173]. The fresco shows all that results when rebels and law-breakers hold sway.

Clarity and order before all else – this was what the statutes said, and with this aim in mind the frescoes were designed and provided with inscriptions[174]. The entire west wall was covered with depictions of criminals, foes and rebels, and in contrast, at right angles to this image, were shown the group of good, just people striving to achieve peace and harmony[175]. With the additional device of seasonal contrasts, autumn and winter being opposed to spring and summer, the opposition of war and peace was more marked still. The town councillors depicted on the north wall gaze proudly on the effects of their policy, with everything they opposed put firmly behind them.

On the east wall were thus displayed a city and countryside fashioned by human hands, bearing the imprint of the ideals of government espoused by the rulers who conducted their business in this chamber (see fig. 36). This applies not only to the general message conveyed by the paintings but to countless details that correspond to the texts of the statutes. Sienna was built according to physical planning regulations laid down in its laws, and the city presided over by its cathedral dome and tower rising on the left is represented as faithfully adhering to these regulations. For instance, the distribution of windows complies with the statutes[176]. So does the absence of any personal coats of arms on public buildings, as these were prohibited[177]. The activities depicted are equally in accordance with the law. Bricklayers are shown suitably hard at work and the main branches of industry and shopkeeping are represented. We see a cobbler exchanging a civil word

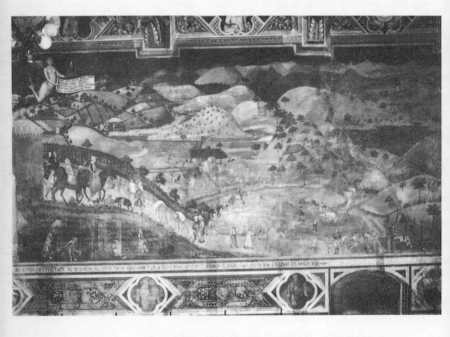

36. Ambrogio Lorenzetti, *The territory of Sienna in Peace and Prosperity*;
Palazzo Pubblico, Sienna (photograph Grassi)

with a customer in his workshop. The image of a working teacher lends force to the prominent role accorded the liberal arts, as designated in the fresco border[178]. We see an orderly and hygienic butcher's shop with a neat array of sausages and hams, unsullied by any blood or discarded waste. There is no question here of customers being duped by one kind of meat being sold as another or by dead animals being brought surreptitiously into the city to be sold as fresh meat[179]. Bankers and notaries are at their desks and weavers at their looms. Firewood, grain and cattle for slaughter are being transported into Sienna, activities that give rise to prosperity and swell the state's income from taxes[180].

Hand in hand with this healthy economy went a flourishing cultural life. This is suggested by the image of two noblemen and a noblewoman proceeding on horseback to the Duomo, and the nine ladies in the centre getting ready for a dance. It seems that Sienna has only the merriest of citizens: of the poor or unkempt, the distressed or the sick, of widows or orphans there is not a trace.

At the same time as illustrating the workings of the Siennese statutes, Lorenzetti's frescoes accurately rendered the contemporary aspect of the city and its surroundings. There, in the meeting chamber of the rulers of Sienna, the frescoes reflected all the decisions on building that had been made in their own town hall, from the Duomo in the west to the roads traversing the Arbia valley in the south-east. At the border between town and country is the wall of Sienna with its Porta Romana, identified by the she-wolf. The personification of Security, holding a miscreant on the gallows, rules over the entire city-state with its *contado*[181]. In her right hand is an inscription saying that all citizens may work without fear as long as Sienna is ruled by the 'Signoria', as the Nine and the chief magistrates are referred to here. This reassuring figure watches over a country scene showing a shepherd tending his flock, farmers threshing and nobles hunting game. At the city wall people are hard at work in a vineyard. Roads, bridges and watermills are in excellent condition, all as decreed by law[182]. The woods, fields and vineyards have all been taken care of in the prescribed way, and correspond to the actual contemporary situation[183]. This scene is a faithful representation of the Arbia valley, showing the road from Montaperti to Asciano and in the foreground the main road to Rome, the backbone of Sienna's urban and agrarian economy. But with this as well as the other frescoes Lorenzetti has not only achieved verisimilitude; he has also translated the city statutes, hardly a lively series of texts, into an evocative pictorial form. It is an astonishing achievement.

4. THE PROFESSION OF PAINTING

===

PATRONAGE AND PROFESSIONALIZATION

The history of the Siennese school is a striking illustration of the dependency of artists upon the scope created for them by commissions. Before the great upsurge of patronage around 1280 there was scarcely anything that could be called a painting tradition in Sienna. In the early stages, when artistic commissions were still given only sporadically, they would go to craftsmen from other cities belonging to professional groups that were already well established: sculptors and glaziers from French towns, workers in marble and mosaic or painters from Rome, sculptors from Pisa and workers in precious metals from various towns, specialists consolidated as groups in or even before the thirteenth century. As crafts and trade flourished in Sienna, however, fertile conditions were created for those wishing to develop new skills, and as commissions multiplied, artists in the city-state itself were enabled to specialize in the art of painting. Those who did so were to a great extent inspired by the work of painters from other cities and by ancient statues that had remained intact. By 1340 the Siennese school of painting was renowned.

There was an incipient professionalization of decorative work in many cities during the thirteenth century. Sculptors from Pisa, for instance, regularly took on work outside the city, and the painter Guinta Pisano (also from Pisa) received a commission from Fra Elias in 1236 to paint a crucifix for S. Francesco in Assisi[184]. The Master of St Francis worked for the Franciscan order in Assisi and in Perugia[185]. Many other artists from numerous cities went where their work took them. At first, painters would only be charged with relatively simple tasks; it was only after about 1300 that they came to be entrusted with the more prestigious commissions. The machinery of patronage operating between 1200 and 1350 generated in two cities, and two cities only, an enduring and dynamic professional tradition in the art of painting: these cities were Florence and Sienna.

A number of factors worked to the advantage of painters, as against other

decorative artists, when commissions were being weighed in the balance. In particular, paintings were far less expensive than mosaics, work in precious metals, or woven material such as tapestries. This was partly because the necessary raw materials, except for gold leaf and certain specific pigments, were cheaper, and partly because painting was less labour-intensive than other decorative crafts. Such factors made painting particularly attractive as a form of decoration for the walls of mendicant churches; the friars wanted large surfaces to be covered with new images in a short space of time that would be impressive without being suggestive of opulence. Siennese and Florentine painters were called to Assisi, Perugia, Rome and Naples to embellish mendicant churches, and with each such commission their position became more assured.

More and more employment for painters presented itself in central Italy. Court residences provided a particularly fertile source of work, having an altogether lower level of specialization in crafts and other forms of industry than the communes. The courts of princes and popes had no professional traditions of artistic excellence, so they were dependent on artists from major cities who would be professionals affiliated to an organized group. Sienna had a better reputation than Florence when it came to attracting commissions from potential clients in Naples, Rome, Orvieto and Perugia. In fact until around 1325 even the main commissions for panel paintings in Florence were executed by artists from Sienna. It was only at a later stage that the balance between the two Tuscan city-states was to swing the other way.

The existing network of patronage fostered the development of a handful of centres of production, each with numerous workshops. Most cities were too small to sustain an established professional group of painters that would be able to guarantee a varied supply of high quality work from one generation to the next. There was too little work for artists to be able to rely solely upon commissions in their own city, in Sienna as elsewhere, but when these were combined with work provided from clients in neighbouring regions it proved possible for an enduring professionalization to be consolidated in both Sienna and Florence.

As the professional skills of painters became more widely acclaimed, commissions were also gained for cathedrals and town halls. Examples suggesting how to proceed here scarcely existed. In their exertions for the cathedral of Sienna, painters collaborated with carpenters to create a new product which would improve their competitive position with more established craftsmen. Thus was born the altarpiece.

After a period of experimentation the altarpiece was to evolve into a genre that permitted an infinite number of variations on its shape and function and on the subjects it depicted within the given frame[186]. The novel item was itself depicted in paintings made in various places around 1340. In the S. Francesco in Sienna, Lippo Vanni painted a polyptych on the wall[187]. Bolognese miniaturists included altarpieces in their illuminations for papal statute books[188]. In the papal basilica in Rome, a portrait of Cardinal Stefaneschi shows him presenting a polyptych to St Peter (see fig. 13). A fresco in Paris of a ceremonial meeting between Clement VI and the crown prince of France has at its centre a diptych from Sienna which changed hands as a diplomatic gift on this occasion[189].

Growth escalated between 1250 and 1350. More plentiful painting commissions enabled artists to develop greater technical expertise, thus improving their chances of gaining still more commissions. The driving force behind both patronage and professionalization in Sienna in these hundred years was the vast potential of previously untapped resources, on the part of both those issuing the commissions and the artists themselves.

Another stimulus was the changed social context inhabited by clients and artists alike; their world had grown larger and more highly structured. This had many different consequences. The greater organization within the State and the Church had given rise to substantial funds, and in the wake of the intense building activity of the thirteenth and early fourteenth centuries a growing share of these funds was used for artistic commissions. Also, within the city-state an organizational framework for craftsmen had evolved in the form of guilds and the court of the Merchant Guild, or *Mercanzia*, that was empowered to adjudicate in industrial disputes. Furthermore, mobility had been greatly improved by the more pacific state of the region; both potential clients and craftsmen were now able to travel from one city to another over well-maintained roads and bridges without having to be on the alert continuously for bandits or plundering troops.

The process of civilization within church communities, city-states and courts created a favourable climate for money to be spent on images; images that were not only themselves expressions of the new civilization but which also served to disseminate it[190]. Looking upon them, the illiterate, too, were instructed in religious doctrine and in the desirability of acquiring such civilized virtues as learning, charity and compassion. This instruction was therefore to a considerable extent the task of painters.

DUCCIO: MASTER OF AN AGE

The commissions issued for Sienna Cathedral were of historic importance for the professionalization of painters. More specifically, this building was to prove as crucial to the development of panel painting as S. Francesco in Assisi had been to fresco work.

It is fair to say that the paintings made at the beginning of the thirteenth century show little command of painterly technique. Early Madonna icons were painted with rudimentary form and taut lines; the first Madonna in Sienna Cathedral showed Mary seated upon a schematically rendered seat with only crude indications of legs and cushions (see fig. 23). Both Mary and the Christ Child on her lap were painted squarely from the front. Three-dimensionality was suggested mainly by relief work on the panel, and precious stones inserted around the image accounted for an important part of the total visual effect. The way the work was painted did not constitute a major focus of attention.

A distinct step forwards in painting practice is signalled by the work of Guido da Siena. In the panel he produced for the Duomo a dynamic unity dominates the conception of the Madonna and Child. As Vasari would say, the figures are a little less 'rough'. There is a greater variation than previously found in glance and attitude. Once Guido da Siena had taken this initial step in the direction of the professionalization of painting, he was in turn surpassed by Duccio di Buoninsegna.

Duccio painted no less than thirty figures around the Madonna and Child in his great altarpiece (see figs. 24–5). The biblical episodes he depicted on the back exhibit tremendous variety, ranging from the intimacy of the Annunciation to the pageantry of Christ's entry into Jerusalem. In addition to portraying human figures in all manner of attitudes Duccio also painted town scenes, church interiors and landscapes. He had a sure command of representing constructions, whether of thrones or of buildings. Clothing was depicted with new elegance, and Duccio gradually abandoned the custom of using gold lines to indicate folds in the material. As a result of his procuring and executing this intensely demanding commission of the *Maestà*, Duccio acquired the reputation of being the best craftsman in the region[191].

It also meant a considerable rise in income. From one who in 1278 had been engaged for a few *soldi* a day in the almost menial task of painting chests in which to store civic documents, Duccio had risen to gain the most prestigious of commissions, earning a daily wage of sixteen *soldi* – more

than any of his contemporaries[192]. The wages were stipulated in a contract drawn up in October 1308 by a notary in the presence of witnesses. This agreement also included provisions for fines if either side were in breach of contract, and the artist was further obliged to 'work continuously on the said panel at all times in which he is able to do so, and not to accept or take receipt of any other work'[193]. Contracts drawn up with artists frequently included such a clause; when Nicola Pisano had been given the commission to execute the great pulpit for the cathedral in 1266 he had committed himself to settling in Sienna and working uninterruptedly on this commission for two years[194].

Just like Pisano before him, Duccio was able to rise to a new economic standing by virtue of the substantial commissions entrusted to him, coming to occupy a privileged place in the community of craftsmen. Whereas the former was a sculptor from Pisa, however, the latter was a painter from Sienna itself. How keenly the identification between artist and his city-state was felt may be seen in an inscription Duccio wrote on the Madonna's throne; it named Mary as the source of peace in Sienna and Duccio as the painter of Mary.

The *Maestà* was the unique product of circumstances specific to Sienna. The special function of the cathedral in civic life was a prime source of innovation. To this we can trace the particular emphasis on painting that distinguished Sienna's artistic patronage from that of other cities; though mosaics and work in precious metals and stones were also ordered for the Duomo, altarpieces played an unusually dominant role. And as an altarpiece, too, Duccio's *Maestà* was unique in that it drew on and integrated different traditions in the visual arts. The monumental panel visible to the laity from a great distance resembled similar images commonly seen at the apse mosaics and at the choir partition in mendicant churches discussed in the previous chapter. The smaller narrative scenes on the back, on the other hand, bore a similarity to miniatures: they were in the way of an illuminated gradual minus text for the canons perusing them. In combining such disparate elements, Duccio provided a new synthesis in a work whose form and thematic content answered to a particular set of demands.

This specificity meant that the *Maestà* was not emulated to any significant extent[195]. The only instance of such emulation that can be pointed to in a large-scale decoration for the main altar of a cathedral is that of the Duomo of Massa Marittima, a town heavily dependent on Sienna. A similar altarpiece was made for this cathedral, with a painted crucifix above it, perhaps ordered in honour of Sienna's imminent annexation of the town[196]. In 1316 work

on this altarpiece was temporarily suspended through lack of funds. The rulers of Sienna ensured its continuation, however; they approved a loan to the cathedral works, accepting as security a certain quantity of wax that was to be donated on the festival of the Assumption.

DUCCIO'S SUCCESSORS: ART AS A PROFESSION

Although the *Maestà* as a whole was not suitable for use as a model for commissions given in different circumstances, the type of skills it displayed could be used in any number of contexts. Working on the altarpiece gave Duccio's assistants and pupils the opportunity to master these skills, which new expertise they later drew on for smaller commissions executed under the master's supervision and for major orders after Duccio's death in 1318[197]. Their career prospects had been considerably enhanced by their experience in Duccio's workshop.

Altarpieces from Siennese workshops gradually evolved from simple panels into elaborate constructions of carpentry painted with an immense variety of images. In sheer dimensions they grew from about two metres by seventy centimetres to a breadth of almost three and a half metres and a height of over two metres. They were also given a more graceful form, not only in the actual images of figures or buildings painted, but in various additions. They acquired small turned columns culminating in pinnacles embellished with a repertory of ornaments including finials. Elegant wood carvings would surround standing figures, narrative biblical scenes and images from hagiography. More rows were added, on top of a predella, and sometimes buttresses were used, each in turn painted and gilded. Painters looked to the knowledge amassed by carpenters, furniture makers, goldsmiths and sculptors, and used it in the developing genre of the altarpiece.

The altarpiece found particular favour with the mendicant orders. The artists Duccio, Vigoroso da Siena, Guido da Siena and Meo da Siena all executed numerous works for Dominicans, Servites and Franciscans in Perugia and Sienna[198]. The friars also provided important commissions for Ugolino da Sienna; between 1320 and 1324 Ugolino made polyptychs for the high altar of the mendicant churches of S. Croce and S. Maria Novella in Florence. The painter Ambrogio Lorenzetti worked for Franciscans and Augustinians in both Florence and Sienna, and his brother Pietro, who had produced frescoes for the Lower Church of S. Francesco in Assisi (1317–19) was working on an altarpiece for the Siennese Carmelite order in

37. Ambrogio Lorenzetti, *Purification of the Virgin Mary*, 1343; Galleria degli Uffizi, Florence (photograph Anderson)

1324[199]. Simone Martini had also worked first in Assisi; now he collaborated with his brother-in-law Lippo Memmi executing commissions for the Dominicans of Pisa and Orvieto and the Augustinians in S. Gimignano. The altarpiece he had made for Trasmundo Monaldeschi, the Dominican Bishop of Sovana, now stood in Orvieto; he also made one for the Servites in that city[200]. In cases such as that of Segna di Bonaventura the work done for mendicant orders was of relatively minor significance; Segna mainly worked for the commune authorities and for secular churches in Castiglion Fiorentino, Casole d'Elsa and Murlo, but he also made an altarpiece for the Benedictines, showing (as one might expect) the founder of the order beside the Virgin Mary and Christ[201]. It was particularly thanks to the patronage of the mendicant orders that Siennese painters were in constant demand in central Italy. A type of polyptych was developed in Sienna that would serve for any of the various monastic orders, allowing for certain variations in saints, family arms and an occasional devotional figure. Great popularity took the Siennese painted panels to many different cities; but the workshops remained in Sienna.

The initial experience of a painter trained in Sienna was as a pupil in one of these workshops. Once he could call himself a master, a young man would extend his operational range to include centres of population in the surrounding area and then gradually further afield, from small villages to towns such as S. Gimignano and eventually to Florence or Naples. An artist of exceptional skill would eventually be able to crown his career, at a more advanced age, as the leading painter of a major city or at an influential court.

As young masters, Pietro and Ambrogio Lorenzetti and Simone Martini all worked outside Sienna, as Duccio had also done. Simone Martini executed the most important commissions in Sienna from 1325 to 1333, and when he left for Avignon, Ambrogio Lorenzetti replaced him as the city's leading painter. In 1343 Lorenzetti finished an altarpiece for the Duomo that depicted at its centre a group of figures in a meticulously detailed church interior. They are standing before an altar on a tiled floor, the intricate pattern of which is rendered in perspective (see fig. 37). Ambrogio Lorenzetti had mastered the technique of designing an interior space and placing within this space a large group of figures engaged in a dramatic action, whilst not neglecting to incorporate details of architecture, landscape, clothing and facial expression. It was a far cry from the work of Guido da Siena less than a hundred years before.

SIMONE MARTINI, COURT PAINTER OF AVIGNON

Simone Martini, like Giotto, was one of the few painters to acquire wealth and fame[202]. After an initial period of working for his native city he made paintings for clients from diverse places – Assisi, Pisa, S. Gimignano, Orvieto and Perugia – before once again fulfilling commissions for Sienna, producing the paintings for the town hall that have been discussed above. His contacts with prominent Dominicans and Franciscans and with the rulers of the commune took him into the circles of the courtly élite and finally led him to the papal court of Avignon.

One of the works executed prior to the move to Avignon was an altarpiece commissioned by Robert of Anjou, King of Naples, in honour of his brother, Louis of Anjou. The Neapolitan court had requested several times that Louis be canonized, and in 1317, on the recommendation of a papal committee, Pope John XXII gave his approval. In the altarpiece painted by Simone Martini the new saint is depicted enthroned; whilst he crowns Robert, who kneels to his left, he is himself being crowned by angels. The fleur-de-lis, emblem of the House of Anjou, adorns both the frame and the back of the panel. The images in the predella show, on the left, Louis avowing his loyalty to the Franciscan order before Boniface VIII and his ordination as a bishop. On the right several miracles ascribed to the new saint are depicted[203].

Robert's commission of the altarpiece was entirely in keeping with the grand scale of his artistic patronage, which grew to a peak of activity between 1325 and 1340. The same subjects recur repeatedly in his commissions: himself and his wife, his successor and Franciscan saints, now including his late brother, Louis[204]. Giotto, too, was given commissions by Robert of Anjou; he worked not only in the monumental church of St Clare's but also in Robert's palace, painting, amongst other things, a series of famous men and women[205].

In Naples it was the king who represented authority, and not, as in Sienna, the Virgin Mary and the patron saints of the city. The frontispiece of an ode dedicated to Robert of Anjou shows him seated upon a throne against a background of fleurs-de-lis[206]. He is also shown enthroned – in the company of predecessors, successors and personified virtues – in the Bible of Niccolò d'Alife[207]. Both in Naples and later in Avignon the painter from Sienna came into contact with a culture very different from that in which he had grown up.

Around 1335 Simone Martini arrived in Avignon, where he painted a portrait of Napoleone Orsini on the panel that was to be carried in the funeral procession of this high-ranking Italian prelate. Martini's assignments were extremely varied. Jacopo Stefaneschi chose the Siennese painter to illuminate his treatise on a miraculous intervention by the Virgin Mary to save a child from perishing in a fire. Another commission, also stemming from Stefaneschi, was to paint a monumental fresco of St George freeing the princess from the dragon, a theme that in Sienna was charged with the political significance of the age-old struggle with the Florentines. In Avignon the dragon's role was played by the French. Simone Martini portrayed his patron giving thanks to God on the occasion of this liberation. In another image of Stefaneschi painted by Simone, above the entrance to the papal church adjoining the palace (Notre-Dame-des-Doms) Simone shows his patron praying to a figure of the Virgin Mary seated on the ground. Above this Madonna of Humility the Saviour is depicted, just as in Stefaneschi's altarpiece in St Peter's. The fact of Mary's being portrayed without a throne was an indirect reference to Stefaneschi's fervent wish, shared by the Italian cardinals in general, for the papal throne to be once more in Rome rather than in Avignon[208].

It was Petrarch (for whom Simone illustrated a Virgil codex) who introduced the metaphor of exile for the papacy in Avignon, expressing the hope that the papal keys would return to their original home[209]. The papal envoy in Italy, Cardinal Bertrand de Deux, though French, used an artistic medium to make the same point, by having two illustrations of the festival of the Liberation of St Peter included in his missal[210]. In a manuscript dedicated to Robert of Anjou around 1340 the theme is presented by way of a personification of Rome dressed in mourning, who is beseeching the king temporarily to assume supreme authority in Italy.

In Naples and in Avignon Simone Martini, the city painter from Sienna, inhabited a different cultural world once he became established as a court painter and his commissions required him to depict courtly ideals. It was, of course, a world that allowed more scope for luxury and individual ostentation than did the republican commune. This meant that there were also more openings for skilled artists. Just as Giotto had done, Simone Martini received higher fees and more accolades at the courts where he worked than would have been possible in Sienna. On his death in 1344 his estate amounted to a modest fortune, and he was buried in the church of S. Domenico in Sienna. In 1347 his widow donated a chalice and a missal

to the church, in addition to nineteen florins for commemorative Masses to be said for the painter's soul[211].

OF PAINTERS BY WRITERS

Simone Martini and Giotto both acquired renown through the praise meted out to them by literary men. Sometimes the writers concerned were honouring the contribution of fellow townsmen to the prestige of their city. Dante and Villani paid tribute to Giotto as an artist of Florence, Villani dwelling on the grand distinction of his appointment as the supervisor of Florence Cathedral in 1334, his noteworthy intermezzo at the court of Milan and his state funeral in 1336[212]. In Sienna Agnolo di Tura praised the achievements of Duccio, Ambrogio Lorenzetti and Simone Martini.

Petrarch was particularly interested in the art of painting and devoted many discussions to it in letters and dissertations. He drew on classical allusions to do so, likening certain painters, including Simone Martini, to Apelles, and claiming such verisimilitude for their work that it seemed to possess life itself[213]. His dialogue about the art of painting conducted by Gaudium and Ratio (Joy and Reason) highlighted the quality of restrained enjoyment that Petrarch valued most highly[214]. The great poet loved two paintings – one by Giotto, the other by Simone Martini – most of all his possessions. He singled them out for especial honours in the will he drew up in 1370; these two works, and these only, did he find worthy to be bequeathed to the man who had been his patron, Francesco Carrara, Lord of Padua[215].

Eighty years later the work of Siennese painters was much acclaimed by the Florentine artist Ghiberti. He accorded them a leading role in his historical survey of the visual arts from the mid-thirteenth to the mid-fifteenth centuries. Ambrogio Lorenzetti figured in Ghiberti's pages as 'a learned painter and master of composition', and Simone Martini as 'a most noble painter and greatly renowned'.

WORKING AS A PAINTER: CONDITIONS OF EMPLOYMENT

Most painters acquired neither wealth nor fame. They never saw a court in their lives; in fact, most travelled very little. They had no experience of influential patrons, and the work they did called for little in the way of

ingenuity. In addition to a few unremarkable altarpieces and a vast quantity of panels for private devotion they painted saddles, signboards, escutcheons, chests, carts, cupboards, books, statues, flags and banners[216]. While Simone Martini rose to the highest ranks of society, no such future lay in store for the majority of his fellow artists. Petrarch focused his attention on scholars as patrons and public, but large numbers of painted images were produced for less sophisticated beholders[217]. Most artists did not spend their time making elaborate frescoes for a large town hall, or yet polyptychs for the main altar of a renowned church; neither did they illuminate manuscripts for the aristocratic élite. The bulk of their everyday work, as is clear from the 1355 guild statutes, had to be accessible even to those unable to read[218].

The painters' guild had an important regulatory role to play. A substantial portion of the guild regulations was devoted to ecclesiastical affairs. Painters were obliged to take part in the festivals of the Assumption, Easter, Andrea Gallerani and St Luke, patron saint of the art of painting. On these days they were obliged to make an offering of wax, and work was not allowed[219]. There were also numerous rules governing the organization of the guild and the positions of rector, treasurer and councillors. Members were obliged to conduct themselves civilly towards officers of the guild, fellow craftsmen and clients. They were further obliged to comply with the city's statutes and pay their taxes. There was a regulation requiring painters to be honest in the supply of raw materials and another forbidding them to take work from one another[220]. Painters from outside Sienna were obliged to pay one florin in taxes, and more if opening a workshop[221].

This strict professional code did not, it is true, necessarily go hand in hand with civilized conduct outside the workshop. (Duccio, for instance, a man who displayed great restraint in his profession, is known to have been fined again and again for violating various regulations[222].) The great importance of the guilds was as instruments of social control; they created a particular tie between individuals and the state.

An oral clarification of clients' wishes was usually thought to suffice when commissions were issued, given the number of things already regulated in the guild statutes. This was certainly true of the everyday work that artists carried out for fellow citizens. Where major commissions were involved, however, or agreements between people from different cities, contracts were often drawn up.

Contracts chiefly stipulated certain material demands and the corresponding sums of money involved; sometimes the diverse details would all be arranged in one document, and sometimes separate agreements were

preferred[223]. Contracts specified dimensions, materials and techniques to be applied, described the subject to be depicted in broad outline, determined the instalments by which payment would be made and in which coinage, and specified the date by which the work must be delivered, often with an accompanying clause forbidding the artist to take on any other work. Specific details would include instructions on the use of gold and of precious pigments such as lapis lazuli. The degree of latitude left for the individual painter is indicated by a contract drawn up in 1320 between Pietro Lorenzetti and Guido Tarlati, the Bishop of Arezzo; Lorenzetti was to produce 'a large panel with at the centre the image of the Virgin Mary with her Son and four figures on either side according to the wishes of the Lord Bishop ... In the remaining portions representations of prophets and saints should be painted according to the wishes of the Lord Bishop, in good and choice colours'[224].

In some cases the materials were supplied by the client, in others the price for which the painter would purchase them was agreed upon beforehand. In the case of altarpieces, once a standard form had been developed, the cursory description *moda et forma* (in the manner and form of) followed by a particular example came into favour as a way of indicating what was required. Where murals were concerned, it was common to stipulate whether the painting was to be done on wet or dry plaster, that is, fresco or secco. The popularity of murals was undoubtedly related to their being relatively inexpensive in terms of labour and materials; to cover the same surface area with panel paintings would be a far more costly business[225].

Ample documentation exists for the status associated with the painting profession between around 1270 and 1350. The evidence of payments received, purchases of houses and land, mentions of sums of money paid for images in death announcements of patrons' legacies and donations to ecclesiastical bodies makes it quite clear that only a fraction of those practising this profession rose to the higher ranks of society. The average artist lived and died an ordinary craftsman, his house simple and his grave obscure. What we are talking about when we consider the professional class of painters in Sienna is a group of about thirty artists at any one time, two or three of whom would constitute the élite. An intermediate tier of about five respected artists ranked between this select few and the rest, who were ordinary craftsmen. The situation in Florence was essentially the same.

This division into three ranks of artists did not undergo any material change after 1350, though conditions became harder. The broad

characterization of the profession remained the same in the following period: some few painters struggled free of their lowly – or in some cases middle-class – origins to achieve success thanks to commissions from patrons at court, whilst the great majority, like carpenters, bricklayers, saddlers and butchers, performed a fairly standard set of tasks for an unremarkable wage.

CONTINUITY AND STAGNATION

The mid-fourteenth century saw a decline in patronage, which affected Sienna more than it did Florence. As a result, developments in skills stagnated somewhat, and the possibility of a painter attaining a high rank in society became still more elusive.

From 1350 onwards fewer major commissions were issued to Siennese painters; mendicants, in particular, were now ordering fewer elaborate polyptychs for their choir altars than previously, partly because most altars already had one. The patronage of courts in Naples, Rome and Avignon also fell off, and the princes ruling Milan, Verona and Padua were now rather inclined to approach artists from Florence or from the north of the peninsula. French cardinals and princes gave no more than an occasional commission to Italian painters. Florentines closed ranks, as it were, and Venice, too, developed a flourishing professional tradition of its own. These changes meant that the further growth of the painting profession in Sienna was systematically stunted. The status quo was largely preserved, thanks to fairly modest commissions granted by civic bodies and churches in Sienna's *contado*. But after one hundred years of dynamic progress, the two processes of patronage and professionalization had reached a static equilibrium.

After the devastating plague of 1348, the hospital of S. Maria della Scala became one of the main sources of artistic commissions. In addition to pilgrims and orphans, wealthy sufferers of the plague were tended here for substantial sums of money, enabling the hospital to order precious relics and costly altarpieces. Laymen took control of this affluent hospital and issued artistic commissions as part of their endeavour to set their position on a surer footing. Thus the altarpieces ordered for the hospital church between 1350 and 1400 were more costly than those ordered for the cathedral[226].

Less ingenuity was called for in the design of images in this period, as so many examples were now available to refer to, and with a decreased urge towards innovation came a steady stream of similar paintings. When families,

confraternities and guilds allocated funds for the painting of altarpieces or frescoes they felt less need than before to impose special demands, beyond some few details. Kindred paintings appeared in Asciano, Montalcino, S. Quirico, Montepulciano, S. Gimignano and Volterra; in numerous churches throughout the area the priest would celebrate the Eucharist before altarpieces of a standard type from Sienna. These paintings were slightly simplified versions of existing works; a particular attribute might be added in one painting and a new saint in another, prophets might figure in one work and not in another, portraits of devotional figures might or might not be included and family escutcheons would differ from one place to the next. It was continuity in craftsmanship, however, that was essentially safeguarded by the fixed patterns that had developed; the urge to innovate had petered out.

SIENNA IN RELATION TO FLORENCE AND ROME

Several factors contributed to the stagnation in artistic patronage in Sienna: economic decline, political decentralization and outbursts of violence. The established merchant élite suffered from the dearth of financial opportunities in trade and banking and many were ruined in a slump already under way earlier in the 1340s that was greatly exacerbated in 1348 by the outbreak of the plague. Treasury funds were depleted and finally exhausted by the large sums needed to defend the city and to purchase food in times of famine, this coming on top of the vast sums that had been spent on the cathedral. None of this was calculated to sustain confidence in the Nine, the ruling oligarchy of Sienna, who were also suffering the loss of many capable administrators in the plague[227]. Groups such as the hospital administrators and guild officers as well as nobles and clerics were able to make political capital of this situation, and the élite that had had corporate responsibility for commissioning major works on the state's behalf lost its position of power. The implications for painting of the state's reduced income are obvious. But a significant role was also played by the decentralization of political authority, which meant a piecemeal approach to the commissions issued at this juncture. In short, both the economic means and the political aspirations that had enabled and impelled the commune of Sienna to commission monumental works of art ebbed away. Siennese painters could therefore not find sufficient major commissions locally or, indeed, elsewhere[228]

This was but one aspect of a wider issue. The whole concept of urban civilization came under pressure at this time. No fresh impetus was being given to the formulation of civic ideals; instead, smaller groups such as the hospital authorities, families of the city or the *contado* and clerical institutions outside Sienna each developed codes more tailored to their particular circumstances. Accompanying such trends towards decentralization came an increase in violence within Sienna and a greater threat of attack from forces outside the state.

Though further state formation had been abruptly halted in Sienna this was not a general tendency; north and south of the city the process was still continuing. In Florence a culture of rich merchants was being consolidated at this time, and in Rome the popes, back from Avignon, laid the foundation for a political and cultural revival. This in its turn had a positive effect on Sienna, in that painters and patrons travelling between these cities would break their journey there. Masaccio, Masolino, Pisanello and Gentile da Fabriano were all given important commissions in Rome by Martin V (1417–31) – for instance, a great altarpiece for the canons' choir of S. Maria Maggiore and frescoes for St John Lateran[229]. All stayed in Sienna *en route*, spreading elements of their knowledge, so that artistic innovations such as the square altarpiece and improved techniques for painting figures and buildings entered the Siennese repertoire. Prevailing practice in other cities came to play a dominant role in Siennese design and representation[230]. For instance, when the hospital administrators had their church renovated they did so according to the new design that had been developed chiefly in Florence, which also determined the type of altarpieces to be installed[231]. At this stage, then, it was particularly Florence and Rome that provided a fresh impulse to the art of Sienna.

INNOVATION IN SIENNA: INCIDENTAL DEVELOPMENTS

In 1430 Donna Lodovica, the widow of a master of the cathedral works, commissioned an altarpiece from Sassetta. She was the first individual to have a say in the subject to be painted in a work for the cathedral – something that would have been unthinkable under the rule of the Nine, but was now made possible because of the influence of Florence and Rome. This influence even left traces in the images depicted. For besides her family escutcheon and an image of St Francis, Donna Lodovica gave instructions for a Roman theme to be depicted – the foundation of the basilica of

S. Maria Maggiore – on the predella. The emphasis in the altarpiece made in Sienna differed, however, from the depiction of the same event in Rome, where the pope occupied a central role; in Sienna the patron–citizen had a more prominent place.

The few artists able to attain a level higher than that of a craftsman in these new conditions included Sassetta, Vecchietta and Francesco di Giorgio Martini. They worked for clients both in and outside the city and introduced some novel features into their work[232]. It is a telling sign of Vecchietta's status that he founded his own burial chapel in the hospital church, for which he made a statue and an altarpiece himself[233].

Vecchietta also made one of the altarpieces that Pius II (1458–64) ordered for Pienza, a small town in the *contado* of Sienna. Pius II, or rather Enea Silvio Piccolomini, had been born in this village, which was originally called Corsignano, and he concentrated his energies as an artistic patron here rather than on Rome when he became pope. Having renamed the town Pienza (roughly 'town of Pius'!) he proceeded to raise the church to the dignity of a cathedral, having it completely rebuilt and furnished. He had its altarpieces painted by the best artists of Sienna, as he remarked in his memoirs, and ensured that only the saints of his choice were portrayed in them. There was no polyptych on the main altar, because in Pienza the altar stood in front of the priest as he faced the *capella maggiore*. Pius had the Piccolomini family arms blazoned in the cathedral, on the outside wall of the cathedral, on the fountain in front of the cathedral, in the palace next to the cathedral and in the church of S. Francesco on the other side of the new family palace. These arms turned up in Sienna too – on the covers of Biccherna annual reports, on the outside wall of the family palace and its adjoining loggia, in S. Francesco, in S. Agostino and throughout the cathedral.

The Piccolomini images appeared elsewhere in the city too. Whereas images figuring in the Biccherna annual reports well into the fifteenth century were mainly urban scenes of Sienna, interspersed with pictures of the Virgin Mary as the protectress of the city in times of both peace and war, a change of accent can be seen in the middle of the century. First there is a picture of the ceremony in which Piccolomini is created a cardinal, and later, in 1460, there is the proud image of his coronation in Rome as pope Pius II.

A NEW ERA: COURTLY PATRONS AND PAINTERS FROM
ROME

We can judge how little still remained of Sienna's own tradition in painting and in republican imagery by the opening of the sixteenth century by looking at the 1502 commission for a new library in the cathedral. Francesco Todeschini Piccolomini, a nephew of Pius II whose ecclesiastical career had been given a helping hand by his uncle, commissioned a painting that would serve as a monumental tribute to his illustrious kinsman. He was the Archbishop of Sienna, but the commission went to a painter who had begun his career in Rome – Bernardo Pinturicchio, originally from Perugia, who completed the decorations in 1508 with a representation in the nave of the papal coronation of Pius III in 1503[234].

Pinturicchio had learnt his profession working with painters and for patrons who had virtually no connection with Sienna. In 1492 he was commissioned by Rodrigo Borgia, Pope Alexander VI (1492–1503) to decorate his working and residential quarters in the Vatican Palace – the so-called Borgia apartments, and his work had found considerable favour with his patron[235]. In 1497 he had put the final touch to a fresco cycle for the same patron in the loggia of Castel Sant'Angelo. The cycle took as its theme the sovereignty of the pope in relation to the king of France, in this case Charles VIII, who had passed through with his army in January 1495 on the way to Naples[236].

The subject of Pinturicchio's frescoes in Sienna was the life of Pius II – not, it should be added, as it actually was, but as Pius himself had described it in his Commentaries (see fig. 38)[237]. Both paintings and the accompanying inscriptions are anti-republican in import. Their frame of reference, rather than the proud city-state of Sienna, was the European network of courts in relation to which Sienna dwindled to insignificance. They show Aeneas Silvius impressing his audience in 1431 as an orator at the Council of Basel. He is then shown furthering his career at the successive courts of the king of Scotland and Emperor Frederick III. There are images of the 1456 ceremony by which he was created cardinal and the 1458 papal coronation, followed by the congress of Mantua, the canonization of Catherine of Sienna and finally, immediately before his death in 1464, his departure from Ancona for a Crusade expedition to liberate Jerusalem[238].

The images bear no relation whatever to the cathedral liturgy as it had been described by Canon Oderic almost three centuries before, nor to the civic rituals decreed in the statutes when the Nine had ruled Sienna. All

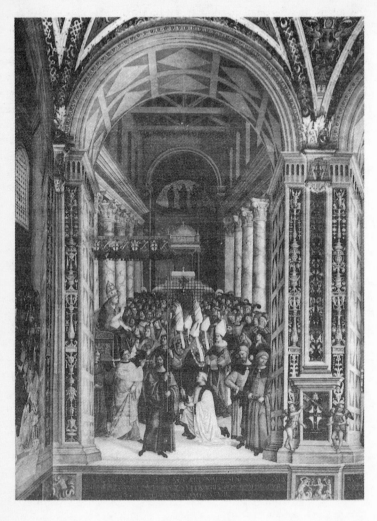

38. Pinturicchio, *Pius II accepts the papacy in the Lateran*, 1508; Biblioteca
Piccolomini, Sienna Cathedral (photograph Grassi)

the solemnities depicted are dominated by papal ceremony, as prescribed by Patrizi Piccolomini, the official responsible for committing them to paper and a kinsman of Pius II[239]. Pinturicchio's paintings do not depict any Siennese polyptychs, but baldachins and apse mosaics such as had remained the customary decorations in Rome. And in 1506, when Pandolfo Petrucci had come to power and established courtly rule in Sienna, he instructed that the symbol of the sovereign city-state, Duccio's *Maestà*, should be taken down from the high altar where it had stood for almost two hundred years.

PART III

FLORENTINE FAMILIES

1. THE PROFESSIONALIZATION OF PAINTERS IN FLORENCE

ORGANIZATIONS AND STATUS

Professionalization was defined in the Introduction as a general concept involving advances in four distinct areas: skills, organizational structure, theory and historiography. Craftsmen's associations were highly influential, monitoring as they did standards of training, the quality of work, members' conduct and standing in society and their proper participation in communal rituals. The following section will examine these diverse elements as they developed in the Florentine painting profession of the fourteenth and fifteenth centuries.

Other, related issues may also be raised concerning this period and this city. One is the interplay between the professionalization of painters and developments in patronage, particularly where family chapels were concerned. Another is the extent to which the subject-matter of a painting related to the circumstances in which it was commissioned. Finally, all the developments in the painting profession, patronage and images should be fitted into the broader context of the processes of civilization and state formation.

The historiography and theories developed in Florence came to present a biased picture of professionalization. Florentines tended to play down the fact that before the painting profession had developed momentum in their own city there was a good deal happening elsewhere. In the Florentine version of history, Giotto stood firmly at the centre. In 1334 Giotto was appointed to the position of city architect, by which means the administrators established him unequivocally as a Florentine artist. It is true that he had worked in Florence before, decorating various family chapels in S. Croce in about 1325, for instance, but he had also worked in Assisi, Rome, Padua and Naples. Those who set down the history of Florence saw Giotto, together with great men of letters, Dante in particular, as symbolizing

Florentine pride – typified by his being given a state funeral in the cathedral. After his death, in 1337, Giotto was retrospectively cast in the role of forefather of a Florentine artistic tradition with a long-established position of dominance whose foundations had been laid by his master, Cimabue[1].

Giotto's reputation was further enhanced by persistent claims that none of his pupils could match him. The following anecdote was written down in 1390.

Some time ago a number of painters and other masters from the city of Florence, always so favoured by newcomers, were staying for a time outside the city at a place called S. Miniato al Monte, in order to do some painting and other work in the church there. After feasting and drinking royally with the abbot, they set to considering certain questions. The following question was put by one of their number, a certain Orcagna, who was *capomaestro* of the splendid oratory of Our Lady of Orsan Michele: 'Who is the best master of painting that we have had, after Giotto?' Some said Cimabue and some said Stefano, Bernardo or Buffalmacco, some gave this name and some advanced another. Taddeo Gaddi was of the party, and he replied: 'Certainly there have been many skilled painters, and they have painted in a way that can never be equalled by anyone, but such art is of the past now, and each day it becomes worse.'

A sculptor among them said, however, that there were still painters working at that time whose excellence ranked with that of Giotto[2].

This little exchange shows that a well-informed and critical public – clients, advisers and painters – judged the art of the day. Together they endeavoured to form a just appraisal of the respective merits of painters active since the latter part of the thirteenth century. What is missing from their appraisal, however, is an acknowledgement of the fact that the qualities of these artists were the product of a longer development in which Florence had not, in the first instance, set the tone.

The painters of Florence were able to build on the Roman tradition of monumental mural decorations, both in mosaic and fresco. There had also been a flourishing tradition of professional artists working in marble in Rome and the surrounding area since about 1100, and in Pisa and other cities the art of sculpture was coming into its own. Artists working in Florence could also profit from developments in panel painting, largely concentrated in Sienna. Gradually from all these elements a Florentine professional tradition of art took shape, Cimabue and Giotto indeed first paving the way.

It was not until the beginning of the fourteenth century that ample opportunity arose for painters trained in Florence to work in their own

city. Before that time they were obliged to seek commissions in other parts of Tuscany or even further afield. Between 1200 and 1300 the level of employment in Florence was on a par with that in Pistoia or Pisa, where the Florentines Coppo di Marcovaldo and Cimabue were able to find work. Murals ordered in Florence were less lavish than those in Rome and Assisi, and altarpieces appearing there were outshone by those of Sienna. When a major commission was issued in Florence for a panel painting, it usually went to a Siennese painter until about 1325.

A professional tradition of art gradually took root in Florence between around 1270 and 1350, the first stirrings having been felt some forty years earlier. The number of commissions issued by institutions and individuals in the city increased sharply, attracting more artists to establish a more or less permanent base there. Moreover, invitations started to come to the artists of Florence to execute prestigious commissions outside the city of their apprenticeship.

The professional position of painters was underpinned in the first years of the fourteenth century by their incorporation into the Florentine guilds. Between 1312 and 1327 Giotto, Daddi, Maso, Gaddo Gaddi and Ambrogio Lorenzetti all joined the *Arte dei Medici e Speciali*, the doctors' and apothecaries' guild, one of the seven *Arte Maggiori*, others representing, for instance, the wool trade, the silk merchants and banking[3]. Painters were somewhat on the fringe of the guild of doctors and apothecaries, along with bottle-makers, barbers and hatters. They were recognized as a separate group, but as craftsmen their position was subordinate to that of the merchants[4].

In 1339 another organization was formed – a confraternity of painters, dedicated to St Luke. Its statutes included obligations to take part in Mass and to offer candles on holy days, and like their fellow painters in Sienna the Florentines were bound to observe other general rules[5]. Membership of both guild and confraternity imposed an obligation to conform to prescribed codes of civilized behaviour, codes to a great extent communicated by religious rituals. Rituals also helped create a sense of corporate identity. On holy days the painters of Florence gathered in their own chapel, located in the church of S. Egidio. Jacopo del Casentino made an altarpiece for this chapel that showed St Luke painting the Virgin Mary, a group of worshipping painters round about[6].

Numerically speaking, the professional community of painters in Florence paralleled that of Sienna from about 1230 to 1350; around the turn of the century it consisted of some thirty practitioners. There were more painters

in Florence and Sienna than in London, Ghent, Bruges, Paris, Venice, Bologna or Prague, all of which were also emerging as centres of artistic production[7]. Between 1350 and 1500 Florentine painters came to out-number the Siennese, passing the forty mark by 1440[8]. Just like its neigh-bouring city, the great majority of this professional community comprised those involved in fairly minor commissions[9].

A few painters achieved a high professional standing[10]. But this élite class, too, had to comply with regulations governing images, delivery dates, the dimensions of a work and the materials used. For a larger intermediate group, a decline in the use of gold and lapis lazuli from about 1440 onwards increased their potential earnings, proportionally speaking; clients and beholders alike were coming to value professional skill more than precious materials. Because of such shifts in public opinion this middle group became more numerous, and more painters were able to aspire to an income above the level of an ordinary craftsman in Florence than in other cities[11].

A competitive system of patronage in which courts played a major role made it possible for a prodigious painter such as Giotto to acquire wealth and renown[12]. In these exceptional cases a client's honour and that of painters working for him became intertwined. The chief asset of such an artist was his extraordinary skill, as acknowledged by clauses imposed on well-paid painters requiring them to do all the work unaided[13]. In the quattrocento the really wealthy, famous painters were not so much to be found in Florence, however, as in the court residences; this was where a select group of artists from various cities worked their way up to a peak of social eminence[14].

With the shifting balance of dependencies among clients, advisers and artists came higher prices and greater recognition for the professional skills possessed by the higher and intermediate ranks of painters[15]. Whatever a painter's expertise, however, the images to be represented would essentially be devised not by himself, but by clients and their advisers. It was only later, in cinquecento courts far more than quattrocento republics, that even the most highly respected of artists started to have a say in designing the images to be depicted.

NEW SKILLS AND TECHNIQUES

Trecento paintings did not render the relationship between figures and buildings in the background in the correct proportions. Architectonic

elements were represented inaccurately on the flat surface because of an imperfect command of linear perspective. The painters of Florence took a leading role in the quattrocento; in contrast to the fairly standard images and types of paintings coming out of Sienna by then, the Florentines were breaking new ground. Masaccio was one of the great driving forces behind this process of innovation. His interest in perspective and composition was already in evidence in his early work, produced outside Florence. Early in his career he worked, for instance, in Pisa, which had been annexed to the Florentine state in 1406; craftsmen belonging to the guilds of Florence were therefore able to practise their profession there, and in 1426 Masaccio was commissioned by a Pisan notary to make an altarpiece for S. Maria del Carmine in that city[16]. After the Pisa commission Masaccio executed a fresco in front of the rood screen of S. Maria Novella in Florence, in the fourth bay of the left aisle[17]. It shows the client, Domenico Lenzi, who had died in 1427, kneeling in worship with his wife before the Holy Trinity (see fig. 39)[18]. The fresco was not intended to figure behind an altar; it was a painted burial monument[19]. In this work Masaccio showed a new mastery of linear perspective with a single vanishing-point, applying the technique with new consistency.

Masaccio was the first painter systematically to exploit the findings of mathematics. His fresco presents a view of an imaginary chapel depicted with a strong suggestion of space. The Virgin Mary and St John stand one step higher than the kneeling citizens; Mary's hand points to the crucified Christ, behind whom God the Father can be seen. The figures are not, as had been customary hitherto, too large for the space they inhabit. The separate architectural elements, both ornamental and structural, are rendered with geometrical precision.

Ornamental features were also subject to innovation. From about 1425 Gothic forms came to be replaced more and more by classical elements such as fluted pilasters, Corinthian capitals and round arches. Classical examples played an ever greater stylistic role, whilst composition was also adapted to accord with geometrical principles. This movement towards geometrical composition represented a change of emphasis from the prior cultivation of elegance and variety of motif. Between 1380 and 1425 painters such as Gentile da Fabriano and Lorenzo Monaco had produced altarpieces with images characterized by complex forms and graceful lines. Now the two separate aims – geometric ordering and decorative ornamentation – became entwined, as images began to be placed in a larger framework. The central painted surface was enlarged. Rather than a division into numerous

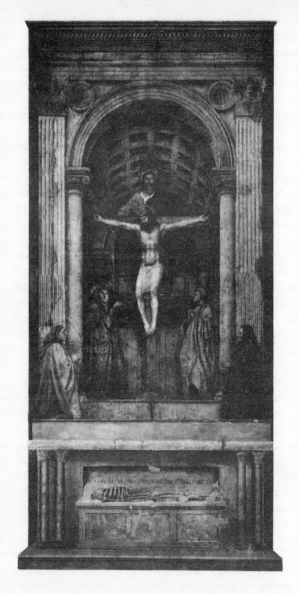

39. Masaccio, *Holy Trinity with Domenico Lenzi and his wife*, *c.* 1426; S. Maria Novella (photograph Gabinetto fotografico, Florence)

small panels, each with images enclosed in their own framework and each separated from the next by gilded ornaments, artists now endeavoured to produce a painted surface that created the illusion of depth and space.

Around 1420 Lorenzo Monaco decorated the Bartolini chapel in the church of S. Trinità (see fig. 40). The altarpiece has a larger main panel than had been customary before, but the figures in a predella, buttresses and pinnacles are all still in evidence[20]. Attention to detail and elegance of design were both clearly of paramount concern to the artist.

A rapid succession of commissions and a good deal of experimentation gave rise around 1440 to a new form – the square altarpiece, or *tavola quadrata*[21]. The commissions were generally more complex than, for instance, Masaccio's memorial to Lenzi, in which he had had no windows to contend with, no altar slab, no candles in front of a gold background and no very elaborate subject. In the period from about 1430 to 1450, however, Masaccio's innovations – solutions that had initially been tested in such relatively simple and not particularly prestigious commissions – were gradually adopted by other artists, who applied them to altarpieces[22].

The *tavola quadrata* was introduced by Fra Filippo Lippi and Fra Angelico (see fig. 41). From 1450 onwards, the altarpiece with a large painted surface became the norm. Neri di Bicci, the son of Bicci di Lorenzo, turned them out in great quantities, just as his father and the painters of Sienna kept up a plentiful supply of Gothic altarpieces. Among the commissions fulfilled by father and son together were decorations for the Lenzi chapels in the Ognissanti and for the church of the Ospedale degli Innocenti[23]. Another painter to incorporate the new developments into his work was Francesco Botticini. Around 1475 he made a large rectangular altarpiece for the burial chapel of Matteo Palmieri and his wife in S. Pier Maggiore (see fig. 51)[24]. The patrons are depicted kneeling beneath the celestial company, while the background shows the valleys of the Arno and the Elsa.

As painters evolved new designs and new accomplishments, an added impulse was transmitted to the dynamics of patronage. Rich merchants wanted to own modern altarpieces that were made in the prevailing fashion, and to put them in their own chapels. As the process of professionalization among painters gained momentum, competition among their clients also increased. Those whose means did not extend to the sum necessary to purchase the latest style of altarpiece would sometimes resort to having an old polyptych suitably adapted. This would involve the surrounding ornaments being sawn off and the holes being filled up, the final product being square or at least rectangular[25].

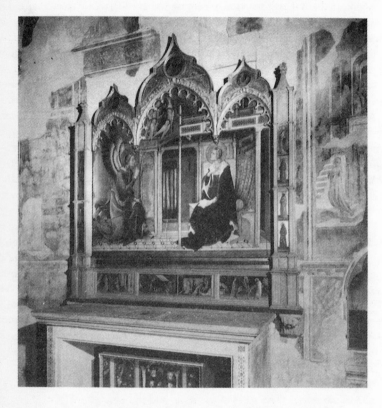

40. Lorenzo Monaco, altarpiece and frescoes in the Bartolini chapel, S. Trinità, *c.* 1420 (photograph Gabinetto fotografico, Florence)

A painter was expected to acquire an ever-expanding range of skills. One was the ability to render details with precision, which those producing altarpieces focused on far more than did those engaged on large-scale fresco work. In this line Italian artists and clients were influenced by panel paintings from Bruges and Ghent, which were now distributed more widely than before. The Flemish painters bound their paint with oil rather than egg, which enabled them to achieve a more limpid colouring and gentler transitions. With the new technique flowers and faces, buildings and clothing could all be rendered with greater accuracy than had been possible before.

The Italians adopted the innovations of the Flemish painters and combined them with the fruits of their own tradition in monumental frescoes. Their compositions of large groups of figures were superior to those of their fellow artists from the north, and the attitudes of their individual figures exhibited greater variety. Having mastered the rules of linear perspective, they had a surer command of the depiction of buildings and of rendering human figures and architectural background features in the correct proportion.

Many Florentine painters mastered these diverse new skills. In about 1474 Botticelli painted a rectangular altarpiece depicting the Adoration of the Magi, which included more than thirty figures in a variety of poses. In the same period Piero and Antonio Pollaiuolo produced a tall altarpiece that showed a number of archers shooting arrows at St Sebastian, all drawing their bows in different postures (see fig. 43)[26]. They diversified the representation by adding a detailed landscape, accurately rendered buildings in the background and figures depicted both with the aid of live models and modelled on antique precedent. Ghirlandaio, too, painted varied and elaborate images on altarpieces and frescoes (see fig. 42). He took great pains to render the details with care without losing sight of the integrity of the composition. The new elements he added to traditional themes gave the whole greater verisimilitude than similar scenes by his predecessors.

HISTORIOGRAPHY AND THEORY

The new painterly accomplishments soon became food for reflection. Tracts started to appear on the progress of the art of painting – written by painters, sculptors, architects, clients and advisers – that drew on observation to make conjectures on the theory of art. This constituted a further stage in professionalization; not only in skills but also in terms of historiography and

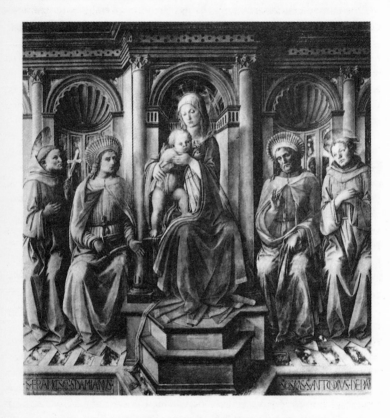

41. Fra Filippo Lippi, *The Virgin Mary with St Francis, St Damian, St Cosmas and St Antony of Padua*, *c.* 1440; Galleria degli Uffizi, Florence (photograph Alinari)

the development of theory, had painting advanced as a profession far beyond its situation a hundred years before. Furthermore, these developments were far more marked in Florence than in contemporary Sienna.

One commentator was the Florentine Cennino Cennini, who was resident at the court of Padua during 1398 and produced a treatise on the accomplishments of painters some two years later, describing them in detail. His work places the main emphasis on technical control and goes on to enumerate general ideals of conduct seen as befitting the profession, which echo the rules that appear in the statutes of guilds and confraternities. Cennini urges painters to adopt regular habits and to practise temperance in respect of food, drink and relations with women[27].

Leon Battista Alberti (1404–72) was a gentleman by birth and an architect by profession; what painting he did was more in the nature of a pastime. His writings on the art of painting, however, made a considerable impact on contemporary thought. He formulated the nature of the profession in terms more general than those of previous authors, drawing more freely on classical writers and paying greater attention to the mathematical accomplishments of his own day. In his letter of dedication – to the architect Brunelleschi – attached to the Italian version of his *De Pictura* in about 1435, he bestowed great praise on Masaccio and his contribution to the art of painting. The dedication couples Masaccio's name with that of Donatello, and credits the latter with having introduced momentous mathematical innovations. Alberti writes of the generations of painters active since the late thirteenth century (though only Giotto is mentioned by name) as possessing no less ingenuity than the ancients. Although his text does focus on classical painters, Alberti adduces the honourable professional position of these men as an example to his contemporaries.

Alberti devotes considerable attention to the mathematical aspects of rendering perceptions of reality, developing abstract concepts for such qualities as light, colour and shade, movement, perspective and proportion[28]. Formulating the general task with which the painter is confronted as that of giving visual form to what he terms a *historia*, he defines this as requiring two successive stages, *inventione* and *disegno*. *Inventione* covers the selection of pictorial elements and the conception of an image best suited to illustrate a *historia*; *disegno* is the combining of all the individual elements into one composite image[29]. Alberti's *historia* is based on what he regards – following traditional ecclesiastical views that go back to Pope Gregory the Great – as two major functions fulfilled by the art of painting, one being devotional and the other being to provide memorials to the deceased. To fulfil these

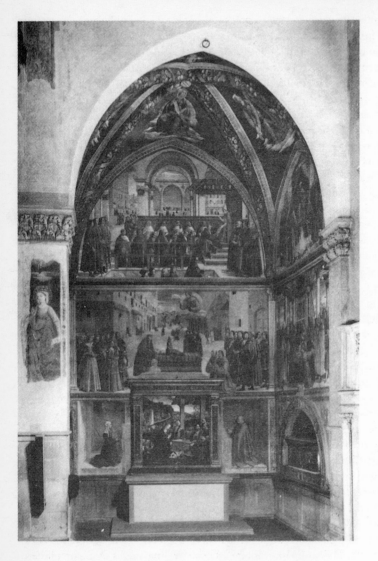

42. Ghirlandaio, Sassetti chapel in S. Trinità, c. 1485 (photograph Gabinetto fotografico, Florence)

functions successfully, the painter must attract the beholder's attention and give him pleasure[30].

Alberti provides concrete examples to elucidate his theoretical points. One such argument is that beauty is definable in terms of pragmatic and mathematical criteria, the correct proportions being paramount. He gives copious instances of how such criteria may be violated: a head painted too large or feet too thick; a philosopher given the muscles and attitude of a wrestler; Nestor depicted as a youth or Mars in female attire; paintings that are too small, too cluttered or have too much empty space; or a plough pulled by an ox that is painted to resemble the favourite horse of Alexander the Great[31].

The goldsmith Ghiberti uses many terms similar to those of Alberti[32]. Alberti distinguishes himself by discussing at greater length and in much more detail the period 1250–1410 than earlier commentators on the history of painting. Yet another writer, the architect Filarete, was concerned to develop artistic theory at the same time as considering recent historical developments. Proceeding from the notion of an artistic revival he goes from a discussion of the ancient painters to consider the Florentines, but also refers to the achievements of Jan van Eyck, Roger van der Weyden and Jean Fouquet (see fig. 44)[33]. Filarete emulates Alberti in trying to arrive at an abstract description of the painter's task in terms of visualizing *storie*, and also deals with techniques, mastering features such as colour, light and shade, sizes and dimensions, the expression of feelings, historically accurate modes of dress and good poses[34]. He makes an explicit connection between the new accomplishments of painters and the role played by clients and advisers, especially the Medici and the Sforza families, to whom his words, in the first instance, are addressed[35]. The architect also emphasizes the connection between the (widely diverging) functions of rooms and the nature of their decorations; in each case decorations must be tailored to the situation so as to inspire virtuous conduct in those who view them[36].

There is an extensive commentary on the generation of painters active between 1420 and 1480 in Landino's commentary (appearing in 1481) on Dante[37]. We also find references to the prominent painters of the fifteenth century in Ugolino Verino's ode to the city of Florence and Giovanni Santi's ode to the Duke of Montefeltro[38]. Those owning works by accomplished painters started to mention them with pride[39]. Clearly, by this point it was not only painters, architects and goldsmiths who were evolving a critical eye for the accomplishments of individual painters; potential clients and their advisers had also developed greater powers of discernment. The Duke

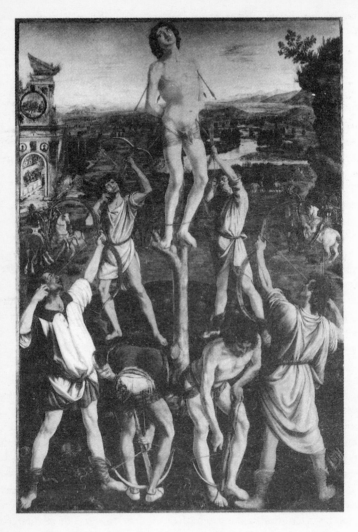

43. Piero and Antonio Pollaiuolo, *The Martyrdom of St Sebastian*, 1475
(photograph National Gallery, London)

of Milan sought to grant painting commissions for the decoration of his stately mausoleum, the Carthusian monastery of Pavia. His agent specified not only the speed at which work should proceed but also noted that the frescoes and panel paintings by Botticelli, Filippino Lippi, Perugino and Ghirlandaio showed that they possessed the necessary skills[40].

From 1450 onwards references to painters, their abilities and their reputations are more and more common in the network of professional connections and client–artist relations, in which Florence by then played a major role. Finally, allusions to painters – the Florentines, the Flemish, and the artists in the north of the peninsula – had come to figure in the courtly literature of the day[41].

People from widely differing backgrounds – from clients to craftsmen – were responsible for the first clear moves towards formulating a theory and historiography of the art of painting. The various works by no means had the same impact, however. Ghiberti's treatise, for instance, was distributed far less widely than the texts written by Alberti. And where literary texts were concerned, painters and their art tended to be incidental subjects touched on in poems celebrating a city, or perhaps a prince, a court or a church[42]. There was no question, in the fifteenth century, of a cohesive body of writings being produced on the history and theory of art. The texts written did, however, form initial impulses in this direction that would be exploited by those writing in the next century.

Around 1550, having gathered and assimilated a variety of texts and combined their findings with his personal observations, Giorgio Vasari placed the theory and history of the painting profession firmly at the centre of his extensive *Lives* of the painters since Cimabue. His vantage-point is essentially and explicitly that of a professional artist. What Vasari develops in his texts (including his letters, essays and personal recollections) is an ideal vision of the profession which would allow painters as great a say as possible in the work they produced in relation to clients and advisers. This ideal of professional autonomy, however, bore scarcely any relation to quattrocento practice[43].

Vasari's emphasis falls squarely on the eminent painters of Florence, thus contributing to another distortion in received opinion, the tendency already discussed above to overvalue the historical importance of the artists from that city. He makes short shrift of art produced before 1270, and of German and Byzantine work. The men of Sienna also receive comparatively little attention. Like Cavallini, who mainly worked in Rome, the Siennese are presented as following the example of Giotto[44].

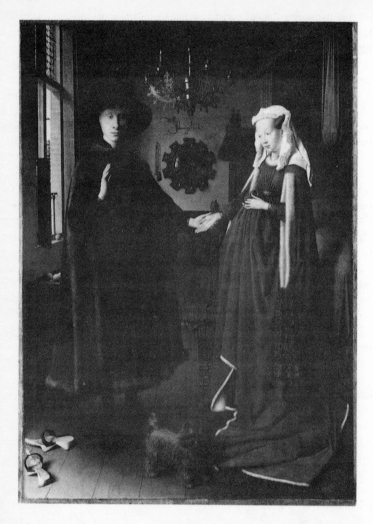

44. Jan van Eyck, *The Arnolfini wedding*, 1434 (photograph National Gallery, London)

Vasari highlights the differences between quattrocento painters and their predecessors by pointing out the errors that used to be made in perspective, proportion and design. Introducing what he views as the second period of the Renaissance Vasari goes over the achievements of Cimabue and Giotto once more before discussing the progress of the next generations. The advances he mentions include improvements in colouring, draughtsmanship and design, a sounder mastery of perspective and the refinement of composition, and he dwells particularly on the correct proportions with which painters have learnt to depict pilasters, columns, capitals and the like. The credit for having inaugurated the *maniera moderna* goes to Masaccio[45].

After the 'rebirth' of painting in the age of Giotto comes its 'youth', presided over by Masaccio; Vasari illustrates his view of the general line of progress by providing numerous examples in the biographies following that of Masaccio. He describes Ghirlandaio, for instance, as having made advances in vitality, naturalness, elegance, variety of pose and apparel, the number of figures he is able to incorporate into his work and the accurate elaboration of architectural features in the background. Antonio and Piero Pollaiuolo are praised for their precision, use of colour and mastery of diverse techniques. Botticelli is credited with combining beauty and delight in his work. In all, Vasari sees such progress in a wide range of accomplishments as preparing the way for what is to him the final maturation of painting attained in the sixteenth century[46].

2. PATRONAGE:
COMMISSIONS AND NEGOTIATIONS

═══════

THE SOCIAL BACKGROUND OF FLORENTINE PAINTING

The major advances in painterly accomplishments that were so unanimously greeted as such by painters, architects, sculptors, clients and advisers were made possible by a steady stream of competitive commissions. If we compare the chronology of the professionalization of painters in Florence and the history of patronage in the period 1230–1500 we find direct parallels in the stages they passed through. The two processes had a mutually enriching effect upon each other, and for a far longer period of time than in any other city with an established community of professional artists such as Sienna, Venice or Bruges.

The question of why it should have been Florence that saw such momentous artistic developments in these centuries (from around 1230–1500) is highly complex. Answers must be sought first and foremost, however, by focusing on trends in patronage. Nowhere was there such a boom in challenging commissions for painters, sculptors and architects as was seen in Florence during this period. There was immense rivalry, too, among clients. At the same time artists in Florence, in particular, were acquiring knowledge that gave an added impetus to the process of professionalization: on the one hand mathematical and empirical knowledge, and on the other hand a range of concepts and a repertoire of themes deriving from classical and more recent literary traditions. Finally, the city-state's central location in an extended network of client–artist relations was a contributory factor, because it placed painters in a position to draw maximum profit from the fierce spirit of competition among all those who were eager to hire their services.

A form of artistic patronage touched on only briefly in the first two chapters is that of images ordered for chapels. These ranged from paintings

in large walled-off areas such as the *capella maggiore* to decorations for an altar in a recess in the nave, the word *cappella* being used indiscriminately for any such situation. Florence was pre-eminently the centre of painting commissions for chapels. From around 1320 to 1490 artistic patronage for Florentine chapels was marked by an unparalleled continuity and cohesiveness across an unusually broad sweep of the social spectrum[47]. And there was no other city in which painters, sculptors and architects threw themselves as one man into such a flurry of related experiments, creating a fertile soil for new commissions. The dynamics of Florentine patronage, in a word, were quite unique[48].

Notwithstanding this hectic activity, those who founded chapels in Florence were less inclined towards self-aggrandizement than were courtly patrons. The burial chapels of popes in Rome, cardinals in Assisi, princes in Naples or Padua and jurists in Bologna all surpassed those of the Florentine merchants in terms of size and costliness and laid far greater emphasis on portraits[49]. The kings of England and France, too, with whom the Florentine bankers conducted their business, had themselves buried in greater style, generally in free-standing monuments in abbey churches[50].

In Florence it was merchant families rather than princes or nobles that played the key role in artistic patronage. Mendicant orders, though continuing to play a part, did so more and more in conjunction with families. Guilds and fraternities as such founded fewer chapels than did the merchants, and those fraternities that did so would frequently be dominated by a cluster of families that constituted a particular faction[51]. Dominant as the merchants were, commissions were still given by nobles and clergy[52].

The civic authorities were also active patrons, as in neighbouring Sienna, ordering works in particular for the cathedral, the baptistry and the town hall. In Florence the large merchant guilds mediated between commune and church in such situations[53]. In some cases the city council would commission a work directly, in others a particular committee or institution would do so[54]. Increasingly, though, even this type of commission came to be dominated by wealthy citizens who would oversee the work or raise more money[55].

Painters found employment more frequently by far with merchant families than elsewhere. It was a type of patronage that centred to a large extent on the family's chapel in a church, usually one belonging to a mendicant order. But families were also concerned to decorate their houses, or rather their villas and palaces, as their dwellings may be more accurately described increasingly from around 1440 onwards. They had these embellished with

a variety of profane images, sometimes taking their themes from decorations found in the palaces of princes. For instance, it was common for Florentine citizens to have a series of famous men painted[56]. In the Medici Palace the decorations included scenes of war and hunting[57]. Portraits of members of the family also looked down from the walls, as well as those of the family's diplomatic connections[58]. Where images had a military theme or were erotic in nature, the source was generally a text from classical literature[59].

Merchants almost always had religious images produced for their private worship, whether individual or for the family as a whole. Older decorations consisting of several panels now came to be replaced by a type of painting that depicted numerous figures on one larger pictorial plane, a round or rectangular image known as a *Sacra Conversazione*[60]. This development paralleled to a certain extent that of the altarpiece in churches during this period[61]. The larger merchant palaces also had their own chapels which would be decorated with frescoes and an altarpiece; it was for the chapel of the Medici palace that Gozzoli painted his *Procession of the Magi* in 1459, which shows the kings followed by diverse members of the Medici family[62].

THE FOUNDATION OF CHAPELS: GIFTS AND OBLIGATIONS

The Church had strong views on ways in which images should function, often repeated in sermons and disseminated in printed (and reprinted) treatises throughout the fifteenth century. Images were to be used to convey knowledge and moral principles to the entire community. Images could strengthen the beholder's sense of decorum and remind him of the standards of conduct to be upheld. The clergy also believed that a painting should adhere as closely as possible to a particular prescribed representation or *historia*[63]. Where decorations produced for chapels were concerned, the subject depicted was decided upon in a process of negotiation between laymen and clergy, who were tied to each other in a relationship cemented by gifts.

Clergymen wanting to order works of art – especially when they were mendicants – were dependent on the money made available by merchants and bankers. A protracted period of consultation was often the rule where an artistic commission for chapel decorations was to be given. Friars would approach a merchant with delicately phrased inquiries as to whether their order was likely to be a beneficiary of his will. Once promised, the financial

contribution was a form of exchange that strengthened the interdependence of the two parties[64]. The balance in this relationship coincided with the extent to which clericalization or secularization prevailed, and was expressed by the dominance of sacred or similar content in a work of art.

Donors on their deathbeds endeavoured to enforce their wishes on the next of kin and the clergy. Mutual consultations would finally result in one or more wills being drawn up, frequently expanded by means of codicils[65]. These generally specified the bequests together with the conditions attached to them. When new chapels were to be built, specifications were often listed in foundation charters, and in the case of existing chapels a concession would be granted[66]. Notarized documents would give a family or confraternity the 'right of patronage' over a chapel[67]. Thus regulations allocated the right to appoint a chaplain, to determine the nature of Masses and to decide on provisions for burials. Acquiring such rights also often meant assuming the role of client in ordering artistic commissions, though this might not be until one or more generations after the initial negotiations for the chapel dedication had taken place[68].

Memorial Masses constituted a element of the chapel liturgy[69]. On the one hand the foundation of Masses meant more employment, and a substantial source of income, for priests. On the other hand such Masses gave the laity more influence in the church. In other words both clericalization and secularization were strengthened by the same series of transactions. Memorial Masses included set prayers for the departed souls. Priests urging saints to mediate in heaven on behalf of such citizens would draw on their own experiences with property agents and bargaining situations, projecting such mutual interplay on to the relations between heaven and earth[70]. The desire for such intercession might be for the benefit of a kinsman, a neighbourhood or the city, and more and more patriarchs attempted to influence the worship of saints in chapels. Founders generally preferred their name saint or another personal patron saint to intercede for them and would try to steer the worship in this direction.

Votive Masses also played an important part in the liturgy. These were founded on the basis of a pledge (or *votum*) and were thanksgivings in the event that accident, illness, a murder attempt or a battle had not ended in disaster, or when a son had been born[71].

Arrangements made in connection with chapel liturgy determined the artistic commissions that donors wanted to issue. For instance, someone who had purchased an annual memorial Mass would also have certain wishes concerning their burial monument, be it a slab in the floor or a wall

plaque. Donors also often wanted to see images of their family coat of arms, portraits of those who had died and inscriptions bearing their own name. Whatever donors had requested in connection with forms of worship would also be reflected in the choice of saints to be depicted. A pledge made as an expression of gratitude often resulted in a commission for a painting to provide a visual record of the favour that had been granted[72].

The act of exchanging capital for salvation also enabled one to increase one's standing in the community[73]. Beside the desire for a certain self-proclamation in an aesthetic form there was also an urge to influence the way a particular group was perceived, or its symbolic 'collective representation'[74]. For instance, rich bankers would often be suspected of violating the law against usury. By attending church regularly and making donations they could buy indulgences pardoning them for their sins[75]. When clergymen pointed out to laymen ways in which their conduct had fallen short of the standard required, it was implied that a donation to the church would be a sound move. Thus a priest rushing to the deathbed of a banker to administer the last sacraments would not shrink from exploiting the man's mortal fear by urging him to make a generous bequest to the church[76]. Such negotiations would frequently have taken place already, the clergy being put under pressure by the merchants while they were still in the peak of health[77].

Exchange relations between monks and merchants sanctioned acquired wealth because part of that wealth was transferred to church ownership. However dubious the means by which the great private profits had been earned, the clergy could now use the money for good works, and the donations of the rich bankers earned them a respected position in society. The mendicant orders were particularly well placed to participate in such transactions because of their vows of collective poverty and their strident rejection of usury[78]. Indeed, the friars profited considerably more from merchants' donations than did, say, the canons or the Benedictines.

Mendicants preached poverty and urged the rich to perform benevolent acts, creating, as it were, a bond of charity between rich and poor that defused the potential for class conflict. The friars strengthened people's sense of mutual dependency within neighbourhoods and in the city as a whole[79]. With their wealth, the successful patriarchs could buy esteem, exoneration from a sense of sinfulness and protection from a sense of shame. Finally, friars had capital at their disposal to use for their churches and convents. In diverse ways, the multiple system of religious exchange thus bound the workings of patronage together with the wider, increasingly civilized social

context in which clients and all those concerned with artistic commissions
lived their lives.

COMMISSIONS: MONEY, RELIGION AND ART

Donors and clerics would already have met for extensive consultations on
any new work to be ordered before calling on the services of a painter, and
formal records were sometimes kept of their talks[80]. It was uncommon for
wills, codicils or notarized deeds concerning foundations or concessions to
be explicit on the precise nature of the decorations desired. This therefore
had to be deliberated upon, although the choice of subjects to be depicted
was restricted by pre-existing agreements concluded between families and
clergy in respect of Masses, burial rights and the depiction of arms. The
subject to be represented was often set down in a separate contract with
the painter. This type of labour contract, given the force of law, was specific
to commissions for chapel decorations, where it was important to ensure
that the dividing lines between the rights and responsibilities of lay clients,
clerical advisers and professional painters respectively left little room for
misunderstanding[81].

The balance of power between merchants and monks varied greatly. On
the whole, though, from the early fourteenth century onwards the well-
to-do families gradually acquired more influence. Sometimes patriarchs
bequeathed money to church institutions without stipulating how it was to
be used, but generally they preferred to include a clause earmarking the
bequest for a chapel, a façade or chapter-room. Wealthy bankers tried
increasingly to steer commissions as they saw fit, and inter-family rivalry
played no small part in their endeavours. If there was any controversy about
the subjects to be painted, the dispute was between clients and advisers;
painters had no part in it.

Just how dependent painters were on those who provided them with
their commissions is documented not only in contracts but also in letters
written between the parties involved. For instance, there is a letter from
Benozzo Gozzoli to Piero de' Medici (dated 10 July 1459) written in
response to a complaint of Piero's concerning the painting of the Medici
palace chapel. Benozzo acknowledges his client's dissatisfaction with the
inclusion of two angels in the work, before embarking on the following
spirited self-defence:

On one side I did one among some clouds, and of this you hardly see anything

except tips of its wings; it is so hidden and covered by the clouds that it does not deform the picture but rather adds beauty, and it is beside the column. I did another on the other side of the altar, but concealed it in the same manner. Roberto Martelli saw them and said they were not worth worrying about. Nevertheless I will do as you command, two little clouds will take them away[82].

A painter's task was to display craftsmanship primarily to the greater glory of his client. In 1438 the young Domenico Veneziano wrote from Venice to Cosimo de' Medici that he had heard of the latter's desire to order an altarpiece, saying:

I am very glad about this, and should be even more glad if I might paint it myself, through your mediation. And should this happen, I hope to God I should produce something wonderful for you, equal to good masters like Fra Filippo [Lippi] and Fra Giovanni [Angelico], who have much work to do[83].

The specific instructions always given to painters, either by contract or by word of mouth, sometimes referred to other decorations or designs on which the work was to be modelled[84]. Given the dependence of painters on clients and advisers – whose decisions were made with a view to pleasing a particular group of people – the resulting 'collective' images constitute a historical source of information on the social relationships in which artistic patronage was embedded.

3. SACRED IMAGES AND SOCIAL HISTORY

===

FRIARS VERSUS FAMILIES

Merchant families had no great influence on chapel decorations until the early fourteenth century; monks still determined the main features of the images in their churches, including chapels directly financed by the laity. There were only incidental cases of family arms and votive portraits being depicted or saints being clearly linked to a particular family. In about 1325 Giovanni Peruzzi commissioned decorations for his family chapel in S. Croce, but the pictures of St John that Giotto painted there were not a direct tribute to the patron[85]. The adjoining chapel, founded by the Bardi family, was decorated – also by Giotto – with pictures of St Francis, though none of the family members involved in the commission bore the saint's name. Slightly more influence was exerted by the Bardi di Vernio family in their S. Sylvester chapel, as witnessed by family arms displayed there and burial monuments with portraits[86].

From about the third decade of the fourteenth century onwards there was a sharp increase of interest in spending sums of money on chapels, burial monuments, altarpieces and frescoes, and merchants began exploring means by which they might have a say in the development of visual images. Members of the Guidalotti family funded the painting of S. Maria Novella's chapter house around 1368, the commissions resulting in a fresco cycle with far more figures than had been customary in similar frescoes before. Portraits and inscriptions attest to the involvement of the Guidalotti in the decision-making process (see fig. 45)[87].

The Strozzi were able to gain lasting and widespread influence on painted images. The burial chapel in the western transept of S. Maria Novella was founded by Rosso de Strozzi as early as 1319, and around 1355 the family exerted substantial influence on decorations painted there[88].

Inscriptions bearing the names of Rosso's sons figured in the crypt beneath the steps leading to the chapel, and female members of the Strozzi family, too, were commemorated in this chamber, which boasted a large

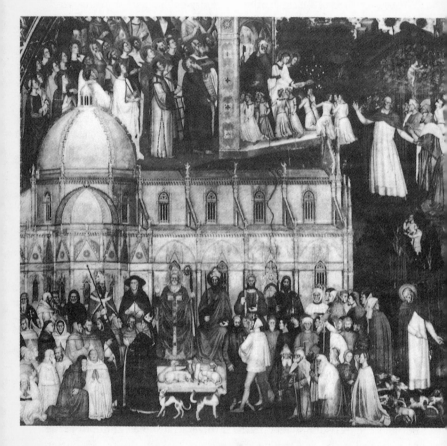

45. Andrea da Firenze, detail of Spanish chapel fresco, *c.* 1368; S. Maria Novella (photograph Alinari)

image of the family escutcheon. The paintings commissioned at this time, by Rosso's grandson, Tommaso di Rosselino Strozzi, included frescoes with portraits of his kinsmen.

On the altarpiece Orcagna painted an image of his patrons' name-saint[89]. The unusual scene in the predella related to these patrons' business affairs. It showed the redemption of the soul of Emperor Henry II, the balance just being tipped in his favour by the donation of a golden chalice. The general theme of redemption through making a gift to the church was an astute choice for a patron who had himself been suspected of usury[90]. In the face of such suspicion the Strozzi had expressed their willingness to found a chapel, which might offset any financial irregularity. This solution had met with some opposition, however, not everyone being willing to accept the legitimacy of the bargain. The Bishop of Florence was at that very time engaged in improving the laws on usury and repayments, and he wrote a treatise on the subject. He also intervened to help settle the conflict relating to the disposition of the Strozzi estate[91]. A series of negotiations between the family, their business partners, monks, bishop and the *Curia* finally produced a solution to which the subsequent decorations bore witness.

Much later the family commissioned a chapel-cum-sacristy in S. Trinità; the patrons in this case were Onofrio Strozzi and his son Palla, the latter of whom was described in 1427 as the richest man in Florence[92]. Predella and buttresses of the altarpiece showed saints who were of importance both to the Strozzi and to the monks of Vallombrosa[93]. This altarpiece was not completed, however, and another was ordered from Gentile da Fabriano; this work, finished in 1423, contained portraits of Palla and Onofrio in the company of the Magi[94]. This was one of several projects intended to assure Palla Strozzi of a great reputation as a patron of art[95]. He decided to augment the sacristy by adding another chapel, and also took steps to have the first altarpiece completed at this later stage[96]. In about 1432 a free-standing burial monument in classical style appeared in the archway between the two areas; this showed the Strozzi manifesting their presence in an innovative genre also adopted by the Medici, the latter moving more to the fore after 1434, in which year the Strozzi, banished from Florence, were obliged to call a temporary halt to their activities of issuing artistic commissions.

The Strozzi resumed their artistic patronage some fifty years later, Filippo Strozzi buying the chapel to the right of the *cappella maggiore* in S. Maria Novella, the patrons of which were the Boni family[97]. After completing the frescoes in the Brancacci chapel in S. Maria del Carmine, Filippino Lippi

accepted the commission to decorate the Strozzis' new chapel. In 1488, however, he agreed to do some painting for Cardinal Caraffa's burial chapel in S. Maria sopra Minerva, the Dominican church in Rome[98]. This delayed the completion of his work on the Strozzi chapel in Florence – no uncommon occurrence in these times – and the work was not finished until 1502[99].

THE MEDICI COMMISSIONS

The commissions for churches and chapels issued by the Medici family overshadowed those of the Strozzi and of all the other houses of Florence. This family's patronage made possible the innovations of architects Brunelleschi, Michelozzo and Alberti, the sculptor Donatello and the leading painters of Florence[100]. A need arose for chapels – and thus for churches – with scope for the Medici to make their position felt, culminating in a spate of artistic creativity in architecture, sculpture and painting that was without parallel (see fig. 46).

Not only was there a clear link between the issuing of commissions and the process of professionalization among painters, but the workings of patronage undoubtedly had repercussions upon the nature of the images made. The choice of a painting's subject-matter depended upon the balance of power between those involved in ordering it. Where mendicant orders were in a dominant position their saints would hold pride of place and would be recognizably linked to the order concerned. Where civic authorities were in the ascendant the saints would instead be presented as patron saints of the city, and in family chapels they would be cast in the role of patron saints of that particular family.

The relationships that prevailed in a city-republic were not conducive to any excessive show of power in the form of huge funerary monuments with portraits such as were commonly chosen by princes, cardinals and popes. The Medici manifested themselves chiefly by displaying their escutcheon and the family's patron saints[101]. The ubiquitous emblems consolidated the prestige of the family to all who saw them and in 1462 we find a Florentine merchant writing to Piero de' Medici from Geneva with the suggestion that Piero might wish to finance the building of a church in that city. The writer pointed out that the arms of all the merchants whose businesses were established in Geneva could be seen there except those of the Medici, and yet the Medici bank was the oldest and the most important[102].

In the fourteenth century, to all intents and purposes before any specific-ally Florentine artistic innovations, monuments to the Medici could already be found[103]. The family amassed its wealth between 1380 and 1420 and acquired great political power in the decades that followed; the next half-century saw the Medici family emerge as grand patrons of the arts[104].

Giovanni di Bicci de' Medici (1360–1429) highlighted his position as the second richest citizen of Florence by the extent of his donations to S. Lorenzo, his parish church. In around 1417 the chapter requested a subsidy from the city's funds for a proposed enlargement of the church. The civic authorities co-operated in the requisite expropriation procedures, and then sounded a number of wealthy members of the parish to discover whether there was a willingness to help finance the new buildings. Giovanni de' Medici was one of these men. Having requested the pope's advice on the matter of violations of the prohibition of usury, he redeemed his sins – partly at the pope's instigation – by virtue of generous contributions to church restoration work in Rome and church building in Florence[105]. The pope himself, in fact, was not above suspicion; voices had been raised in accusation that his cardinal's hat had been purchased with money from the Medici bank, and that he and 'certain merchants as well as quite ungodly usurers in the *Curia* [...] were dealing cleverly and most inventively with large sums of money and making great profits'[106].

Giovanni and his son Cosimo took it upon themselves to finance the walls of the nave, the sacristy and the choir, a sound investment even from the limited perspective of creating burial facilities. Giovanni was buried in a sarcophagus beneath the altar of the sacristy, and in 1464 Cosimo was finally laid to rest close to the high altar, his grave marked by an inscription in the floor reading *'Pater Patriae'*, the honorary title that had been bestowed upon him.

Cosimo de' Medici gave S. Lorenzo's prior and chapter to understand that he would make generous provision for the church, but not without attaching a string of reciprocal demands:

... provided the choir and nave of the church, as far as the original main altar, were assigned to him and his sons, together with all the structures so far erected, he would pledge himself to complete that section of the building within six years out of the fortunes that God had granted him, at his own expense and with his own coats of arms and devices; it being understood that no other coats of arms or devices or tombs should be placed in the aforesaid choir and nave, except those of Cosimo and of members of the chapter[107].

46. View of Florence showing the major churches and palaces in around 1480 (drawing Bram Kempers)

Cosimo paid for most of the work on the enlargement of S. Lorenzo, transferring the requisite sums to the civic treasury through his bookkeeper, a member of the Sassetti family[108]. Some of those who did business with the Medici, including the Sassetti and Tornabuoni families, founded chapels in the nave with their own donations. Adjustments were made to the original plans for the building in accordance with the shifting balance of power and the prominence of the Medici[109]. In all, S. Lorenzo underwent a metamorphosis between 1420 and 1490; from a modest old parish church it emerged as a modern monument to the Medici[110].

FAMILY SAINTS

An important element of the artistic patronage practised by the Medici was their emphasis on the worship of the brothers, St Cosmas and St Damian, who were Cosimo's name-saints. For the novice's chapel founded by Cosimo in the Franciscan church of S. Croce, Fra Filippo Lippi painted a retable with an enthroned Madonna. Standing beside her are not only St Francis and St Antony, saints of the order, but also St Cosmas and St Damian, neither of whom had generally figured prominently hitherto in Florentine paintings. Their relationship with the patron's family is clarified by the inclusion of the Medici arms – the *palle* or balls – in the background, and by the images in the predella, which shows the services performed free of charge by the legendary *medici*, or physicians[111]. The tale as traditionally told depicted the early Medici as virtuous citizens willing to serve their fellow-townsmen in a disinterested but professional manner, a tradition that charmingly enhanced the reputation of the doctors' descendants. St Cosmas and St Damian had themselves been *medici* by profession; they were known both for their effective cures and for their piety and almsgiving. As good Christians the two were martyred under Emperor Diocletian, succumbing to the onslaught of stones and arrows which preceded their being received into heaven.

Fra Angelico also depicted St Cosmas and St Damian several times (see fig. 47)[112]. His most elaborate portrayal of the brothers was in the altarpiece for the high altar of S. Marco, the Dominican church and convent that were rebuilt at the expense of Cosimo de' Medici[113]. In the predella the lives and martyrdom of Cosmas and Damian were narrated in images against a background that showed the convent that had been built with Cosimo's money. The consecration of the high altar, in keeping with this emphasis,

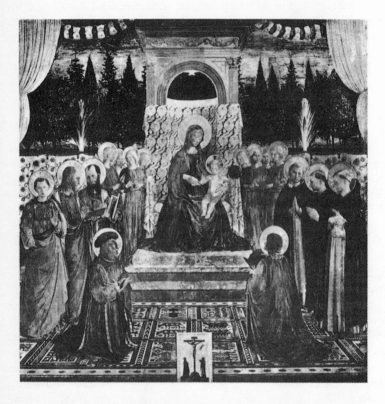

47. Fra Angelico, *The Virgin Mary with St Cosmas, St Damian and other saints, c.* 1440; Museo di S. Marco (photograph Alinari)

extended beyond St Mark; in a ceremony attended by numerous churchmen and a large congregation a cardinal dedicated the new altar also to St Cosmas and St Damian, the family saints of the Medici[114].

Cosimo de' Medici acquired his rights of patronage in S. Marco in the context of efforts to reform the old monastic order that worshipped there, the Sylvestrines. Where Pope Martin V had failed to push these reforms through, Eugenius IV (1431–47) succeeded with the support of the Medici, transferring both church and convent to the Dominicans of Fiesole[115]. Cosimo lent his weight and funds to this move partly on account of the important contacts he thus gained with Dominicans and members of the *Curia*. Of these his relationship with Fra Antonino was to have great significance; Fra Antonino rose to become prior of the convent, the city's emissary to the *Curia* and finally Archbishop of Florence[116].

Despite the attempted interference of other families and the Dominicans' reluctance to agree to forms of outward display, Cosimo and his brother Lorenzo were able to ensure that the renovation and extension work was done largely according to their wishes[117]. Altarpieces made by Fra Angelico were installed in what was now totally a laymen's nave, the monks having removed to a large chapel or *tribuna* behind the high altar. Upon the altar was placed a *tavola quadrata* in which a prominent place was assigned to the clients' family saints[118]. In the church chronicle the Medici were commemorated as generous donors who had financed the rebuilding of the church as well as paying for altarpieces, liturgical items and numerous illuminated manuscripts[119].

The line of monks' cells in the convent contained one for Cosimo de' Medici. It was a place to which he could retreat, a place outside the bustling sphere of civic administration where he could meditate and exchange views with learned Dominicans[120]. An inscription above the door of his cell commemorated Cosimo's foundation of the convent and its consecration by the pope, who had granted indulgences on the occasion[121]. Throughout church and convent the Medici coat of arms was resplendent, so that the building gained the aspect of a monument built in their honour.

From 1445 onwards, Medici ostentation struck a more aristocratic note. The burial monuments, *palle* and inscriptions that appeared in the Servite church of SS. Annunziata are a case in point[122]. Originally the Falconieri family had put themselves forward as chief patrons, but the Medici were able to edge them aside through the mediation of faction members and of a highly placed ally, Lodovico Gonzaga, Marquis of Mantua. In 1449 Cosimo de' Medici suggested that the Marquis might wish to spend his

prospective fee as *capitano generale* of the Florentine republic on renovating SS. Annunziata. Several rounds of talks at the civic and at diplomatic level produced the agreement of the commune: the money would be transferred to the Servites for the funding of a new *cappella maggiore* on the condition that no escutcheons should be displayed there other than those of the Gonzaga and Medici families[123].

After thirty years of negotiations involving the city's administrators, Servites and various families, the church was quite transformed. As in the case of S. Marco, the monks moved out of the choir in the nave, conducting their worship in a new *tribuna*. Most of the chapels in the renovated church were assigned to members of the Medici family, their business associates and their allies. The family also made much use of the new atrium, placing votive statues there, many of which commemorated the unsuccessful attempt of the Pazzi and others, including Pope Sixtus IV himself (1471–84) to overthrow the Medici regime in 1478. The altar to the left of the door in the nave was one of the main places of cult worship in Florence, boasting a fresco said to have been miraculously painted by St Luke himself. The Madonna of this fresco was likewise believed to work miracles, and votive offerings were heaped before her. Piero's pride in this famous relic found expression in the marble canopy he ordered to overhang it, which bore the enthusiastic banker's inscription 'The marble alone cost four thousand florins'[124].

Another interior that bore the stamp of Piero's aristocratic pretensions was that of S. Miniato al Monte, the Benedictine church to the south of the city. In donating a canopy to be set above the central altar in the nave, Piero stipulated that his escutcheon and emblems should be blazoned upon it. The wool guild, for centuries the chief patrons in this church, were now quite overshadowed by the ostentatious diamond ring, ostrich feathers and falcon that marked the Medici's dominion[125].

Donations brought ecclesiastical office within reach of many of the Medici, thus broadening their sphere of influence. Cosimo's illegitimate son Carlo even rose to become Dean of Prato Cathedral[126]. Frescoes in the main chapel here centred upon St Stephen, patron saint of the city and of the cathedral, and the festival celebrating the discovery of the saint's relics loomed large in the calendar. The day held personal significance for Carlo too, coinciding with his appointment as dean of the cathedral. Carlo's role as one of the advisers and clients responsible for commissioning the work was heightened by the inclusion of a portrait showing him in the company of Pius II[127].

Both St Stephen and St Lawrence came to be, as it were, co-opted into the Medici gallery alongside the brothers Cosmas and Damian, and Fra Angelico painted them in numerous frescoes and altarpieces. Both had held the office of deacon, one in Rome and the other in Jerusalem, administering the church's goods on behalf of the pope. This made them apt patron saints for a family that had gained much of its fortune from being the pope's bankers[128].

Besides taking a special interest in St Stephen and St Lawrence, the Medici also took to commissioning grandiose images showing themselves mingling with the Magi. Such an association, like the princely emblems, was a visual expression of the special status the successful bankers laid claim to within the republic, and the family played a prominent role in the fraternity dedicated to the Magi that gathered in S. Marco[129]. And along the walls of the family palace chapel on the Via Larga rode processions of the Magi with Medici in their train.

PORTRAITS OF HONOUR AND SHAME

Despite the tendency of the Medici and others among the Florentine élite in the second half of the quattrocento to adopt certain flourishes reminiscent of the aristocracy, they took great care not to overstep the mark of what was deemed acceptable in a republican city-state. Giovanni, Cosimo, Piero and Lorenzo de' Medici were all somewhat restrained in commissioning self-portraits, more often arranging to appear in paintings commissioned by their satellites. An extensive network of artistic patrons developed to the greater glory of the Medici family, which was firmly at its hub[130].

Just as countless churches displayed the Medici arms, countless chapels contained portraits of the Medici and those of their faction. Guasparre del Lama founded a burial chapel by the right door of S. Maria Novella, for which Botticelli painted a rectangular altarpiece with an Adoration of the Magi. Guasparre is portrayed among those present at the scene, and the company of the Magi contains certain figures whose faces bear a striking resemblance to members of the Medici family (see fig. 48)[131].

Pigello Portinari, who represented the Medici bank in Milan, had a new chapel built and decorated in the Milanese church of S. Eustorgio, prominent features of which were a burial monument commemorating the Dominican saint Peter of Verona and a portrait of the patron at prayer. The Bruges representative, Tommaso Portinari, commissioned Hugo van der

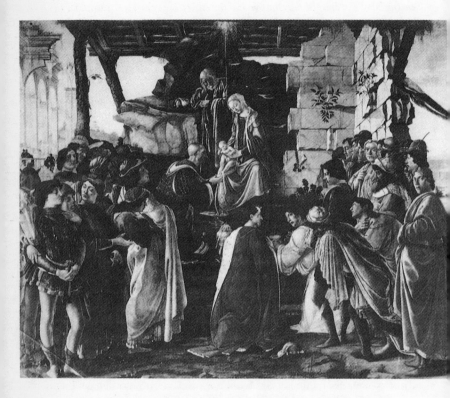

48. Botticelli, *Adoration of the Magi, c.* 1474; Galleria degli Uffizi, Florence (photograph Alinari)

Goes to paint an altarpiece for the hospital church of S. Egidio in Florence
that had been founded by his ancestors. To the left of the Adoration of the
Shepherds kneel Portinari and his sons, to the right his wife and daughter
(see fig. 49)[132]. Also, in an altarpiece painted by Memling, Tommaso Por-
tinari was assigned a place on the scales of the Last Judgement, while the
patrons Angelo Tani and his wife themselves appear on the wings[133].

Members of the Medici faction founded a steadily expanding domain of
chapels between 1450 and 1490[134]. Many were funded by the Tornabuoni
family[135]. There was a concentration of these chapels in S. Maria Maddalena
di Cestello, built partly on the initiative of the *Curia* as part of their
programme to reform the convent[136]. The city's rulers lent their support to
the project, as did several wealthy citizens such as Giuliano de' Medici, who
was on amicable terms with the Cistercian abbott. The Cestello, too, thus
became a monument to the Medici circle[137].

New in the Medici repertoire were unflattering portraits of their
opponents, a genre previously wielded in the fourteenth century to vilify
rebellious cities and noblemen rather than rival merchant families. In 1440,
six years after Cosimo's accession to power, a painting by Andrea del
Castagno appeared on the façade of the Palazzo del Podestà depicting the
members of the ousted faction in the guise of rebels hanging from their
feet[138]. The conspiracy hatched in 1478, with the Pazzi family at the fore,
also occasioned such a commission. The advisory committee in charge, the
Otto di Balìa, had the opponents of the Medici portrayed as enemies of the
republic. A year later a new committee requested that the portrait of the
Bishop of Florence be removed from this group – a request emanating from
Sixtus IV as one of the demands he made in his peace negotiations with
Florence[139].

In October 1481 intensive consultations between Sixtus IV and the
Florentine republic produced the contract with Botticelli and Ghirlandaio
for the painting of the Sistine Chapel, the most important chapel in the
papal palace, which Sixtus was having rebuilt. The pope had himself
portrayed at prayer on the wall behind the altar, at the end of a long
row of figures beginning with Moses and Christ and continuing through
countless other popes[140]. Portraits of Florentine envoys were among the
images on the walls. One such was Giovanni Tornabuoni who, together
with Francesco Sassetti, a fellow-director of the Medici bank, commissioned
Ghirlandaio to make elaborate paintings for their family chapels in Florence.

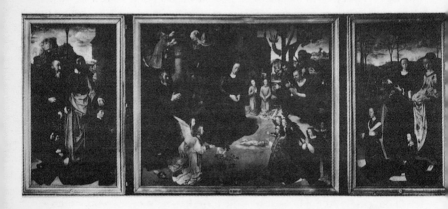

49. Hugo van der Goes, *Portinari altarpiece*, 1473–5; Galleria degli Uffizi, Florence (photograph Gabinetto fotografico, Florence)

THE SASSETTI CHAPEL: INFLUENCE IN IMAGES

The commission that finally produced the Sassetti chapel decorations in S. Trinità sprang from Francesco Sassetti's thwarted desire to determine the nature of a series of frescoes for the main chapel of S. Maria Novella[141]. His family had a long-standing connection with the latter church, Fra Baro Sassetti having ordered the polyptych for its high altar in about 1320 and Fiondina Sassetti having bequeathed a sum to be spent on new decorations for the high altar in 1429. In 1469 the Dominican monks had conferred upon Francesco Sassetti the right, 'out of respect for his ancestors', to provide new decorations with the attendant privileges and responsibilities[142]. Yet the contract drawn up with Ghirlandaio in 1485 made clear that the rights of patronage belonged to Giovanni Tornabuoni, and this was confirmed by the order a year later[143]. Meanwhile Ghirlandaio had been working for Sassetti in S. Trinità: he designed and painted the burial chapel, and by 1485 the work was finished[144]. This time Francesco Sassetti made sure of his rights of patronage and the memorial masses he wished to have celebrated by including certain clauses in his will; he also added a note complaining about the turn events had taken in S. Maria Novella[145].

Francesco Sassetti in person was largely responsible for the choice of both the subject-matter to be depicted in the chapel decorations and the way in which it was elaborated. He decided upon scenes from the life of his name-saint, Francis. This was not in itself novel, but Sassetti had striking new elements added, particularly on the conspicuous back wall above the altar.

As the setting for the establishment of the Franciscan order Ghirlandaio was instructed to paint not the Lateran palace in Rome but the Florentine Piazza della Signoria. To the right of the pope conferring benediction were depicted the patron himself and his son, his employer – Lorenzo de Medici – and a member of the Pucci family. Ghirlandaio's original design incorporated neither the Florentine background nor the son and fellow-citizens in the foreground[146]. By deciding to include these figures Sassetti demonstrated his loyalty to Lorenzo de' Medici as the head of the Medici bank and leader of the dominant faction in Florence (see fig. 50).

The foreground shows a number of children and a man emerging from a stairwell: Lorenzo Poliziano, the prominent humanist, and his pupils, children of Lorenzo de' Medici, including Giovanni, who was made a cardinal in 1489, and twenty-four years later became pope[147]. Lorenzo referred to the cardinal's appointment as 'the greatest success that our House has achieved'[148]. His desire to assure his children of careers within the

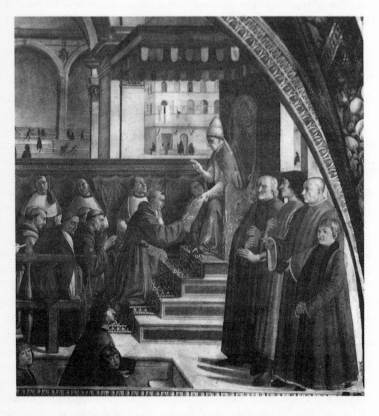

50. Ghirlandaio, *Honorius III sanctions the Rule of the Franciscans*; detail of the Sassetti chapel fresco (photograph Gabinetto fotografico, Florence)

Church had initially augured well long before then. In 1471 Lorenzo had been present in the capacity of an envoy from Florence at the ceremony installing Sixtus IV as pope, and wrote of his experiences, 'I was received with great show of respect, and came away with two statues, one of Augustus and the other of Agrippa, which the pope presented to me as gifts.' Relations between the Medici and Sixtus deteriorated visibly, however, culminating in a crisis around 1478 that was deepened by the Pazzi-led assault on Giuliano and Lorenzo at the Duomo during Mass on Easter Sunday[149].

The unusual depiction of the papal approval of the Franciscan rule – which at the same time gave Ghirlandaio the scope to demonstrate his powers of invention and composition – was occasioned by political and diplomatic motives. Sassetti's decision to include the somewhat anomalous elements in a scene historically set in Rome was prompted partly by the relations between the Sassetti and the Medici families and partly by the diplomatic *rapprochement* around 1480 between Florence and Rome. Furthermore, interest in the link between the two cities was fuelled by a traditional belief that Florence had been founded by the Romans for which Poliziano – the figure emerging from the stairwell – claimed to have found historical evidence[150]. Architectural features of the chapel and the design of sarcophagi placed there likewise testified to the growing trend among humanists, patrons and painters to orient themselves towards Rome[151].

Beneath the painting with its unhistorical setting was another in which Sassetti made key modifications. At the last moment of the decision-making process he veered away from the planned (and customary) image of Francis's Apparition at Arles, fixing instead upon the seldom represented scene of the saint raising a notary's little son from the dead[152]. The explanation for this may be found in the death of Sassetti's son Teodoro in 1478, and the birth soon afterwards of another son given the same name[153]. The miracle is set in the square before S. Trinità, with the bridge over the Arno in the background. On the left and right sides of the painting can be seen images of some of Sassetti's youthful kinsmen.

At a lower level on the back wall is a *tavola quadrata* with an Adoration of the Shepherds; beside the shepherds kneel the patron and his wife. Above their sarcophagi, which stand against the side walls, Ghirlandaio painted other scenes from the life of St Francis. In the frame of the altarpiece and on the outer wall of the chapel in a far larger format is blazoned the Sassetti escutcheon.

The main elements of a painting can only be understood within the wider context that has given rise to a particular programme of decorations.

In Sienna, town scenes were designed primarily to express civic pride. The town scenes in the Florentine Sassetti chapel, on the other hand, betokened a family ideal that spread beyond the Sassetti to include the wider faction to which they belonged. Again, in the frescoes painted around 1295 in Assisi St Francis symbolized an order approved by the papacy. In the Sassetti chapel, however, Francis was a family saint rather than the figurehead of his order. The significance of the city scenes in the background is therefore just as dependent on the social context in which the painting has been commissioned – whether dominated by a particular mendicant order, the city commune or by a great family – as the saints in the foreground. The details Sassetti chose to include in the chapel's decorations shed light on countless economic, political and cultural configurations: connections within the family itself, Sassetti's relations with the Medici and his position in Florence, in particular the ties with Rome and the *Curia*, which was growing in social importance for the élite of the city-state day by day.

THE TORNABUONI CHAPEL:
FAMILY MONUMENT IN A MENDICANT CHURCH

In the *cappella maggiore* of S. Maria Novella secular elements were again added to conventional sacred images, the theme in this case being episodes from the lives of St John and the Virgin Mary. The patron and his wife are shown with their arms crossed, kneeling in devotion. Views of Florence and of Tuscan scenery make up the background, and family arms are much in evidence. The figures depicted by Ghirlandaio are a mixture of biblical characters interspersed with several Florentine humanists and countless other members of the Tornabuoni clan[154].

Renovations to this largest and most impressive chapel were completed in around 1490[155]. The additions included new frescoes, a monumental altarpiece painted on both sides, new windows – depicting family arms, the Madonna of the Snows and several saints – and choir stalls in the chapel. The Dominicans' own contribution to the decorations included the choice of religious images and the representation of saints of their order[156].

Tornabuoni took pains to stress, as Sassetti had, his own role within the flourishing Florentine republic. Inscribed on a building painted behind an image of St Zacharias are the words 'In the year 1490 when the most glorious city, renowned for its wealth, its victories, its art and architecture, lived in affluence, prosperity and peace.'

Here too we can trace the power structure forming the context for the decorations. Not only Francesco Sassetti but also descendants of some of the Ricci who lay buried in the chapel vied for a say in the renovations and protested against imposing Tornabuoni arms being blazoned on both sides of the entrance, dwarfing the image of the Ricci arms on the tabernacle. When appealed to, however, the city's rulers favoured the Tornabuoni cause apparently swayed by Giovanni Tornabuoni's eminence as well as his argument that Ricci's arms actually occupied a place of far greater honour, being in such close proximity to the Host[157].

Giovanni Tornabuoni owed his dominance as a patron of art to his key position in the Medici bank. He was the director of the Roman branch of the bank, Lorenzo de' Medici's uncle and gonfaloniere of justice, and thus exerted considerably more influence in the city than Francesco Sassetti, who had long been established in Geneva[158]. This gap widened further when the northern branches suffered serious losses for which Sassetti was called to account, and in 1484 Tornabuoni was installed in his place[159]. Another influential factor was the long and respected role played by the Tornabuoni clan in the Dominican convent to which Giovanni was able to give a fresh impulse at this time, drawing on his great wealth and reputation.

The struggle for ascendancy in the issuing of artistic commissions for the *cappella maggiore* in S. Maria Novella was finally settled in 1485[160]. Giovanni Tornabuoni had renovations made to the decorations in the main chapel that had been paid for by his ancestors and stipulated in the artist's contract that

he is to paint and depict figures, buildings, castles, cities, mountains, hills, plains, water, rocks, garments, birds and beasts, of whatever kind as seems proper to the said Giovanni, but according to the stipulation of colours and gold as laid down above; and he should apply and paint all the arms which the said Giovanni should require on any part according to his own wish and pleasure[161].

Some notion of the context in which the choice of images – both sacred and profane – arose can be gleaned from the following paragraph in the contract according to which

to the praise, magnitude, and honour of Almighty God and His glorious Mother, ever Virgin, and of St John, St Dominic and other saints as detailed below, and of the whole host of heaven, the magnificent and noble Giovanni, son of Francesco Tornabuoni, citizen and merchant of Florence, has proposed, as patron of the greater chapel in the church of S. Maria Novella in Florence, to decorate the said

chapel with noble, worthy, exquisite and decorative paintings at his own expense, as an act of piety and love of God, to the exaltation of his house and family and the enhancement of the said church and chapel[162].

4. CIVILIZATION AND STATE FORMATION

===

FAMILIES AND THE IDEALS OF CIVILIZATION

Two general concepts were broached in the Introduction as being inextricably linked to professionalization. Both these concepts – civilization and state formation – were briefly placed in a historical context, and both have been touched on implicitly throughout the present section. Now the links may be made more explicit: a pattern of relationships begins to emerge between the professionalization of painters, patronage and imagery on the one hand, and the more far-reaching processes of civilization and state formation on the other.

Florentine civilization was rooted in several interlaced cultures. One was that of mendicant orders, in which the laity participated in a variety of ways: as members of confraternities, as donors, or simply by virtue of having monks in the family. Part I described the way in which the friars imposed codes of conduct on the entire community in what may be called the 'civilizing process'. Other codes of conduct had a similar effect – those of painters' guilds and confraternities have also been discussed. Family relations in particular played a key role in developing such codes or social standards, expressed in moral attitudes, legislation, religious observance and reinforced by constant exposure to images that drove the points home.

In the two hundred years from 1300 to 1500 the range of standards was expanded, refined upon and systematized, and specific elements were brought variously into focus for different groups and organizations. The most effective channel along which these ethics were transmitted and developed was from parents to their children, and there was no longer any question of the instilling of good principles being primarily a matter for clerics. Equally, good behaviour was no longer something showed only to one's betters – it was recognized to be an end in itself. A plethora of treatises on virtuous behaviour was published and disseminated among a broad section of the Florentine population.

Civilization developed in Florence in terms of a systematic and dynamic range of ideals. Different groups would place their emphases differently and shifts of emphasis also took place over time, but all classes of society that subjected themselves to the prevailing codes of virtuous conduct developed a keen sense of belonging to the same community. Mendicant orders, civic institutions, families and courts all had a stake in Florentine civilization, and all were therefore absorbed into a far-flung network of relations that, as it developed, was ultimately oriented towards courtly circles. The ways in which individuals identified themselves with their church, their city, their family and later also with the court developed a certain mutual harmony, and the different interactions were often compared. Exempla derived from biblical or classical sources or from Christian texts were seized upon to define the virtues to be cultivated more sharply and to provide apt illustrations[163].

The ongoing process of civilization suggested by the trends that have been described in these pages – in rituals, in influence acquired by virtue of donations, in architecture and in painted images – is echoed in a series of treatises that appeared on the subject of ideal modes of conduct within the family. The family picture that emerges here – man, wife, children and kinsmen surrounded by their emblems, coats of arms and patron saints – corresponds with texts that underscored the importance of families in the context of Church, city and state. During these two centuries (1300–1500) and particularly in Florence, a major theme addressed in pedagogical texts, personal recollections and essays was the essential virtue of loyalty to the family.

A merchant by the name of Paolo, from the town of Certaldo, having settled in Florence in around 1370 where he had come on business, wrote a Book of Good Habits (*Libro di buoni costumi*). This was a catalogue of 388 notes concerning the relationship between the uncomplicated and familiar life as lived with one's family and friends and the more precarious contacts outside this circle. The author of these admonitory notes urged his fellow merchants to adopt regular and moderate habits, pointing a sobering finger in the direction of great lords and wealthy citizens who had fallen from their heights through having exerted too little self-discipline in the way they apportioned their time[164].

The Florentine merchant Giovanni di Paolo Morelli took to recording reminiscences of his life (from around 1391) for the benefit of his children. More learned than Paolo of Certaldo, he was able to draw on tales from the ancient and Christian traditions to embellish his *Ricordi*. His advice was to acquire a good name and an honourable reputation and to be obliging,

courteous and respectful. He wrote that the path leading to esteem and to the development of courtesy – in short, to a principled and virtuous life – was that of religion combined with scholarship. (In common with contemporaries such as Boccaccio, Morelli warned against those who hid their true, uncultivated natures 'under the cloak of religion'.) Such was the value to be gained from this dual application that Morelli advised merchants and their children to supplement readings of the prophets and the Gospel with Aristotle, Virgil and Dante[165].

The images installed in Florentine chapels and homes revealed the influence of secular as well as sacred texts, but the worship of saints remained a dominant theme that exerted a persistent hold on citizens' emotional lives. Though the process of secularization meant that the laity acquired more say in the liturgy and in the church's interior design and imagery, it left the citizens' desire to identify with saints quite intact.

Alberti's extensive writings cover not only architecture, sculpture and the art of painting but also dwell on the family. He advocates a balance between the mercantile and scholarly frames of mind, and urges the more experienced merchants to instruct their younger kinsmen accordingly. Making a profit is an honourable goal, he advises, because the money benefits one's family and the state, in part by enabling commissions to be granted to artists. Like Morelli, Alberti stresses the importance of leading an active life and not wasting time. People should refrain from passion, lust, cruelty, idleness and other forms of sinful behaviour; in short, they must conduct themselves in a civilized fashion. Alberti deals with civilization in terms of ideals inculcated within the family, and places this model within the wider social context of Church and city[166]. Nor does the master architect neglect to draw the link between such ideals and the professions of architecture, sculpture and painting[167].

The written comments of artists, advisers and clients concerning the art of painting are expressions of a broad-ranging civilization, as are the paintings themselves. Increased control of technique and a greater fund of knowledge were the most visible fruits of that culture, but countless other developments were aspects of the same process taking place in Florentine society; these included a growing appreciation for art and the evolution of a critical vocabulary and artistic theory as well as an increasing awareness of history. In diverse ways professionalization, as described at the beginning of this part, was embedded in a civilizing process in which merchants and humanists, goldsmiths, architects and painters were all caught up and to which all contributed.

Bindo Bonichi's verses have illuminated the social code that grew up in Sienna attendant upon the rise of the rich merchant classes there. In Florence this development was more marked still. Standards of behaviour were formulated that derived their rationale from the community's reliance on professional services provided in a civilized manner. It was considered praiseworthy to engage in a sustained effort to make a profit within a long-term perspective, and the mentors of merchants' children therefore impressed upon their charges the need for study and diligence besides developing due respect for religion and a community spirit. By 'due respect' should be understood a proper appreciation of the relevance of religious precepts to life outside church or convent, but without any extreme sense of sinfulness or excesses of asceticism, without vehement forms of penance, absolution or indulgences – a religious sense, in short, governed by moderation[168].

The loyalty of wealthy citizens to their kinsmen narrowed in focus somewhat from the mid-fifteenth century, and though extended networks of relations continued to have a certain influence, attention centred on the nuclear family together with some few business partners[169]. At the same time Florentines were more apt to look beyond the boundaries of their state more than before, seeking models in the aristocracy.

Though democracy had prevailed at times – during the rise of the mendicant orders and the early stages of the republican city-states – the rule of aristocrats proved the stronger force during the fifteenth century. One expression of this tendency was the praise lavished on grand patrons of art, especially the Medici; another was the appreciative response to tasteful outward show or *magnificentia*[170]. Thus people took an ever greater interest in the refined forms of display appearing in chapels, palaces and villas.

Florentine citizens continued to feel a strong sense of identification with the city as such, however. Writings published by the scholarly chancellors Salutati and Bruni in the period 1390–1440 had sung the praises of their city. Salutati pinpointed the fatherland as the rightful source of all joy, according it precedence over wife and children as determining one's sense of identity[171]. Florence deserved to be called the 'flower of Italy', he felt, because of its superb buildings and also on account of the great men of letters it had brought forth[172]. He described his perceptions of the beauty of his city as viewed from the surrounding hills and attached a symbolic value to his observations, seeing the circular plan of the city that radiated out from cathedral and town hall through mendicant churches to the villas beyond the city walls as a mirror of social harmony[173]. Bruni's paeans on

the splendour of Florence similarly highlighted the beauty of the city – it was more magnificent, he believed, than either Rome or Athens[174]. It is quite plain from the images and inscriptions crowding the walls of the Sassetti and Tornabuoni chapels that these leading citizens, the élite of Florence, also felt loyalty to their city-state to be a point of honour (see fig. 51).

The accolades bestowed upon Florence bathed the city's leading families in tributes too. The Medici in particular became known as a family that had acquired a fortune without encroaching upon republican values, in part by treading an astute line in the forms of display they adopted; they exercised enough restraint to defuse accusations that they were putting on magnates' airs whilst manifesting themselves sufficiently to gain public esteem[175]. Outside Florence the Medici built up a reputation as cultivated rulers within a great republic, men who in terms of power and patronage were virtually on an equal footing with princes[176].

REPUBLICAN FLORENCE AND COURTLY STATES

Florentine civilization evolved along lines constrained by the process of state formation in Tuscany, Italy and indeed in Europe. In Florence itself the state acquired an ever more cohesive structure in the period from about 1250 to 1500, despite the changing coalitions that came to power and the financial crises, the uprisings and even the catastrophic 1348 outbreak of the plague.

The republic gained a firm control of taxation early on, and consolidated its grip still further during the fifteenth century. The other monopoly advanced in the Introduction chapter as characteristic of a state, that of armed force, was almost as far-reaching: weapons were largely concentrated within the army, which proved equal to its often arduous task of safeguarding the republic's liberty and promoting security within its frontiers. As these frontiers expanded, taxation and the control of violence inevitably marched onwards in concert, eventually taking in an area that included Pisa, Volterra and Arezzo. Administration of the state proceeded to a great extent on the basis of laws, as did that of neighbouring Sienna. In Florence, too, citizens developed idealized visions of their republic, emphasizing virtues such as peace, liberty and justice which they felt it embodied. In some areas they went further; Florentines were intent upon refining their language and upon achieving a more accurate and systematized historiography of their

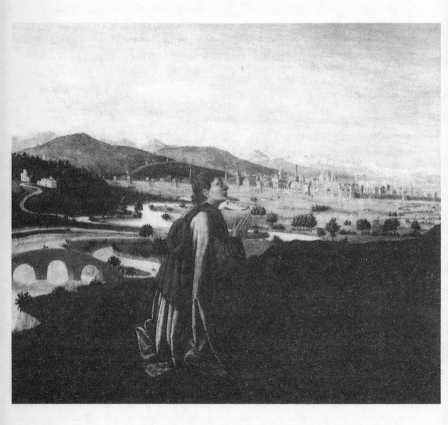

51. Francesco Botticini, *Matteo Palmieri at Prayer*, detail of *Altarpiece with Assumption, c.* 1475 (photograph National Gallery, London)

state. In the main, Florentine developments ran parallel to those of Sienna as described in the previous part between 1200 and 1350. After this point, however, their paths diverged. Whereas Sienna relapsed into stagnation in the late fourteenth century, all the diverse elements of state formation in Florence were further consolidated: controls on taxation and on the exercise of force were increased, expansion in terms of territory, bureaucratic apparatus and legislation took place and the historiography and civic ideals crystallized[177].

The esteem enjoyed by leading Florentine families was a function of their role in state affairs. Besides the importance of their diverse informal contacts, many held official posts and had a considerable say in the administration of public funds. Economically, politically and culturally, the network of families discussed above in the light of their artistic patronage was the backbone of the Florentine state. It was within the framework of the republic that their coalitions were formed and their rivalries fought out. The fighting was largely a matter of words and images, not weapons, however; decisions were reached by way of consultations and negotiations, and diplomatic missions, gifts, rituals, moves calculated to sway public opinion and forms of display all had a role to play in this process. Artistic patronage, in particular, became a vital tool used to strengthen mutual ties and to settle conflicts by peaceful means.

The development of the Florentine state was closely linked with changes taking place in the surrounding territories that were administered from courts, including Milan, Mantua, Urbino, Rome and Naples; the Papal State, above all, had risen to great prominence in the peninsula during the fifteenth century. None of these states ever gained lasting ascendancy over another; the balance of power between Florence and such courtly centres fluctuated constantly.

This situation had numerous repercussions upon patronage. It was in this context, for instance, that the Marquis of Mantua came to be involved in the renovation of SS. Annunziata, that the Medici evolved an aristocratic mode of patronage, that changes were made to the original designs for the Sassetti chapel and that Florentine painters undertook journeys to Rome. Patrons still competed for commissions, but in a civilized manner. Clear lines thus emerge between the continuing professionalization of painters and the flourishing of patronage and imagery on the one hand, and developments in civilization and state formation on the other. No single unified state emerged in Italy, but rather a number of mutually dependent territories with distinct, though related, cultures developed. Such were the special

dynamics of state formation and civilization that characterized the Italian peninsula at this time. Gradually the focus of these ongoing processes and the cultural forces they generated shifted decisively away from republican city-states towards princes and their courts.

PART IV

THE COURTS OF URBINO, ROME AND FLORENCE

1. FEDERICO DA MONTEFELTRO:
KNIGHT, SCHOLAR AND PATRON OF ART

=====

ARISTOCRATIC CULTURE

In 1472 Federico da Montefeltro led a Florentine army high up into the hills of Tuscany and laid siege to the town of Volterra. The city was forced to yield, and the general entered Florence in glorious and festive procession, showered with gifts[1]. Among other things Federico received an illuminated manuscript with a portrait of honour; it shows him wreathed in laurels and clasping his general's staff as he rides triumphantly through the Tuscan hills with Volterra in the background[2]. A second miniature depicts Florence with its myriad churches built with the money of the Medici.

In the years following upon this victory, the court of Federico da Montefeltro (1420–82) acquired a pivotal position within the network of states in Italy (see fig. 52). Urbino maintained contacts with the papal court and the courts of Milan, Naples and Burgundy, those of Mantua and nearby Pesaro as well as with the republics of Sienna, Florence and Venice. All such ties oiled the machinery of cultural exchange. Federico's patronage played a decisive role in the careers of numerous painters, architects and scholars; indeed his style of patronage became a model for others, and writings of the day recorded its splendour.

The courtly culture that grew up in Urbino, Rome and Florence was praised by the humanist Cortesi of Volterra. In his treatise on the role of cardinals as courtiers and administrators he included a chapter on the cardinal's palace, in which he discussed examples of patronage. The two men he named as exemplary patrons of art were Cosimo de' Medici and Federico da Montefeltro[3].

Cortesi's treatise, which appeared in 1510, was eclipsed by that of the diplomat Castiglione, who held up the courtly culture continued by Federico's son Guidobaldo (1472–1508) as a radiant example to all in his

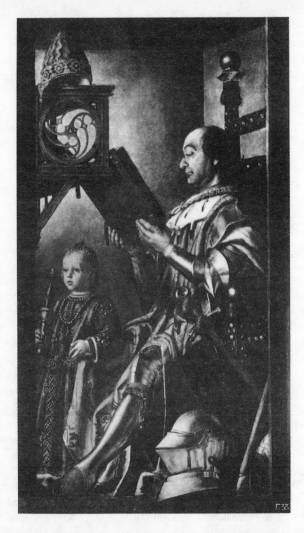

52. Justus of Ghent, *Federico da Montefeltro reads to his son Guidobaldo*, *c.* 1475; Galleria Nazionale delle Marche, Urbino (photograph Alinari)

Il Libro del Cortegiano, which comprises a dialogue at the court of Urbino[4]. *The Book of the Courtier* rapidly became the standard by which courtly behaviour should be measured and remained such for centuries. In Castiglione's account of Federico's patronage the palace interior is singled out for special praise: it had 'countless antique statues in marble and bronze, rare paintings [...] and a large number of the most beautiful and rarest manuscripts in Greek, Latin and Hebrew, all of which he had illuminated with gold and silver, in the conviction that these formed the crowning glory of his great palace'[5].

At the dawning of the quattrocento there was no trace of courtly culture in Urbino. Those of Federico's ancestors who had crossed the pages of Dante's *Inferno* and *Purgatorio* were styled warlike knights, one ending his life in Franciscan piety and the next vanishing into oblivion[6]. Their power did not extend beyond the mountainous and sparsely populated region surrounding Urbino. They had no elegant palaces, and their libraries extended no further than a handful of simple manuscripts.

The economic basis for the new aristocratic culture of Urbino was laid with the money earned by Federico da Montefeltro for serving other states in the capacity of General, or *condottiere*. Over a period of thirty years (1444–74) Federico built up a reputation as a supremely able military commander, which enabled him steadily to step up his fees. After twenty years of this successful career money overflowed into artistic patronage, which was particularly lavish during the last ten years of his life[7]. In 1474 his career was crowned with several orders of chivalry and the title of Duke. During this period commissions flowed freely, benefiting palaces, churches, manuscripts, statuary and paintings; in sum this was the great era of courtly patronage at Urbino[8].

THE STATE EXPANDS

Federico da Montefeltro was born illegitimate in 1420. His early training included both a general humanist education and military experience, the one at the court of Mantua, at the school run by the scholar Vittorino da Feltre, the other gained serving under senior generals including the great Niccolò Piccinino[9]. Federico succeeded his half-brother Oddantonio, the legitimate heir, as Count of Urbino upon the latter's assassination in 1444. The civic authorities gave him their support and a covenant was signed between the young prince and the city, although he was denied the

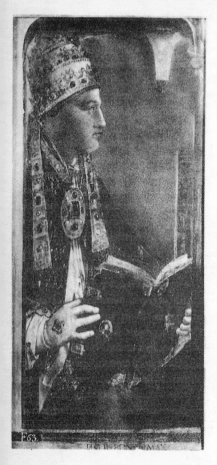

53. Justus of Ghent, *Pius II*, *c.* 1475; Galleria Nazionale delle Marche, Urbino (photograph Alinari)

54. Justus of Ghent, *Sixtus IV*, *c.* 1475 (photograph Louvre)

customary right to designate his own successor. Most of the nobles in the area surrounding Urbino joined the union between city and Signore. Federico gained a reputation as peacemaker in the state of Urbino and was spoken of as having laid the foundations of an aristocratic civilization[10].

By forging alliances with other courts and republics on the peninsula the Signore was able to broaden his power base. It was not a power deriving solely from the use of physical force; Federico was also a skilled negotiator and diplomat, and he deployed his army to give a decisive turn to events as coalitions formed and dissolved and the threat of war loomed and receded. He received payment from diverse parties, fees climbing steeply during wartime. The network of relations he built up with powers beyond the immediate area enabled Federico to expand his territory considerably, to promote peace and ensure security within its bounds, and to finance an adminstrative apparatus[11]. Under his rule Urbino became a territorial state.

When conflict arose between the pope and Sigismondo Malatesta, lord of Rimini, as the Papal State expanded towards the north-east, Federico da Montefeltro sided with the papacy. In the memoirs of this pope – Pius II (1458–64), who started his career as a rhetorician, secretary and diplomat – his *Commentarii* deal mainly with this expansion and his friendly and hostile relations with neighbouring powers (see fig. 53)[12]. The pope accused Sigismondo Malatesta of murder, avarice, heresy, adultery, sacrilege, cruelty and duplicity. Notwithstanding such an array of charges, Pius acknowledged Sigismondo's abilities as a great general and respected him as a man with historical insight, a sound knowledge of philosophy and a gift for eloquence[13].

On one level the conflict was fought as a propaganda war; besmirching the foe's reputation was a weapon wielded to great effect by Pius II. In this context the pope referred to 'the ceremony we term canonization' and suggested that its obverse – ritualized consignment to hell – be introduced. His writings make it clear that he saw canonization as conveying political as well as ecclesiastical approval, a form of secularization that suited his purposes as head of state. His views emerge strongly from the remarks in which he contrasts the qualities of candidates for heaven with those he would consign to the nether regions:

We have been requested to include Catharine of Sienna, Rosa of Viterbo and Francesca Romana among the names of virgins and widows who are saints of Christ [. . .] what has been said of these maidens must be proven true; Sigismondo's misdeeds are many and manifest [. . .] Let him therefore go first, and before they are admitted to heaven let him be registered as a citizen of hell. [. . .] No mortal

has yet descended to hell with the ceremony of canonization. Sigismondo will be the first to be found worthy of such an honour[14].

Continuing in this vein of vilification, in 1462 Pius went as far as to stage a grand spectacle which he described as follows:

Before the steps of St Peter's a great bonfire of dry wood was built, and on top a figure representing Sigismondo Malatesta was placed that was so accurate as to his clothing and his evil and accursed features that it resembled a real person more than an effigy. But lest any person be left in any doubt, an inscription was added, issuing from his mouth, which read: 'Sigismondo Malatesta, son of Pandolph, king of traitors, hated by God and by man, condemned to the flames by order of the holy senate.' This text was read by many. Then, in the presence of the people, the wood was ignited and the effigy immediately caught fire. Thus was the stigma branded on the impious house of Malatesta.

Pius reported his victory over the lord of Rimini at great length; Sigismondo lost most of his territory to the papacy and to Urbino, and at the end of his life he was obliged to kneel to the pope to beg forgiveness[15].

Before the fortunes of the lord of Rimini were thus overturned, however, he had been able to broaden his sphere of influence considerably. He, like Federico da Montefeltro, had acquired his authority through a combination of the regional power of his family and military services offered on a wider scale. The General used his riches to build a new castle, and gave symbolic expression to his status by having his arms displayed in numerous places throughout his territory. Sigismondo gave Alberti a commission encompassing extensive renovation work on S. Francesco in Rimini, which was later renamed the Tempio Malatestiano and furnished as a burial church for him and his beloved Isotta[16]. Existing votive portraits and funerary monuments were removed and in 1451 Piero della Francesca painted a portrait of the lord at prayer before his name-saint[17]. Two dogs are depicted in graceful lines behind the worshipping figure, and the family arms are shown both above Sigismondo and in the border. A medallion on the back wall shows his castle, which was completed, according to the inscription, in 1446. During this period Sigismondo Malatesta had been aiming, through his activities as a patron of art, to achieve the very opposite of the reputation that Pius was to spread by word and fortify by macabre ceremony. In other words, when Sigismondo Malatesta commissioned Piero della Francesca to paint a votive portrait of him in the church Alberti had designed, it was just as deliberately aimed to enhance his image as Pius's mock burning was intended to destroy it.

Towards Federico da Montefeltro, in contrast, Pius was in the main favourably inclined, although he viewed his own dependency upon Federico with some ambivalence[18]. In 1464 he gave the Signore of Urbino the right to pass on the title of apostolic vicar – conferred in 1447 by Nicholas V – to his legitimate son. It was in fact partly owing to his good relations with the papacy that Federico came to be considered a reliable ally. It was not so much that Federico was a better commander than Sigismondo, but rather that he had a sounder command of negotiations and diplomacy, and his public relations skills were decidedly superior. As states became more tightly knit units and courtly life flourished, it was imperative even for generals to be well-versed in these forms of control.

After Florence had received Federico with honour to celebrate the taking of Volterra, his meteoric rise to glory was confirmed by his acquisition of a new title. In a grand ceremony in 1474 Sixtus IV (see fig. 54) conferred a dukedom upon the Signore of Urbino. On 20 August Federico rode through Rome at the head of two thousand horsemen. Clad in a golden mantle and with Girolamo Riario and Giovanni della Rovere (prominent members of the papal entourage) to present him, he knelt before the pope. In the ceremony that followed in St Peter's, Sixtus IV gave Federico his blessing and decorated him with the insignia of Commander-in-chief of the papal forces. Cardinal Orsini gave him the gilded spurs and Cardinal Gonzaga led him to the sacristy, where the Signore received the ducal robes. After Mass had been celebrated the new duke knelt once more before Sixtus IV to receive the remaining insignia and to swear his allegiance to the pope and the Church. Then followed the wedding ceremonies of two of the duke's daughters: one with Giovanni della Rovere and the other with Fabrizio Colonna. More honours followed in the autumn of that year, when Federico was presented with the Order of the Garter by the king of England and the Order of the Ermine by the king of Naples[19].

PALACE, COURT AND SCHOLARS

Federico da Montefeltro expanded the principality of Urbino to three times its former size. He also built up a network of diplomatic contacts, and gradually what had been a minor county grew into a substantial dukedom. Forts, towers and castles were erected in those places where the security of his territory was vulnerable, and within the pacific realm rose great palaces in Gubbio and in Urbino itself. These palaces had no military function to

serve and were far more spacious and comfortable than the castles of Federico's ancestors.

The palace at Urbino attracted growing numbers of courtiers. The duke's own relatives constituted a sizeable group: this included several of his daughters and those of his assassinated half-brother, his one legitimate son Guidobaldo and kinsmen of the houses of Malatesta, Sforza, della Rovere and Ubaldini[20]. A second group of courtiers comprised those with professional ties with the dukedom, painters, architects, calligraphers and miniaturists among them[21]. Scholars fulfilled the functions of secretaries, diplomats, orators and advisers. These court humanists were at once the administrative mainstay of the court-led state and theorists whose writings explored the balance of power both at court and between states. Such scholars were to a large extent instrumental (as were painters, in their different way) in building up the duke's prestige.

One such humanist, Pierantonio Paltroni, was a jurist and notary of aristocratic descent. He wrote a treatise that prescribed a code of courtly conduct, with especial reference to Urbino. He also produced a biography of Federico that was used as a source by later authors[22]. The picture that Paltroni draws of the Signore was elaborated in letters and public orations in the years that followed, which lavished praise on Federico of Urbino[23].

Other courtiers besides Paltroni ensured that Federico achieved widespread renown[24]. Vespasiano da Bisticci, whose line of business was copying and selling fine manuscripts, wrote a series of biographies between 1470 and 1485: after a succession of ecclesiastical officials he turned to Federico da Montefeltro, and subsequently to other princely rulers and celebrated merchants, including Palla Strozzi and Cosimo de' Medici – nearly all of whom purchased manuscripts from Vespasiano. Besides extolling individual lives Vespasiano's biographies are also an ode to patronage. His chief client was the Duke of Montefeltro, whom the manuscript salesman praised both as a knight and a patron of the arts[25].

Vespasiano links Federico's martial prowess with his virtuousness and theoretical knowledge. He describes his subject as a wise, honest, learned, pious and cultivated ruler who was equally familiar with sacred texts and secular history[26]. The Signore knew how to strike the proper balance between quiet contemplation and decisive action and between trusting to his own judgement and profiting from examples that have been tried and tested. Vespasiano stresses the importance of education and training, both as gained in practice serving under senior generals and as learnt from studying exemplary soldiers such as Hannibal and Fabius Maximus.

Federico's rise to social prominence among rulers throughout the penin-
sula, which gave him his power, is attributed by Vespasiano to Federico's
keen sense of strategy and unflinching self-control. According to the biogra-
pher, the crucial qualities needed beyond sheer force to negotiate relations
between states are circumspection, theoretical knowledge and the ability to
seek solutions in consultation. Federico possessed the wisdom, he con-
cluded, to preserve unity and to serve the wider cause of *pax italica*.

In discussing Federico's learning, Vespasiano dwells on the vastness of
the palace library and notes in passing that most of the manuscripts have
been provided by himself. The major texts in philosophy, the writings of
the Church fathers, theologians and humanists are all to be found there,
he claims. Like other humanists Vespasiano hardly distinguished between
ancient and Christian writers, treating them as one exemplary body of
scholarship from which Federico took his bearings. The texts covered an
immense historical range, from Homer and Maecenas (the exemplary patron
who lived during the reign of Emperor Augustus) by way of Dante and
Boccaccio to the duke's own contemporaries.

The library is only one aspect of Federico's patronage; Vespasiano also
refers to his ecclesiastical foundations and his palaces. He also notes the
scholars and artists in attendance at court. A special mention is given to
Justus of Ghent, mainly in connection with Federico's great appreciation
of the technique of oil painting, which had not yet been mastered by Italian
painters.

ALTARPIECES AND COURTLY AUTHORITY

Like the wealthy merchants of the republican city-states before him, the
Duke of Urbino consolidated his position by gaining influence in the
Church. An important part of Federico's patronage was taken up with
rebuilding numerous churches and monasteries within his realm. Within
the holy edifices he imposed a new design distinctively his own, emphasizing
his presence still further in the arms and portraits displayed and by the
choice of saints to be depicted[27]. Courtiers emulated their duke in giving
similar commissions, just as the Medici had led the way for numerous others
of their faction. Akin to the images in Florentine churches, altarpieces in
Urbino and the surrounding area, too, bore portraits of the duke's circle at
prayer[28].

Justus of Ghent was commissioned to paint a large square altarpiece, the

55. Justus of Ghent, detail of *The Last Supper*, with Federico da Montefeltro, 1472–4; Galleria Nazionale delle Marche, Urbino (photograph Alinari)

predella of which had already been produced by Paolo Uccello[29]. On this predella, which was to form part of a retable for the Corpus Domini confraternity's high altar, Uccello had depicted the commotion caused by the miraculous bleeding of a holy wafer viewed by doubting Jews[30]. The Florentine returned to his city in 1469 without having done any more work on the altarpiece. Shortly before this, Piero della Francesca was given travelling expenses by the painter Giovanni Santi, the father of Raphael, to come and inspect the uncompleted altarpiece with a view to finishing it, but other commissions intervened. The work was left for Justus of Ghent.

Federico da Montefeltro apparently helped subsidize the completion of this altarpiece. Justus's panel shows Jesus performing the ceremony that is to become the Eucharist at the Last Supper (see fig. 55). The bread and a chalice for the wine are on the table before the disciples, and a richly dressed bearded figure turns aside from the ceremony[31]. The five figures on the right are not from the Gospel, however; they are Federico da Montefeltro, a wet nurse with Federico's newborn son Guidobaldo and two courtiers engaged in a dispute. The duke makes a gesture of disapproval directed at the bearded man, thus avowing his loyalty to the Christian Church.

Piero della Francesca's *Flagellation* also refers to Jesus's enemies, though in a different way (see fig. 56). Inscribed on the frame of this picture were the words 'CONVENERUNT IN UNUM', a phrase deriving from the Old Testament prophecy of the earthly rulers who will turn against the Lord and his anointed[32]. The fulfilment of this prophecy as described in the New Testament is related to Pilate, the Roman procurator of Judaea, and Herod, the local Jewish ruler[33]. Together with the high priests these two are the key figures in the trial of Jesus; when the trial was commemorated on Good Friday, the canons took the second psalm, from which this text derives, as their refrain.

The curious figures in the right foreground are probably not contemporaries of the patron, as has often been suggested[34]. Given the biblical source of the Flagellation, once one takes the related psalm together with the New Testament passages and the liturgical verses concerned a more plausible identification of these unusual foreground figures emerges. The man on the left is probably Pilate, in the middle is Christ as a young anointed king according to the prophecy in Psalm 2, and pictured on the right is Herod Antipas, who was reconciled with Pilate on the day on which Jesus was condemned to be crucified. Pilate is depicted twice more in this panel: in the far left background on his judge's seat, and again standing before the soldiers with their scourges.

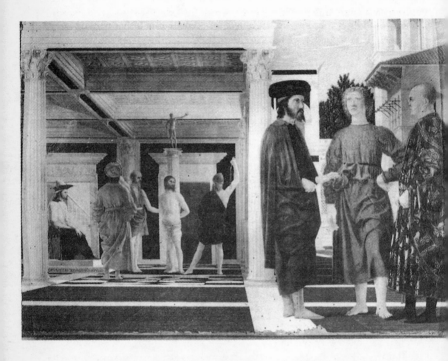

56. Piero della Francesca, *The Flagellation*, *c.* 1474; Galleria Nazionale
delle Marche, Urbino (photograph Alinari)

Images of the flagellation of Christ almost never appeared as independent works[35]. They generally constituted one element in a series of images showing the life and Passion of Christ. The dimensions of Piero's panel correspond with those of the larger type of predella panels that became common around 1470[36]. Piero's *Flagellation* probably belonged to the predella for a polyptych designed for the high altar of Urbino Cathedral, the interior of which was restructured at the behest of Federico da Montefeltro[37]. (The choir of the new cathedral apparently figured in Federico's plans as a possible burial place, but in fact it was decided after his death to construct a memorial tomb in the newly renovated S. Bernardino monastery outside Urbino[38]. At the same time plans were made for a free-standing monument in the palace gardens)[39].

Federico also ordered a votive portrait for an altarpiece from Piero della Francesca now known as the *Brera Madonna* (see fig. 57)[40]. It shows him clad in a suit of armour, kneeling before the Virgin, saints and angels in a spacious church interior. Francesco di Giorgio Martini, who took charge of the design and interior arrangement of the cathedral (and the palace) of Urbino, did so in accordance with the style recently introduced by Alberti. There is a strong resemblance between the background architecture and the way in which the figures, furniture and clothing are painted in the two panels, the one showing the *Flagellation* and the other a votive portrait. Moreover, the theme of the predella – Christ's Passion and Resurrection – links up with the Christ child and the ostrich egg, symbolizing his Incarnation, in the portrait[41]. These observations tend to support the hypothesis that the two panels were designed as parts of one polyptych.

This hypothetical reconstruction of the memorial painting with a predella is compatible with a date of around 1474. At that point Federico da Montefeltro's patronage reached a decisive stage in its development; it was only after 1472 that his commissions – from illuminated manuscripts to buildings – came to radiate *magnificentia*. On the wall of the palace courtyard he had his titles inscribed in classical capital lettering: ECCLESIAE CONFALONIERIS and IMPERATOR ITALICAE CONFEDERATIONIS, followed by the emblems signifying his virtues in both ecclesiastical and secular functions: from vigilance to dignity and from martial prowess to the love of peace. Rather than FEDERICUS COMES or F.C. the initials he used after receiving the dukedom were F.D., or FE DUX.

Given Federico's birth as a bastard of Ghibelline ancestry and his function as a *condottiere* in the service of the pope, it was of immense political

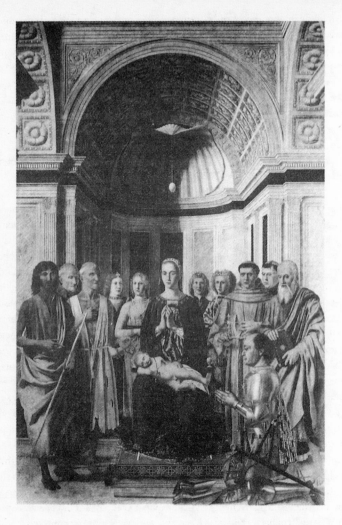

57. Piero della Francesca, *The Brera Madonna*, *c.* 1474; Galleria Brera, Milan (photograph Alinari)

importance that he should express his loyalty to the Church, especially because his legal status, until the 1470s, was quite vulnerable. This explains why he chose to present himself in the Corpus Domini altarpiece as a ruler who repudiated Judas, the Jews and all those who denied that Christ was the Messiah. On the altarpiece by Piero della Francesca, the Signore appeared in the main panel as *Miles Christi* (the soldier of Christ), kneeling in armour, in stark contrast to the *reges terrae* (kings of the earth) shown in the predella, who had turned against Jesus. Thus arose a coherent sacred presentation of the successful regional overlord in the service of the Pope.

MAGNIFICENT MANUSCRIPTS

Federico's attainments also found ample visual expression in his palace. His manuscript of Petrarch's songs, sonnets and *Trionfi* was embellished with his own insignia. After the portrait of Petrarch comes the image of a procession of four ceremonial carriages drawn by horses and unicorns, with figures alluding to the triumph of charity and chastity, life and glory. The front-ispiece miniature of Filelfo's translation of Xenophon's *Cyropedia* depicts Federico da Montefeltro riding towards Cyrus, King of Persia; the scholar–king addresses the Duke of Urbino from his throne. In another picture, Federico appears in velvet robes beside an erudite humanist. This particular miniature was pasted into the *Disputationes Camaldulensis*, a treatise on the active versus the contemplative life, which bore a dedication to Federico[42].

Many other types of images appeared in the duke's manuscripts. Federico ordered town views of Florence, Volterra, Rome, Venice, Jerusalem and Alexandria. There were medallions containing the portraits of generals, too, thus placing the Signore of Urbino in the tradition of imperial rulers[43].

After Federico acquired the title of duke greater care still was bestowed on his manuscripts. They were copied in the regular handwriting of the humanists' calligraphy, they were more elaborately illluminated and more beautifully bound. Decorative motifs in the margin that had in earlier volumes been no more than simple pen and ink drawings evolved into detailed figurative images, and the artists who did such work drew freely on examples from antiquity. Every aspect of the work was refined upon, including graphic design, and the finished products were luxurious as none had been before. With his manuscripts, that were indeed often proudly

prefaced by the phrase *in hoc ornatissimo codice*, Federico earned a reputation as a bibliophile without peer[44].

An extensive repertoire of aristocratic symbols was incorporated into these illustrations. In 1474 a new crown appeared above the family escutcheon with its blue and gold stripes and the crowned eagle. Accompanying it were the crossed keys that symbolized the command of the papal forces. There were many other additions to these insignia: the crane with a stone in its claws representing vigilance; an exploding shell in token of military strength; the olive leaf of peace; the laurel wreath of glory; the ermine and garter signifying decorations received from the kings of Naples and England; and finally the firestone, halo and the ostrich with its egg. Interspersed among such symbols were numerous mottoes[45].

The manuscripts reflected both the duke's scholarship and his aristocratic attitude. A signal instance is his possession of a splendid copy of the treatises of Sixtus IV, in which the duke's insignia appear beside the pope's portrait. This is a text on the Eucharist, comprising a disputation between scholars ranging in time from Aristotle through the Church Fathers up to fourteenth- and fifteenth-century theologians[46].

PORTRAITS OF PRINCES AND SCHOLARS

Soon after 1465 the process began of incorporating Count Antonio's old castle, together with several houses, into a new palace that was unparalleled in size and splendour. By around 1474 a cohesive machinery of patronage had evolved centring on the civilized ruler and his court.

From the courtyard a large staircase led to the throne hall, which was decorated with tapestries, paintings and relief work. This hall gave access to a smaller judicial chamber, the state bedchamber, the duke's study and, on a lower level, the *Cappella del Perdono* with a *Madonna* and the *Tempietto delle Muse* with images of the nine muses and Apollo[47].

Personages and emblems seen in Federico's manuscripts also appeared on the palace walls. Federico had the panelwork of his study embellished with images in intarsia, representing the theological virtues, allegories of concord and peace, the liberal arts, compasses and astrological measuring instruments, timepieces, musical instruments and books. The duke himself was portrayed as a scholar, although an array of attributes – armour, sword, general's staff, spurs and helmet – allude to the active military career he had left behind him.

Above the wainscot, in 1474, Justus of Ghent painted his panels of 'Famous Men'[48]. The lower row was devoted to Old Testament lawgivers, Church Fathers and theologians, the upper row to jurists, astronomers and poets. The emphasis was on famous Italians, including four contemporaries of the patron: Vittorino da Feltre, Cardinal Bessarion, Pius II and Sixtus IV (see figs. 53 and 54).

A crucial element in the palace decorations is the portrait of the duke with his son. Federico is shown seated in his study wearing armour, with the order of the ermine around his neck and the order of the garter around his outstretched leg. He is reading a large manuscript; the other volume of his Bible is in view on a lectern. Also portrayed is Guidobaldo, Federico's legitimate son, heir and successor to the ducal throne. Guidobaldo is being brought up with examples of both the active and the contemplative life – classical heroes and Christian scholars – to guide him (see fig. 52). The young prince stands richly arrayed, sceptre in hand, beside his experienced father.

There is a comparable portrait of Guidobaldo – also painted in oils by Justus of Ghent, and similarly displaying the insignia and honorary titles of the duke – that shows him listening with his father to a lecture being given by one of the courtly scholars. A series of panels by the same artist is devoted to the liberal arts; Federico is shown kneeling before the enthroned female personifications, first as a young prince and in the last panel as an old man (see fig. 58). Portraits of the duke pervade the palace[49]. Piero della Francesca twice portrayed him with his wife[50]. The couple is depicted on two double-sided panels, possibly originally fashioned as cupboard doors[51]. Federico is shown here in a triumphal chariot, in exactly the same armour as in the portraits in his study and on the altarpiece, and seated in a movable chair, or faldstool, which is upholstered in red and resting on a gold-coloured platform (see fig. 59). A winged woman on a globe, representing Victory, places a crown on his balding head. The duke points with his sceptre to the personifications of the four cardinal virtues seated before him on the red carpet: Justice, with her sword and scales, Wisdom, with a mirror, Fortitude, with a broken column, and Temperance. Opposite Federico's triumphal chariot is another, drawn by unicorns; in it sits his wife, Battista Sforza, who holds a prayer-book in her hand[52]. Around her stand the three theological virtues of Faith, Hope and Charity.

Below each of the triumphal chariots is an inscription in flawless Latin. The one accompanying the duke reads 'He rides illustrious in glorious triumph – he whom, as he wields the sceptre in moderation, the eternal

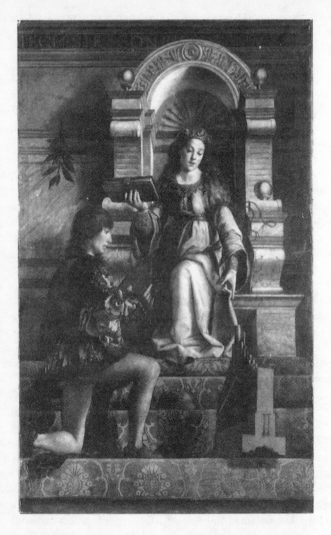

58. Justus of Ghent, *Music*, 1477 (photograph National Gallery, London)

fame of his virtues celebrates as equal to the greatest generals.' His late wife's inscription reads 'She who observed self-restraint in success flies on all men's lips honoured by the praise of her great husband's exploits'[53].

The scenes shown here form one whole. For this reason, and given their subject-matter and inscriptions, the Triumphs are likely to have been the front of the panels and not the back, as is generally assumed; the representations on the other side of the panels, in contrast, are not well aligned. The panels may have been the shutters or doors of a closet in which the ducal insignia were kept, rather in the nature of a secular reliquary.

The triumphal scenes accord entirely with the civilized and virtuous rule that courtiers and other princes associated with Federico and Battista. The legitimate basis of the duke's authority is represented by crown and sceptre, and his territorial claims by the landscape: painted behind the lord and his lady are the lands of the state of Urbino over which Federico da Montefeltro had dominion.

On the inside of the panels, as a complement to Federico's military triumphs, Piero painted images suggesting the more contemplative life he and his wife led at court (see fig. 60). In the palace the duke was able to devote himself to culture, thanks to the pacification he had achieved as a general and the riches this profession had brought him. The lands of Urbino are again shown in the background, in which Piero incorporated fortresses built by the duke. The painter has also included ships at sea, illustrating the expansion of what was once a modest little county in the hills into a famous dukedom extending as far as the Adriatic.

COURTLY PATRONAGE

A comprehensive repertoire of overlapping images developed in Urbino around 1474 centring on the duke. Around Federico himself, his wife and legitimate son were ranged: symbols of his rule such as the throne, triumphal chariot, general's staff, sceptre and crown; decorations, orders of chivalry, emblems and mottoes; administrators and diplomats at his court; other rulers; Greek and Roman generals and Christian scholars exemplifying the two chief aspects of sound administration; personifications of the liberal arts, Muses and virtues; and the duke's domain with its cluster of castles.

Most of these elements had been represented before, in commissions given by popes, emperors and kings[54]. It was new, however, for such symbols to be appropriated by a less exalted ruler, and new for the entire

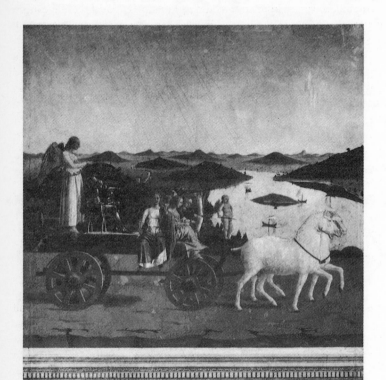

CLARVS INSIGNI VEHITVR TRIVMPHO ·
QVEM PAREM SVMMIS DVCIBVS PERHENNIS ·
FAMA VIRTVTVM CELEBRAT DECENTER ·
SCEPTRA TENENTEM

59. Piero della Francesca, *Federico da Montefeltro on triumphal chariot*,
c. 1474; Galleria degli Uffizi, Florence (photograph Alinari)

set of princely symbols to be thus refined and systematized[55]. Because Urbino itself possessed no tradition of images for him to draw on, Federico took his examples from rulers with an established tradition of patronage.

Another source of inspiration could be found in pictorial representations of public authority in town halls. For instance, paintings in the town hall of Sienna showed the commune's territory with its castles together with personifications of virtues and the arts as well as symbols of state such as the crown and sceptre. The main difference between images in city-states and those in a courtly centre was the overriding importance to the latter of the ruler himself at the centre of government; the prince's image was pivotal to courtly representations of the state and its ideals. Artistic expressions were also aimed at different target-groups in the two types of state: courtiers and diplomats in a centre such as Urbino, as against the far broader range of citizenry in a republic.

Courtly standards of conduct, as expressed in word and image, differed from the cultures of mendicant orders and republican cities. Outward display on the part of individuals gradually gained general acceptance without the rule of self-restraint being relaxed[56]. The virtues of self-possession and moderation were fused with standards of refinement and *magnificentia* to produce features characteristic of aristocratic patronage: personal ostentation and the tasteful accentuation of different levels of power[57].

At the centre of courtly patronage was the palace, where information was recorded and exchanged. Scholars, architects and painters were all engaged in elaborating ideas on the civilizing function of paintings in palaces, applying what were in the first instance ecclesiastical views to the most secular of surroundings. Thus arose, between 1450 and 1600, a complete set of paradigms determining the most suitable images for each type of hall and chamber within the palace according to its function and the people who would frequent it. Whereas chapels should naturally be decorated with devotional images, public reception halls required pictures that would move those who looked upon them to strive for virtue in council and heroism in the field. For rooms looking out on the garden and private rooms in villas were prescribed lighthearted paintings, perhaps of an erotic tint[58]. For each room and each pictorial theme, Cortesi specified the civilizing effect achieved by different types of images. It was his belief that palaces that were beautifully designed and magnificently executed so impressed the people that the likelihood of rebellion was greatly reduced[59].

The tendency towards aristocratization was one phase in the many-stranded process of civilization. The growth of courtly culture, unlike the

60. Piero della Francesca, *Battista Sforza and Federico da Montefeltro*,
c. 1474; Galleria degli Uffizi, Florence (photograph Alinari)

culture of the friars or the republics, did not move unreservedly towards ever-stricter controls on behaviour. Asceticism, with its far narrower social range, was prized less fervently at court than in the other two cultures. Indeed, there was an increased emphasis – for the few – on ostentation, elegance and extravagant expense. This development prevailed, in the main, in population centres previously marked by a relatively low level of civilization and state organization. Rulers would set themselves up as focal points of a court, vying with each other for the most impressive and elegant forms of display, and the social pressure to evolve a personal style increased. In order to command and hold power in the network of courts it was essential to be a magnificent Maecenas. The courtly princes sought to explore every avenue of patronage to strengthen their position – a desire that was equally to the advantage of painters.

PROFESSIONALIZATION AND COURT PAINTERS

One of the painters who benefited from the rapid growth of patronage at Urbino, receiving a number of commissions from the court, was Giovanni Santi[60]. Giovanni also wrote a long ode praising the life of his patron, most of which is devoted to Federico's military and diplomatic successes. Towards the end of the poem Santi refers to a state visit to Mantua, where the Duke of Urbino, on his way to Milan, is received by the Marquis[61]. In the palace Federico admires the frescoes painted by Mantegna, who had made portraits of the Gonzaga family and their court on the walls of the Camera degli Sposi (Spouses' Room)[62]. The duke studies Mantegna's work and discusses the artist with much enthusiasm[63].

Mantegna is praised in Santi's poem for his draughtsmanship, and his imaginative powers, his sense of beauty and his use of colour, his architecture and his vistas, as well as his knowledge of foreshortening and geometry and his ability to suggest space. Santi also mentions the qualities of the leading painters of Florence and of certain court painters, including Pisanello, Piero della Francesca, Jan van Eyck and Roger van der Weyden. His praise of Gentile and Giovanni Bellini shows awareness of the rise of Venice as a centre of production[64]. With his lengthy survey of quattrocento painters Santi made a real contribution to the historiography of his own profession.

An important figure in terms of professionalization was Piero della Francesca. Piero strove to perfect detail in depicting, for instance, gold brocade mantles, precious stones and portraits, drawing on technical

improvements introduced by Northern painters such as Justus of Ghent and combining them with Italian advances in suggesting space, monumentality and composition. Piero's achievements in representing complicated images in perspective surpassed those of Masaccio, as witnessed by the tiled floor in his *Flagellation* and the church interior in the *Brera Madonna*. Piero recorded his knowledge in three treatises on, respectively, perspective in painting, geometrical figures and algebra; they were written late in life, apparently after his eyesight failed.

Increased skill, greater accuracy in historiography and the systematization of theory all went to consolidate the position of the élite among painters. But the great individual rise in status for some few court painters did not make itself felt in the entire profession; more than before, and more than in the city-states, a kind of flair was being developed that could not simply be passed on to budding new painters. Those who rose to courtly heights were beyond the reach of guilds and fraternities. This polarization had happened before, for instance in the cases of Simone Martini and Giotto, whose income, eminence and mobility had set them apart from the majority. Now, with an increasing number of courts being drawn into competitive patronage, such distinctions were drawn more sharply.

A group of painters that included Piero della Francesca, Justus of Ghent and Giovanni Santi became men of position and of property; Piero had a fine house built in Borgo San Sepolcro, and Santi owned a mansion in Urbino. Mantegna received a letter from Lodovico Gonzaga in 1458 inviting him to work in Mantua[65], and he accepted the offer, acquiring the highly esteemed position of court painter[66]. During the visit of Emperor Frederick III to Ferrara in 1469 Mantegna was elevated to the nobility – an honour he shared, among other painters, with his brother-in-law Gentile Bellini[67]. Mantegna was also a propertied man, spending rather beyond his means, however, on a beautifully designed palace and a fine art collection[68]. He also founded a funerary chapel in S. Andrea in Mantua, which he decorated with his own work[69].

Court painters shook off the trammels of the guild, and often gained exemptions from paying contributions not only to the guild but also to civic taxes. The important role played by guild and civic institutions in Sienna, Florence and Venice was far less in evidence in most princely residences. The occasional dispute between a court painter and the guild did arise, but the court generally had such an unquestionable ascendancy as to preclude conflict[70].

Painters who were in great demand were far less dependent on clients

and advisers than were their fellow-artists. In some cases a client's desire to procure a work from a particular famous painter took precedence over the desire to prescribe the subject, as we can read in the correspondence between painters, advisers and Isabella d'Este[71].

The cinquecento produced certain notable instances of such singular marches to fame: Leonardo da Vinci and Michelangelo of Florence, the Venetian Titian and − of particular importance in the present context − Raphael, the son of Giovanni Santi[72]. Raphael received his training in and around Urbino, executed commissions in Florence, and in Rome the architect Bramante presented him to Pope Julius II. As a young painter he was one of a group commissioned to decorate several new apartments in the pope's palace. In 1509 the pope decided to send all the others home and entrusted the entire project to Raphael, appointing him *scriptor brevium*, a courtly office[73]. Raphael worked at court as painter, architect and organizer, and in his multi-faceted role he acquired great esteem[74].

Among those writers whose authority brought fame to patrons and painters alike was Castiglione. The conversations in *The Courtier*, his standard work on courtly behaviour, show painters such as Apelles, Mantegna, Leonardo da Vinci, Giorgione, Michelangelo and Raphael conversing as professionals on equal terms with popes and princes. In the pages of Castiglione's book, Raphael is depicted as an exemplary courtier[75].

2. The pope as statesman and patron

THE PAPAL STATE IN EUROPE

On 25 September 1506, Julius II (1503–13) entered Urbino in high pomp. The occasion marked a stage in the annexation of Urbino by the Papal State in the course of the pope's Bologna campaign. Julius and his twenty-two cardinals were met by twice that number of mounted nobles, who presented him with the keys to the city[76]. Guidobaldo da Montefeltro, who had married a niece of Sixtus IV in 1474, had commanded the papal forces since 1503. Himself childless, Guidobaldo cemented the special alliance with the Vatican by adopting one of Julius's nephews, Francesco Maria della Rovere (1491–1538), and making him the legitimate heir to the ducal throne[77]. Francesco's father, Giovanni della Rovere, had been a prefect of Rome, and after Giovanni's death in 1508 the annexation of Urbino was further consolidated by the institution of a three-pronged office: prefect of Rome, duke of Urbino and commander of the papal army. The once sovereign dukes of Urbino became courtiers of the pope.

The taking of Bologna in November 1506 was commemorated by an ode to Julius II and his family, the text of which was accompanied by a miniature celebrating his triumph (see fig. 61)[78]. This illustration was conceived in a similar vein to Piero's painting described above in connection with Federico da Montefeltro's triumph thirty years before. Portrayed on the chariot, however, were not personifications of virtues, but members of Julius's family; judging from the text and title page these are probably Giovanni della Rovere and – wearing the armour of ancient Rome – Francesco Maria della Rovere. The commander of the Swiss Guard, the pope's professional bodyguard, walks beside the chariot, with prisoners-of-war and a knight in ancient armour. He carries a flag displaying the Della Rovere arms – a golden oak on a blue ground (*rovere* being Italian for 'oak tree') – together with the papal insignia.

Forces did gather to counter the expansion of the Papal State towards Urbino, Rimini, Bologna and Piacenza, the aristocrat–rulers of the cities

seeking support from such powerful states as Venice, France, the Empire and Spain. In 1494 King Charles VIII of France had conducted a successful Italian campaign, much commemorated in word and image[79], and consequently Milan was held by the French and so, temporarily, was Naples. In Bologna the Bentivoglio family made a bid to regain power in 1511, and with French support they were able to spark off a rebellion in which Michelangelo's statue of Julius representing him as sovereign was destroyed as an act of defiance. This statue, together with medallions Julius had put into circulation showing him as a liberator and peacemaker, was among the means he used to publicize his sovereignty over Bologna[80]. Charles's successor Louis XII, who had been the pope's ally up to 1509, shifted his allegiance and opposed the Papal State, lending his support to a General Council – formally empowered to remove a pope from office – directed against Julius; the assemblies concerned were held in Milan in 1510 and Pisa (once again under Florentine rule since 1509) in the following year[81].

From the early cinquecento onwards both warfare and diplomacy were conducted on a larger scale. Two great alliances confronted each other, the one under the pope, the other led by the king of France. Urbino, Bologna and Milan were consumed in an ongoing process of state formation, and of the Po valley cities only Ferrara and Mantua retained a qualified sovereignty in which they were heavily dependent upon larger political entities. Small states gradually lost their dual monopolies of taxation and the exercise of force within their realm as their diplomacy, armies and administration were absorbed by larger powers. They relied increasingly upon France, Spain and the Empire. Though both Rome and Florence expanded, they became more and more dependent on the great states beyond the Alps as the century progressed. Both war and diplomacy had the effect of strengthening ties between states[82]. Despite outward differences between republics, principalities and lands under papal rule, in many ways the forms of government developed along similar lines. At the same time ecclesiastical institutions became more and more closely linked with the states in which they operated[83].

Within these new constellations there was also a continuing shift of emphasis in the role played by the pope; the pontiff became more and more the statesman and even the great military commander. Julius II fulfilled his office as a secular leader without renouncing his claims to sacred authority. On the contrary, his status as the Vicar of Christ and successor to St Peter gave his position as head of state all the more substance. Financially, too, the pope's position had two mainstays: ecclesiastical taxes on the one hand

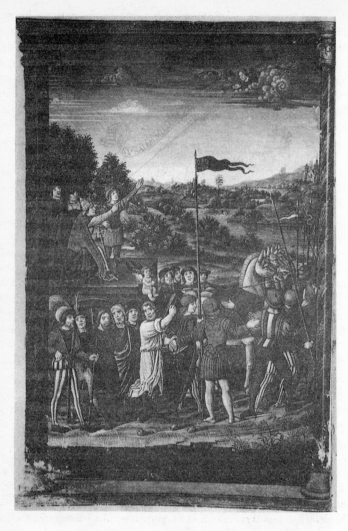

61. *Julius II in Triumph*, 1508 (photograph Biblioteca Apostolica
Vaticana, Vaticanum latinum 1682 fol. 8v)

and secular taxes imposed throughout his state on the other. This was a significant factor where patronage was concerned; like other generals, and indeed bankers, who became great patrons of art, the popes drew freely on external funds, which enabled them to have major commissions executed in a short space of time.

As a corollary to the secularization of the papal office came a clericalization in the papal court. Courtiers who were to act in the capacity of diplomats or advisers to the pope were obliged to take orders and to be made bishops so that they might be created cardinals. The popes themselves had gone through the same rites of passage.

Both Julius II and Leo X were concerned to have texts and images produced that recorded the changes that had taken place in the papacy – changes that did not go uncriticized[84]. In ceremonial terms the papal court became the hub of diplomatic relations in Europe; it was at Rome that the prevailing hierarchy among European rulers became visible[85]. Indeed, the order of precedence within particular courts and among states was often clarified as a result of a conflict about precedence at Rome[86]. In politics and economics the papal court remained highly influential; in culture and art it set the tone. As social changes occurred they left their traces in theatre, music, literature, art and architecture. It was in this context that Raphael and Michelangelo achieved renown as the greatest among artists.

THE NEW ST PETER'S AND THE JULIUS MONUMENT

The patronage of Julius II is famed for its magnificence. He began to give artistic commissions while still a cardinal, but it was after his election to the papacy that his patronage acquired especial grandeur[87]. Among his courtiers and visiting diplomats Julius II was held up as unequalled by any other patron of art, past or present[88].

The changes in the papacy had drastic repercussions upon the church of churches and its place in Rome. Julius II gave orders for the old St Peter's to be demolished and rebuilt on an altogether grander scale. Paris de Grassis, the pope's master of ceremonies, remarked that this earned the architect, Bramante, the nickname 'Bramante ruinante'[89]. For over twelve centuries St Peter's burial church had been a cathedral catering largely for its papal liturgy and its pilgrims. Now it became a monument for Church and State in Europe – a pontifical state monument with a huge dome, with an equally imposing palace beside it[90].

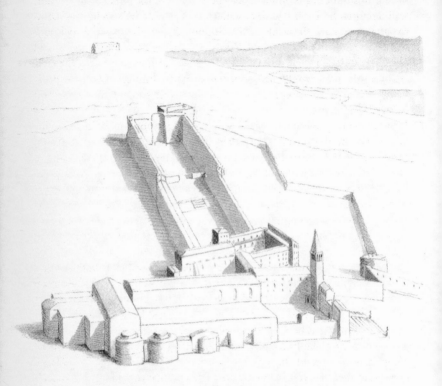

62. The old St Peter's, Vatican Palace and Belvedere, *c.* 1510 (drawing
Bram Kempers)

There was an immense surge of activity in both building and painting during this pontificate. Julius II had new ceremonial flights of steps built, leading from St Peter's to the Vatican Palace. Michelangelo was commissioned to paint the vault of the Sistine Chapel, the papal chapel constructed under Sixtus IV, whilst Raphael decorated the pope's living and working apartments[91]. Julius had a loggia added to the wing facing the city. Between the palace and Villa Belvedere, built by Innocent VIII, the great *Cortile Belvedere* appeared, a spacious court with gardens, fountains and statuary (see fig. 62).

Signs attesting to papal dominion appeared far beyond the Vatican. Julius had a straight road (Via Giulia) laid between the old bridge at Castel Sant'Angelo, the imperial mausoleum converted into papal citadel, and the Ponte Sisto, the bridge built by Sixtus IV. By this road he had two great palaces erected to house the financial and legal departments of the Papal State, both of whose budgets and staff had multiplied in recent years. As Rome underwent countless renovations the Vatican complex came to dominate the city, quite overshadowing older administrative centres like the republican Capitol and the Lateran palace.

The expansion of the Papal State and the shift of emphasis in the pope's role found expression in Julius's planned tomb, which not only outdid by far his predecessors Sixtus IV and Innocent VIII, but also would have outprinced most princes[92]. Sixtus IV, Julius's uncle, had been buried in a freestanding monument bearing a recumbent effigy of himself, housed within the canons' choir he had commissioned. More startling still, Julius opted completely to rebuild the church, reserving for his burial place a large portion of the presbytery close to the high altar marking the spot at which St Peter himself was assumed to have been buried[93].

The designs for the mausoleum comprised a vast free-standing tomb, the height of a man, surrounded on all sides by statues. The decorations were to consist of putti, narrative scenes and some forty figures; at the four corners would be St Paul, Moses, and allegorical figures representing the active and the contemplative life. Scenes below would refer to just administration, the subjection of various regions, the sciences, the liberal arts and the virtues of good government. The statue of the pope above would show him enthroned on his gestatorial chair (a portable throne) and wearing the papal tiara, making the gesture of benediction[94]. Michelangelo completed the designs but only partially executed them, adjustments made to the original conception occasioning many disputes with the pope and his descendants[95]. After Julius's death the more modest plan was approved of a

63. Raphael, *School of Athens*, 1509; Stanza della Segnatura, Vatican
Palace (photograph Anderson)

wall-tomb with Moses as the main figure, the diminished whole being consigned to S. Pietro in Vincoli.

One project whose completion Julius did witness – unlike St Peter's or his own grandiose monument – was the renovation of two Stanze, rooms within the Vatican Palace used for working: the Stanza della Segnatura and the Stanza d'Eliodoro. The former served as a study, and the pope had a small library and a desk there. In the Stanza d'Eliodoro (of Heliodorus) he could grant an audience to envoys, who would enter the palace by St Peter's and present themselves in the ceremonial rooms between the Sistine chapel and the Stanze[96].

Ambassadors and courtiers were among those who regularly came to the Stanze[97]. A larger adjoining room, the Sala di Costantino, was frequented by the same circles, but on more ceremonious occasions[98]. The decorations in this suite formed a comprehensive whole. Julius II (and from the beginning of 1513 Leo X), in consultation with various advisers and painters, here devised a contemporary version of the long-established symbolism of ecclesiastical civilization and pontifical authority that would edify visiting dignitaries[99]. Choice of subject-matter and mode of elaboration were both partly determined by events of the day. Thus the struggles attending the gradual consolidation of the Papal State not only affected the mutual relations between the pope, other heads of state, cardinals and courtiers, but also to a great extent determined the images – extensive and detailed – in which all such interdependencies were given visual expression.

CHRISTIAN IMAGERY AND THE *SCHOOL OF ATHENS* (1509)

Vasari gives a lengthy account of the commissioning in the Vatican Palace[100]. He names the various rooms according to their decorations, and lavishly praises Raphael, the artist responsible for the later work in the Stanze, for his sense of proportion and his command of perspective, for his *dolce maniera* (sweetness of style) and for his ability to design complicated scenes involving numerous figures. Julius himself had been so enamoured of the first of Raphael's frescoes, the one now known (misleadingly) as the *School of Athens*, that he had decided to put the supervision of all the work being done into the hands of this painter (see fig. 63).

Vasari's dating of the *School of Athens* and his interpretation of it as a Christian scene are generally swept aside. There are insufficient grounds to deal so cursorily with his views, however. Vasari was, after all, acquainted

64. Raphael, *Disputa*, 1511; Stanza della Segnatura, Vatican Palace
(photograph Anderson)

with many who advised Julius II and his Florentine successors, and he also knew some of Raphael's pupils. In 1532 Vasari obtained permission to visit the Stanze and to make drawings there while Clement VII was staying in his country residence. Several of these drawings have been preserved. All things considered, the suggestion often repeated that Vasari confused the *School of Athens* with the *Disputation concerning the Blessed Sacrament* (or *Disputa*), the title by which Raphael's other great fresco in the Stanza della Segnatura is known, would seem far-fetched (see fig. 64).

According to Vasari, the *School of Athens* shows how astronomy, geometry, philosophy and poetry can be reconciled with each other by theology. This ideal of integrating all knowledge occupied a central position in the voluminous treatises produced by the Roman humanists at the court of Julius II. The interpretation of classical thought as undertaken by Vigerio, Cortesi and Egidius of Viterbo was couched in terms used by the Evangelists, Church Fathers and theologians; these humanists effectively plucked *spolia* from the ancients that could be incorporated into a new intellectual edifice lit by divine grace.

In the left foreground, states Vasari, the Evangelists are clarifying texts by philosophers and other secular scholars that angels have brought them and are reconciling them with Christian revelation. The apostle Matthew is mentioned by name. Given later paintings of Matthew, also showing an angel, and given the stone on which this figure rests his foot, this identification is entirely plausible. The stone is a biblical motif with a rich exegetical tradition, and it identifies the figures in the foreground as biblical characters. Furthermore, as this was the pope's study, containing a collection of manuscripts in which the Gospels play a particularly important role, the absence of any images of the Evangelists themselves would appear almost sacrilegious. Finally, the slate held up by Matthew, which displays musical chords, refers to the notion of creating harmony between diverse intellectual traditions, as expressed by Vigerio in a musical metaphor.

Raphael elaborated the biblical motif of the foundation stone and cornerstone on which the Christian Church is built by including a grand temple in the background. This not only served to increase the suggestiveness of space, but also constituted an allusion to the new St Peter's as a symbol of the Golden Age which Julius II was felt by his courtiers to have brought about.

Continuing the integration of profane figures into a theological scheme, Raphael painted the *Parnassus* with its poets and Muses on the adjacent wall. During the winter of 1510–11 work on the decorations came to a

halt, as Julius was obliged to conduct a second campaign to Bologna[101]. It was also at this time that he had to defend his actions against the *conciliabulum*, as Julius derisively named General Council of Pisa[102]. He countered the propaganda offensive being waged by his antagonists by unleashing one of his own with a wealth of pamphlets and treatises[103]. He also decided to convene a Council himself in the Lateran, though he viewed the event with some trepidation[104]. Following his return from Bologna in June 1511, this Fifth Lateran Council was announced[105].

POLITICAL PROPAGANDA, 1511–12

Julius's humanists opposed the view that a General Council could possess the highest authority, and the pope strengthened his own position by creating a number of loyal cardinals. He was troubled both by the threat of schism within the Church and by the antagonism of the Roman nobles. While Louis XII propagated the *conciliabulum* of Pisa and forbade French clerics to visit the papal court, pro-French cardinals fled Rome and joined the French king.

The air of drama surrounding Julius at this time is graphically conveyed by a chronicler who relates that the pope 'let his beard grow in token of vengefulness, insisting that he would neither cut nor shave it until he had driven Louis, King of France, out of Italy'[106]. It fell to prominent courtiers to make speeches and to write pamphlets, letters and dissertations in defence of the pope's position. They argued that it was the Council of Rome rather than that of Pisa that was legitimate, and that the pope was not accountable to any Council but only to God[107]. Julius II and his diplomats tried to win a maximum of allegiance from diverse quarters, successfully wooing in turn numerous bishops and generals of religious orders and certain of the Italian republics and principalities. By the winter of 1511–12 they had also secured the support of the kings of Spain and Scotland, the Swiss and the German Emperor, who had originally sided with Louis[108].

This more felicitous turn in the pope's fortunes was duly registered; in his diary entry for 10 April 1512 the Venetian diplomat Sanudo noted that 'the pope has had his beard cut and shaved, as he sees things are changing for the better'[109]. The decisive action in military terms was the Battle of Ravenna, which wrought carnage on both sides. On 27 June the victory of the papal forces was celebrated with a triumphal procession into Rome,

since the French had been driven from Italy, as the papal master of ceremonies remarked with satisfaction[110].

In 1511 Julius's courtiers intensified his political programme, presenting their pope as the preserver of peace, security, justice and liberty and the enemy of tyrants and barbarians, schismatics and warmongers. They emphasized the link between the pope's roles as leader of the Papal State and head of the Christian Church. The pope was Christ's representative on earth; this was expounded in texts and in the papal liturgy before the high altar at St Peter's and St John Lateran. During processions in Urbino, Bologna and Rome it was also given ritual expression, the Host being raised and carried beneath a canopy as an emblem of the papacy. Another setting shrewdly exploited for its propaganda potential was the Fifth Lateran Council. For the grand assembly – *Curia*, bishops and generals of the orders, the ambassadors and heads of state and the officers of the council – the pope's master of ceremonies and architect designed a council hall in the nave of the Lateran that emphasized on the one hand their mutual ties and on the other each hierarchical distinction[111]. In his diary the master of ceremonies noted that in performing this task he had referred to numerous sources, 'whether written, in the form of buildings or in pictorial images'[112].

LAWS, POWERS AND IDEALS:
DISPUTA AND *JUSTICE* FRESCOES

Image-building was not only a matter for the master of ceremonies, architect and scholars; the court painter Raphael was also deeply involved. Two walls of the Stanza della Segnatura still remained to be painted, and existing designs were adjusted to reflect the changed circumstances. The point was to devise images that portrayed Julius II unambiguously as autonomous lawgiver, sovereign head of state and unchallenged head of the Church, and to this end Raphael painted numerous uncommon scenes that highlighted key elements of the symbolism of the Papal State.

There was a certain fund of iconographic tradition to draw on: the imagery in the Lateran Palace and S. Quattro Coronati, the frescoes by Pinturicchio illustrating the exploits of Pius II and Alexander VI, the paintings already covering the other walls of the Stanze and the princely state portraits of overlords such as Federico da Montefeltro. But whatever the usefulness of these earlier images, it was not appropriate to take them without qualification as models in this new situation. In comparison to

fellow artists Piero della Francesca, Justus of Ghent and others, Raphael adopted a far more systematic approach to the symbolism of Church and State, and was better able to integrate a multiplicity of elements within one picture. He surpassed his predecessors in imagination and composition, variation, perspective and grace. It was in fact the exacting commissions given by Julius II and his advisers, at this turning-point in the history of the Papal State, that propelled Raphael into a great upsurge of artistic creativity.

Raphael's search for material also took in miniatures. A good many illuminated manuscripts were to be found in the Stanza della Segnatura itself: besides Bibles, odes to Julius II and treatises on the integration of ancient and Christian knowledge there was a particularly large collection of papal decretals and accompanying commentaries[113]. Two types of images lent themselves particularly well to the depiction of Julius's position as he desired it to be shown: scenes of General Councils and the attached ceremony of the enactment of laws[114]. The precise images that Raphael added to the first series of sketches for the remaining two walls could all be found in the legal scenes included in decretals. The additions to the earlier designs for *Disputa* encompass a free-standing altar with the Host and a large group of deliberating scholars amidst their books, set against a background of the palace, the first column of a new church and the Holy Trinity (see fig. 64)[115]. Eliminated from the initial sketches were some stones in the foreground and certain architecture in the background, both of which strongly recall the *School of Athens*[116]. For the adjacent wall, dedicated to the theme of Justice, an entirely new composition was made. Rather than the Apocalypse with St John pictured writing and Julius II at prayer it comprised images of lawgiving and the ruler's virtues. Miniatures provided models for images of a pope signing lawbooks or giving the author his benediction, with officials kneeling or standing around his throne, personifications of virtues inspiring the papal decrees and Justinian giving the imperial seal of approval[117].

At the centre of the *Disputa* Raphael painted a free-standing altar with a monstrance. White mitres are worn by three of the prelates standing to the left of the altar. The combination of these elements was characteristic of General Council ceremonies[118]. These three figures, added in the final design phase, may represent the leading ecclesiastics who supported Julius in their dissertations and in addresses to the Fifth Lateran Council[119]. At the last moment Raphael added four more deliberating figures on the far left, probably Julius's chief legal advisers, whose texts and orations

underpinned his position. Together with the adjacent scene with its portrayal of Julius himself, the group on the left gave the entire picture topical significance.

To the right of the altar a pope stands in front of a monumental plinth of a column, an allusion to the new St Peter's. This is Sixtus IV, who is mentioned in numerous odes to Julius II. The book lying before him is probably his own *De Sanguine Christi*, composed, like the fresco itself, as a disputation, a formal rhetorical structure built up of several distinct stages: declaration, negation, confirmation and response followed by a binding, universally valid conclusion and solution[120]. The theological conclusion of this work was based on the work of older thinkers who are depicted around the altar and above in heaven. They derived their ideas partly from other scholars, the most significant of whom had been portrayed in the *School of Athens*, and partly from the Divine Revelation that the pagan writers lacked. The dogmatic essence of papal ideology was expressed in the picture's central axis and in the figures above the altar; at the heart of the fresco is the Holy Ghost hovering directly above the altar and radiating golden beams all about.

On the left of the *Justice* wall Raphael painted in profile Emperor Justinian together with his jurists. Between this and Justice, shown in the vault, he depicted Strength, Wisdom and Temperance, the emphasis being on the image of Strength, who is dressed as Pallas Athene and bears a heavy branch of oak. Raphael used the oak symbolism to link the dynasty of Julius II to the cardinal virtues that were traditional symbols of good government.

The patron had himself portrayed (with the beard that had aroused so much comment) to the right of the window as enthroned pontiff, with an allusion to Gregory IX, the first official papal lawgiver (see fig. 65)[121]. Like Sixtus IV, Julius wears a cope and tiara both displaying the emblem of the acorn. Behind him, bareheaded as prescribed by the masters of ceremony, stand the two oldest cardinal deans. All the solemnities are shown in accordance with prevailing ceremonial rules[122]. Because of this, and taking other portraits into account, Vasari is certainly right to identify the two figures as Giovanni de' Medici and Alessandro Farnese[123]. Both played a leading role in papal diplomacy as legates to Bologna and Ferrara respectively, and as participants in the Fifth Lateran Council[124]. According to Vasari the cardinal behind Giovanni de' Medici is Antonio del Monte, at whose initiative the Council had been summoned. Del Monte also edited the 1521 *Acta Concilii Lateranense*. Accompanying this report was a woodcut deriving from a similar image of the Council that had been used for pamphlets in

65. Raphael, *Julius II as lawgiver*, 1511; Stanza della Segnatura, Vatican Palace (photograph Anderson)

1514. These woodcuts contain a great many elements that also occur in the miniatures depicting the Council and decrees issuing from it, and in the *Disputa* and *Justice* walls.

The same elements are described in the detailed diary kept by Paris de Grassis, the pope's master of ceremonies. He also notes where he himself stood at the Council – in the background, but close to the pope. So in this portrayal of judicial ceremony, designed to express the pope's ambitions concerning the Lateran Council, the figure shown in the background must surely be none other than Paris de Grassis.

MONOPOLIES OF FORCE AND TAXATION IN THE STANZA D'ELIODORO

The *Disputa* and *Justice* walls extolled the virtues of the papacy. Both elaborated the symbolic images of civilization that, though they had been included in the *School of Athens* and *Parnassus* frescoes, had scarcely been accompanied by any explicit reference to governance in these earlier scenes. The imagery coming into use at this time related to the war against other states, to coalitions and to Councils, and, it came to colour speeches and rituals as well as finding expression in texts and pictures.

During the preparations for the Council in 1511–12 the Stanza d'Eliodoro, where legates were received, was a splendid choice of room in which to bring Julius II's claims to authority to the attention of visiting dignitaries[125]. In four scenes Raphael highlighted the liturgical, fiscal, military and diplomatic aspects of the papacy. He also took great pains to depict accurately the insignia of the pope's courtiers, so that the frescoes also became frozen tributes to those who participated in the pontifical ceremonies of the early sixteenth century[126].

Patron, advisers and artist were all obliged, by the extreme tensions of the day, to introduce a stronger topical and political accent than was usual in the case of palace decorations. In this respect Raphael's 1511 and 1512 frescoes resembled the decorations introduced into the Lateran palace almost four centuries before. In the Stanza d'Eliodoro even more than in the Stanza della Segnatura, Raphael incorporated into his paintings historical images, current issues and political objectives that together validated the pope's authority. He gave visual form to views of past, present and future in narrative scenes that contained, both in the detail of his work and in its overall design, a great many new elements.

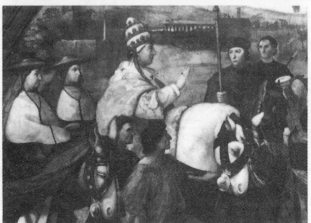

66. Raphael, Julius II in a detail from *The Expulsion of Heliodorus*, 1511–12; Stanza d'Eliodoro, Vatican Palace (photograph Vatican Museum)

67. Raphael, Leo X in a detail from *The Expulsion of Attila*, 1513–14; Stanza d'Eliodoro, Vatican Palace (photograph Vatican Museum)

The Miracle of the Mass at Bolsena, with Julius at prayer, was probably painted immediately after the work in which he appears as lawgiver (see fig. 1). The painting is based on a miracle involving a consecrated wafer that was said to have occurred at Bolsena in 1263. Legend had it that a priest from over the Alps denied the doctrine of transubstantiation; the Host bled and the priest acquired faith in the dogma propagated by the pope and therefore also in the pontiff's authority. More recent connections were Julius II's worship of relics of the blood-stained altarcloth from Bolsena in Orvieto and his carrying the Host on triumphal processions. To Julius the Bolsena relic was connected with his holy war against the heads of state beyond the Alps, and he clearly linked it to the Host he proudly bore along with him in grand processions from Rome to Bologna[127].

The prominent portrait of the bearded Julius II at prayer gave the picture greater topical interest. Chalice, candlesticks, ampullae and an icon appear on the altar. The older of the two cardinals standing behind the pope is Riario, Dean of the College of Cardinals. Behind the cardinals are two canons, while to their left are two singing acolytes. On the lower level the papal bearers (rather than members of the Swiss guard) wait with the gestatorial chair[128]. This scene corresponds to De Grassis's descrip-tions of Masses and processions. It also recalls the votive prayers of Julius II on the eve of momentous occasions such as the signing of a new treaty, his third Bologna campaign and the Lateran Council[129]. In the background Raphael once more painted a partly completed church building. In the left fore-ground he depicted a group of women and children supplicants.

Supplicants also figure in the adjacent scene, *The Expulsion of Heliodorus from the Temple* (see fig. 66). Here again Julius himself is the crucial figure; he is shown being carried in his chair into the temple, whilst women and children beg for alms, spiritual succour and military protection. On the right a mounted knight is driving away a band of thieves who are already hauling off the sacred treasure on their backs. The dragon on the helmet, the blue and gold colours of the family coat of arms and the armour of ancient Rome that was also used in the triumphal portrait of Julius II in 1508 all identify the knight as Francesco Maria della Rovere.

These main figures have been added to the biblical scene, which is from the Second Book of Maccabees, to make a political point. Among those referred to in this Book are the praying priest Onias, and Heliodorus, who plunders the treasure of Jerusalem at the request of his king; unhistorical additions are the reigning pope with his bearers, his nephew and the indigent widows and orphans. Both the unusual choice of theme and the topical

additions allow us to see how a particular view of the past and present was aligned with a vision of the future to make a consistent whole. Ambassadors and advisers could see a connection between Heliodorus and the rulers of Ferrara, Bologna, Florence and France, who refused to pay ecclesiastical taxes[130]. What speaks from this painting is a justification of the papal right to collect taxes. The pope is shown as concerned to relieve the distress of the poor, in contrast to princes and their subjects, who are depicted as thieves in the night. This representation partly served to counter accusations that Julius II was wrongfully appropriating ecclesiastical taxes to build vast churches and to fund unlawful wars.

On the wall opposite *The Miracle of the Mass at Bolsena* Raphael then executed a *Liberation of St Peter*, deriving from the Acts of the Apostles. It was a scene already used politically two hundred years before in the missal belonging to Cardinal–legate Bertrand de Deux, who had also been obliged, in around 1330, to defend papal sovereignty against the French[131].

The *Liberation of St Peter* had further significance for Julius II in that he himself was a successor to St Peter, and because S. Pietro in Vincoli, where Peter's chains were preserved in a reliquary, was his titular church. He frequently went there after the solemnities of Council in 1512 to pray for the liberation of Italy. On the eve of the triumphal procession on 27 June 1512 he dined there, the *gubernator* of Rome coming to accompany him back the following day. In this church, too, participants in the Council came to attend Mass[132].

Political change accelerated at this time, pro–French cardinals losing their office in the counter–offensive launched by Julius[133]. The pope announced a new alliance in S. Maria del Popolo on 5 October 1511: the Holy League[134]. He also acquired the support of the Swiss. On 9 January 1512 he gave two diplomats the task of liberating the north of the peninsula; Giovanni de' Medici was to relieve Romagna and the Swiss Schiner was to come to the aid of Lombardy[135]. The pontiff's objectives were described in Paris de Grassis's diary as threefold: to retake Bologna, end the schism and drive the French out of Italy[136]. De Grassis kept a detailed record of the military campaign and the accompanying manoeuvres in diplomatic spheres[137].

All those who beheld the painting *The Expulsion of Attila* clearly saw in it allusions to these events. According to tradition the Huns, led by Attila, had encamped by Mantua, but upon the approach of Leo I (440–61) a heavenly vision had terrified them into a hasty retreat (see fig. 67). Raphael painted Peter and Paul in the heavens above the barbarian host and gave

not only Paul but also Peter the attribute of a sword rather than his customary keys. Julius had been recorded as saying that Peter's keys served no purpose, and that it was only by the sword that he could liberate Italy; indeed, he was said to have made the pronouncement whilst marching over a bridge leaving Rome for Bologna in 1510, and cast the keys into the Tiber[138].

Raphael made several different designs for this painting[139]. In the first the expulsion was entirely the work of Peter (without a sword) and Paul; the reigning pope did not appear. In the next Julius II was added; recognizable from his beard, he was pictured on the left, on his gestatorial chair. In the final fresco the pope – beardless and mounted – is Leo X. Behind the pontiff are two cardinal–legates[140]. The one in the middle may be Schiner, who played a major role in the offensive conducted by Julius II, partly owing to his influential position among the Swiss[141]. The mounted men on the pope's right are not churchmen. Given the prominent position of the youngest and his black apparel – black being the colour of high office in the city of Rome – this figure should probably be taken to represent Francesco Maria della Rovere, Prefect of Rome, Duke of Urbino and commander-in-chief of the papal armies[142]. Finally, the age, clothing and attributes of the horseman holding the general's staff – as well as his place in the procession – suggest that this is Raymond de Cardona, general of the Spanish–Neapolitan troops and commander-in-chief of the allied armies of the Holy League[143].

Untold ferocity characterized the military clashes between the papal armies and their antagonists, and both sides sustained terrible losses. Giovanni de Medici was taken prisoner, and Francesco Maria della Rovere turned traitor[144]. When the initial reports reached Julius in Rome on 14 April 1512 he had ships prepared, in case he might have to take flight. Shortly afterwards, however, Giulio de' Medici brought news of heavy losses on the French side, and informed the pope that the Swiss were about to take Milan. Julius was thus in a position to force negotiations upon Louis XII. In June the French were driven out, after which the schismatic cardinals returned to the papal court[145]. The members of the Holy League held talks with a view to distributing the cities and principalities gained among themselves[146]. In the Sala di Costantino a succession of solemn ceremonies was enacted, as the ambassadors of Reggio, Parma, Piacenza and the Swiss alliance all came to pledge their loyalty to Julius II[147].

TRIUMPHAL PROCESSIONS

On 27 June 1512 a triumphal procession made its way to Rome from
S. Pietro in Vincoli. In his diary Paris de Grassis linked the victory that this
procession was celebrating with the liberation of Italy; he went further,
seeing the expulsion of the French from the peninsula as winning greater
freedom for much of Europe. The master of ceremonies expressed his
delight at the vanquishing of the French in the bluntest of terms[148]. He
wrote that even the French inhabitants of Rome were happy with the
victory and the peace thus gained[149].

The triumph of the papal alliance was publicly celebrated during the
carnival procession of February 1513. The pope, too, could avail himself
of embellished triumphal chariots and triumphal arches. Such props had
become standard elements of festive processions held by rulers, and they
would frequently be covered with paintings that unambiguously brought
home political points[150]. The representations were closely linked to those
of the palace frescoes, but they were more overt in their propaganda[151].
They could afford to be so, given that, like pamphlets, they were ephemeral;
such material was therefore more explicit, showing specific antagonists and
particular battles, unlike the frescoes in the Vatican palace.

Paintings appeared on the triumphal chariots commemorating the lib-
eration of the Italian territories, noted the envoy from Ferrara in a report
to his court on 20 February[152]. The procession began with the Romans,
identifiable in all their various ranks from their apparel and insignia, wrote
the envoy. After the soldiers came chariots. On the first of these, the papal
territory was depicted as a chained Queen with her hands bound behind
her. On the second was written ITALIA LIBERATA, and above the
letters was painted a fasces, that is, a bundle of rods around an axe. Texts and
emblems indicated which cities had been liberated and annexed: Bologna,
Reggio, Parma, Piacenza and Genoa. All the objectives pursued by Julius
as leader, priest, lawgiver and fierce opponent of heresy were expressed in
images of Moses, Aaron and Ambrose. The chariot boasting an image of
Apollo overturned when rounding the corner by Castel Sant'Angelo, which
put it out of action for the rest of the proceedings.

In front of the unfortunate chariot of Apollo rode one with an obelisk.
It carried texts in Greek, Hebrew, Egyptian and Latin that emphasized the
role of Julius II as liberator and the keeper of concord: *Jul. II Pont. Max.
Italiae Liberatori et Scismatis Extinctori*. Above the text appeared an angel
hacking a monster's head off with its sword. Behind Apollo rode the chariot

bearing the inscription *Concilium Lateranense Triumphans* and texts which recalled the great powers that had come together in the Council: the pope, the emperor and the kings of Spain and England, in addition to representatives of city-states such as Venice and Milan together with numerous cardinals. The connections between annexation of territories, the support of allies and the key role of the pope himself were highlighted by the familiar oak symbolism and the sword by which Julius set so much store.

On 20–21 February 1513, a few days after the triumphal carnival procession, Julius II died – sick, old and weary of life. Paris de Grassis rose to what were for him unusual heights of eloquence to describe how a great multitude gathered, crying out through their tears that Julius had been the true Vicar of Christ who had triumphed over the tyrants, preserved justice and expanded the territory of the Papal State. As noted by the master of ceremonies in his diary, Julius was seen by all Rome as the guardian of justice, protector of the Church and victor over tyrants and hostile powers – an image already carefully built up by Raphael's frescoes in the Vatican[153]. De Grassis's own conclusion was that 'this pope has liberated us all, all Italy and all Christendom, from the yoke of the barbarians and the Gauls[154].'

STATE SYMBOLISM UNDER LEO X

In December 1513 Leo X had Giulio de' Medici and several other intimates ordained as priests and bishops to clear the way to creating them cardinals. He conducted this ceremony in one of the Stanze, an unusual choice for such an occasion[155]. A similar ceremony was enacted there again in 1517, shortly after Raphael's decorations were completed[156]. The secular administrative functions of the cardinals had assumed prime importance; to be eligible for the office, however, it was still of course necessary to be ordained first. Leo X exploited these occasions of ordination to put the Stanze frescoes on special display for those for whom they had particularly been designed: members of his own court and the envoys of other heads of state.

Leo X naturally replaced emblems specific to Julius II with others appropriate to himself and his family. His repertoire of images included the Medici arms, the *palle* and the ring with feathers that was his own particular emblem. He had portraits made of himself, his courtiers and his advisers, many of whom hailed from Florence. In some cases Raphael changed designs and repainted fragments of existing works[157].

Mutual ties between the papal court, other states and the Church as a whole were alluded to once again in paintings executed in the Stanza dell'Incendio. The panegyrists of Leo X laid increased emphasis on the pope's role as a peacemaker who helped forge unity among all Christian states, including the Kingdom of France[158]. The enemies were now the Turks, and in 1513, during the Council sessions, the pope and the French king declared their willingness to end their mutual hostilities[159]. Orations, panegyrics and treatises produced under Leo X focus on the concepts of peace, concord, justice and good administration within the Church and within the system of Christian states that were together responsible for Council decisions. In Paris de Grassis's diary the same concerns may be traced[160]. For the Stanza dell'Incendio Raphael designed frescoes that brought out the values the new pope wished to stress[161].

The Fire in the Borgo derives from a traditional legend that Leo IV (847–55) had helped put out a fire in the neighbourhood of St Peter's. In the foreground Raphael once more painted the destitute women and children. He reproduced with the meticulousness of an archaeologist the façade and annexes of St Peter's as he deduced that they had been some five hundred years before. The pope and his general (with his staff of office) are shown standing in the loggia. The extinguishing of the fire served as a metaphor for the ending of schism and war.

In *The Battle of Ostia* the focus is on Leo's successes against the saracens. Leo X is the pope portrayed in this fresco, and the cardinals behind him are the recently ordained Giulio de' Medici and Bernardo Dovizi, called Bibbiena (a fellow Florentine). In the foreground, wearing the armour of ancient Rome, stands the commander-in-chief of the papal armies: it is Giuliano de' Medici, who had succeeded Francesco Maria della Rovere, previously portrayed in this function.

The Medici, whose various attempts to regain power in Florence had foundered before, succeeded in their efforts, partly through the influence of friends in the *Curia* and with French support. Florence, too, now benefited from a new spate of major artistic commissions. Michelangelo was entrusted with the task of completing work on the façade of S. Lorenzo, the Medici family church, and of designing a new funerary chapel in honour of Giuliano de' Medici, his brother Lorenzo and other kinsmen[162].

In 1515 Leo X entered Florence in great ceremony. Decorated triumphal arches were erected, and the pope was given a magnificent reception. The Medici had climbed to the top once again. Some forty-five years later Vasari would depict the role played by the Medici in the constant struggle for

power in Rome and Florence in his paintings for the Palazzo Vecchio[163]. From Florence Leo travelled on to Bologna for one of the first summit meetings ever held as such, proceeding to the town hall to conduct negotiations (of which the content was initially kept secret) with Francis I[164]. This diplomatic meeting and the resulting agreement reached between the pope and the French king concerning the latter's obligations to the Church were to be renowned as major achievements on the part of Leo X[165]. The results were announced ceremoniously on 15 December 1516 in the Sistine chapel, with summaries being read out of the bulls that effected a 'Concordat between the pope and the king of France', the abolition of the Pragmatic Sanction (which had asserted that the authority of a General Council superseded that of the papacy as well as granting relative autonomy to the Gallican Church) and ecclesiastical reforms. A Council meeting followed four days later, those present including representatives of the Emperor, the kings of Spain and Portugal, and the new Duke of Urbino, Lorenzo de' Medici, who had ousted Francesco Maria della Rovere with the aid of Leo X[166]. After this renewed ritual of reconciliation with the French at the Fifth Lateran Council Leo took his leave early, out of respect for the older cardinals, and set off homewards in the drizzle on a donkey[167].

The highlight in the Stanza dell'Incendio is a scene showing the coronation of Charlemagne by Leo III (795–816). Again the figures are updated; Vasari describes the picture as containing many of Leo X's courtiers and officials. Leo X is indeed the central figure, and he is shown placing a crown on an emperor whose features are those of Francis I. After the secret negotiations in Bologna a Dutch observer had noted the following rumours in his diary. The pope, it was said, had promised Francis I the imperial crown of Byzantium if he would agree to lead the forces against the Turks. Moreover, Leo was willing to support Francis in his efforts to become Holy Roman Emperor. Any such move would in fact have exceeded his competence, quite apart from the fact that while Emperor Maximilian, the emperor-elect, was still alive, the question of the succession could not formally be broached. The diarist went on to write that the French inhabitants of Rome were decorating their homes with their king's coat of arms topped with the imperial crown[168]. They apparently hoped that the Bologna talks might fulfil the prophecy of the coming of a second Charlemagne of French descent[169]. The fresco of the imperial coronation can therefore be seen as a visualization of the Bologna talks and the ensuing alliance of all Christian states, not the least among which was France.

Between the Coronation and the Battle, Raphael painted the Oath sworn

by Leo III, who is again depicted with the features of Leo X. Once more Raphael's design accorded precisely with the regulations governing cinquecento papal ceremony as formulated by Paris de Grassis; that is to say, the rules dictating apparel and attributes, positions and gestures, the colour of tapestries and the arrangement of throne, altar and baldachin[170]. The papal court possessed a system of ceremonial props and practices more elaborate and more comprehensive than any other court, and its intricacies were captured and conveyed in the vast paintings designed by Raphael. The political significance of this scene is clarified by the inscription: 'The pope may be judged only by God and not by man'. On the eve of Charlemagne's coronation Leo III had answered to a charge of treason. From the pulpit of St Peter's he swore upon the Gospel that he was innocent, and insisted that it was to God that he must account for his deeds and not to men. In this painting Raphael depicted the figure of Leo X before a free-standing altar, and the platform is defended by the knights of St John of Jerusalem and the *mazzieri* (a section of the pope's militia), as was customary during assemblies of the Council[171]. Above the soldiers can be seen the person of Lorenzo de' Medici, the controversial Prefect of Rome and Duke of Urbino. Hence the reference to Leo III and his oath. Lorenzo's position had been gained through violence and treachery, which had damaged the credibility (and reputation for impartiality) of his sponsor Leo X, the pope who had so recently united the Christian rulers in a Council and an alliance. This painting reminded beholders of the legitimacy of the authority wielded by the pope.

Papal authority was further visualized in the grisailles beneath the four narrative frescoes in the Stanza dell'Incendio. These portrayed the reigning European princes or their historical predecessors as secular rulers who willingly served the pope. This was yet another example to those who were received in the Stanze.

Through Raphael, more aspects of the Papal State found visual expression than ever before: the state's army and police that guaranteed its security and kept the peace within its borders; its apparatus of diplomats, administrators and councillors; its territory and the income gained from taxation; its laws and its seat of government; its elaborate ceremonial practices; its glorious past and its auspicious future. What is more, like Julius II, Leo X presented himself as the uncontestable leader of all Christians, including the most powerful monarchs. The paintings in the three Stanze shed light on papal sovereignty within the state itself and on the superiority of the papacy as a sacred repository of authority over republics and principalities.

Once the peak of political polarization in 1511–12 had passed, the paintings produced were no longer shot through with topical allusions. Raphael's cartoons for the Sistine Chapel tapestries were historical and theological in subject-matter; overt political messages, ruled out anyway in sacred surroundings, were absent. The biblical passages were chosen and illustrated to fit texts written for Council sessions, however[172]. This was also true of the initial designs made by Raphael for the Sala di Costantino.

The type of paintings developed to new heights of sophistication by Raphael became a model for countless other commissions, both in the Vatican Palace and in other palaces of popes and cardinals. The great artist's pupils and young assistants continued working in the genre of history painting that he had perfected, though his powers of imagination, his draughtsmanship and his versatility, could hardly be reproduced.

PAINTERS AND *CURIA* PATRONAGE

The monumental narrative scenes described above, with their mix of programmatic, contemporary and historical elements, put new strain upon professional skills. To arrive at the conception and design of such a painting, to depict all its diverse individual parts, from portraits to landscape, from armour to architecture, required far more professional creativity than the production of a trecento altarpiece or even a quattrocento chapel fresco. The paintings were composed of standing figures, flying angels and rearing horses, as well as grand buildings and broad vistas. Their artists were obliged to draw on examples from ancient as well as quite recent times and to use geometrical models together with their imagination, memory and observation – an immensely exacting combination. With the commissions given by Julius II and Leo X, Raphael – partly driven by his rivalry with Michelangelo – created models for paintings of the greatest complexity.

The role of such painters had changed; it was no longer sufficient to depict a given theme after a particular model. Clients and advisers formulated their initial assignments ever more loosely, and increasingly conception and design became the concern of the artist. Sometimes contemporary events might make a certain change desirable, putting painters' inventiveness at a premium. The court painters who proved equal to these challenges became more and more a distinct élite. Moreover, they emancipated themselves still further as a group by taking on other jobs, collaborating on architecture, military works and town planning projects and organizing festivals. In short,

68. Raphael, *Julius II*, 1511 (photograph National Gallery, London)

far more than in the preceding century, there was now a great divide between the gifted court painters and the rest of their profession. Their skills could only be passed on to a select few.

An endless variety of commissions flowed from the popes: besides the Stanze frescoes and the paintings and tapestries for the Sistine chapel there were countless portraits of rulers and courtiers, altarpieces, and funerary monuments and designs for many buildings in addition to the great St Peter's itself. With their training and previous experience in less exacting commissions and by virtue of having studied examples both ancient and modern in Urbino, Florence and Rome, two artists in particular – Raphael and Michelangelo – emerged as able to respond to the high expectations and extreme demands put upon them[173].

Raphael did some of his work in the relatively simple areas of altarpieces, portraits and religious images for private homes[174]. Here too he exploited predecessors' innovations to great effect. One notable instance is his development from diverse sources of what may be called the genre of the easel painting: a movable picture in tempera or oils with an image painted from a single perspective. He set figures exhibiting a variety of poses and gestures in a dramatic context, using geometrical devices for architectural features and overall composition. One such altarpiece by Raphael was given by Julius II to S. Sisto in Piacenza in token of gratitude for that city's loyalty[175].

Another of Raphael's achievements, notably in the most renowned of his portraits of Julius II, was that he created an archetypal portrait for reigning princes. Vasari described this work as 'so wonderfully lifelike and true to nature that it inspired as much fear as if it had been alive'. Probably made to celebrate the proclamation in October 1511 of the formation of the Holy League, it was displayed in S. Maria del Popolo (see fig. 68)[176]. Other portraits by Raphael, such as that of Castiglione, exemplified the civilized courtier (see fig. 69).

Subjects would be shown seated or standing, almost life-sized, within a rectangular pictorial plane and generally viewed from an oblique angle. Sometimes Raphael would portray several figures within one frame, adding a desk, books and writing materials. He was meticulous in individualizing faces, rendering jaw and cheekbones, eyes and nose, hair and beard with the greatest of accuracy. Whilst placing his subjects in a limpid light that delineated their forms clearly, he kept to flowing lines, shunning sharp transitions as determinedly as he avoided distracting detail.

Producing portraits of heads of state, courtiers and diplomats came to be one of the main occupations of painters such as Raphael, Titian and

69. Raphael, *Baldassare Castiglione*, 1514–15 (photograph Louvre)

70. Titian, *Francis I*, 1538 (photograph Louvre)

Bronzino. Titian, less involved than Raphael in monumental frescoes charged with political significance, did correspondingly more work on portraits and on narrative scenes with elegant mythological figures. He executed commissions for the courts of Mantua, Ferrara and Urbino, for his own republic of Venice, and for the German emperor Charles V, his courtiers and his son Philip II of Spain. The Venetian also made portraits of Paul III (1534–49) and King Francis I (see fig. 70).

Large-scale commissions with state symbolism continued to be given, within the papal domain and beyond it, though none of the ensuing paintings were ever regarded more highly than were those of Raphael. Clement VII (1523–34), Paul III (1534–49) and Sixtus V (1585–90) all ordered decorations for various rooms in the Vatican Palace, the Palazzo della Cancelleria and their family palaces and villas[177]. Funerary monuments and church decorations, too, were constantly commissioned by popes and their kinsmen[178].

Rulers of lands beyond the bounds of the peninsula also ensured that they and their courtiers, their dynasties and territories, and the cultural values they cherished, were displayed in pictorial images. At the same time, as an expression of their civilization they took to collecting paintings made by the Italian artists; the concept of the masterpiece was born. Within the European network of courts and states the Italian professional tradition of painting set the tone. In Italy itself among the most prestigious commissions being issued were those for the Doge's Palace in Venice, which exalted the Venetian state and and its Doges in its parade of images. But of all Italian patrons of art in the second half of the cinquecento, the most influential was Cosimo I, the Grand Duke of Tuscany.

3. COSIMO I AND VASARI:

EXCELLENCE IN GOVERNMENT AND IN ART

═══

THE DUKE OF THE REPUBLIC

Cosimo's aristocratic patronage did not flourish until after 1555, when Florence finally conquered neighbouring Sienna. For some fifty years after 1494, the year in which Piero de' Medici had been driven into exile, the position of the Medici had dipped and rallied without steadying[179]. Efforts made to revive the family's active role in commissioning works of art foundered whenever their fortunes were at an ebb. When Cosimo first came to power in 1537, at the age of eighteen, his hold on authority was tenuous[180]. Unease within the young duchy was exacerbated on all fronts: conflict dogged relations with the papacy, the threat of military hostilities loomed from Turkey, France and Spain, and close at hand the ongoing struggle continued with Sienna. After 1555, the latter issue was resolved and there was a general easing of tension. Cosimo consolidated his position as head of state with a series of new laws (1551–61) that took effect throughout Tuscany[181]. In 1565 his son Francesco married Johanna of Austria, and in 1570 Cosimo became Grand Duke of Tuscany, taking his place as one of the leading princes of Europe[182].

Cosimo advertised his princely authority in tapestries, statues, medals, engravings and paintings, including an immense series of portraits[183]. He initiated town planning schemes that would give Florence the air of a court residence and thus help confirm him in his new role. He turned to the mendicant churches and drew up plans for their interiors to be renewed[184]. The town hall also came under his energetic redecoration programme[185]. Cosimo had old monuments to old power structures altered in such a way that they contrived to give his newly won authority a more venerable slant.

After the court had moved to the Pitti Palace, the town hall was renamed (in 1543) the Palazzo Vecchio. Between the two palaces and over the Ponte Vecchio a covered gallery was built, and beside the renovated town hall

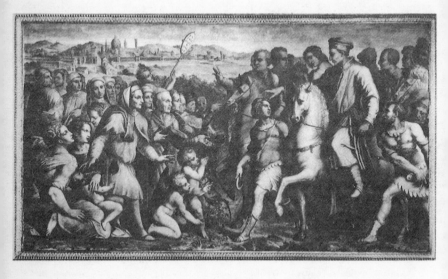

71. Giorgio Vasari, *The ceremonious entry of Cosimo the Elder in 1434*,
c. 1560; Palazzo Vecchio (photograph Alinari)

rose offices or 'Uffizi' designed by Vasari, their top storey, in particular the *Tribuna*, becoming a display room that housed a collection of paintings.

Like the pictures ordered by Popes Julius II and Leo X, the decorations commissioned for the Palazzo Vecchio by Cosimo I were a historical, topical and programmatic blend. Vasari modelled both his overall design and all manner of detail on the decorations in the Vatican Palace, where he had once sat copying Raphael's frescoes and had indeed executed some himself.

The Sala Grande or great reception hall was also known as the Salone de' Cinquecento after the 500 councillors for whom the hall had been built by the republic in 1504, following the example of Venice. Vasari executed forty-two paintings on the ceiling of this hall and a further six enormous frescoes on two of its walls. In the surrounding chambers he depicted the rise of the house of Medici as part of the political history not only of Florence, but also of Rome, Italy and Europe.

Vasari and Pontormo portrayed the duke together with his namesake Cosimo the Elder as the family saints, St Damian and St Cosmas, on the wings of an altarpiece which had as its centrepiece a work by Raphael[186]. Elsewhere in the *Quartiere di Leone X* Palazzo Vecchio were other works that suggested parallels between the two Cosimos. Cosimo the Elder's return from exile in 1434 was pictured as a prince's ceremonious entry into the city and transposed to the times of Cosimo I (see fig. 71). By such devices the duke placed himself squarely in the line of an awe-inspiring dynasty, of which he depicted only its finest moments[187]. In historical paintings Cosimo emphasized the artistic commissions that had come from the Medici; patronage came to symbolize dominion[188].

The view history had taken of the grand duke's ancestors was modified to show a more satisfying continuity with his own position. Cosimo the Elder and Cosimo I were both shown as patrons in the midst of artists and courtiers. One painting showed Cosimo the Elder as the patron of S. Lorenzo, with Ghiberti and Brunelleschi at his feet. They are presenting him with a model of the church, as if it had been designed, discussed, approved and executed in one uninterrupted sequence of events. Patron, advisers and the artist responsible for this rendering were all glossing over the fact that S. Lorenzo had been erected in various stages of building activity spanning the period 1419 to 1490, that frequent alterations had been made to the original conception and that many others beside the Medici – the clergy as well as other families – had also been involved in the project[189]. The composite mercantile patronage of the quattrocento was

pressed by Vasari into the mould of the more single-minded court patronage that actually only began to take effect around 1560. It was only then that the duke could make his mark upon the churches that he built in the way suggested by the picture. At the same time Vasari was expressing his biased view of the professional artist, whose first design would be a finished product. He projected a situation that was dominated by one patron whose artists could instantly devise solutions for each new commission on to a vastly more heterogeneous past. This apparent continuity lent greater legitimacy to the practices of Vasari's patron and to his own professional ambitions.

As the historical image-building got under way, two of its greatest celebrities were the Medici popes, Leo X and Clement VII. Vasari could take as his models portraits that Raphael and Titian had made of heads of state and courtiers of the day. The rise of the Medici was presented as a steady and inevitable development towards ever more power wielded in ever-increasing circles. One hundred and fifty years of it had led straight to the position held by Cosimo I. One of the portraits in the chamber dedicated to his rule showed Cosimo I at his ducal coronation, attended by prominent Florentine citizens whose berets and apparel proudly displayed their names.

The previous decorations in the Sala Grande, which Vasari was instructed by Cosimo I to paint over, included the famed though unfinished murals by Michelangelo and Leonardo da Vinci. In 1505 these artists had produced designs commissioned by the Council of Ten for paintings to commemorate the battles of Cascina and Anghiari[190], the one a victory over Pisa in 1364, the other over Milan in 1440. These were decisive moments in the formation of the Florentine state. The two painters, both already famous, planned their historical battle scenes in such mutual rivalry and ambitiousness that the resulting designs were for paintings of immense size and inordinate complexity. In executing these scenes Leonardo experimented unsuccessfully with oil paint as a technique for use in murals.

Vasari kept to the original programme of images for the hall, but introduced a courtly flavour. Just as the republic of Sienna had depicted the annexation of Montemassi around 1330 led by a general in the service of the state, Cosimo I had the subjection of Pisa recorded in images around 1565, followed by the triumph over Sienna itself. As in Sienna, the statutory basis of public authority was stressed and the virtues that belonged with sound government placed centrally. As in Sienna, paintings reflected the political events of the day and new legislation that was being enacted; republican motifs were thus combined with courtly elements that had been developed in Urbino and Rome.

All the images in this hall revolve around the figure of the duke himself. Cosimo I is pictured in the centre of the ceiling, seated on a cloud in heaven, his ducal crown held by a cherub. A personification of Florence, *Fiorenza*, crowns the duke with oak-leaves, a symbol derived from classical antiquity (see fig. 72). A second cherub bears the insignia of the Order of the Golden Fleece, conferred upon Cosimo by the emperor in 1545, and the cross of the Order of St Stephen, which Cosimo had founded in 1561. Cherubs hover about him, bearing the coats of arms belonging to guilds, areas, regions and cities that had all been united as one state under his rule[191]. Vasari referred to this portrait as the duke in triumph as the prince of Florence. He also recalled the historical origins of this position with their mix of republican and dynastic elements: 'After the death of Duke Alexander, forty-eight citizens representing the state nominate and elect lord Cosimo to be the new duke of the republic of Florence'[192].

Spread across the other ceiling panels is the state over which the 'duke of the republic' ruled. Round about the prince Vasari painted the four districts of the city, S. Maria Novella, S. Croce, S. Giovanni and S. Spirito, each of which administered part of the territory[193]. The remaining paintings depict the composition and integration of the lands belonging to the state.

The most important episode in the expansion of Florence was the recent annexation of Sienna. On the ceiling Cosimo is shown in his study, making his plans (see fig. 73). Armed with compasses, set square, inkpot and paper he deliberates over the siege, of which he has an image before him. His preparations for war are professional, unhurried and well thought out. He wears an ermine mantle; his armour and helmet lie on the ground before him. As a strategist Cosimo takes inspiration from the virtues ranged behind him, and an angel with a laurel wreath predicts the glorious outcome[194]. The victory over Sienna is depicted as a product of the duke's strategic acumen[195].

This is manifestly different from the depiction of the taking of Pisa, with the Florentine General Giacomini appealing to the people's representatives in the Sala Grande to deploy a people's army to continue the war in 1505[196]. Other scenes shown on the ceiling are the conquest of Cascina in 1499 and various subsequent skirmishes – disconnected and uphill struggles.

Vasari further elaborated on the annexations of Pisa and Sienna – the decisive episodes in the expansion of the Florentine state – in frescoes executed from 1567 to 1571. On one side of the Sala Grande he executed monumental scenes showing key events leading up to the taking of Pisa:

72. Giorgio Vasari, *Cosimo I crowned by Fiorenza*, 1564–5; Sala del cinquecento (photograph Gabinetto fotografico, Florence)

(from left to right) the 1499 siege laid to the Pisan fortress of Stampace under Paolo Vitelli's command; Emperor Maximilian raising the siege at Livorno in 1496, and the triumph under Giacomini in 1505[197]. On the opposite wall appeared scenes of the crushing victories (1554–5) that had resulted in the subjection of Sienna[198].

In his *Ragionamenti*, a dialogue, Vasari explains the scenes to his patron's son, Francesco de' Medici[199]. He underscores the artists's professional autonomy – the representations are the product of his own invention, he asserts[200]. Vasari further points out the discrepancy between the fourteen years taken up by the struggle for Pisa and the mere fourteen months needed to conquer Sienna[201]. The former is depicted as having been arduously wrung out; although the republican army was commanded by able generals, there was a lack of long-term strategy[202]. Nevertheless, the efforts of the generals and of patriotic Florentines finally succeeded in subjecting Pisa. The images relating to the subjection of Sienna show no dissenting citizens but rather a shrewdly operating prince[203].

The two contrasting episodes exemplify progress in government. Cosimo has woven the republican achievements evenly into a courtly state of which the communes of Florence, Sienna and Pisa have all become constituent parts. With Cosimo the venerable republican traditions have reached their apogee: one constitutional territorial state ruled by a civilized prince.

The ceiling decorations in the Sala Grande include a representation of Cosimo I's festive entry into Sienna[204]. Finally there is the baptism scene of his son Francesco, the ceremony being conducted before a vast crowd of nobles, dukes and envoys of great princes. The continuation of the Medici ducal reign is thus shown to be assured with Francesco.

Propaganda on behalf of the Florentine court and the Tuscan state obviously had more exuberant outlets. For instance, part of the festivities surrounding Francesco de' Medici's wedding to Johanna of Austria was the erection of some dozen triumphal arches that transformed the city, their extensive decorations constituting an impressive backdrop to the state ceremonies[205]. Decorations on the arches corresponded to scenes in the great hall. Antonio Giacomini was portrayed on one arch as the protagonist in the struggle against Pisa in a picture dedicated to Florentine military excellence; Cosimo I appeared on another accompanied by the personified virtues of sound rule, as exemplifying civil excellence[206].

Shortly before the wedding ceremony a rather delicate problem arose in the Sala Grande, where a great reception marking the occasion was to be held. There was apparently a missing link in the pictorial narrative. Early

73. Giorgio Vasari, *Cosimo I plans the Siege of Sienna*, 1564–5; Sala del cinquecento (photograph Gabinetto fotografico, Florence)

in November 1564 Cosimo I requested in writing an additional scene to indicate that Florentine history had unfolded uninterruptedly since ancient times, as appeared from several chronicles. A new phase dawned in the development of ideas on the early history of Florence. The Duke asked his courtier Borghini to devise an *inventione* that met three conditions: the historical scene should make it clear that Florence had 'never been laid waste'; it should be in accordance with the truth; and finally it had to be finished before the ceremonious entry of Johanna of Austria in 1565[207].

As a suitable solution Borghini suggested showing the defeat suffered near Florence by the Goths, led by King Radagasius, in AD 405. One version of the story was that the enemy army had been starved into surrender. A different chronicle told of a smallish battle. According to yet a third source Florence had been besieged. The preference was for the last version, from which the Florentines could emerge as heroes. Borghini and Vasari collaborated to develop this theme in a more specific way. A painting was produced that gave the impression of the Florentines having fought off a formidable attack by the Goths, preparing the ground for the Romans to defeat the barbarians. They had saved Christianity and liberated both Florence and Rome at a stroke. The artist and adviser went further with this elaboration than simple compliance with the patron's request. For him it would have sufficed to show that Florence had never been destroyed, from its foundation up to the prosperous days of the republic under the protection of the House of Medici.

The design of this painting planted the seed of legend. A crop of related panegyrics and pictures sprang up in mutual inspiration, a process that gave rise to a new view of Florentine history. The tale would be told of Cosimo's legendary ancestor Medix, who had engaged in armed combat with Radagasius, his triumph saving civilization from impending doom. In the next phase of legend-forming, Medix would become known as *Il Cosmo* and bear a shield displaying the Medici coat of arms. As commander-in-chief of the imperial forces he had saved Italy and Latin Christendom by inflicting a crushing defeat upon the barbarians[208]. The banking family thus forged for themselves an aristocratic military pedigree which cast them in a leading role already evident in late antiquity.

It would not have been politic to go that far in adulation of the prince and his dynasty during the rule of Cosimo I. In 1565 the ideals and modes of government generally respected were still dominated by a strong tradition of republicanism. The outspoken courtly flattery, historical distortion and political propaganda that was to come later was not sought after at this

moment in time; nor would it have been opportune. It was Cosimo's policy to respect republican values, and like his quattrocento predecessors he kept the established administrative apparatus largely intact, though installing over the republican system an aristocratic household with personal advisers. Aided by these councillors the duke exercised control over the various administrative institutions without undermining them[209]. The highest organs of decision-making throughout the state of Tuscany were joined by one court.

In the days of Cosimo I the picture projected of the ruler still kept close to the realities of government. One may speak of an absolute ruler in connection with seventeenth-century image-making, but not in the 1560s. The duke required the services of competent administrators; he was dependent on the republican institutions and on the councillors that made up his court household. The duke did become a symbol of the state, but was far from being an autocrat or 'absolute' ruler.

Artistic patronage was marked by the same configurations, as shown in pictorial images. Cosimo I was personally involved at the initial planning stage, but whenever possible he would delegate responsibilities to scholars such as Bartoli and Borghini. These two, together with Vasari, operated as authorized experts, collaborating to design cohesive programmes of decoration with the mix of courtly and republican subjects and symbols that represented the Tuscan state.

Triumphal arches were designed partly with a view to impressing the people. Inside the place, the decorations were primarily intended for Tuscan courtiers, Italian princes and ambassadors from other states, who saw a city with the aspect of a princely residence, the old town hall refurbished as a ducal palace at its centre. And within this palace was displayed to these dignitaries a systematic summary of all the elements that had gone to make up the State of Tuscany[210].

DEMOLITION AND RENOVATION IN MENDICANT CHURCHES

Cosimo I made ecclesiastical patronage heavily dependent on court and state, greatly reducing the scope available to friars, guilds, confraternities and families. In church naves, monks' choirs were cleared and *tramezzi* taken down. New decorations came to replace the panel paintings and altarpieces that had been installed in the period 1261–1490 by friars,

fraternities and families. The old frescoes disappeared under coats of white-wash. Some of the panel paintings were hung on walls but many were sold; thus the majority of the saints honoured by mendicants and families vanished from churches they had dominated for more than a hundred years. Most of the rights of patronage over chapels were cancelled. The duke also had funerary monuments, memorial slabs and family coats of arms removed; the chapels in the nave all came to bear a family resemblance. The attention of the laity in the nave was focused on the pulpit and the high altar with its monstrance, without any distracting altarpiece[211].

The duke was able to subject the mendicant orders, civic institutions, confraternities and merchant families to a centralized authority because he was supported by the pope and by foreign kings. The Church reforms gaining momentum in Rome were crystallized in the decisions emerging from the Council of Trent (1545–63). Ecclesiastical doctrines were to prevail, and interpretations favoured by particular groups or individuals to be discouraged; restraints were placed on the worship of saints linked specifically to certain families or corporate bodies. Stricter centralized regulations came to govern the entire business of giving artistic commissions within an ecclesiastical setting. At the same time social control came to the fore, with greater emphasis being placed on confession, communion and sermons. Cosimo I supported the papal policies in the Church, exploiting them to strengthen his own position. Conversely, the consolidation of the state apparatus in Rome and Florence, whose rulers enjoyed the support of the kings of Spain and France, benefited those eager to expedite ecclesiastical reform.

Commissions to painters were profoundly affected by the grip exercised by *Curia* and ducal court on ecclesiastical patronage in Florence. Church dignitaries desired images that would popularize religious views with a maximum of effectiveness; they wanted none of the distracting inventions painters had been filling their works with, nudes and other figures in all manner of poses, extraneous additions all serving to divert attention from the Divine message. It was the task of painters, the prelates felt, to represent the religious ideals of civilization that had now been rewritten with such renewed fervour, and to do so as plainly and directly as possible[212].

With the graduated partitioning that had once marked the stages from a profane outside world to the high altar removed, a single space was created from which the entire congregation had the same view of the high altar. Cosimo's renovation scheme, carrying on the programme of integrated church building already initiated in the previous century, encompassed a

choir in the main chapel, and side chapels all much alike. The Medici had already been moving in this direction from 1420 to 1480 with churches such as S. Lorenzo, S. Marco, SS. Annunziata and S. Spirito.

Centralized government meant centralized patronage. As his agents Cosimo I appointed the scholar Borghini and the artist Vasari[213]. It was they who supervised the planning and execution of work to be done on behalf of the state. Vasari was thus enabled by Cosimo, as *capomaestro* and master heading a team of painters, to develop a decorative programme for S. Croce and S. Maria Novella whose form and content formed a harmonious whole.

As a painter Vasari was no great innovator. He was immersed as none other in the history of his profession, and the use to which he now put this knowledge was to devise a standardized model for an altarpiece. Vasari derived from works such as Masaccio's *Trinity* fresco the notion of the altarpiece as a window revealing a heavenly vision. He avoided the complicated perspective constructions that had absorbed Uccello and Piero della Francesca, nor did he favour the extremes of attitude or expression associated with Pontormo and Rosso; he did make use of the kind of asymmetrical composition found in works by Titian, however. The result was a compromise between professional skills and the standard product that those issuing commissions were now calling for. Vasari's model could be used by all, including painters whose ability and powers of invention were unremarkable. Pupils and young assistants of Vasari (for example, Santi di Tito) carried the process of simplification still further.

Towards the end of the sixteenth century the professionalization of painters in Florence stagnated. At the same time, patronage lost its dynamic thrust, and the state as a whole – like Sienna two hundred and fifty years before – entered upon a fairly static phase. The various centres of art and communication emerged in a reshuffled order of precedence. Other states and cities began to take over Florence's leading role; in patronage and the painting profession it was soon Rome, Bologna, Venice, Paris, Antwerp and at length Amsterdam that set the tone[214].

THE FOUNDING OF THE ACCADEMIA DEL DISEGNO

The establishment of academies in Rome, Bologna, Paris and Antwerp followed in the train of the Florentine Accademia del Disegno, founded in 1563. In each case the initiative was taken by the fashionable élite among painters, sculptors and architects[215]. For generations past there had been

painters who insisted on higher fees and who rejoiced in a better annual salary than the majority of the profession, who acquired titles, built fashionable villas and had all the honours of a church burial. But what was initially no more than the incidental forming of an élite was solidified by court patronage into an enduring class distinction within the painting profession.

Vasari was numbered among these fortunate few[216]. He attained to this position thanks to singular skills, such as his ability to compose scenes hitherto unrepresented and his talent for managing large-scale projects. His patron would therefore leave much of the designing in his hands rather than giving only clearly defined commissions. Cosimo had him design buildings too, and put him in charge of numerous civic planning schemes. As Vasari, like Raphael, was a capable organizer, he was accorded a managerial role in the business of patronage, mediating between Cosimo and the craftsmen executing commissions. Vasari and Borghini together coordinated virtually all big building and decoration projects in Tuscany.

Vasari owned a mansion in Arezzo and another large house in Florence. In the former he made paintings that had as their theme the history of his profession, and it was in Arezzo that he had a burial chapel designed[217]. He also amassed a collection of drawings, which was both a status symbol and a document to the history of his profession. A painter of Vasari's standing tended to regard guild membership as beneath his dignity[218]. Several court painters before him had freed themselves from the guilds, but now individual efforts towards social advancement joined in a collective effort to reorganize the profession. In this new phase of professionalization Vasari was a key figure; as organizer, historian and theorist he was at the very heart of the new order.

The establishment of the academy was not the sole province of artists. Since the late quattrocento fashionable societies of scholars had existed that did not have any specific professional role, sometimes growing out of civic confraternities of well-to-do citizens who wished to immerse themselves in courtly culture. Men of learning and wealth came together to found a *studio* or *accademia*, associations that rarely had statutes and were often not officially recognized by the state. Members gathered to discourse on the nature of beauty, truth and the good, or perhaps to analyse the art of telling jokes. At these gatherings, dignified and courteous in tone, the phrases uttered would be as elegant as they were eloquent. Sometimes the talk might settle on painting, sculpture or architecture, contemporary works being considered alongside those of antiquity. At such academies painting was originally a side-issue. Their members were not professional craftsmen with

their own workshops but erudite gentlemen distinguished for their good taste. In addition to their debates and studies they made drawings after antique models, and appraised the art of their own day[219].

It was at first only incidentally that academies were connected with the art of painting as a profession. Around 1500 the word 'academy' was used in connection with Leonardo da Vinci; texts appearing in engravings referred to an academy at which he played a role[220]. The concerns of academies are exemplified by a praiseworthy and scholarly debate on the status of the arts that took place at Castello Sforzesco at the court of Milan on 9 February 1498, in which all the scholars of the court took part: theologians, astronomers and jurists as well as 'the most perspicacious of architects and engineers and assiduous inventors of new things'. Gatherings similar to this one were sometimes documented pictorially by participants. The engravings made by Bandinelli in Rome in 1531 and 1550 are a case in point: there is not a professional painter in sight, only smartly attired gentlemen studying pictures by candlelight. Beneath his print Bandinelli added the inscription ACADEMIA[221].

Learned circles offered successful painters a forum in which to strive towards redefining their professional ideals. From classical texts circulating among scholars they derived notions of the relatedness of different forms of art encapsulated, for instance, in such a phrase *ut pictura poesis* – poetry is like painting – and debated in *paragone*, which were discussions comparing the arts of sculpture, painting, poetry and other arts. Classical texts were also pressed into service to justify the claims of successful painters to a higher social status. Furthermore, these scholarly societies furnished the fashionable élite among painters with an organizational model *par excellence* to match their aspirations.

The painters of Florence, Vasari at the forefront, strove to found their own academy, hoping that they might revive the Compagnia di S. Luca, the confraternity of painters that had existed two centuries before[222]. At the same time they were eager for a connection with the scholars' societies, into which they could infuse greater professionalism. The time was right; radical changes were taking place in the configuration of guilds and confraternities in Florence in connection with the establishment, under Cosimo I, of the Tuscan state. Lines were drawn up anew across the map of professional interest-groups, partly because numerous institutions were being restructured so as to bind them more closely to the central authority exercised by the duke[223]. These realignments gave the painters an opportunity to adopt an organizational form attuned to their class aspirations and

at the same time to join with sculptors and architects. The Academy in Florence became a professional association.

The élite of painters in Florence could count on the support of the clergy, who hoped to offset the disturbingly great profane influence of the wealthy families in this way. This support stemmed from ecclesiastical policies pursued by the ducal court, to which the eminent artists themselves belonged. Between painters and the humanists at court the spirit of co-operation was heightened by combined efforts to design programmes of images for festivals or ceremonious entries into the city, for palace decorations and for altarpieces. It was this co-operation that led Borghini, among others, to back Vasari's plans for a new organization. The Florentine Academy thus owed its early success to a unique combination of developments: the newly acquired status of court painters, the rise of learned societies with an interest in classical and contemporary art, church reforms, the flourishing of court patronage and sweeping changes within the constitution.

There were two phases in the establishment of the Florentine Academy. In the early 1560s speeches were made and letters written in which the intellectual and élitist aspects of the new institution were particularly dwelt upon. These high-flown ambitions soon gave way to a more modest cast of aspirations, and the period 1571–82 was marked by a series of reforms. By the seventeenth century the final result was an organizational form within the context of the state that wove together strands of various bodies that had existed in the fourteenth century: the guild of physicians and apothecaries to which the painters had belonged; the guild of stone-masons which had included sculptors in its ranks, and the confraternity of painters.

A succession of names reflected the shift in emphasis as the academy found its bearings. Initially the Compagnia di San Luca, the Compagnia mutated through Academia e Compagnia into Academia. Furthermore, di San Luca was dropped in favour of Dell'Arte del Disegno[224]. This latter change meant a move away from the patron saint of painters to an abstract concept of art that embraced the concerns of painters, sculptors and archi-tects alike, and that would also, it was hoped, appeal to patrons and advisers, who were manifesting themselves increasingly as a group of connoisseurs and lovers of art. In programmatic terms the new view of art was very far from the definition the guilds had given of the artist's profession. It also diverged considerably from the views of the Church; depicting a prescribed moralistic image without displaying any inventiveness – for centuries the Church's notion of the artist's task – was beneath the dignity of the new

élite. Theory and historical knowledge were now of the essence, and craftsmanship consigned to the limited realm of the workshop.

The regulations drafted in 1563 were put before the members and formally approved, and in 1571 and 1582 new statutes were drawn up. The revised rules moved further away from those of guilds and confraternities, and letters document the still greater changes that were the order of the day. The plans amounted to a more formalized regrouping of professions as well as new accents in training, theory, historical views and professional culture[225]. Painters were no longer to be considered together with apothecaries, potters and physicians, but with sculptors and architects. There was to be a far greater emphasis on theory in training[226]. The concept of *disegno* indicated the focal point of the artist's identity as this was now envisaged: the invention and design of visual images. It was a concept that not only blurred the once sharply defined distinctions between the three forms of art, but also brought patrons, advisers and artists closer together. New courses were devised, and experienced artists were urged to visit studios in the city to give pupils and young masters the benefit of their advice. Academy members made plans for lectures on theoretical issues that received too little attention in the studio. This importance accorded to education was institutionalized in the Collegio delle arti del disegno[227]. Geometry, anatomy and the history of art were to be taught, and Academy members strove to put together a collection of art works to be studied in conjunction with these subjects, a collection with the finest of classical and contemporary examples. There was also to be a library with drawings donated by Academy members[228]. Thus was engineered a drastic reorientation of the profession and as a result, of the culture that went along with it – a culture that now bore the dual imprints of scholarship and a superior social status, and was on the way towards achieving professional autonomy.

The first men requested to lead the Academy were an index of its members' high aspirations: in 1563 the choice fell on Cosimo I and Michelangelo. These two formally accepted the positions, and were described, respectively, as *Primo Accademico* and *capo, padre et maestro di tutti*[229]. The period during which the Academy was headed by the city's ruler and major patron and by its most renowned painter, sculptor and architect was short-lived, however. Cosimo I soon delegated his responsibilities to Borghini and in 1564 Michelangelo died.

The Academy members set to work to provide their celebrated fellow-artist with all honours at his burial. Magnificent tribute was to be paid to Michelangelo in S. Lorenzo, and the still-youthful Academy took on the

project of preparing the decorations. As if a prince had died, the nave was filled with monumental statues and paintings commemorating the extraordinary artist, who was depicted as personifying his profession[230]. Shortly after the exequies these decorations had to be removed, because a memorial service was to be held for the late Emperor Ferdinand I, the successor of Charles V as Holy Roman Emperor. Ferdinand was related to the Medici through the marriage of Francesco de' Medici and Johanna of Austria. The decorations were stored in the sacristy until 1566, when they were again moved to make space for horses needed in a royal progress[231]. Michelangelo was honorably interred in S. Croce, but it was a long time before the plans of Academicians to erect a monument to him came to fruition[232].

From the early 1560s Vasari was engaged on diverse fronts, trying to influence commissions and at the same time trying to improve the collective status of artists and create more training possibilities. He approached the duke with a scheme to complete the Medici chapel in S. Lorenzo; it would be 'the most magnificent work in all the world'. The chapel was 'where we all learnt of art' and would be an excellent choice as a meeting-place for the new Academy. But Vasari's entreaties were not heard[233].

The Academicians did secure a permanent monument to art elsewhere, however, in the chapel that served as the chapter house of SS. Annunziata. Images representing the arts of painting, sculpture and architecture covered the walls of the chapel. Vasari depicted Luke painting a portrait of the Madonna in the estimable company of Vasari himself with his nephew and Michelangelo. The chapel also contained statues by Fra Montorsoli, a *Holy Trinity* by Bronzino, a *Madonna and saints* by Pontormo and a painting by Santi di Tito that depicted the building of the Temple of Solomon – Solomon himself having been a major patron of his day. The chapel became a mausoleum for practitioners of the visual arts[234]. A long tradition of individual funerary monuments was thus concretized in a collective memorial to distinguished masters[235].

Such image-building was not without effect, and Academicians were on occasion asked to advise on commissions[236]. Painters and sculptors of other cities welcomed the establishment of the Florentine Academy; the new ambitious standards set for the arts thus grew deeper roots and radiated out to affect an ever-larger area. In 1566 the prominent painters of Venice submitted a request to join the Florentine Academy: given that their sales hardly needed boosting, this desire attests primarily to the status conferred by such membership[237].

In 1571 Academicians acquired exemption from joining the guild, membership of which had previously been obligatory[238]. In effect the Accademia del Disegno was responsible for breaking the monopoly held by the guilds as professional associations. But within the Academy itself progress was slow and conflicts abundant, which preyed on Vasari's nerves increasingly during the final years of his life. After his death in 1574 a further reorganization was effected and the Academy was firmly set on a less ambitious course.

The Academy acquired the official status of a professional body in 1582, thus moving into the arbitrational orbit of the *Mercanzia* guild, whose special court settled all trade disputes. This status therefore represented a loss as well as a gain; the exalted aspirations for the profession laid down in the early correspondence of the Academicians receded into the background[239]. The regulations stipulating membership dues, budget expenditure, procedures for disputes with clients and liability for the quality of craftsmanship in work delivered were scarcely any different from the old rules of the guilds[240].

Besides the social advancement gained – the professional culture was now definitely linked with the higher social circles – the chief gain was educational, a supplementary, theoretical element being added to the workshop training of young artists. There were more opportunities than before to attend lectures on a variety of subjects, including mathematics. Facilities were created for drawing from models, making studies of drapery and studying works of art[241].

St Luke, for centuries the symbol of the painters' profession, vanished from the Academy's seal, replaced in 1574 by a more abstract image that was better suited to a professional identity bound up with the concept of *disegno*[242]. The Academicians sought a broader orientation than that afforded by the knowledge passed on from masters under whom they had studied. They drew up lists of outstandingly proficient fellow-artists, and in 1602 another list followed, naming those whose works were not allowed to be exported[243]. Heading this pantheon were Michelangelo, Raphael, Leonardo and Andrea del Sarto, followed in order by Beccafumi, Rosso, Titian, Correggio, Parmigianino and Perugino.

Being advocates of an intellectual approach to painting, members of the academies took a special interest in history and theory. But also in terms of sheer craftsmanship they strove to maintain higher standards than were expected among men of the guilds. Stylish in presentation, the Academicians were intent on fostering an élitist concept of art and on ensuring that the

prestige won initially by a few individuals would gradually become the enduring collective prestige of their profession.

Notwithstanding this ideal, the gap between high-flyers and the rest now widened to such an extent as to undermine what unity there had been in the organization of the profession. Academies in various cities, however dissimilar their roots, mainly provided a form of education that supplemented that of the studio. With the notable exception of the Florentine Academy, which assumed the function of the guild, they did not establish a professional monopoly. At one end of the scale were celebrities in the major European courts, who could operate largely untrammelled by guild, confraternity or academy. At the other was the majority of artists, who spent their working lives executing simple commissions and selling standardized works and were not in need of any elegant academy, for whom business went on – as it would for centuries to come – much as before.

HISTORY AND THEORY OF ART

During the sixteenth century earlier impulses towards formulating a history and theory of art were greatly expanded and systematized. In this development, too, the painter and architect Giorgio Vasari was a crucial figure. The response to Vasari's writings was immediate, far-reaching and enduring; during his lifetime his *Lives* were published in two massive editions and commented on at length, and after his death they were used as models, time and again, by those writing subsequent collections of artists' lives. He also inspired other historical and theoretical treatises on art, including some from less successful painters such as Armenini, whose *De veri precetti della pittura libri tre* was published in Ravenna in 1587. A series of dissertations also appeared by men who advised on commissions, expounding on their views of art[244]. After the turn of the century the first major surveys appeared in Italy, by Bellori and Baldinucci among others. The Netherlandish painters and their works were examined in voluminous works by Van Mander, Van Hoogstraeten and De Lairesse. But in art theory and art history, as in painting, sculpture and architecture, it was primarily from the developments in Italy between 1200 and 1600 that patrons, advisers, painters and public continued to draw their professional models.

Vasari claimed for his age not only an acquired superiority of technique but also an expert knowledge of scenes to be depicted and of mathematics, design and composition. The entire range of necessary skills, according to

Vasari, had been developed to perfection by his century, added to which
his contemporaries were acquainted with various theories that contributed
to the excellence of their performance. Although he acknowledged that a
particular painter excelled in his brushstroke or use of colour, his draughts-
manship or style, he regarded these special achievements as so many vari-
ations upon one theme: the consummate skill of cinquecento artists.

In the *Lives* a number of general concepts were developed with which
the diverse skills of the artist could be analysed. It was particularly this
theoretical aspect of his work that set Vasari apart from chroniclers and
panegyrists. Some of his ideas derived from Alberti, but he was far more
concerned than Alberti had been to create a link between theory and
history. Vasari also drew on historical surveys by Ghiberti and others,
combining what he learnt from them with his own observations to produce
by far the most extensive history of art that had yet been seen. History and
theory merged in his *Lives of the Most Excellent Painters, Sculptors and Architects*,
a work that grew from his broad-ranging scholarship, mastery of diverse
literary genres, keen powers of observation, extensive experience, immense
capacity for work and no small measure of self-confidence[245].

Vasari on occasion calls distinguished witnesses to support his case, but a
line from Dante or Petrarch may be given a very different import from
that originally intended. When Dante discusses Giotto's superiority to the
renowned Cimabue he is making a point about the impermanence of
worldly glory[246], but Vasari quotes Dante to show that in 1310 the world
of powerful figures (and patrons) peopling the *Divine Comedy* already saw
that Florentine painters were moving ahead in craftsmanship and admired
them for it. Vasari glosses over the painters from Paris and miniaturists from
Bologna also praised by Dante.

Many of the terms and views in Vasari's work derive from courtly
writers[247]. Elegance, self-control and a flexible conduct attuned to cir-
cumstances are all appropriated by him as standards by which to assess
painting practice. Vasari speaks of *buona grazia* and *bella maniera*, opposing
them to a harshness of style that he disdains[248]. Castiglione had used the
term *sprezzatura* for the standard of graceful conduct to which courtiers
should aspire: it refers to the epitome of courteous behaviour – the most
superior *maniera* – conveying an impression of effortlessness and ease[249].
Vasari could not command the elaborate rhetoric that was meat and drink
to court humanists, but his own style was characterized by a wide range of
rhetorical figures. *Maniera* is the main critical term used by Vasari to appraise
the expertise developed by painters between the thirteenth century and

around 1560. It was a felicitous term, given its associations and the cinquecento painters' desire to be accepted in courtly circles. In his vision of art, the *maniera* of painters had steadily improved over the previous three centuries up to his own day.

The artist's task was, and remained according to the writer of the *Lives*, to depict an *istoria*, a term that embraced subject, content and significance of the pictorial image. Vasari distinguishes between a number of skills that are brought into play by the competent painter between conception and execution. One is the ability to make a composition incorporating human figures in varying attitudes and expressions; another that of representing smaller elements – parts of human figures such as hands, head, torso and legs. Yet another is that of selecting the most suitable elements from nature and exemplary works of art from which to build up an *istoria*. With his use of terms such as *inventione* and *disegno* Vasari stresses the intellectual aspects of the art of painting rather than qualities of craftsmanship[250]. Drawing from imagination played a particularly important role here, given that complicated representations of battles or historical scenes were often called for that could not, of course, be observed at first hand.

Painters' gradual acquisition of a complete range of skills is described in terms of a cumulative process leading to ever-greater control over every aspect of their activities, which Vasari desired to preserve for posterity. From his own position as a painter he reconstructed the successive innovations as a series of accomplishments of outstanding artists. Although stressing the taxing demands now made by patrons, Vasari was more at pains to insist on painters' desire to show what they could do[251]. What they were expected to do was certainly of a new order of difficulty; diverse portraits of scholars each set in a distinct space or a battle-scene crowded with horsemen obviously presented more problems than, say, a group of figures within one space or a row of saints on an altarpiece.

Vasari's history of the painting profession, voluminous though it was, hardly took any account of the work of the average run of craftsmen: no biographies for them. Vasari shone his light into the lives of the most excellent painters and their most eminent patrons. He paid scant attention to the painting of the carts and flags, chests and simple altarpieces that were produced on a massive scale. Furthermore, Vasari was most concerned with new representations. This is true not only of the *Vite* but also of the *Ragionamenti*, in which Vasari explains his own paintings in the Palazzo Vecchio to his patron's son, clearly implying that he has devised them and is the only one capable of properly explaining their meaning.

74. Maarten van Heemskerck, *St Luke painting the Virgin Mary*, 1532 (photograph Frans Hals Museum)

In Vasari's view of history, art first flourished in Greek and Roman times[252]. When decline set in, the actions of the popes, Gregory the Great in particular, served to exacerbate it[253]. Gradually there was a measure of recovery, originating in Tuscany, though it was some time before there was any question of a continuous development from master to pupil or from one patron to the next. With Cimabue and his pupil Giotto the tide turned. In the second edition of the *Lives* more works are attributed to Giotto than in the first, enhancing his role in the rebirth of the art of painting. Vasari regards the two Florentines as the first moderns who were able to follow and then surpass the example of the ancients. He divides the period of rebirth of the arts into three stages. Dealing with the first stage, the role he accords to the painters of Sienna is limited, hardly expanding on what had already been written by Ghiberti. This image of Sienna conforms with his painting of that humbled city in the Sala del cinquecento; Sienna was defeated by Florence while Vasari was working on the second edition of his *Lives*.

The second-stage innovations were likewise due to the Florentines. Vasari showers praise on Brunelleschi, Donatello and Masaccio for their breakthroughs in architecture, sculpture and painting, and he goes on to discuss the qualities of the younger generation of Florentine masters. He writes at length on the contributions of patrons, dwelling particularly on the Medici family and projecting upon the whole fifteenth century the dominant influence of Leo X and Cosimo I. Other patrons – the non-Medici popes, families and courtly clients in Urbino, Mantua, Rome and Naples – all stand in the shadow of the Medici family.

In the version of history presented in the *Lives* the role played by quattrocento court painters is somewhat toned down; many artists such as Piero della Francesca, Mantegna, the court painters of Ferrara, Melozzo da Forli, Jan van Eyck, Justus of Ghent and Roger van der Weyden had more influence than Vasari suggests. The Flemish contribution is limited to the introduction of oil painting; this he ascribes to Van Eyck, who is not, however, honoured with a Life. Splendid invention though oils undoubtedly were, Vasari points out that fresco remains the most superior technique for painting. He stresses the limitations of the Flemish, saying that they mainly produce devotional images for an illiterate public (see fig. 74). They are deficient, he explains, in the skill of *disegno*[254].

Vasari's third stage saw the coming together of all the previous achievements; painters now had the entire range of skills at their command[255]. This included an assimilation of the advances of the Flemish (such as they were)

by the Italians; in the sixteenth century, Vasari claims confidently, the profession reached perfection. He does remark that a certain hardness and sharpness of style could still be observed, for instance in the work of Mantegna[256]. By the 'modern age' painters had acquired the ability to depict all imaginable scenes with apparent effortlessness. With their knowledge of classical art they had perfected style and design. Their lines were smoothly blended, they could depict emotion and suggest vitality, details and movement were correctly rendered and complicated architectural structures represented accurately. Moreover, painters could work faster and more efficiently; Vasari asserts that a painter could now produce 'six paintings in a year, while the earliest artists took six years to produce a single one. I can vouch for this both on the basis of observation and from my own experience'[257]. Although Vasari was to achieve more renown for his writings than for his art, he little doubted his own artistic excellence, taking pride in his special talent for combining high quality with great speed in painting. The vast frescoes in the Palazzo della Cancelleria at Rome were indeed named the '100 days' fresco' because of the pace at which he had worked to complete them. Vasari's glorious self-image was bolstered by this public claim, and he did not mention the verdict on these frescoes pronounced by Michelangelo, for whom he had such admiration: upon being told of the speed with which the work had been executed, the great master had reportedly said 'That is obvious'[258].

PART V

SOCIAL CONTEXTS TO THE PRESENT DAY

1. ITALY, 1200–1600:
A FIRST RENAISSANCE

===

PROFESSIONALIZATION

The complexities of historical change preclude bold assertions of causality between one process and another. Nor can we speak, in general, of the absolute beginning or ending of any of the processes described in this book. A certain pattern of relationships can be traced, however, between painting, power and patronage. In order to reveal this pattern, theoretical notions such as professionalization, state formation and civilization are of invaluable assistance.

No precise definitions of these theoretical notions can be found in the literature. I have approached them by pointing to certain distinguishing features, derived in part from classical sociology and in part from my own studies – the fruits of empirical research, they helped determine the direction my continuing investigations would take. All three concepts refer to processes and to relationships; none can be taken to imply either a value-judgement or a constant march in one direction.

The distinguishing features named in connection with the concept of professionalization were the development of new skills, the establishment of organizations and the evolution of both historiography and theory. In terms of these characteristics, it is indubitably the case that painters went through a process of professionalization in the four centuries that have been discussed.

Italian painters developed an impressive array of skills in the thirteenth and fourteenth centuries, broader in range than the accomplishments of their forefathers or their non-Italian contemporaries and broader than those of most other groups of craftsmen. Innovations were made in fresco work, which was also practised in far more places than before. A new system of panel paintings came into being: images with saints and episodes in their lives placed on altars near the choir partition; ever larger panels – often

ordered by confraternities – to be elevated on rood beams and to which the eyes of the congregation would be directed during hymn-singing; polyptychs on high altars (initially low, then increasingly large) to function as the focal point of the Mass; smaller panel paintings for votive and memorial Masses at side-altars, and still smaller ones for private devotion. (The oldest type of panel painting, icons carried aloft during processions, did not share in the developmental process; these gradually became obsolete.) The tradition of miniatures continued and acquired a larger fund of images. Specialists in arts that had flourished earlier – workers in mosaic, precious metals and marble – found it increasingly hard to compete significantly with the painters, who learnt what they could from these arts but worked faster and used cheaper materials. Since the thirteenth century the entire repertoire of decorations and furnishings supplied by painters had undergone immense diversification.

Like most other craftsmen, painters organized themselves into guilds and confraternities in the course of the fourteenth century. These bodies controlled admittance to the profession by making membership compulsory, monitoring training, imposing codes of conduct on all members and engaging in communal rituals. The organizations guaranteed members a modest income. Some select few, such as Giotto and Simone Martini, gained fame and wealth by virtue of their extraordinary accomplishments, conferring upon the painting profession a new mark of distinction.

In texts on other subjects, scholars started commenting on the remarkable achievements of the most successful painters of their day. Initially little more than asides, such remarks came to be placed more and more often in a historical perspective that stressed the increasing skills of Italian painters since the late thirteenth century. Accompanying these early stirrings of historiography came the first attempts at theorizing.

With the quattrocento new advances were made in all these respects, particularly in Florence and (during a briefer period of time) in various courtly residences. Painters learnt how to use mathematical rules for the depiction of architectural constructions, for determining proportions and designing their compositions. They had better techniques at their command, including the recently introduced technique of working in oils. Observations were rendered into drawings and paintings with greater accuracy and elegance, and the illusion of space was more successfully conveyed. Painters were able to represent complicated scenes for which no models were at hand, and not infrequently they changed the appearance of existing

scenes by adding buildings and landscape in the background and portraits in the foreground.

Many contemporary writers now focused on the art of painting from a variety of vantage-points, and there was a burgeoning of both historiography and theory, carrying on from earlier treatises. Texts on painting were largely concerned with the innovations and with the innovators themselves. Therefore reflections on painting focused on the upper echelons of the profession, which was the breeding-ground of innovation.

As far as organizations were concerned in the quattrocento, guilds and confraternities still existed, but the leading names among painters were gradually able to cast off their shackles and operate more freely. Court painters could set themselves quite beyond the reach of guilds and the like, but moving within the orbit of the court meant that they were subject to different constraints. Higher salaries and greater prestige came with the job of court painter; dependency on the prince and his courtiers was the price paid.

The type of skills mastered by leading artists in the cinquecento was so sophisticated that there could no longer be any question of a large-scale transfer of experience and knowledge to the next generation of aspiring painters. Besides possessing the ability to design intricate scenes never before represented – which pre-supposed a command of all the skills that had been evolved over the previous centuries – the trend-setting élite had studied everything from antique art to anatomy, and had banished all harshnesses of line from their work. Furthermore, some few painters had a remarkable inventiveness in the conception, design and execution of new scenes. From the mid-cinquecento onwards, however, changes in painting practice were no longer seen in the light of an inexorable march of progress. Leonardo da Vinci, Raphael, Michelangelo and Titian were regarded as greatly superior to their masters, but their pupils did not go on to still more exalted heights.

The view that there had been a steady progress in the art of painting from the thirteenth to the mid-sixteenth centuries developed and was propagated, and on this basis a series of interrelated treatises, some of immense bulk, was written that amounted to a historiography of the profession that was more extensive and more soundly underpinned in terms of theory than anything that had existed before.

In this period the most successful painters collaborated with their peers in sculpture and architecture, hoping to found a professional organization

that would do justice to their new status and the more sophisticated training they deemed necessary. With this aim, the academies were established. Academy members demanded far greater independence from clients than guilds and confraternities had done. They wanted to devise a programme of study that was appropriate to the theoretical and historical framework within which their profession was now discussed. Academicians were not in a position to impose their one-sided view of their art on all craftsmen, clients and buyers, however. The individualization and aristocratization of this small group of artists in the sixteenth century – and the resulting gap between them and the majority of craftsmen – in fact heralded the definitive collapse of a large part of the profession towards the end of the nineteenth century.

PATRONAGE

From the specific circumstances in which one painter produced a small panel or miniature to the general sweep of historical change, the professionalization of painters was intimately bound up with the mechanics of patronage. In Italy the entire period from 1200 to 1600 was imbued with a persisting eagerness to commission pictures, and the artist's profession was revitalized in several waves of renewal.

There was no question of isolated initiatives; the needs of clients, advisers and public formed dynamic networks. Patronage was dominated successively by four such networks, which were therefore crucial to the innovations made by the vanguard of painters: they centred on the mendicant orders, the republican city-states, merchant families and princely courts. Within each of these systems in turn a great measure of continuity evolved in the types of commissions given, creating fertile conditions for painters to innovate in response to the demands of their patrons. In each case this burgeoning was followed by a less adventurous period of consolidation, paralleled by stabilization within the profession.

A three-level hierarchy became discernible, with an élite engaged on works that taxed their inventiveness to the full and the great majority turning out standardized products of craftsmanship; an intermediate group straddled these two extremes. A large city would have some twenty ordinary craftsmen. These were the backbone of the profession – preservers of stability and guarantors of continuing production.

Remote from the craftsman's world, a small group of painters tackled prestigious commissions in the most powerful circles of their day. New departures originated in rivalry. Each fresh wave of commissions sharpened competition among clients and among artists. The achievements were in the main cumulative, a result of continuity in similar types of commissions coupled with the constant diversification of particular constituent parts.

This unique combination of tradition and innovation was characteristic of both patronage and painting in Italy. Individual differences between patrons were highlighted by their disparate social milieus, but certain features were common: a typical leading patron would be a man over forty, someone whose upward mobility had come with an institution's rise to power. No single person, however powerful, could set a completely personalized stamp on the commissions that were issued; though individually tinted, each man's choices were heavily influenced by those of contemporaries and predecessors. Deciding on a commission generally meant picking an established precedent and giving a new turn to it. A mix of convention and individuality thus determined Italian patronage, and a similar pattern imposed itself on the art of painting in response.

Painting flourished after two centuries of economic expansion. From 1100 to 1300 the major population centres had prospered; following periods of stagnation and decline had come recovery, consolidating the upward trend. The general economy did not directly determine painting commissions as it did major expenditure: paintings were incomparably cheaper than new city walls or a cathedral, and cheaper than most other forms of decoration. Indirectly, however, economic revival was a vital precondition for patronage, if only in that it filled the coffers of rival factions. The impact of political and cultural change was more direct.

STATE FORMATION AND CIVILIZATION

It was generally after a period of accelerated state formation that major artistic commissions were issued. State formation involved centralized control of taxation and military force, territorial expansion, specialization within administrative institutions, the codification of laws and the elaboration of general ideals with which the state identified and a view of history that tallied with these ideals. All these developments were notably interrelated. Although they did not, of course, keep step with each other or occur

simultaneously throughout the peninsula, the dominant trends in the network of major population centres were very similar. Out of the numerous little sovereign states extant in 1200 grew, over four centuries, a handful of large states that were in turn heavily dependent upon the major European powers.

Accelerations in state formation processes went hand in hand with large-scale patronage and an upturn in professionalization. This happened during various periods: in Rome, Pisa and Assisi from 1200 to 1320; in Sienna from 1290 to 1340; in Florence from 1270 to 1490; in Urbino and Mantua from 1470 to 1500; and again in Rome from 1500 to 1520 and Florence in 1550 to 1580. Similarly, a decline in these political processes charted stagnation in painting: in Rome, Pisa and Assisi after 1320, Sienna after 1350 and Florence after 1580. Sometimes, notably in Rome, stagnation was followed by recovery, in politics as well as in art. Sometimes – and here Sienna is the most poignant example – it was not.

It was a special feature of state formation in Italy that rivalry among a proliferation of states, some of which were quite tiny, persisted over a long period of time without any one power achieving an enduring ascendancy. Relatively small entities such as cities, mendicant orders and factions remained influential far longer than in, say, France or England. A protracted period of political expansion with numerous forward thrusts in different population centres at different times provided a crucial enabling impulse for the flourishing of artistic patronage in Italy.

The state's main features were displayed to the public in pictorial form: examples discussed in this book are the decorations of Sienna town hall (1300–1340), the panel paintings in Urbino (around 1474), the frescoes in the Vatican Palace (around 1512) and the paintings in the Palazzo Vecchio in Florence (around 1560). All the features of the state enumerated above were alluded to in these works. On occasion such themes also found their way into paintings executed for mendicant churches and family chapels. The importance of topical political concerns is underscored by the fact that details of representation were often changed at the last minute. The trends exhibited in painting – an increase in scale together with ever-greater precision in detail – actually parallel and reflect the evolution of the state itself.

The second process crucial to art and artists was that of civilization. Parallels can be traced in short-term developments, and the entire period from 1200 to 1600 shows the same pattern: when the process of civilization

gained momentum, so did patronage, and likewise the professionalization of painters. Periods of decline or stagnation were similarly mirrored. As already noted, the two processes of state formation and civilization also moved in step.

Interest in and exposure to cultural values grew fast between 1200 and 1350. Verbally and visually, ideals formulated as part of the 'civilizing' process impinged upon the consciousness of the populace as never before. In many towns that had been no more than a few houses built around a plain church in the eleventh century, great public buildings were erected. In some of these the fourteenth century saw a striking continuity develop in the reiteration and accentuation of codes of conduct, also expressed in the decorations of these buildings. Codes were constantly refined, expanded and systematized. The persistent need to visualize each detail – especially when power changed hands – was a motor for the giving of commissions. New leaders effectively challenged painters to find fresh solutions to problems and gave them the opportunity to do so.

The power of images was embedded in changing systems of political power. As one group ceded dominance to another, there were fluctuations in codes of conduct. The age of mendicant orders was one in which the theologians' vision of civilization held sway. Under merchants and city–republics the different emphases of jurists and moralists prevailed, and at princely courts the key role was played by humanist scholars. Each successive vision was expressed in an immense range of writings: treatises, statutes, glosses, commentaries, poems, memoirs, speeches, translations, new editions of old texts and historical works. The friars rooted themselves in existing doctrine, inflating traditional distinctions between the sacred and the profane, and gave wide publicity to their proliferating repertoire of ideals. The period of the city–republics (in this book exemplified by Sienna in its prime, around 1250–1340) saw these ideals refined and specifically linked to the notion of loyalty to the state in which the people lived, which meant, for instance, that the moral imperatives to pay taxes and to refrain from violence became much greater. Wealthy merchants (the emphasis here is on trecento and quattrocento Florence) were intent on giving visual expression to their relations with Church and city in addition to their persistent concern with images of kinship. It was princely courts especially that strove to achieve a maximum of sophistication. Here, aristocratization of ideals meant exclusivity in art; paintings were produced primarily for a very select group. Where painting had earlier been an instrument of

democratization in the city-states, in courtly circles towards the close of the fifteenth century images embodying the ideals of the state and its culture were once again a matter for a small élite.

We can find ample testimony for the links suggested here between art and society – or more precisely, between patronage and the professionalization of painters on the one hand, and the processes of civilisation and state formation on the other – in pictures themselves. History, topical interest and ideals became intertwined in works of art. Paintings alluded to the social codes of the community in which they were created: they showed the connections between clients, advisers, the public and painters themselves as well as the wider social contexts in which people lived their lives. The very significance of the paintings derived from the relations between those involved in the commission and the society in which all relations and interactions were embedded.

Paintings were no mere descriptive mirror of social reality but expressed a partly prescriptive totality of codes of conduct, which went so far as to show beholders when to feel fearful or guilty or to have a sense of shame. Cultural ideals publicly displayed or defined by no means fully coincided with people's actual behaviour, any more than images of the state were identical to the everyday realities of central administration. Like religious tracts and moral dissertations, and indeed like laws, pictures helped to guide the actions of individuals bonded in mutual dependency.

Between 1200 and 1350 the number of people exposed to pictures rose dramatically, after which it stabilized and the accent shifted to exchanges between smaller élites. The significance of most publicly displayed images was quite accessible to the community at large. Multiple levels of meaning or veiled allusions were rare, and when they did occur – for instance in mottoes and in certain more private images in palaces – it was in a context in which exclusivity of appeal to a sophisticated clique was essential to the commission.

Cultural ideals, like the features of states, can be recognized in paintings. Artists depicted every kind of virtue, specifying and structuring according to the code of the time. They showed beholders how virtue could lead to glory, and misconduct to punishment and disgrace. Shining examples of civilized conduct and sound government were portrayed in glorious opposition to rebels, robbers and rapists. Painters not only gave visual form to a given set of precepts, but showed when they should be adhered to and by whom.

The above description stops at around 1600. Cultural values were first introduced, disseminated and visualized (1200–1350) then consolidated in cities (1300–1500) and at length refined within increasingly exclusive circles (1450–1600). In a subsequent stage, the process of wide dissemination began again. By and large, a growing section of society was increasingly confronted with a system of cultural values that was by now far more sophisticated and comprehensive, through the medium of pictorial images. Painters became such excellent purveyors of culture that the most successful among them came to be seen as themselves representing the peak of cultural achievement.

2. LOOKING FORWARD: 1600–1900

Much research remains to be done before the further developments of professionalization, state formation and civilization can be described with any confidence. I would not wish to conclude, however, without venturing to make some necessarily speculative reflections on the centuries following the period discussed in the previous chapters. Unlike the preceding four hundred years, during the period from 1600 to 1900 there was no question of an overall increase in skills unanimously hailed as progress by contemporaries. The painting profession was rather characterized by efforts to conserve expertise and to experiment with new variations, and long-established professional associations suffered from flagging interest, some vanishing altogether. As the accomplishments of Italy's Renaissance were disseminated in a wider geographical area, new centres of artistic production sprang up and flourished.

The professional ideal born in Italy gained currency not only among painters, sculptors and architects themselves but also among patrons, advisers and the public. This is clear both from the paintings themselves and from historical and theoretical treatises on painting written in France, Germany, England, the Netherlands and, unsurprisingly, in Italy itself. The consolidation and expansion of the painting profession in Europe was further effected in various new societies, art academies in particular. In the nineteenth century, when guilds everywhere were being dissolved, academies expanded into institutions with their own training programmes and made bids to monopolize the profession.

Artistic ideals were still dominated by classical and late-classical art, together with advances made by the renowned Italian masters of the cinquecento. The title of forefather of the profession fell to Apelles; it was generally accepted that painting had suffered a long period of stagnation both after the fall of the Greek republics and, more dramatically still after the disintegration of the Roman Empire. It was not to be revived until the thirteenth century. In the sixteenth century, painters had such a strong

sense of pride that they saw all their predecessors as forerunners of a professional ideal which they themselves had consummated.

During the nineteenth century, nation states exerted themselves to keep the great traditions of art and patronage intact. In most cities monuments and public buildings were erected, their design and subjects recognizably referring to historical examples. Alterations were made to the existing imagery of states and their cultures, symbols in some cases merging to become emblems of the larger political entities that had absorbed them. Neoclassicism brought out historical allusions, and style itself gained in significance through its associations with the democracy of ancient Athens or the imperial might of Rome. The Neogothic style recalled the sacred grandeur of the medieval church, placing it in the new context of the nation state.

Statues of politicians and national monuments were raised in their hundreds. Large-scale decorations in parliamentary buildings and town halls expressed the history of nation states and the political ideals they stood for, while their tale of economic progress was told in images appearing on the façades of stations, stock exchanges and the like. Pictures made for theatres, opera-houses, academies and museums would focus on the cultural magnificence of the nation. In addition, statues were erected in city squares commemorating famous artists who had been born in the city or worked there. Politicians, after all, tended to be controversial figures. Democratic states therefore increasingly favoured artists as safer symbols of the pride shared by an entire nation.

While patronage continued to be of significance, a steadily increasing role was played by the art market. Initially, during the seventeenth century, this development was most marked in the Netherlands, but by the late nineteenth century it was far more widespread, and collectors in France and the United States were clamouring for landscapes and other small (largely 'realistic') paintings. Many painters, among whom were the Impressionists, took to working for buyers without waiting for well-defined commissions to be given. Beside the demand for cheap standardized paintings and the demand of an élite for old masters arose a third market, as modern art aroused an increasing amount of interest among collectors. At the same time states began to purchase paintings from exhibitions without having commissioned them.

3. THE TWENTIETH CENTURY: ART IN FLUX

NEW POWERS AND THE DECLINE OF PATRONAGE

State formation has been a continuing process in the twentieth century through the consolidation of nation states as political entities and their incorporation into a network of international organizations. The processes of civilization in general have also continued to develop along the lines laid down in preceding centuries. It is in this period that diverse groups such as doctors, lawyers and engineers have become fully 'professionalized' in the sense used in this book.

Painters are something of a special case. Social developments and the professionalization of painters have not continued in parallel as they did during the periods discussed here. Unlike doctors and lawyers in the early twentieth century, painters could already look back on a long and illustrious professional history. The prestige of some old masters was virtually unique. Artists and advisers on matters relating to art live both with this realization and with the memory of the former grandeur of patronage, and the heritage of masterpieces and magnificence has stimulated artists, advisers and the public to seek ways of adapting old solutions to the changing conditions of life.

Both art and patronage have received vigorous injections of energy whenever 'state formation' was being rigidly imposed: fascist Italy, national-socialist Germany and various communist states exemplify this link. Later critics of the regimes in question therefore tended to condemn magnificent display and symbolic art, pointing to the associations between these kinds of art and the abuse of power in totalitarian states. As a result, the role artists had long enjoyed – that of portraying the grandeur of power in ways immediately recognizable to all – lost its legitimacy.

In the twentieth century direct commissions, so influential on the painters' profession for over six hundred years, have gone into definite decline; after 1950 even the brief revival of interest in commissioning war monuments died out. The old patrons of art such as friars, city–republics and

courts have vanished from the social scene. The new powers in society – modern states and wealthy entrepreneurs and companies – express little or no interest in commissioning works from artists, and the tradition of patronage established in the Renaissance has come to an end.

Multinational companies whose business is oil, chemicals or automobiles have not been impelled by any urge to clarify their social identity by commissioning huge works of art with recognizable logos. The custom of decorating railway stations with proud images of train technology and the geographical range of the railways vanished after the 1950s, and sporadic efforts on the part of trades unions and political parties to visualize their manifestoes in grand artistic commissions have also petered out. Whatever the role of banks in furthering prosperity, whatever the caring role played by hospitals, insurance companies and pension funds, artists are not called upon to make pictures clearly displaying the usefulness of these institutions to the public. Even churches order fewer Madonnas than in the past.

THE RISE OF THE COLLECTOR

In general, the *nouveaux riches* have had little interest in commissioning works of art. Many have amassed art collections, however. Some entrepreneurs have been dedicated collectors of old masters, subsequently donating their collection – and their name – to a museum. After 1950, in the train of this development, businesspeople and companies have also begun increasingly to collect contemporary art. In place of the old rivalries between individual patrons we now have worldwide competition among museums. The accent has shifted from commissions to collections. By virtue of this interest a small élite of artists has emerged with fame and wealth by producing the kind of work that fits into museum collections. Next to those museums that preserve the Old Masters, a new species of museum has emerged that generates its own celebrities.

Most states have tended to accept responsibility for fostering the arts by providing grants and tax relief. Governments at local and national level have drawn up general objectives such as preserving the cultural heritage, heightening cultural awareness among the population, ensuring a wider distribution of culture across the social spectrum, promoting higher quality and innovation in art; at times the professional position of artists has also come under their protection. Art policy has been introduced at different moments and in different ways from one country to the next, with variation

in its content. As a broad generalization, however, the role of the state in the art sector has gradually increased and been legitimized in lofty formulations concerning the good of society.

In our times the magnificent display and self-promotion that was associated with patronage has come under a cloud; in modern democratic states it is deemed unseemly and embarrassing. The ideals cherished by modern states have encouraged a shift away from a patronage based on a direct display of power towards an arts policy formulated in general terms, which sanctions the museum of art as a legitimate seat of splendour.

MODERN ART: A SECOND RENAISSANCE

Producing a painting destined to be collected and exhibited in public makes different demands on an artist than producing a work that has been commissioned. Spectacular innovations are hardly to be expected within the existing framework of skills, and craftsmanship is generally thought to be actually declining. Artists are therefore stimulated to explore radical variations that are at once bold departures from tradition and worthy heirs to a golden past.

This situation has been developing for some hundred years. Those attempting to continue the Italian professional tradition have attracted less and less admiration. Even those in the nineteenth century who achieved most success in the eyes of society came to be regarded as producing work inferior to that of the cinquecento. Their clients and advisers thought so – indeed, the artists themselves agreed – and for decades this remained the view of posterity. In our own times, symbolic images have come in for more and more criticism for being obscure, politically tainted and out of step with modern times.

The next step has been to rewrite the history of the profession and to redefine theories of art. The emphasis on the renewal generated by a small élite of artists has increased further, but it has been divorced from any admiration of the specific technical skills enabling a given image to be depicted with maximum clarity. In the new creed, innovation is all, and social context has been swept aside. This also finds expression in the exhibition of Old Masters in museums; thus displayed, the original situation in which they were created, their clients and the public that beheld them have all become invisible.

Voices calling for a reappraisal of generally accepted historical descriptions

of the painting profession were at first isolated and unheeded. In the course of this century, however, old assumptions have been overthrown. The sixteenth century has been looked on for the first time as a period of decline; Vasari and his contemporaries from the age of perfection have been dubbed 'mannerists' and, worse still, 'kitsch'. In course of time some collectors, critics and artists have come to prefer Italian and Flemish 'primitives' to Raphael. True artistry has been discovered in the unfinished works of Michelangelo and Titian, and in sketches produced by their contemporaries. Museums have taken to moving completed works, in particular the monumental works once exalted as the acme of art, into their store-rooms, giving pride of place to small works by 'primitives', a reappraisal that has in passing, it might be added, produced recognition for children's drawings. Rising on the wheel of artistic fortune are the Dutch masters of the seventeenth century, whilst the great history painters of the nineteenth century have fallen from grace.

The re-evaluation of artistic accomplishments and the accompanying new theories and historical views have all been profoundly influenced by the stagnation of traditional skills on the one hand, and the spectacular rise of new professions on the other. Emphasis on technical mastery and theoretical knowledge has steadily increased, but painters – who once led the field in these respects – have entirely lost that role. Numerous new professions have come into existence, overtaking painters in many areas that they monopolized for centuries. Despite efforts to stem the tide, from the nineteenth century onwards painters have gradually lost their hold on design in architecture, town planning, civil engineering and military works to engineers, whose own process of professionalization spanned the nineteenth century. In the transfer of visual information, too, painters have lost their former role to new professions, superseded by photographers, film makers, graphic designers, art directors and information experts.

The de-professionalization, as it were, of painters can be traced not only in terms of skills, theories and historical views but also in their organizations. First guilds and then academies and artists' societies have all lost their influence, and the many new organizations formed have been unable to establish a professional monopoly. Clients and buyers have been lost to the broad base of the painter's profession without being replaced to any great extent. A small élite of artists is able to hold its own, but has no ties with a professional body as do, for example, doctors and lawyers.

The historically based prestige of art has remained unassailed through these developments, even being accentuated by publicity and by the public's

frequenting of museums in vast numbers. In other words, painters have lost their former role but kept their status. For a small group of artists this combination has created openings for what might be termed a partial re-professionalization. In this new construction, side-issues move to the fore and what were once central concerns are marginalized. This has created more scope for specialized authorities on art, those able to explain and justify the new views, styles and trends. The constant debates on quality, innovation and autonomy in modern art have increased the influence of dealers, critics and the advisers of affluent collectors.

Artists have acquired the freedom to eschew representational art and to choose their own subjects. Abstract art and individualized iconographies developed because of the decline in commissions prescribing images. In this changed context, the freedom of artists has grown into a doctrine. Judging the merit of a work of art is more difficult than in the past, and has increasingly become a specialist area in itself. Discussions among artists and others working in the field on trends in the history of art have become unintelligible to the public at large, because it is scarcely possible for the uninitiated to consider qualitative criteria without referring to technical skills and iconographic precepts.

A small group of artists has made a virtue of the social necessity to rethink their aims. They have revamped elements deriving from the prestigious history of the profession in a new social context made up of advisory committees within museums, foundations and companies. It is a world in which originality, autonomy, excellence and individuality have come to take precedence over draughtsmanship, mastery of traditional techniques and the ability to make a recognizable image. With public recognition of artists has come honour and prestige for all those institutions connected with art, precisely because artists are seen as possessing courage, visionary qualities and profound insights. In other words, modern art is equated with the pinnacle of civilization.

Individual innovation in art has been elevated in our times to the status of an unquestioned aim, without reference to any network of patrons. This view has been projected on to the past. What this means is that our view of art history is dominated by artistic geniuses; we tend to regard them as having mapped out their own careers and having been guided solely by a set of ideals set above mundane social reality. Such a reading sees Renaissance artists as having courageously struck out at the risk of being misunderstood, and in fact only achieving true recognition much later, when real taste finally triumphed over the old preference for kitsch.

This sea-change in historical perspective has been consolidated by the transformation of numerous churches, town halls, family chapels and palaces into museums. Wrenched away from its original function and context, art produced in the Renaissance and earlier is cast in the role of the harbinger of modern art. Tourists milling around churches are occasionally pulled up short by the celebration of Mass, without for a moment being confronted with the role once played in that Mass by the paintings they have been admiring.

While the magnetic appeal of religion has declined, art has gained significance in the realm of elevated ideals. The intelligentsia, in particular, have come to regard art as symbolic of freedom, renewal and contemplation. Concern for modern art in turn confers privileged social status – as well as helping leading artists to live affluent lives. Famous modern artists are seen as the true descendants of Renaissance geniuses, and art specialists cast themselves in the role of preservers of the great tradition of patronage. Together they have made museums the cult places of modern society. Intellectual circles honour modern artists while to most of society the new saints are sports champions and pop stars. Where religion no longer has a monopoly on the appeal of the spiritual or the challenge of the unknown, art has itself acquired a sacred significance that has soared far above the social struggle to achieve status, wealth and power.

NOTES

===

INTRODUCTION

1. The Barocchi edition gives the first (1550) version as well as the second. This anecdote comes from Vasari–Milanesi I, 370–72.
2. See Vasari–Milanesi I, 183–4, 224–59, 369–409.
3. See Vasari–Milanesi II, 291: 'Ma quello che vi è bellissimo, oltre alle figure, è una volta a mezza botte, tirata in prospettiva, e spartita in quadri pieni di rosoni, che diminuiscono, e scortano così bene, che pare che sia bucato quel muro'.
4. See Vasari–Milanesi I, 184–5 and VII, 579–92. Vasari mentioned the significance of the invention of oil painting, attributing it to Jan van Eyck, but found it inferior, as a medium, to the fresco technique.
5. See Vasari–Milanesi IV, 7–15.
6. Vasari omitted several apocryphal epitaphs in the second edition of the *Lives*.
7. 'Cominciò l'arte della pictura a sormontare'; of Giotto he remarked, 'Arrechò l'arte nuova, lasciò la roçeza de' Greci' and 'Arecò l'arte naturale ella gentileza con essa, non uscendo delle misure. Fu peritissimo in tutta l'arte, fu inventore et trovatore di tanta doctrina la quale era stata sepulta circa d'anni 600'; see Ghiberti–Fengler, 16–18. An important criterion was complexity; 'istoria . . . copiosa et molto excellentemente fatta' (39, 40). Ambrogio Lorenzetti is praised as a *nobilissimo componitore*. Ghiberti's text shows that he had studied Pliny and Vitruvius and testifies to a tremendous personal pride that emerges more distinctly still in his autobiography.
8. See Baxandall 1971; for the reception of Giotto's work, see also the quotations in Gilbert 1977, 53–4 and Schneider 1974.
9. Sociologists have emphasized that technical rationalization is typical of Western culture. See Weber 1922, 122–30 and 541–79.
10. Alberti uses three concepts: *compositio membrorum, corporum circumscriptio* and *receptio luminum*. The depiction of an image or *historia* involved the following: 'Historiae partes corpora, corporis pars membrum est, membri pars est superficies. Primae igitur operis partes superficies, quod ex his membra, ex membris corpora, ex illis historia, ultimum illud quidem et absolutum pictoris opus perficitur'; see Alberti–Grayson para. 35, with commentary from 33 to 50.

11. Elias 1978, 55–79, refers to 'the sociologist as a myth-hunter', which can well be applied to views of art. Goudsblom 1977, 6 has expressed the essence of the sociological perspective with the words interdependence, development-perspective and relative autonomy. These concepts emphasize that people are dependent on each other, that dependency relations are subject to change, and that these changes have a structure that cannot be determined by individuals or groups. For the controversial contrast between individual and society, see Elias 1978, 13–36, 79–114 and Goudsblom 1977, 111–28.

12. I do not believe that art should be seen as a direct photographic image, or mirror, of society. Style cannot be viewed as the testimony of a particular social class, as suggested in Antal 1948. I further believe that the three-fold distinction between Gothic and Renaissance, conservative and modern, and artistocratic and bourgeois is not tenable. See also similar distinctions made in Hauser 1957.

13. For instance, Antal 1948 sees a direct link between style and class, Meiss 1951 between stylistic developments and social changes relating to the outbreak of the Plague. Both take too little account of patronage. See also Van Os 1981a. The same objections may be made to connections advanced in Hauser 1957.

14. Warburg 1902–7 in Warburg 1969 and Wackernagel 1938 assign an important place to the subject of patronage, laying especial emphasis on quattrocento Florence. The theme has been further elaborated in Haskell 1963; Hirschfeld 1968, with an introductory section on the concept of patronage; Chambers 1970; Larner 1971; Baxandall 1972; Martines 1979, 241–4; Burke 1974, 97–139; Goldthwaite 1980; Ginzburg 1981 and Hope 1981. The publications of Belting, Borsook, Gardner, Hueck, Van Os and Shearman deal with the subject of artistic patronage at length. Belting 1981 also stresses the importance of the targeted public and the connection between taste and social background. See also Goudsblom 1977, 1982, 1984a, 1984b; De Jong 1982; Kempers 1982a; Maso 1982 and Zwaan 1980.

15. Burckhardt 1860 and Huizinga 1919. Burke 1974, 15–36 gives a good survey of the state of scholarship.

16. See Wittkower 1963; Chambers 1970; Baxandall 1971 and 1972; Larner 1971, Martindale 1972; Warnke 1985 and Martines 1979, 244–59 and Burke 1974, 49–96. Most of these publications are largely concerned to trace differences in status between artists, without reference to the concept of professionalization.

17. As an illustration of this, the contribution on 'art and society' in the *International Encyclopedia of the Social Sciences* was written by the art historian Haskell, who focuses on art-historical literature and who, in his *Patrons and Painters*, XVIII–XIX, expresses his opposition to a more general approach. Von Martin 1932 was the first to attribute a major role to sociology in studies of the Renaissance. Burke 1974 (1972) presents his approach as a sociological

one, but emphasizes, in this connection, ' "structures", that is ... factors which remain fairly constant in the course of more than a century ... Artistic, ideological, political and economic elements have been treated in relative isolation' (318).

18. Cf. Burke 1974; Bourdieu 1979; Ginzburg 1981; Becker 1982; Oosterbaan 1985; De Swaan 1985 and Kempers 1985. For the sociological approach taken here, see Goudsblom 1977, 1982, 1984a, 1984b; De Swaan 1976 and 1985; Wilterdink and Van Heerikhuizen 1985 and Wilterdink 1985b.

19. See Carr-Saunders 1933, Johnson 1972, Mok 1973 and De Swaan 1985. The sociological publications on professionalization amount to an empirical tradition rather than providing any comprehensive theoretical framework.

20. See Carr-Saunders 1933. For the introduction of the concept of *Beruf* (profession) and *Beruf und Arten der Berufsgliederung*, see Weber 1922, 80–82.

21. This definition is less specific than the customary one, which is generally used in relation to the liberal professions of modern times. The concept of 'differentiation' as used here (with its counterpart of 'integration') derives from Elias 1971. I see social differentiation as having three aspects: economic, political and cultural.

22. See Weber 1922, 815–68 and Elias 1939/1969 II, 14–37, 123–79.

23. See Weber 1922, 92–121 and Elias 1939/1969, 279–311.

24. See Weber 1922, 815–21 and Elias 1939/1969, 142–59 and 434–41.

25. Weber 1922, 122–8 also uses the terms *bureaukratische Verwaltungsstab* and *legale Herrschaft* in this connection. See also 551ff.

26. See Weber 1922, 122–58, 181–98, 387–531. Elias places less emphasis on formal legislation and more on personal codes of conduct.

27. This is particularly emphasized by Marx under the heading of 'ideology', and more in general with regard to the ruling class.

28. Seminal works in developing the sociology of religion are Durkheim 1899 and 1912; Weber 1904/1905 and 1922, 245–367; and Mauss 1950.

29. See Mauss 1950. When discussing rituals I shall generally use the term 'liturgy' for ecclesiastical rituals and 'ceremony' for palace rituals.

30. Cf. Elias 1939/1969. The elements mentioned here are included in most definitions of culture. Civilization is a multiple concept because it refers to a process, as described in the following paragraphs. I do not accord any significant place here to the concept of 'mentality' because it has little bearing on processes or relations between people.

31. See Elias 1939/1969 II, 369–97, 434–54 and I, vii-lxx, in which the connection is described as being of general application.

32. Goudsblom 1977, 133 refers to a third process in civilization, namely the evolution of the human race. This topic is beyond the scope of the present discussion.

33. See Elias 1939/1969 II, 312–41, 397–409.

34. See Elias 1939/1969 II, 342–51, 409–34.
35. I have incorporated into my definition elements that Weber 1922 refers to in connection with rationalism and that Weber 1904 links with Protestant ethics.
36. See Elias 1939/1969 I, 75–282.
37. For the economic aspects of the building industry, see Goldthwaite 1980 and Vroom 1981.
38. Cf. Hirschfeld 1968; Krautheimer 1980 and De Blaauw 1987.
39. Around 1340 the city-state of Sienna had approximately 100,000 inhabitants, roughly half of whom lived in the city itself. The city of Sienna was larger than Pisa and Padua, but smaller than Florence, whose area (enclosed by city walls) grew from 80 hectares around 1180 to 500 hectares around 1335. The number of inhabitants of the city of Sienna alone increased from 10,000 to 95,000; including the *contado* the number reached about 139,000. This may be compared with Lucca, which had 21,000 inhabitants, Pisa, with 50,000, and Perugia, with a population of about 73,000 around 1280. These estimates derive from Osheim 1977, 3–4 and Bowsky 1981, 7–8 and 19. Taxation in Sienna is discussed in Bowsky 1970.
40. See Bowsky 1981, 117–58. Increasing violence in warfare was particularly a sixteenth-century phenomenon, a notable instance being the Battle of Ravenna in 1512.
41. Cf. von Pastor 1924, 746–895 and Hale 1977, 73–118.
42. See Moorman 1968, 46–52, 124–76; Vauchez 1977 and Little 1978.
43. See Larner 1971, 62–96 and Southard 1979, 453–552.
44. See Bowsky 1981, 1–7, 60–98 and 184–259.
45. See Bowsky 1981, 299–307.
46. See Brucker 1977; Goldthwaite 1980; Martines 1963 and Rubinstein 1966.
47. Cf. Martines 1979, 7–71.
48. See Kent 1977; Kent 1978 and Goldthwaite 1980. Kent 1977 emphasizes the extended family whereas Goldthwaite 1980 focuses on the nuclear family.
49. See Rubinstein 1966 and Kent 1978. The terminology in which networks and patronage are discussed, in this context, is derived largely from anthropology.
50. See Martines 1979, 94–161 and 345–9 for further references.
51. See Hay 1961 and Hyde 1973.
52. Active patrons of art included the rulers of the following courts: Padua, Verona, Mantua, Ferrara, Milan, Rimini, Perugia, Foligno and Naples. The families concerned were: the Carrara and Lupi, Scaliger, Gonzaga, Este, Visconti and Sforza, Malatesta, Baglioni, Trinci and Anjou and Aragon.

PART I

1. Quoted in Ringbom 1965, 11.

2. Archbishop Antonino of Florence (1389–1459), a Dominican, wrote that painters 'are in error if they make images that arouse desire, not because of their beauty but because of the poses of nude women and suchlike ... They must be shown the error of their ways when they make paintings that conflict with the faith ...' And he further commented, 'It is unnecessary and futile to paint curiosities, in stories of saints or in churches, which have no significance in urging devoutness but merely signify amusement and vanity, such as monkeys, dogs chasing hares and suchlike, or excessive show in clothing.'

3. See Gilbert 1980, xix.

4. For example, Gabriele Paleotti, Bishop of Bologna and a participant in the Council of Trent, in his *Discorso intorno alle imagini sacre e profane* (1582), see Boschloo 1974, 121–41, which also mentions several other texts that stressed that the desired effects of church images were *dilettare, insegnare* and *movere*, or to delight, to instruct and to move.

5. For data, see: Kantorowicz 1957, 109–15; Ringbom 1965, 11–22; Smart 1971, 4–7; Braunfels 1969, 246 and Gilbert 1980, xix, xxvii, 143–61. Bonaventure, Thomas Aquinas, Giovanni Dominici, Bernardine of Sienna, Antonino of Florence and Savonarola all addressed themselves to this issue.

6. See Moorman 1968, 62–5, 155–60, 307 and Little 1978, 152.

7. Secular clergy such as pastors, canons and bishops did not live in separate communities or convents. The older monastic or regular orders, i.e. those living according to a common rule included the Benedictines, Cluniacs and Cistercians (Braunfels 1972, 9–10).

8. Mendicants' ideas concerning wealth and display are discussed in Moorman 1968, 145, 180–89, 193–203, 462; Braunfels 1969, 240–46; Belting 1977, 17–21 and Little 1978, 146–69.

9. Some examples are given in: Wood Brown 1902; Orlandi 1955 II, 418–70; Belting 1977, 21–9; Nessi 1982, 385–8 and Riedl 1985, 2–5.

10. For more information relating to the papal court and *Curia* patronage, see: Langlois 1886–90; Moorman 1968, 83–339, 589–91; Grimaldi-Niggl 1972; Ladner 1970 II, 53–349; Gardner 1973, 1974, 1975, 1983; Belting 1977, 87–97; Krautheimer 1980; Wollesen 1977; Dykmans 1981, 25–74; Herde 1981, 31–83; Nessi 1982, 21–94, 301–18, 385–9; Hueck 1969, 1981, 1983 and Kempers–De Blaauw 1987.

11. These processes are discussed, for example, in Barraclough 1968.

12. Ullmann 1949 and Kantorowicz 1957 discuss papal ideology more fully.

13. Gratian's Decretum was extended in the Decretals of Gregory IX (1227–41), Boniface VIII (1295–1303) and Clement V (1305–14); I omit references

here to the literature on legal history, which is also of importance in this connection.

14. These included Constantine, Charlemagne, Lothair III and Frederick Barbarossa.

15. See Ladner 1970 II, 17–22 and Ladner 1941 I, 192–201. This cycle has been lost but may be partially reconstructed on the basis of descriptions and drawings made at a later date. Furthermore, Innocent II commissioned the new version of the apse mosaic in S. Maria in Trastevere, where he also had a portrait made of himself; see Ladner 1970 II, 9–16.

16. See Ladner 1941–84 I–III; Hetherington 1979, 81–7, 117–23; Grimaldi Niggl. See also a more extensive bibliography of *Curia* patronage in Kempers–De Blaauw 1987, notes 3, 10–12, 15.

17. See, for instance, Ladner 1984 III, 321–69.

18. Gregory IX was descended from the same eminent house as Innocent, that of the counts of Segni. See Ladner 1970 II, 68–72, 105–11. Portraits of both of these popes also appeared in the apse of St Peter's; see Ladner II, 56–68, 98–105.

19. See Gardner 1971 and Hetherington 1979, 86–97. After his work in Rome Cavallini went on to fulfil a commission given by Cardinal Jean Cholet, in his will drawn up in 1289, to execute paintings in S. Cecilia, a project that was concluded in 1293, when a new ciborium was installed; see Hetherington 1979, 40–41. Around 1290 he executed the apse mosaic for S. Maria in Trastevere for Cardinal Bertoldo Stefaneschi (see note 15); these mosaics included a depiction of the cardinal in prayer and inscriptions formulated by his younger brother Jacopo (see notes 26–8). Between 1300 and 1308 Cavallini painted the apse frescoes for the church to which Jacopo Stefaneschi was attached by virtue of his cardinal's title (see notes 68–9).

20. See Ladner 1970 II, 80–91; for other portraits and commissions, see Ladner 1970 II, 92–6. Honorius IV (1285–7) also came from the Savelli family. For his portraits see Ladner 1970 II, 229–34.

21. See Gardner 1973b and Ladner 1970 II, 209–26. A statue was also erected to him in Ancona, a kind of public portrait of a ruler later to be emulated by Boniface VIII in Anagni, Rome, Florence, Orvieto and Padua; see Ladner 1970 II, 322–40.

22. See Huyskens 1906.

23. More information on this network in: Moorman 1968, 179, 195–6, 295–313; Belting 1977, 28, 33, 37, 88–95; Borsook 1980, 28; Dykmans 1981 II, 29–31, 59, 61, 63 and Hueck 1984, 173–4, 200, notes 2 and 5.

24. See Belting 1977, 89–90.

25. See Belting 1977, 27–8.

26. See Langlois 1886–90.

27. For Nicholas IV's patronage in S. Maria Maggiore, which was closely linked

to that of the Colonna family who supported him, see Gardner 1973a and Ladner 1970 II, 235–47. Cardinal Jacopo Colonna was also depicted in the mosaic. Before he was removed from his office as archpriest in 1297 by Boniface VIII he founded two altars, one as a memorial to Nicholas IV and the other dedicated to John the Baptist and especially to be used for his own memorial liturgy. His nephew, Cardinal Pietro Colonna, was also buried in the southern transept of S. Maria Maggiore. The inscription for the mosaic, executed by Jacopo Torriti, is dated 1295. See Ladner 1970 II, 235–47 and De Blaauw 1987, 173, 178, 180, 198–201. Nicholas IV's exertions for St John concerned the transept, apse, cathedra (bishop's seat) and the mosaic, which was also by Torriti, and further included the drawing up of new statutes for the chapter in 1290; see De Blaauw 1987, 103, 107, 119.

28. See Ladner 1970 II, 240.

29. Matthew of Acquasparta had been appointed minister-general of the Franciscan order in 1287; Nicholas IV created him a cardinal in 1288, and in 1294 he was present in the Aracoeli at the ceremonious occasion of Louis of Anjou entering the order. See Hetherington 1979, 59–62, 119–21.

30. See Malmstrom 1973, 1–65. The church in which these burial chapels were situated was S. Maria in Capitolio; after it was transferred to the Franciscans it was turned through ninety degrees and acquired a new monumental flight of steps.

31. See, for instance, Ladner 1970 II, 105–11. The towns concerned were Anagni, Grotta Ferrata, Subiaco, Viterbo, Orvieto, Perugia, Assisi and S. Piero a Grado at the mouth of the Arno.

32. See Moorman 1968, 119–22 and Belting 1977, 22: 'Nos cupientes ... dictam ecclesiam et nobili compleri structura et insignis praeeminentia operis decorari'. Thus the money had to be spent 'in idem opus totaliter et fideliter expendendas prout ... cardinalis qui ordinis ... protector extiterit, ordinandum vel disponendum duxerit'.

33. See Belting 1977, 22, 87–8.

34. See Belting 1977, 23 note 32 (*aurifrisium* for the *ornamentum altaris Ipsius Apostolicae Sedis* in 1289, and other donations made in 1288); see also Ladner 1970 II, 247–53. The figures depicted by goldsmith Guccio di Mannaia on the chalice included Francis, Antony, Clare and Christ.

35. See Nessi 1982, 385–8.

36. See Borsook 1980, 14–19; Nessi 1982, 301–18, 382–3 and see Hueck 1983, 192 for the donation of paraments by Matthew of Acquasparta.

37. Smart 1977, 263–93 has transcriptions of the captions accompanying the frescoes, and the notes to Belting 1977, 33–68 contain quotations from Franciscan texts.

38. See Hueck 1984, 176, 182–7.

39. See Battisti 1967, 91.

40. See Previtali 1967, 83–104; Borsook 1980, 29–32 and Hueck 1981.

41. See Braunfels 1969, 241–6.

42. See Borsook 1980, 28 and Hueck 1984.

43. See Borsook 1980, 14–19.

44. See Borsook 1980, 23–9.

45. See Previtali 1967; Belting 1977, 107–234 and Hueck 1981.

46. We may date this work to around 1317; this is borne out by the surviving data on the commissions issued, and moreover, the images accord with the statutes of that year. See Moorman 1968, 307–29; on the three different branches see 205–25 and 417–28.

47. Jacopo Stefaneschi was the cardinal in authority in 1317, and as such was involved in the commission which had worked out the compromise; his confessor was a Franciscan. See Dykmans 1981 II, 37, 62–5, 68 – where there are also references to Napoleone Orsini – and Kempers–De Blaauw 1987, note 39. In 1313 Clement V, who was a moderate, but sympathized with the strict precepts of the spirituals, tried to subdue the conflict within the order by issuing a bull in which the principles of poverty and obedience were emphasized. Clement died in 1314.

48. See Moorman 1968, 311.

49. See Moorman 1968, 311–13.

50. See Moorman 1968, 326.

51. The cities in which such paintings appeared included Naples, Rome, Rieti, Todi, Sienna, Pistoia, Florence, Castelfiorentino, Gubbio, Rimini, Ferrara, Padua and Verona. See Ghiberti–Fengler; Vasari–Milanesi I, especially the Life of Giotto, and Blume 1983. Names are also given of the pupils of Giotto who executed these commissions in Vasari–Milanesi I, 402, 405, 450–51, 626.

52. See Blume 1983, 81–6.

53. For Naples and the surrounding area, see Bologna 1969, 115–286.

54. The whole question of where panel paintings were situated and what functions they fulfilled has received too little attention. Most publications group paintings according to the artist. Hager 1962, Cannon 1982 and Van Os 1984 focus on the history of the form of the altarpiece, but they devote too little attention to the different places for which the different types of panel paintings may have been used. The literature thus creates the impression that a more or less linear development, based on the high altar, took place.

55. See Morçay 1913, 13; the description comes from an entry in the *Cronaca del Convento Fiorentrino di S. Marco* shortly before 1457.

56. Orlandi 1955 II, 397–404 gives the main part of M. Billiotti's description as it appears in V. Borghigiani's eighteenth-century *Cronaca*. Billiotti's 1586 description was intended to document the situation in S. Maria Novella as it had been before the interior of the church was reorganized in 1556; see Part IV.

57. For reconstructions see Hall 1979, 1–6 with refs. in notes 3–5; see also Wood

Brown 1902, 66, 114–44 and Hueck 1984, 176–80, which also gives other examples.

58. See Orlandi 1955 II, 401, 403.

59. See Orlandi 1955 II, 403–4. The execution of the interior with, for example, inlaid walnut mouldings, dates from after 1350, but the internal divisions of the church followed the pattern set in the late thirteenth and early fourteenth centuries.

60. See Orlandi 1955 and De Blaauw 1987, 26–45, 137–41, 207–10, 356–9, 364–9.

61. See Orlandi 1955 II, 398.

62. See Orlandi 1955 II, 403–4.

63. There were circular crypts such as that in the old St Peter's in Rome, and larger underground crypts such as that in the cathedral of Sienna; for these see the final section of chapter 2 and the initial section of Part II, chapter 2.

64. See Hager 1962 fig. 86, 128–33.

65. See Hueck 1984, 174, 194–6. The work was executed by craftsmen from Rome and Umbria; see 199.

66. See Hueck 1984, 173.

67. The first retables of Francis were probably made in 1228, the year of the canonization. The oldest known example is that of S. Miniato al Tedesco, followed by the retable of 1235 by Bonaventura Berlinhieri in Pescia and those in Pistoia, Florence, Assisi and Orte. See Hager 1962, 94–7.

68. It should be noted that it was not only mendicant orders who placed commissions for such panels. See Hager 1962, 88–108 (where examples are also given of saints' images with no accompanying scenes). Others who were painted standing, flanked by scenes from their lives and miracles, included Peter, John, Zenobius, Mary Magdalene, Gemignanus and Miniatus.

69. See Vauchez 1977 and Bowsky 1981, 261–5.

70. See Stubblebine 1962, 69–71 and Torriti 1977, 35–6. The same painter made a similar image of Clare routing the Saracens, and depicted St Francis receiving the stigmata as well as the martyrdom of St Bartholomew and of St Catharine of Alexandria; see Stubblebine 1964, 21–3.

71. The panel is to be found in the S. Pellegrino alla Sapienza. This is the monument described by Bossio in 1575 (quoted in Stubblebine 1964, 69) and not the older one. The monument with the remains of Ambrogio Sansedoni may have been beside it. Sansedoni, renowned for his sermons, died in 1287; in that year the commune contributed a sum of money towards ceremonies to be held in his honour. See Vauchez 1977.

72. Fragments of sculpture showing Giovacchino Piccolomini can be found in the Pinacoteca in Sienna. In 1320 the commune donated candles to the Servites and in 1328–9 the worship of the new saint appeared on the agenda of the *Consiglio Generale*; see Vauchez 1977.

73. See Vauchez 1977, 759. The monument consisted of a tomb, altar and ciborium. Pettinaio had died in 1289. See also Moorman 1968, 191, 223–4.

74. The tomb is described as being situated in the women's church by the choir wall: '*muro di mezzo*' or '*il tramezzo o vero muro*'. See Riedl 1985, 23 note 306 and 25, 162. The source cited in 25 note 319 and in 162 note 19 is one of the very few references to a '*muro di mezzo*' in the fourteenth century (1382).

75. See Vauchez 1977, 360.

76. See Riedl 1985, 89, 210 and notes 62–4, 251–3. The words Bossio uses are virtually identical to those used in reference to the Gallerani monument. There are also numerous examples of such monuments to local saints outside Sienna.

77. See Contini 1970, 96–7.

78. This is also well documented in descriptions of prayers offered to Mary in *Cronache Senesi* esp. 201–3, see below. For example, 'Vergine gloriosa reina del cielo, Madre de' pecatori, aiuto degli orfani, conseglio delle vedove, protetrice degli abandonati e de' misari'; 'Voi, signori citadini sanesi, sapete come noi siamo racomandati a re Manfredi; ora a me parebbe che noi ci diamo in aver e in persona tutta la città e 'l contado di Siena a la reina ...'; 'Vergine Maria, aiutaci al nostro grande bisognio: liberaci da questi malvagi lioni e dragoni che ci vogliano divorare'.

79. See ASS *Consiglio Generale* 107, fol. 33v–41v, 70v–74v and Vauchez 1977, which gives the main passages from the requests for subsidies and the consultations.

80. See Vasari–Milanesi I, 365, which mentions two panels next to each other, one of Catherine (to be identified with Hager 1962 fig. 134) and one of Francis, '... nel tramezzo della chiesa, è appoggiata sopra un altare' in S. Caterina in Pisa. He goes on to describe, 'in Bologna ... una tavola nel tramezzo della chiesa, con la passion di Cristo, e storie die San Francesco' (404). The inventory of S. Agostino in Sienna gives the impression that there was an altar to Catherine next to that to Novello, both clearly distinguished from the altar of the convent and the two others beside it; see Riedl 1985, 237–8.

81. See Vroom 1981, 127–8, 173–7, 187–9, 207 where data are given on this situation in various cathedrals.

82. Cf. Moorman 1968 with Little 1978, 19–41, 184–217.

83. For data on relics and donations, see Vroom 1981, 123–42, 177–80.

84. Hager 1962 and Van Os 1984 have a different hypothesis. They relate the development of the altarpiece to the tradition of decorations at the high altar, taking the *paliotto* and *antependium* as their starting-point. Their thesis is that these were set upon the altar, thus serving as the first beginnings of the altarpiece.

85. See White 1979, 185–7.

86. See Orlandi 1955 I, 445–6.
87. See Hager 1962, 124–5; Little 1978, 207–12, and for Sienna, Bowsky 1981, 265–6. The Billiotti chronicle, parts of which have been published, gives additional information on the liturgy of the choral confraternity and priests. The *Laudesi* chapel, dedicated to Gregory, was equipped with benches and screens in 1316. In 1334 it was transferred to the Bardi family; see Wood Brown 1902, 114–44; Hueck 1976, 262–5 and Stubblebine 1979, 21–7.
88. See Orlandi 1956, 208–12. '. . . pro emendis exinde annuatim duobus urceis olei ex quo oleo unus urceus sit pro tenendo continue illuminata lampade crucifixi entis in eadem ecclesia sancte Marie novelle, picti per egregium pictorem, nomine Giottum bondonis qui est de dicto popolo sancte Marie novelle, coram quo crucifixo est laterna ossea empta per ipsum testatorem. alius vero urceus sit ad alleviandum hanc Societatem expensis solitis fieri per eam in emendo oleo. – pro lampade magne tabule in qua est picta figura beate Maria virginis . . .' (209).
89. See Orlandi 1956, 211.
90. In 1314 the sacristan, Fra Cione, filled the lamp by the '*Crocifixo grande*'. In 1322 oil was provided for the lamp '*ch'e dinanci all'altare maggiore*', and in 1323 for the '*lampana della Donna*'. In 1324 and again in 1332 the sacristan replenished the oil for 'the lamp at the high altar' (the words 'of the Crucifix' do not appear here) and the lamp 'by the panel of Our Lady' once more. In 1329 the only oil to be replenished was that for the lamp by the high altar. In 1426 (no information is available for the intervening 100 years) the lamps by the altar and by the Crucifix were both filled again; see Orlandi 1956, 213–14.
91. Cf. other hypotheses in Hager 1962, 146; White 1979, 32–45; Cannon 1982, 88 and note 142; and Van Os 1984, 31–3. In my view, to place the development of this type of panel painting in the context of the history of the altarpiece for the high altar is incorrect, as is the minority view that such panels were destined for the *Laudesi* chapel in the transept; for the latter view see Stubblebine 1979, 21–7.
92. This variant also appears in the Sylvester chapel of S. Croce, with S. Giovanni Gualberto among the figures depicted at the altar; see Hager 1962, figs. 91–2; for painted crucifixes see figs. 89–99. The same image appears in Pistoia; see Blume 1983, fig. 104, 107, where the depiction of the verification of the stigmata appears in place of panels affixed to a beam.
93. See Vasari–Milanesi I, 365, where the '*Crocifisso sopra un legno che attraversa la chiesa*' is ascribed to Margaritone van Arezzo. In 1623 the crucifix was removed from the beam; see Nessi 1982, 156 note 399 and Hueck 1984, 201 note 34, with the hypothesis that Giunta Pisano's 1236 crucifix was not placed in the Upper Church until 1513. As the altars were dedicated to the

Virgin Mary and to St Michael, panels representing these two figures may well have been displayed beside the cross, corresponding to the images in the fresco. See Nessi 1982, 283, 339, 349 and fig. 96; the information given here suggests that there may have been a *pergula* with images in the lower church.

94. See Hager 1962, 70–71, 79, 80. In 1275 a lamp is mentioned which was 'ante tabulam novam beate Virginis Marie la quale e sopra la trave nel choro di detta chiesa.' The commission given in 1274 also included a 'crocifissum cum una trabe super altare Sancti Michaelis dicte ecclesie et etiam una figura seu sepultura sancti Michaelis' (70).

95. See Blume 1983, fig. 133, S. Fortunato Franciscus chapel.

96. See Hager 1962 fig. 120 and Blume 1983 fig. 245. The panel is now in the cathedral.

97. See Vasari–Milanesi I, 394. Giotto's painting is now in the Uffizi, together with Duccio's *Rucellai Madonna* and a similar painting by Cimabue, which was originally in S. Trinità.

98. See Ghiberti–Fengler, 21:

'a chapel, a large crucifix and four altarpieces, one of which had a truly superb depiction of the death of Our Lady, with angels, the twelve apostles and Our Lord grouped around her. There is a large panel showing Our Lady enthroned, surrounded by many angels, and above the door leading to the cloister is a half-length Madonna, who is painted holding the child in her arms.'

99. See Ghiberti–Fengler, 20–22, 25–7, 42, 45.

100. See Ghiberti-Fengler, 20: '*uno crocifisso con una tavola*'. A crucifix which is also mentioned by Vasari has been preserved in the Ognissanti. He also refers to '*Nel tramezzo . . . una tavolina a tempera*', which had been removed since the first edition of the *Vite* had appeared; see Vasari – Milanesi I, 396, 397 and 403. Puccio Capanna made a '*Crocifisso, una Madonna e un S. Giovanni*' in Pistoia – '*Nel mezzo della chiesa di S. Domenico*'. There was also a *tramezzo* in S. Francesco in Bologna, and it seems likely that it bore a Madonna and a Crucifix, side by side. The sawn-off panel fragment in the Brancacci chapel known as the *Madonna del Carmelo* or the *Madonna del Popolo* and ascribed to Coppo di Marcovaldo was probably originally situated at the choir partition of S. Maria del Carmine in Florence. Examples are given of such paintings to be found elsewhere in Hager 1962, figs. 185–213. Hager 1962 figs. 80–85 gives examples of images that were exhibited at choir partitions. In 1262 Guido da Siena made such a panel for a confraternity attached to S. Maria degli Angeli in Sienna; he also produced one for S. Francesco in Arezzo; see Stubblebine 1964, 61–5, see also 30–43 and 104–5.

101. The *Madonna* is ascribed to Cimabue, and the *St Francis* to Giotto. Both are now in the Louvre. The frame of the *St Francis* displays the arms of a family, presumably the clients.

102. See De Blaauw 1987, 53–8.

103. See De Blaauw 1987, 277–87, 338–41. The large beam was termed the *trabs maior* (285) or according to Alfarano the *magna trabs* and *ponte* (340). Cloths hung in three rings, from the altar outwards: in the baldachin a ciborium, at the presbytery partition and between the columns of the nave. All the transverse connections bore cloths, candles and images (287). In Pinturicchio's fresco in the cathedral library of Sienna (see below), which depicts the ceremonious entry of Pius II partitions can be seen, the height of a man, with a small opening.

104. See Gordon 1982. A similar panel, painted on both sides, can be seen at the Städelsches Institut in Frankfurt. The common term for this type of panel painting – a 'dossal' – is confusing, as this word generally refers to a hanging at the front of an altar. Later variations are the polyptychs of Taddeo di Bartolo in Perugia and of Sassetta in S. Sepolcro, both of which are painted on two sides. This implies that the high altar was placed opposite the choir rather than below the window.

105. See Hager 1962, 108–112 and Van Os 1984, 18–20.

106. See Hager 1962, 113–14 and Battisti 1967, 91–3. Cimabue died in Pisa shortly afterwards.

107. See Bacci 1944, 118–20. He was described as a '*conversus*' and as a '*sacrista super excellens*' with the reference: '*Tabulam praetiosam procuravit fieri maioris altaris*'. In 1320 he was succeeded by a confrère from Prato. His obituary alluded to the fact that he had ordered the magnificent altarpiece painted by Simone from Sienna, who was the best painter of his day; a quotation from Petrarch was included to corroborate this judgement.

108. Jesus is depicted as the Redeemer conferring his blessing; the Bible he holds in his left hand shows the text 'I am alpha and omega, the beginning and the end'. Gabriel, the messenger of Christ's coming, and Michael, the herald of the Day of Judgement, are shown beneath the Saviour. Below the archangels is an image of Mary with the Christ child. The theme of birth and incarnation is elaborated in the bottom row in images of Jesus as the Man of Sorrows, lamented by Mary and John.

109. See Van Os 1969, 16–18, 23–7; Cannon 1982, 69–75 and Van Os 1984, 66–9.

110. See Orlandi 1955 I, 40: 'Fr. Baro de parentela *sasetorum*. Confessor magnus et praedicator. totam sacristiam munivit paramentis. de sero dupplicatis. *ac etiam tabulam altaris* sua procuratione fieri fecit. fuit bis Supprior florentinus. In ordine vero vivens plusquam LX. annis obiit anno domini. – MCCCXXIIII. In vigilia beati Jacobi'. The altarpiece cannot be traced.

111. See Orlandi 1955 II, 290–91 and fig. XIX. Niccolò, a *conversus* from Milan who died in 1367, bequeathed a replacement for the *paliotto* of 1336 in his will.

112. For these commissions, see Orlandi 1955 II, 425, 434 and part III, which discusses the renovations conducted in this chapel.

113. See Hall 1979, 154–5 and Gardner von Teuffel 1979, which gives a reconstruction of this altarpiece, of which the separate parts are exhibited in various museums.

114. See Van Os 1984, 91–9. The connection with the Carmelite statutes, which are in their turn related to the specific liturgy of the order, has not been noted before.

115. They also held celebrations in honour of S. Niccolò, the church's patron saint, with the financial support of the commune. ASS *Consiglio Generale* 107 fol. 70v–74v.

116. It is a late fifteenth-century Franco-Flemish representation of the St Giles Mass celebrated in the presence of Charlemagne in the abbey choir of S. Denis.

117. See Riedl 1985, 236–8, which has the 1360 inventory of S. Agostino in Sienna; the inventory includes ivory, items worked in gold and silver, *vela* including a *velum aureum* to carry the crucifix, *davanzalia* in various colours, a number of *thuribula*, a *tabernaculum*, *tabalia*, *paramenta* and a *patena*. See Orlandi 1955 passim and Morçay 1913, 10, 12, 14, 22–4, 27 for the new arrangement of the interior of S. Marco in Florence, as it was shortly after 1435. Churches that had movable icons include S. Maria Maggiore, St Peter's in Rome and the cathedral of Pisa; see Kempers–De Blaauw 1987, notes 53 and 126, and part II.

118. Cf. Van Os 1969, 11–33; Little 1978, 173–83 and Cannon 1982.

119. This was in an altarpiece by Simone Martini, dated 1324, originally intended for the choir altar of S. Domenico at Orvieto. See Cannon 1982, 83–4 and Van Os 1984, 69.

120. There were incidental cases of commissions being given for collegiate churches and for cathedrals. In 1311 a large altarpiece, painted on both sides, was installed at the high altar of the cathedral in Sienna (see below). Bishop Guido Tarlati, who was also the sovereign ruler of Sienna, ordered a large burial tomb for the cathedral. He had his own portrait painted on an altarpiece in the Pieve in 1324, directing that he should be represented in the capacity of Donatus, the patron saint of Arezzo. The contract that Tarlati had drawn up with Pietro Lorenzetti specified that the choice of the subject of the painting was the province of the patron. See Van Os 1984, 69–71.

121. See Previtali 1967, 96–8, 114–21, 369–75; Ladner 1970 II, 277–89; Gardner 1974; Hueck 1977; Dykmans 1981 II, 75–118; Ciardi Dupré and Kempers–De Blaauw 1987, which each give more extensive references to sources and literature.

122. See Herde 1981.

123. See BAV, Vat. lat. 4932 with the portrait of Stefaneschi on fol. 36r, and Vat.

lat. 4933 with the coronation on fol. 7v; Ladner 1970 II, 266–9, 285–7 and Kempers–De Blaauw 1987, 84–5. In this period Stefaneschi also wrote a booklet aimed at spreading the fame of St Peter's and the indulgences that were to be obtained there in the Jubilee year, that was also sober in terms of style and iconography: *Liber de Centesimo seu Jubileo*, BAV Archivio Capitolare di S. Pietro C 3. See Dykmans 1981 II, 119–31.

124. See BAV Vat. lat. 4932 fol. 1r. All the miniatures that Stefaneschi had made in Rome around the year 1300 were plain in execution and modest in respect of his own role; cf. Ciardi Dupré 1981 and Dykmans 1981 II, 116–18.

125. See Gardner 1983.

126. A fragment of this fresco is now to be seen on a column in St John Lateran.

127. Cf. Ullmann 1949 and Kantorowicz 1957, 193–232.

128. See Dykmans 1981 II, 119–22 and Kempers–De Blaauw 1987, 85–6. Dykmans also deals with the historical background related in the previous paragraph.

129. See BAV, ACSP C129 fol. 17r, 18r, 41r, 42v, 68r, 70r, 85r and Dykmans 1981 II, 65, 148–53. For the missal see Ciardi Dupré 1981, 127–55 with illustrations.

130. Stefaneschi also had this view of Church politics depicted on the atrium of St Peter's, where a mosaic with the *Navicella* made it clear that Jesus's mission to Peter must also be fulfilled in turbulent times. The patron is seen kneeling in prayer before the ship, which is being tossed about in a rough sea.

131. See Hueck 1977 and Dykmans 1981 II, 28–9, 75–6.

132. See Dykmans 1981 II, 65.

133. It was probably for Stefaneschi's burial chapel that the Master of the St George Codex painted an altarpiece which included depictions of St Lawrence and St Stephen, the patron saints, and an Annunciation; see Ciardi Dupré 1981, figs. 181–2 and pages 155–8, 225–6.

134. See Otto 1937.

135. For the theory that the intended place was the high altar, see: Hager 1962, 194; Ladner 1970 II, 281; Gardner 1974, 58–76; White 1979, 182 and Dykmans 1981 II, 79–84.

136. There are miniatures of singers inside the choir in and on the *ambones*, in Stefaneschi's *Exultet* BAV, Archivio Capitolare San Pietro B 78, fol. 3r, 7r, 13v; illustrations are given in Ciardi Dupré 1981, 74–7.

137. Liturgical information about Stefaneschi is given in Dykmans 1981 II, 224–5, 288, 314–16, 365, 441, 450, 452 and in Kempers–De Blaauw 1987, 93–101.

138. See the edition prepared by Dykmans 1981 II, 317.

139. See Kempers–De Blaauw 1987, 99–101. The Vatican side means here – even though the opposite appears to be indicated – the south side, i.e., viewed from the entrance it is to the left of the singers' choir in the middle.

140. See Kempers–De Blaauw 1987, 101 '*retro corum dominorum canonicorum*', references after the cardinal's death and after the restoration work was completed. Pinturicchio painted a new retable with 'la Nostra Donna maggior che il vivo' for the choir altar in the course of the renovations commissioned by Innocent VIII; see Vasari–Milanesi III, 498. Vasari saw the Stefaneschi altarpiece in the sacristy, where it remained until the Fabbrica di S. Pietro gave permission for it to be exhibited on loan to the Vatican Pinacoteca.

141. Families referred to are: the Orsini, the Colonna, the Savelli of Rome, the Monaldeschi of Orvieto, the Partino of Montefiore and the Anjou of Naples.

142. There is separate documentation for this as far as Naples, Rimini, Urbino, Mantua, Ferrara, Padua, Verona and Milan, in Vasari–Milanesi I, especially in the *Life of Giotto* and in monographs on the mendicant churches.

143. See Gardner 1976 and Bologna 1969.

144. See Milanesi 1854 I, 160–62 has a request from the Franciscans dated 1286, 193; Vauchez 1977 and Riedl 1985, 2–5.

145. See ASS *Consiglio Generale* 107 fol. 70v–74v and Milanesi 1854 I, 193; the documents published here are not complete.

146. See Belting 1977, 235. Scrovegni was married to Jacopina d'Este, a niece of Bertoldo Orsini, who was *rettore* (papal governor) of Romagna. The reference to Scrovegni's father is in *Inferno* XVII. See also Hueck 1973.

147. See Previtali 1967, 70–83, 148, 337–65.

148. Donations made to S. Maria Novella are listed in Orlandi 1955 II, 418–70.

149. See Van Os 1969, 75–142, figs. 7, 8, 16, 17, 49–97 and Belting 1981.

150. Cardinal Dominici (1356–1419) gave the following advice in his *Regola del Governo di cura familiare*: 'You should observe five small rules ... The first is to have images of holy boys and maidens in your home, which give pleasure to your child.' This is followed by a survey of images that are suitable from an educational point of view, and a warning against unnecessary extravagance; see Gilbert 1980, 145–6.

151. Gilbert 1980 gives a quotation from Antonino, 148: 'Painters more or less reasonably request to be paid the wage of their profession not solely according to the quantity of work, but more according to their industry and their greater expertise in the art.'

PART II

1. The five volumes of this carefully ordered constitution are termed *Distinctiones*. ASS *Statuti* 2, Constitutum Comunis Senensis, ed. Zdekauer 1897 (subsequently to be referred to as 'Const. 1262'); the Introduction of this edition gives a survey of previous legislation. See Guida-inventario (Inventory of Sienna) 1951, 61–76 for an overview of Sienna's laws. The oldest regulations preserved date from 1179.

2. See Const. 1262 *Dist*. I, rubrics i–cxxvii.

3. See ASS *Capitoli* I or *Caleffo Vecchio*, ed. Cecchini *et al.*, vol. IV. The same documents are contained in ASS *Capitoli* 2. See also Bowsky 1981, 1, 4, 7, 30, 46, 49, 60–98, 141, 151, 157, 174–5, 181–259, 304, 310.

4. Sometimes with other epithets added (e.g. *comitatus*, *iurisdictio* or *terra*); cf., for example, ASS *Statuti* 26, Constitutum Comunis Senensis (referred to hereafter as Const. 1337), *Dist*. IV with the regulations for the *Domini Novem gubernatores et defensores comunis Senarum et populi*.

5. See Bowsky 1981, 63, derived from ASS *Statuti* 17, fol. 389r, 'De his possint esse de novem. Item quod domini Novem qui sunt et esse debent defensores comunis et populi senensis et civitatis et districtus eiusdem sint et esse debeant de mercatoribus et de numero mercatorum civitas senensis vel de media gente.' See also Guida-inventario *Consistoro*, 177–9. This ruling is repeated in ASS *Statuti* 19–20, Costituto del Comune di Siena, ed. Lisini 1903 (referred to hereafter as Cost. 1309), *Dist*. VI and Const. 1337 fol. 203r. References given here to this law are to page numbers, as there is an inconsistency in the rubric numbers between table of contents and text.

6. See Bowsky 1981, 23–6. The statutes refer to *consistoro* and *signoria* respectively (board of governors and administrators). The tax officials are known as *provisores* (or popularly as *provveditori*) and *executores*. The merchant guild with its court for settling disputes is the *Mercanzia*. The party leaders are the *capitani* of the *Parte Guelfa*.

7. See Bowsky 1981, 34–45.

8. Cost. 1309, *Dist*. VI, rubrics iv–xii. See Bowsky 1981, 24–5, 85–103.

9. This 1287 rubric was repeated in a later version, Cost. 1309 *Dist*. II, rubric cclvii, 'Che la contrarietà de' capitoli de lo statuto si debbia stare a la sententia de li Signori Nove,' after which the same point is made again in different words. Rubric cclvi reads 'Et che neuna interpretatione s'admietta sopra alcuno capitolo del costoduto di Siena, ma secondo che sempricemente le perole giacciono et poste sono, così sempricemente s'intenda, senza alcuna interpretatione.' See also *Dist*. I rubric dlvii of 1299 on the necessity of militating against confusion by expanding legislation. ASS *Statuti* 23, fol. 33v reads 'Item cum manifeste dicitur et per evidentiam rei apparet quod … Providerunt et ordinaverunt sapientes …' It is repeated in Const. 1337 *Dist*. I, rubrics 207–9, 'Quod nulla interpretatio …' and 'De contrarietate capitolorum statutorum tollenda per dominos.'

10. See Bowsky 1970, 12, derived from Cost. 1309 *Dist*. VI, rubric xlvii.

11. See Bowsky 1970, 114.

12. See Cost. 1309 *Dist*. I, rubrics cxxxii and cxxxiv.

13. See ASS Capitoli 1 and 2, or *Caleffo Vecchio* and *Caleffo dell'Assunta*, see Cecchini edition, introduction v–x and Guida-inventario 1951, 122–5.

14. See *Cronache Senesi*, 417–23, 464, 477–8 and Bowsky 1970, 27, 28 and 211.

15. See *Caleffo Vecchio* IV, 1735–53; on 1735 'Instrumentum dationis et concessionis dimidie castri, casseri, curie et districtus de Arcidosso.' Elsewhere the document also refers to the terms *territorium, terra, possessiones, bona et iura,* as well as *mixtum imperium* and *plena iurisdictio.*

16. See Const. 1337 fol. 217r–220v; *Capitoli* 2 fol. 522r–553v and Bowsky 1981, 7, 9, 131, 152, 156–7, 164–6, 174, 194, 218. Some few towns enjoyed the special status of ally rather than being annexed by the city-state.

17. *Purgatorio* XIII, 151–4.

18. Const. 1337 fol. 66v–69v, 215r–v, 219r.

19. See ASS *Statuti* 21 fol. 27r–v and Bowsky 1981, 55–6.

20. See Bowsky 1970; also *statuti* and the accounts of the Gabella and Biccherna.

21. Guida-inventario 1951, 218–30 and in ASS *Arti* 165, which lists numbers of persons for each particular occupation: for example, there were 138 notaries, 21 barbers, 22 goldsmiths, 30 painters, 89 shoemakers and 19 key-makers.

22. See Cost. 1309 *Dist.* V, rubrics ccclvii–ccclxi, ccclxxvi–ccclxxxiii.

23. See Cost. 1309 rubrics clxii–clxiv.

24. See Bowsky 1981, 117–58 and Const. 1337 *Dist.* IV, fol. 211r–221v.

25. See Cost. 1309 *Dist.* III and Const. 1337–1339, fol. 254r–257r.

26. See Bowsky 1970, 11, 30–31, 39, 40, 66, 78, 216–21, 224 and 271; Bowsky 1981, 140, 260–75; Const. 1262 *Dist.* I, rubrics xl–cxviii; Cost. 1309 *Dist.* I, rubrics vi–lxii; *Statuti* 21, fol. 21r, 27r–v and Guida-inventario II, 41–214.

27. See *Cronache Senesi*, 121–2, 313, 390–91, 'Lo studio era in Siena assai florido co' molti scolari e dottori in ogni facoltà e facendo ogni qualche disputa fra i dottori.' See also Bowsky 1981, 76, 277–8.

28. See Cost. 1309 *Dist.* I, rubrics iii–v; Const. 1337 fol. 3r–8v. Virtually the same text appears in Const. 1262.

29. These themes were also addressed in the statutes of institutions; for example, ASS *Gabella* 3, fol. 3r, 16r, 38r, 41r–47r, 53v, 60v, 61v.

30. See Luciano Banchi, ed., *Rime di Bindo Bonichi da Siena*, Scelta di curiosità letterarie inedite o rare, LXXXII (Bologna, 1867), 187. Bindo Bonichi's verses are quoted in Bowsky 1981, 281–3 (English translation given here is new).

31. See *Cronache Senesi* and quotations in Bowsky 1981, 60, 68, 75, 76, 94, 131, 132, 157.

32. See Milanesi 1854 I, 180–81 and Southard 1979, 7 notes 8 and 9; 'magnus honor etiam comunibus singulis, ut eorum rectores et presides bene, pulchre et honorifice habitent, tum ratione eorum et ipsorum, tum ratione forensium, qui persepe ad domos rectorum accedunt ex causis plurimis et diversis. Multo tamen costat comuni Senensi secundum qualitatem ipsius.'

33. See Milanesi 1854 I, 1.

34. As witnessed by the ten-florin commission given to Simone Martini in 1327 to paint banners for the reception of the Duke and Duchess of Calabria, see Bacci 1944, 152–3. Carlo of Calabria became podestà of Sienna in 1327.

35. See *Cronache Senesi*, 496.

36. See *Cronache Senesi*, 496.

37. Cf. Southard 1979.

38. See *Cronache Senesi*, 41–57 and 187–94 and Bowsky 1981, 160–66.

39. See Vroom 1981, 32–47.

40. See Vroom 1981, 60–94 and 109–117; for Sienna, Bowsky 1981, 271–5; for Lucca, Osheim 1977; for Rome, Huyskens 1906 and De Blaauw 1987, 137–41 and 364–9, with data concerning the canons' liturgy in St John Lateran and St Peter's.

41. See Vroom 1981, 32–47.

42. Various reconstructions have been proposed in the literature, none of which, however, includes the possibility of a 'Romanesque' cathedral of 1200 as suggested here: Lusini 1911 I; Middeldorf-Kosegarten 1970; Carli 1979, 1–28 and White 1979, 95–102. Cf. the sources in Milanesi 1854 I, 139–58, 161–72 and 204–9.

43. Cf. the cathedrals of Modena, Todi, Atri, Fidenza, Otranto, Salerno, Piacenza, Parma, Orvieto and Rome. A semi-circular apse was customary in churches built before 1250.

44. Pietramellara 1980 and Van der Ploeg 1984 have emphasized the importance of the crypt. See also the criticism of Van der Ploeg, 137, 139 concerning the reconstruction proposed in White 1979, 98.

45. Odericus–Trombelli 1766.

46. See *Cronache Senesi*, 4. He was a legate of Gregory IX, and mediated between the monks of Monte Amiata and the Bishop of Chiusi and Sovana in 1232. He died in 1235 and was referred to in the cathedral death notices as the author of the *Ordo*. Odericus–Trombelli 1766, 4 has a reference to Gelasius, a significant figure in relation to Roman tradition.

47. Sienna Cathedral, of course, was far smaller than St Peter's, and the canons' choir was not to the side but occupied a central position in the nave. The *Ordo* has been used previously by Middeldorf-Kosegarten 1970, which includes quotations in notes 44–52; see also Carli 1979 and Van der Ploeg 1984, 107–56. They have taken precisely the opposite reading of the position relative to the altar. The passages which are of relevance to the architecture are in Odericus–Trombelli 1766, 9, 12, 37, 39, 45, 98, 102, 123, 132, 173, 179, 186, 220, 293, 391 and 418.

48. See Odericus–Trombelli 1766, for example, 357, 363–5, 367 and 371. Van der Ploeg mistakenly locates most of the altars in the crypt.

49. See *Cronache Senesi*, 5 and Odericus–Trombelli 1766, 273–4 for the festival of St Ansanus.

50. See Odericus–Trombelli 1766, 364, '... *et nota quod hodie tabula ... super altare.*'

51. See Odericus–Trombelli 1766, 13, 38, 74, 106, 148, 280, 293, 450–57 and 472. There is no evidence to support the claim that the stone pulpit was used for the gospel, opposite a wooden lectern used for the epistles, as was customary in Roman churches.

52. Where the choir is described in 1368 as 'straight' ('che 'I coro si murasse, secondo che va el vecchio a retta linea'), this implies that the old choir was rectangular. The pavement suggests that the new one had a hexagonal form. The documents from the 1360s to the 1390s refer to a new antechoir in the nave and, after 1377–8, to a second choir around the high altar in the *cappella maggiore*. The antechoir was used for the offices, the second choir for Mass. See Milanesi 1854 I, 331–46.

53. See Odericus–Trombelli 1766, 12, 348, 392, 418, 450–57 and 472.

54. See Odericus–Trombelli 1766, 9, 33–7, 122–3, 139, 186, 418. Certain passages from the service are quoted in van der Ploeg 1984, 134.

55. See Odericus–Trombelli 1766, 45, 179–80.

56. See Odericus–Trombelli 1766, 379–80, 426–7 and 455–7.

57. See Odericus–Trombelli 1766, 379. There was also a *claustrum canonicae*, used during processions.

58. See Bowsky 1981, 10, 267–75. More data are available concerning Lucca and a number of other towns; see Osheim 1977, 20–29, 48–52, 59 and 88–116. See also Vroom 1981, 59–227.

59. See Vroom 1981, 87–9, 91–3 and 110–16

60. See Odericus–Trombelli 1766, 426, 'Et nota quod in Ecclesie duo sunt ordines, sapientes et insapientes, sic dua sunt lectionum materies.'

61. See Odericus–Trombelli 1766, 466.

62. See the death announcements in *Cronache Senesi*, 3–38 and Vroom 1981, 60–94 and 109–17 for the tasks assigned to, for example, doorkeeper, sacristan and treasurer.

63. See Carli 1979, 17–18.

64. See Milanesi 1854 I, 140–41; Pietramellara 1980, 53–4 and Van der Ploeg 1984, 135–9.

65. See Pietramellara 1980, 54: '... quod fieri faciat unam voltam inter ultimas duas colunnas marmoreas ...' points directly to the enlargement as suggested here. The decisions taken in May and June 1260 are discussed on 54–5. The 1196 reference to the *Opera Sancte Marie* in a will also points to the existence of a smaller Romanesque church towards the end of the twelfth century; see Lusini 1911 I, 12 and 22 note 12. The old dome is depicted in a 1224 miniature; see Middeldorf-Kosegarten 1970 fig. 1. The purchasing of houses is mentioned in Const. 1262. Payments were made between 1147 and 1260; see Pietramellara 1980, 21–30.

66. See Milanesi 1854 I, 309, 310, 317, 329; Lusini 1911 I, 262, 272, 276 and van der Ploeg 1984, 156 note 165.

67. See *Cronache Senesi*, 58–9 and extensive comments on 202–3.

68. See *Cronache Senesi*, 202–3.

69. This work is presently in the cathedral museum. The hypothesis put forward here concerning its original location is a new one. See also below, note 75.

70. This is indicated in later inventories and the chronicle of Niccolò di Giovanni Francesco Ventura; I shall be publishing a separate article on this subject.

71. There was a similar custom in S. Maria Maggiore in Rome, where a Madonna icon and one of the Saviour (from St John Lateran) were carried in processions and worshipped during the entry into the church before being placed by the pulpits. See De Grassis's *Diarium* 12272 fol. 22v and 12268 fol. 237r. At festivals in honour of the Virgin Mary, eighteen *imagines* were carried in this way; see De Blaauw 1987, 206, 216. In Pisa Cathedral there was a silver *tabula* that was set upon the high altar on holy days; see Kempers–De Blaauw 1987, 107 note 53.

72. See Borghesi 1898, 269, 'Una ymagine di legno di nostro Signore resucitato, con bandiera in mano, si mette in sull' altare maggiore per la Pasqua della resurrectione.' It would appear that fifteenth-century references to works 'upon the altar' are assumptions made about the customs of two centuries before.

73. See *Cronache Senesi*, 222.

74. See Const. 1262 *Dist.* I rubric xiv, 'exinde fuerint requisiti a domino episcopo Senarum, invenire et videre et ordinare locum unum, in quo eis videretur magis conveniens, pro construendo et faciendo fieri, expensis operis Sancte Marie, unam cappellam ad reverentiam dei et beate Marie Virginis et illorum Sanctorum, in quorum solempnitate dominus dedit Senensibus victoriam de inimicis'.

75. The usual hypothesis is that Guido's *Madonna* replaced a relief panel – that had originally been placed in front of the altar – as the main altarpiece; see Hager 1962, 106, 134–5; Van Os 1969, 157; Carli 1979, 81, 105, 108, 130–31 and Van Os 1984, 12, 17–18. This implies that Guido's panel, the *Madonna delle grazie*, that has hung in the *Cappella del Voto* founded by Alexander VII since 1658, was originally painted on both sides. I believe that the renovations in the 1440s and again in the 1650s, in the course of which the original *Cappella delle Grazie* was demolished, have occasioned the later confusion between the *Madonna di mezzo relievo* and the Madonna in the *Cappella delle* Grazie, which was called the *Madonna degli occhi grossi* in the fifteenth century.

76. See Borghesi 1898, 261–330. In the *Cappella della nostra Donna delle gratie* there was: Uno altare con tavola dipincta alle antica, con figura di nostra Donna col suo figliuolo in collo, con una corona di rame dorata, con una istella d'argento et una corona in capo al bambino [...] con più para d'occhi

d'argento. (318). This panel was sawn down between 1448 and 1455 so that
it could be carried in processions. The *Madonna di mezzo relievo* had by
this time been removed from the cathedral to S. Ansano. This hypothesis
concerning the original destination for Guido's panel, and for the older icon,
is put forward here for the first time.

77. See Seidel 1970, 60, which has the descriptions in the inventories.
78. See Milanesi 1854 I, 155–6.
79. See Van Os 1969, 147–62 and White 1979, 99, 137–40. In 1288 payment
was made for 'the window that is to be made above the altar'.
80. See White 1979, 192–3.
81. See White 1979, 194.
82. See White 1979, 195.
83. See White 1979, 195–6.
84. See White 1979, 102–40; Stubblebine 1979, 31–62 and Van Os 1984,
39–61.
85. The sum involved was eight *soldi*; see White 1979, 196–7.
86. See *Cronache Senesi*, 313.
87. See Cost. 1309 *Dist.* I rubrics xiii, xiv, xxxvi (on the wax tribute), lvii–lxii
(on funding and allocation of tasks), dlxxxiii–vi (on Assumption Day and the
palio), *Dist.* III rubrics cclxiv, cclviii, cclxxxii and cclxviii (on adjustments
made to the baptistery); see also *Dist.* V rubrics ccxvi–vii and Const. 1337
fol. 9r–10v.
88. See Cost. 1309 *Dist.* I rubric xxxvi, which includes regulations on the *opera
Sancte marie*.
89. See White 1979, 195, *secundum formam statuti*, a formula often used; here it
is a direct reference to patronage.
90. Regulations and payments are cited in Cecchini 1957. In 1147 the lords of
Montepescali gave a tribute of wax. Regulations were already in existence
in 1200 (11–12). In 1298 the commune donated a 100–pound candle and
300 litres of wine, also paying for garlands and flags (19). Later payments for
confetti, musicians and children's clothes are mentioned on 136–7. The silk
tribute is referred to in Riedl 1985, 159. One of those to give silk was Count
Ranieri Pannocchieschi d'Elci of Castle Giuncarico.
91. See Cost. 1309 *Dist.* I rubric dlxxxvi and Cecchini 1957.
92. See Bowsky 1981, 263.
93. See Borghesi 1898, 319–27. The banners were kept in the *Opera* premises.
94. See ASS *Statuti* 21 fol. 259r and Const. 1337 fol. 9r–12v, which enumerates
the castles and towns that participated.
95. See Borghesi 1898, 313–14 and Lusini 1911 I, 262–5.
96. See *Cronache Senesi*, 552; Milanesi 1854 I, 194–6, 226–32, 240–42, 249–57;
Lusini 1911 I, 237, 372 and Bacci 1944, 163–73.
97. See Degenhart–Schmitt 1968 I, 94–6 and Van der Ploeg 1984, 140–47.

98. See Van Os 1969, 3–33 and 1984, 77–89, which has references to payments and inventories.

99. See Van Os 1984, 82–3.

100. See Lusini 1911 I, 237.

101. Cf. the payment made to Andrea di Bartolo in 1405, for frescoes depicting St Victor. These chapels too were equipped with screens, pews, angels and ostrich eggs; see Borghesi 1898, 313–17 and Van Os 1969, 6.

102. See the reconstruction in Van der Ploeg 1984, 144 and fig. 24 in this book. For the hospital, see also Ghiberti–Fengler, 42–3 and Eisenberg 1981, 135–6, 147–8 with the contract with Sano di Pietro and his 1448 predella panels in Rome, with the aid of which it is possible to reconstruct the fresco series painted around 1330.

103. See Const. 1262 *Dist.* I rubrics xviii, xl–lxxxvi, cxxii–vi for the contributions made to mendicant orders and ii–viii for the Cathedral; see note 87 for the 1309 statutes.

104. See Const. 1262 *Dist.* I rubrics x, xvii.

105. See Const. 1262 *Dist.* I rubrics ii, iii, xiv.

106. See Lusini 1911 I, 26–31, 61; Carli 1979, 32–3, 47–51; Pietramellara 1980, 22–5, 53–6 and Borghia 1984, 7–9.

107. See ASS *Statuti* 11, fol. 1r.

108. See ASS *Biccherna* 1, fol. 1r.

109. ASS *Statuti* 16 fol. 1r and 89r, and Const. 1337 fol. 1r and 203r. Ecclesiastical affairs in fol. 1r–15r, 205r.

110. See illustrations in Borghia 1984, 10–11, 72–3.

111. Borghia 1984 contains numerous illustrations: 78–9 has a monk (from the annual report for 1320), 88–9 the Virgin and the birth of Jesus (1334), 108–9 the Assumption (1337), 114–15 the Crucifixion (1367), 128–9 St Michael, 134–5 St Antony Abbot (1414), 140–41 St Jerome (1436), 144–5 St Peter (1440), 148–9 the Flagellation (1441), 150–51 St Michael (1444), 152–3 the Annunciation (1445), 156–7 the Virgin as the city's protectress (1451), 158–9 the Virgin in the Biccherna offices (1452), 160–2 the Annunciation and St Bernard (1456) together with a dove and Giovacchino Piccolomini (1457), 170–71 shows the Virgin protecting besieged Sienna (1467) and 182–3 shows her dedicating the city to Jesus (1488), and finally 190–91 shows the Virgin guiding the ship of the republic to calm waters (1487). See also Catalogue Sienna and *Il Gotico a Siena*.

112. See Southard 1979, 440.

113. See Van Os 1969, 48–9.

114. See Borghia 1984, 96–7, 112–13, 116–17.

115. Cf. Vroom 1981, 41–8 for these functions within chapters.

116. See Cost. 1309 *Dist.* I rubric lxi, with the *palio* inaugurated on his feast-day in 1306. The order is repeated in Const. 1337 fol. 12v.

117. See Vauchez 1977 with transcriptions of various passages from the minutes in notes and Appendix; (minutes from ASS *Consiglio Generale* 107, 33r–41v, 70v–74v) and of petitions submitted by the orders.

118. See Milanesi 1854 I, 160–62, 193; Vauchez 1977 and Bowsky 1981, 261–5.

119. See ASS *Consiglio Generale* 107 fol. 33r–41v, 70v–74v.

'Dominis Novem gubernatoribus et defensoribus Comunis et populi civitatis Senensis proposuerunt et dixerunt pro parte Prioris Fratrum et conventus Eremitarum S. Agostini de Senis, quod sicuti et omnibus Senensibus manifestum Beatus Augustinus Novellus de ordinie sancto dicto, cujus corpus est in ecclesie dicti loci de Senis, tam propter sanctitatem quam propter magnam dilectionem et affectionem quam habuit ad Comune Senese, et singulares homines et personas ipsius comunis est merito honoramdus per Comune prefatum, maxime cum credi debeat imo(quod) a certo teneri quod pro dicto comuni et civitate Senensi et statu ejus pacifico in celesti curia continue sit maximus advocatus ...' (Vauchez 1977, 765) and 'Deua omnipotens meritus et precibus Beati augustini predicti Comune Senense ab omnibus adversitatibus custodiat et ejus statum pacificum conservet et de bono in medius augeat et eccrescat ... Summa et concordia dicti Consilii ...' (766).

For equivalent formulations with references to the Virgin Mary, and to the civic rulers, in the podestà's oath, see Cost. 1309 *Dist.* VI, rubric i.

120. See Fanti 1980, 1–35. In Bologna St. Petronius was the patron saint of both the city and its major church. S. Pietro was the cathedral.

121. See Fanti 1980, 81–100. In Arezzo, Volterra, Pisa and Modena the city councils had no such great influence on the Opera, and the cathedrals were correspondingly smaller.

122. See Vroom 1981, 57.

123. See Vroom 1981, 56 and for the Opera Fanti 1980, 101–59.

124. Cf. Vroom 1981, 344–52, 368. There was no cathedral in Brussels, Antwerp, Bruges, Ghent, Malines, Bois-le-Duc, Haarlem, Amsterdam, Delft, Ulm or Vienna.

125. See Vroom 1981, 52–5.

126. Cf. Vroom 1981, 354–69. See also Goldthwaite 1980.

127. See Cecchini 1931, viii in *Caleffo Vecchio*.

128. See Southard 1979, 11–14. The churches, S. Ansano in Campo, *sito platea senense*, and S. Luca in Riedl 1985, 321–2.

129. See Southard 1979, diagrams 1–3.

130. See Southard 1979, 155–6.

131. See Southard 1979, 430–32.

132. See Southard 1979, 436.

133. See Southard 1979, 436–8.

134. See White 1979, 191. Duccio was paid for this work by the Biccherna on 4 December, the payment having been approved by the Nine.

135. See Borghesi 1898, 8.

136. See Bacci 1944, 40–41. Its location is described as *dinanzi al Concestoro de' Nove* and *ante Consistorum*. This designation also occurs in the *Caleffo Vecchio*: 'in palatio comunis Senarum, in loco qui dicitur consistorium, in quo dicti domini Novem morantur pro eorum offitio more solito exercendo'; see for example *Caleffo Vecchio* IV, 1719, 1722, 1724. This chamber may have been the 'Peace Room' and not the later Sala del Concistoro; cf. Southard 1979, 394–402.

137. See Bacci 1944, 134–8, 140–42.

138. The source of this information is Bacci 1944, 157. The hypothesis concerning Simone Martini's polyptych is advanced in Eisenberg 1981, 142–7, though Eisenberg posits too large a work.

139. These were apparently the two city scenes presently hanging in Sienna Pinacoteca; see Torriti 1977, 113–15, where other hypotheses are also enumerated. The panels are generally assumed to have belonged to Sassetta's guild altarpiece. For Talamone see ASS *Capitoli* 2 fol. 568v–569v. The name of 'Silva Lacus' occurs in the statutes with great frequency. See Zdekauer 1897 (Index); Costituto (ed. Lisini) 1903; and *Caleffo Vecchio* IV, 1508–1512.

140. See Southard 1979, 213–14, 237–41.

141. See Southard 1979, 257–61.

142. See Seidel 1982, 18–21. Seidel's notes and bibliography list various sources. One of the conclusions he reaches differs from that advanced here, namely that the later town is Giuncarico, painted by Duccio in 1315.

143. Published in Seidel 1982, 35–6.

144. See Southard 1979, 215 and Seidel 1982, 36: 'Sed in perpetuam sint et remaneant in Comuni et apud Comune Senarum, et quod dictum castrum pingatur in palatio Comunis Senarum ubi fiunt Consilia, ubi sunt picta alia castra acquistata per Comune Senarum et numquam possit talis pictura tolli abradi vel vituperari . . .'

145. See Southard 1979, 216–28 and Borsook 1980, 19–23.

146. The commission was for the *Sala Palatii dominorum Novem*; see Bacci 1944, 134–6. Simone Martini and his pupils received payment for the town hall frescoes in 1321.

147. See Borsook 1980, 19–20.

148. See Bacci 1944, 160–63.

149. See *Cronache Senesi*, 496, which attributes this work, like the picture of Montemassi, to Simone di Lorenzo.

150. For other – highly divergent – interpretations of Guidoriccio and the town below the horseman, see Moran 1977 and Seidel 1982. The present fresco is the result of drastic restoration and renovation work, which explains why certain elements do not correspond to the actual situation in 1330; this also explains the differences between this fresco and the Pannocchieschi castle – probably Elci – as pictured below. To the right of the general a catapult may

be seen, beside which are the tents of the Siennese army (each displaying the city arms) and a vineyard. To the left is the palisade which the Siennese had erected around Montemassi, precisely corresponding to the descriptions in the city chronicle. At the outer edge of the painting can be seen the arms of Sienna and the date of the victory, 1328.

151. See *Caleffo Vecchio* IV, 1735–9 and ASS *Capitoli* 2; the same treaties with the *Comites sancte Flore* are in fol. 315r–346r. For Arcidosso see fol. 334r–336r and for Castel del Piano fol. 336r–337r, supplements in 391r–425v. Const. 1337 fol. 215r–v deals with the *castellanus* of Montemassi and Arcidosso, with fol. 32r on the *vicarius Arcidossi*, fol. 68r–70v on Sassoforte. Scanzano, that was returned in exchange for Buriano and Montemassi, is referred to in fol. 126r and *Capitoli* fol. 338v–339v. To the left of the Arcidosso fresco may have been depicted the transfer of the castle to Sienna, which – according to custom – appointed a deputy (*vicarius*) to whom the lord of the castle was subordinate.

152. See ASS *Capitoli* 338v–339v and the series of treaties in *Caleffo Vecchio* IV, 1717–53.

153. See Southard 1979, 241–8, 252–7. The globe executed by Ambrogio Lorenzetti, which obscured from view the annexation of the Pannocchieschi castle, needed restoration work as early as 1393. The battle in the Val di Chiana (1363) and the battle by Poggio Imperiale (1479) were painted on the north wall shortly afterwards.

154. See Southard 1979, 249–52, 257–65.

155. See Southard 1979, 119–23; all the examples of *pitture infamante* have been lost. The adjustments continued with the *consistoro*'s commissions to Sodoma to paint Ansanus, Victor, Bernardo Tolomei, Ambrogio Sansedoni and Andrea Gallerani.

156. In Const. 1337, fol. 50v, 66v–69v, 213v, 213r–219r, 233r–v and in the city chronicles the emphasis was on the captain of war as the chief servant of the city-state. This in itself suffices to indicate that there was nothing 'un-republican' about Guidoriccio's portrait of honour.

157. See Southard 1979, 396: 'una figura [. . .] nel consistoro de nove di Marco Regolo et avemo policia di signori Nove.' See also note 136.

158. See Southard 1979, 117–19, and on 119–22 the rebels portrayed on the façade (the so-called *pitture infamante*) are mentioned.

159. See *Cronache Senesi*, 525, 535.

160. See *Cronache Senesi*, 121, 313, 390–91 and Bowsky 1981, 76, 277–8.

161. Quotations referring to these frescoes can be found in Southard 1979, 273, 277. Payments are cited on 272–3.

162. Various writers' ideas may be traced in the statutes, including those of Thomas Aquinus, Hugo of Saint Victor, Brunetto Latini, Domenico Cavalca, Restoro d'Arezzo and Remigio dei Girolami. There is no evidence, however, that the frescoes should be understood as directly reflecting theories of a general

nature with no specific bearing on Sienna. Cf. Rubinstein 1958 and Feldges-Henning 1972; bibliographies in Southard 1979, 293–4 and Borsook 1980, 37–8. Despite traces of the ideas of the authors cited above in the thinking of the jurists there is unlikely to have been any direct influence; nor, indeed, would the supposition of such influence be particularly helpful in clarifying the images.

163. Cf. Melnikas 1975; Cassee 1980 and Conti 1981.

164. See Novella in libros Decretalium, Milan, Biblioteca Ambrosiana Ms. B 42 inf. fol. 1r.

165. See Sienna Biblioteca Communale degli Intronati, Ms. K I 3 and K I 8; see also the legal texts in the inventory given in Borghesi 1898, 274–82.

166. See *Cronache Senesi*, x–xi. The worship of saints Ansanus, Savino, Crescenzio and Victor can also be seen as related to Siennese interest in the Roman past, all having been martyred by Roman emperors.

167. These virtues were mentioned with great frequency in the statutes; they also featured in minutes of meetings and the oath of office taken by the Nine. Bindo's moral treatise also refers to them. See ASS *Statuti* 15, fol. 290r, 264r, 266r; *Statuti* 21, 1r–v, 7r, 27r–v; Bowsky 1981, 55–6, 143, 281–3.

168. For these officials – the 'maggior sindaco', 'capitano del popolo' and the podestà (who wears gloves) with the consuls of the Merchant Guild behind them – see Const. 1337 fol. 23r–58v, 73r–75r, 124r–125v, 150r–156v, 197r–208v and Bowsky 1981, 34–42, 42–5, 23–34, 78, 87–90, 222–32.

169. See, for example, ASS *Arti* 61, fol. 25r from 1292 and *Podestà* i fol. 1r.

170. On the links between peace and the struggle to put down rebels, see, for example, Const. 1337 fol. 223v:

'Et quod Comune et populus Sen. conservetur in bono et pacifico statu. et inveniant diligenter de statu et condictionibus inimicorum et proditorum et rebellium Comunis et populi Senarum et que invenerint et que providerint de predictis referant domino potestati et dominis Novem. Et tunc ipsi domini Novem possint super predictis relatis providere et procedere prout eis videbitur pro honore et bono statu Civitatis Senarum et in dampnum et persecutionem inimicorum et rebellium atque proditorum predictorum ...'

171. The *comites* and *magnates consules militum* (that is, the nobles) are opposite the captains of the Guelf party. The *cavalieri* or *equites* and the *fanti* or *pedites* were both referred to as *paciarii* of the commune; in other words both horsemen and foot-soldiers preserved the monopoly of armed force. See Const. 1337 fol. 75r–76v, 211r–228v; see also *Costituto* (ed. Lisini) 1903 (entries listed in Index) and Bowsky 1981, 117–58.

172. The best orientation is provided by the Index of *Costituto* (ed. Lisini) 1903, given that the regulations in this area are far from systematic. Also helpful are the remarks in ASS *Statuti* 15.

173. On fire-fighting officers see *Cronache Senesi*, 489 and Bowsky 1981, 296–8. See also Goudsblom 1984b.

174. Transcriptions may be found in Borsook 1980, 36.

175. For this contrast see ASS *Statuti* 16, fol. 252, 256–7v and Const. 1337 fol. 127r–129v, 144v–149v, 155v, and for criminal law see fol. 158r–175.

176. See Cost. 1309 *Dist*. III rubrics xxxvii–iii.

177. See Const. 1337 fol. 71v: 'De armis non pingendis in palatio, porta vel fonte comunis.'

178. See Cost. 1309 *Dist*. I, rubric xcv, *Dist*. II rubrics clix–clxxxviii, *Dist*. IV rubrics xiv–xviii.

179. See Cost. 1309 *Dist*. V, rubrics ccclvii–ccclxi, ccclxxvi, ccclxxxiii and Const. 1337 fol. 83v–84r, 85r, 230r, 231r–323v.

180. Cf. Sienna Inventory 1951, 225–35; Bowsky 1970, 35–8, 117; Bowsky 1981, 219–23 and, for example, Const. 1337 fol. 207v '*De electione kabelleriorum ad portas*' and 228v '*De augmentatione artis Lane*'.

181. See Const. 1337 fol. 155r '*De consilio fiendo pro securitate*' and the inscription in Borsook 1980, 35.

182. On bridges (*ponte*) and watermills (*moline*) see the Index to *Costituto* (ed. Lisini) 1903 and Const. 1337 fol. 246r–251v.

183. Cf. Cost. 1309 *Dist*. III rubrics xii, xiv, xviii, xix and Const. 1337 fol. 256v–258r.

184. See Belting 1977, 25. Fra Elias, general of the order (1232–9) also had his name inscribed on two bells that he had cast in Pisa in 1239. In 1299 Attone, *pictor de senis*, was working in Assisi; see also Nessi 1982.

185. See Gordon 1982.

186. See Hager 1962; Gardner von Teuffel 1979; White 1979; Cannon 1982 and Van Os 1984, where the co-operation that took place between carpenters and painters is also discussed.

187. See Borsook 1980, 46–8.

188. See Pal. lat. 631, fol. 170r; Pal. lat. 626, fol. 132r; Pal. lat. 623, fol. 293r, 333v; Vat. lat. 76r, 198r, Vat. lat. 2492, fol. 273r; Vat. lat. 2634, fol. 1r; Vat. lat. 1389, fol. 173r, 241r; Urb. lat. 161, fol. 297r, 338r.

189. See Avril 1978, 22, 27–8.

190. Painters clearly considered they had a responsibility to society in this respect, as witness the preamble to their guild statutes: '*Imperciochè noi siamo per la gratia di Dio manifestatori agli uomini grossi che non sanno lectera, de le cose miracolose operate per virtù et in virtù de la santa fede*'; see Milanesi 1854 I, 1.

191. See White 1979 and Van Os 1984 for analysis and illustrations.

192. See White 1979, 185–9.

193. See White 1979, 194.

194. See Seidel 1970, 60 and notes 36–8.

195. For the high altar of the Duomo in Florence an altarpiece of more modest

proportions was ordered around 1320 which had St Eugenius, St Minias, St Zenobius and St Crescenzio beside the Virgin on the front, and St Reparata, patron saint of the cathedral, St John the Baptist, Mary Magdalene and St Nicholas on the back; see Paatz 1940 III, 382–3.

196. See Van Os 1984, 58–61. For the ties between Sienna and Massa Marittima see *Cronache Senesi*, 497–508 and Bowsky 1981, 5–8, 131, 164–6, 174, 194 and 229.

197. Cf. Stubblebine 1979.

198. See Van Os 1984, 21–38, 63–9.

199. See Milanesi 1854 I, 194–6 and Van Os 1984, 91–9.

200. See Bacci 1944, 118–24 and Cannon 1982.

201. See Bacci 1944, 1–47.

202. See Previtali 1967, 151–2; Schneider 1974 and Gilbert 1977.

203. See Bologna 1969 (with illustrations) 11, 115–16, 132–3, 150–73, 210–12, 219–23 and Gardner 1976 for this altarpiece and other commissions given by Robert of Anjou. See also Toynbee 1929. In 1329, when the construction of the monumental church of St Clare's was in full swing, Robert had relics of Louis brought from Provence to Naples. The church had three parts: a monks' choir, a mausoleum for the Anjou dynasty and a nave with side chapels, of which the one nearest to the funerary monuments was dedicated to Louis. I hope to publish a paper on this subject in due course, partly in the light of the findings cited in Part I with reference to saints' altars.

204. The payment made to *Symone Martini milite* in 1317 at Naples cannot be related to the painter, who was known as *depintore* or *SYMON DE SENIS* and would not have been referred to as *miles*; see Bacci 1944, 117 and Contini 1970, 86–7. This payment cannot therefore be used as an argument in dating Martini's work, and the fact that Louis was canonized in 1317 does not in itself constitute sufficient evidence.

205. See Ghiberti–Fengler, 19: 'Molto egregiamente dipinse la sala del re Uberto de' uomini famosi. In Napoli dipinse nel castello dell'uovo.'

206. '*Laudatio ad Robertum regem Napoli*', Biblioteca Nazionale Centrale Florence, BR 38.

207. Theological Institute Library in Louvain, Ms. 1. The inscription on the baldachin above the king reads *REX ROBERTUS REX EXPERTUS IN OMNI SCIENTIA*.

208. The data from this paragraph derive from Kempers–De Blaauw 1987, 90–91, which gives references and contains illustrations.

209. See Cassee 1980, 42–4.

210. See Cassee 1980, 42–4.

211. See Bacci 1944, 177–8, 185–91.

212. Sources in Previtali 1967, 151–3 and Gilbert 1977, 55, 59, 60; on 32, 41, 53, 72 there are references to Giotto's position in Florence as *capomaestro* of

the Duomo and supervisor of city planning. See also Warnke 1985, 23–6, 29.

213. See Baxandall 1972, 51–60 and Warnke 1985, 31. The formulations were *cedat Apelles, vultus viventes* and for statues *signa spirantia* and *vox sola deest*.

214. See Baxandall 1972, 53–8.

215. See Baxandall 1972, 60 and Warnke 1985, 31.

216. Other examples are mentioned in Martindale 1972. For this aspect of the profession in fifteenth-century Florence see Neri di Bicci's *Ricordanze*.

217. 'cuius pulchritudinem ignorantes non intelligunt, magistri autem artis stupent', Baxandall 1972, 60.

218. See Milanesi 1854 I, 1.

219. See Milanesi 1854 I, 2, 5, 11, 14, 15, 20, 21, 23, 24.

220. See Milanesi 1854 I, 7, 8, 13, 16, 25.

221. See Milanesi 1854 I, 22.

222. See White 1979, 185, 188, 190, 191.

223. We know of several contracts concluded between Duccio and his clients: they include one drawn up in 1285 with the rector of a lay confraternity in Florence, and several documents dated between 1309 and 1311 referring to the arrangements and payments made in connection with commissions for the commune of Sienna. See White 1979, 185–7, 192–8.

224. See Borghesi 1898, 4–5.

225. See documents relating to commissions in Milanesi I–III; Gaye 1839; Chambers 1970; Glasser 1977; and Gilbert 1980. The contract between Tornabuoni and Ghirlandaio also contained extensive instructions concerning use of raw materials and images to be depicted.

226. See Van Os 1974 and 1981.

227. See Bowsky 1981, 299–314.

228. See also Van Os 1981a as a critique of Meiss 1951.

229. See Christiansen 1982, 50–58, 136–7, 167–73.

230. Information on innovative commissions can be found in: Pope-Hennesy 1939, 6–16, 25–52; Carli 1979, 84–7, 115–24; Torriti 1979, 138–40, 289, 316, 350–61, 394–6.

231. See Van Os 1974, 8–17, 57–61, 78.

232. See Milanesi 1854 I, 350–51, 362–3, 366–71 and Borghesi 1898, 250, 255–9.

233. See Milanesi 1854 II, 368–9.

234. See Milanesi 1856 III, 9–16. Borghesi 1898, 366–8 refers to Michelangelo's commission to execute statues for the Piccolomini chapel in the Duomo.

235. See Vasari–Milanesi III, 498.

236. See Vasari–Milanesi III, 497–503; Castel Sant'Angelo is mentioned on 500.

237. Various editions of these Commentaries are available. Cf. the Gragg and Gabel translation, 1937–57.

238. See Carli 1979, 122–3 with illustrations.
239. See Dykmans 1980.

PART III

1. See Previtali 1967; for the literature relating to Giotto, see Baxandall 1971, 70–78. Boccaccio has a striking description of the contribution made by this artist: '... avendo egli quella arte di pittura ritornata in luce, che molti secoli sotto gli errori d'alcuni che più a dilettar gli occhi degl'ignoranti che a compiacere all'nteletto de' savi dipignendo era stata sepulta ...' quoted in Baxandall 1971, 74.
2. Taken from Franco Sacchetti's *Novelle* by Meiss 1951, 3.
3. See Doren 1908.
4. Antal 1948, 11–20, 278–9; Wittkower 1963, 9–12 and Reynolds 1982, 14–20. In 1349 the statutes were translated into Italian, all members having access to a copy. Silversmiths and sculptors belonged to different guilds. The conflict between guilds and 'independent artists', as described by Wittkower, was the exception rather than the rule; furthermore, Wittkower's treatment of the subject is too heavily determined by modern views of the artistic profession. Guilds and artists striving after an independent position coexisted between 1400 and 1600, interests seldom clashing; some artists gained a higher social standing within the guild, others were honorary members, some fulfilled functions in convents or had positions at court. See Warnke 1985, 85–98 and Miedema 1980a and 1980b.
5. The description of the 25 members in the new 1386 statutes included the words '*savi e discreti*' (wise and judicious), the previous description having been of the '*buoni e discreti uomini dell' Arte di Dipintori . . . puri e netti di peccato*' (good and judicious men of the Guild of Painters ... pure and free of sin); see Reynolds 1982, 25 and 43. The organization's aim was '*per lodare Iddio, e per fare molte opere pie, e con fabulare tutte le cose dell' arte loro*' (to praise God, and to make many pious works by using all the skill at their command).
6. See Vasari–Milanesi I, 675. The altarpiece has been lost.
7. This estimation is based on references to painters' names in contracts, payments, guild registers and literature. Cf. Martindale 1972, 9–52 and Warnke 1985, 16–21.
8. Between 1409 and 1444, forty-two names are listed in the guild registers. In connection with votive offerings of candles made by members of the St Luke Fraternity, 42 names are referred to in 1472, including such craftsmen as makers of gold leaf; see Wackernagel 1938, 299–303. The merchant Benedetto Dei is referred to by name in 1470. A 1472 text cited 270 workshops in the wool guild, 83 in the silk guild, 33 banks, 84 carpenters, 54 stonemasons, 44 workers in precious metals and 70 butchers; see Gilbert 1980, 181–4.

9. Documentation concerning this section of the professional community can be found in the *Ricordanze* kept by Neri di Bicci from 1452 to 1475; it should be noted, however, that his was a particularly flourishing workshop.

10. For an impression of the composition of the 'creative élite', see Burke 1974, 276–9 and 349–63 as well as comparisons with other groups, 290–301.

11. See Chambers 1970, 11–17; Baxandall 1972, 3–23 and Glasser 1977, 41–8.

12. See Warnke 1985, 39–105.

13. Glasser 1977, 73–80.

14. The rise of painters from Flemish cities at this time is noteworthy. Jan van Eyck, Roger van der Weyden and Hugo van der Goes all gained a higher status than fellow artists from Florence, partly owing to the patronage of the court of Burgundy.

15. Prices are also documented in the *Ricordi* of Neri di Bicci (ed. Santi) and Baldovinetti in Kennedy 1938, 236–8, as well as in the other sources on Neri di Bicci's work. Complaints about payments being too low, such as that made by Fra Filippo Lippi to Piero de Medici in 1439 and to Giovanni de Medici in 1457, serve to corroborate painters' rising financial expectations. See Chambers 1970, 93–4.

16. See Vasari–Milanesi II, 292 and Gardner von Teuffel 1977.

17. See Offerhaus 1976, 172 note 8, which discusses the evidence supporting the various dates to which this fresco has been assigned.

18. See Offerhaus 1976, 21–68, for a survey of the literature and a discussion of this work.

19. See Borsook 1980, 58, which has a reference to the inscription on the gravestone in front of the fresco: 'Domenico Lenzi et suorum 1426'. His son Benedetto was a prior from 1426 to 1428 (see note 7). Vasari–Milanesi II, 291 omits to mention the fact that a skeleton was concealed behind an altar slab at that time. In 1569 Zucchi completed an altarpiece that was installed a year later at the place originally occupied by the memorial; see Hall 1979, 114–17.

20. See Gardner von Teuffel 1982, 5–9, 13.

21. One example of a transitional piece is Fra Filippo Lippi's altarpiece in the Martelli chapel of S. Lorenzo; see Gardner von Teuffel 1982, 17–19.

22. See the examples cited in Gardner von Teuffel 1982.

23. See Vasari–Milanesi II, 58–9; Paatz vol. II, 449 and vol. IV, 422; Neri di Bicci–Santi, 145–6, 160, 166, 383. The chapels concerned were founded by Bartolomeo di Lorenzo and Lorenzo Lenzi.

24. See Vasari–Milanesi III, 314–15, which attributes the work to Sandro Botticelli. The painting is now in the London National Gallery.

25. One example of an adapted altarpiece is to be found in the Baroncelli chapel of S. Croce (attributed to Giotto) and others can be seen in the church of S. Martino a Mensola, between Florence and Settignano.

350 *Painting, Power and Patronage*

26. This work was painted for the Pucci chapel in SS. Annunziata, completed in 1452, and was higher than the customary (square) altarpieces, being 292 cm high and 205 cm wide; see Ettlinger 1978, 139–40. In 1467–8 the brothers together executed a square altarpiece for the burial chapel of the Cardinal of Portugal, who had died in 1459, in S. Miniato al Monte; see Ettlinger 1978, 139.

27. See Wittkower 1963, 14–15 and Warnke 1985, 53.

28. These discussions are largely confined to vol. I.

29. See Alberti–Grayson, esp. paras. 33–50, with a summary on 35. ('Historiae partes corpora, corporis pars membrum est, membri pars est superficies. Primae igitur operis partes superficies, quod ex his membra, ex membris corpora, ex illis historia, ultimum illud quidem et absolutum pictoris operis perficitur'); see also Blunt 1940, 1–22. It would not seem to me feasible to give precise definitions of these professional concepts or to point to differences from those developed by later writers; nor is it possible, though such concepts are modelled on others deriving from rhetoric and poetics, to establish direct links between them.

30. See Alberti–Grayson, 60–61, 94, 104.

31. See Alberti–Grayson vol. II, 72–8, 84.

32. Ghiberti employs concepts such as *istoria, inventore, doctrina, ingegno, designatore* and *teorica*. See Ghiberti–Fengler 16, 18, 38, 39. That he, too, takes the painter's basic task as that of rendering a concept in visual form is clear from such praise as '*Questa istoria è molto copiosa et molto excellentemente fatta*'; see 39–40.

33. See Filarete–Spencer, 116–20, 175 (giving Lodovico Gonzaga's experience of *rinascere a vedere*), 312 (which contains discussions of Giotto and Cavallini) and 327 (where reference is made to Foppa, a painter working in Milan).

34. See Filarete–Spencer, 308–15. Filarete held the accomplishments of painters in such high regard that he found work in *rilievo* unnecessary, since the suggestion of depth could be evoked by painterly means. This realization accords with the criticism of the use of gold, also being voiced at the time.

35. See Filarete–Spencer, xxii–xx, 317–26. He dwells at length on the building projects of the Medici (dealt with later in this chapter) and also refers to the patronage of the Duc de Berry.

36. See Filarete–Spencer, 17, 117–21, 185–7 and 245–69.

37. Earlier commentaries on Dante with references to painters appear in Meiss 1951, 4–6. Landino, who was the secretary of the Signory (and who died in 1504) discussed Masaccio, Fra Filippo Lippi, Fra Angelico, Castagno, Uccello, Pisanello and Gentile da Fabriano, employing such words and phrases as *imitatore della natura* and *del vero, rilievo delle figure, puro senza ornato, facilità, compositione, colorire, prospettivo* and *scorci, gratioso, ornato, varietà, designatore, amatore delle difficultà* and *prompto*. See Baxandall 1972, 114–51 and Gilbert 1980, 191–2.

38. See Gilbert 1980, 192–7 and 94–100.

39. Giovanni Rucellai, for instance, who had commissioned a palace, a loggia and a chapel, has many such references in his *Zibaldone*, written 1460–70. He mentions the monuments he had seen as a pilgrim in Rome in 1450, and enumerates various painters of whom he owns works; see Baxandall 1972, 2–3; Wohl 1980, 348–9 (which also has other references to Domenico Veneziano) and Gilbert 1980, 110–12.

40. See Baxandall 1972, 25–7 and 110–11, where an explanation is given of terms such as *integra proportione*, *aria più dolce* and *aria virile*.

41. See Baxandall 1971, 78–96, with references to Pisanello, Gentile da Fabriano, Jan van Eyck and Roger van der Weyden; see also Gilbert 1980, 173–81, 193–210 and Warnke 1985, 53–78. The centres concerned are Naples, Sienna, Pisa, Padua and Venice. Letters are also illuminating in this respect; see Chambers 1970, 112–62.

42. Morçay 1913, 14 contains the following comment on Fra Angelico: '... summo magistro in arte pictoria in Italia, qui frater Johannes Petri de Mugello dicebatur, homo totius modestiae et vitae religiosae.'

43. See the discussion in the introductory chapter. The sociological studies of Carr-Saunders 1933, Johnson 1972 and De Swaan 1985 attach considerable significance to this putative autonomy.

44. See Vasari–Milanesi I, 404–5. Vasari also mentions Taddeo Gaddi, Puccio Capanna, Stefano Fiorentino, Ottaviano da Faenza and Pace da Faenza as pupils of Giotto (402); for Gaddo Gaddi see 345.

45. See Vasari–Milanesi II, 106–7.

46. See Vasari–Milanesi III, 255–7, 263, 269, 287, 290, 291, 315, 323.

47. Elsewhere, major commissions for chapels were more incidental in nature. One noteworthy case is the painting of the main chapel of S. Francesco in Arezzo, commissioned by the Bacci family, which was begun by Bicci di Lorenzo and completed around 1466 by Piero della Francesca; see Borsook 1980, 92 (where the documentation is given) and Ginzburg 1981 for a more general historical explanation. Another example of a major commission in another city is the Griffoni family altarpiece from Bologna, now divided and distributed among several different museums.

48. See surveys in Wackernagel 1938, Chambers 1970, Larner 1971 and Burke 1974, 97–139.

49. These commissions primarily benefited sculptors and workers in marble, and had far less effect upon painters.

50. For example, Westminster Abbey in London, S. Denis in Paris or Fontevrault as well as various cathedrals. These and other client–artist relations were extremely important in developing the professional traditions of sculptors.

51. This latter feature is significantly different from the period from 1250 to 1290, when the choral confraternities ordered large Madonna panels and

played a leading role in their development. For the period after 1400 see Paatz's comments on individual churches and Wackernagel 1938, 212–19. See Chambers 1970, 195–6, 53–5 for a contract drawn up in 1433 between the wool merchants' guild and Fra Angelico for an altarpiece (now in the Florentine S. Marco museum) and one dating from 1461 between the Candlemas Confraternity and Benozzo Gozzoli for an altarpiece (now in the London National Gallery). For confraternities in the S. Marco see Morçay 1913, 15–6. See Hatfield 1976, 20, 26 on the close connections between fraternities and factions, and see Borsook 1980, 63 for the commission given to Masolino in 1425 to paint clouds and angels for a Candlemas play performed by the S. Agnes Confraternity in S. Maria del Carmine, the church which houses the Brancacci chapel decorated by Masolino and Masaccio.

52. One example of such a commission is Lorenzo Monaco's altarpiece produced in 1411 for a chapel in S. Maria dei Angeli, paid for through a legacy in 1394 by the banished Gherardo degli Alberti; another is the *Coronation of the Madonna* (in the Louvre) that Fra Filippo Lippi made for Francesco de' Maringhi, chaplain of S. Ambrogio and a canon of S. Lorenzo; see Wackernagel 1938, 246 (note 47) and 247 (note 50).

53. The commissions mainly given to Donatello and Ghiberti for statues for the cathedral and the baptistry were issued by the wool guild and the corn guild. Bicci di Lorenzo, having been chosen for the task by the available '*bonos et optimos magistros*', painted a series of fifteen chapels in around 1440. There then followed the intarsia panels for the sacristies, a number of painted funerary monuments to scholars and generals, a portrait of Dante made by Michelino in 1466 to replace an older one, and designs made by painters for windows, mosaics and liturgical items; see Wackernagel 1938, 20–38 and Chambers 1970, 39–41, 47–51, 200–201.

54. For example, the panel paintings with personified virtues ordered in 1469 by the Sei di Mercanti, a body responsible for administering commercial law; Gaddi had previously made a fresco for them showing Truth pulling out the tongue of the Lie. See records and payments in Ettlinger 1978, 192–5. For the Guelf party see Wackernagel 1938, 210–11.

55. See Glasser 1977, 98–104.

56. For instance Castagno painted Dante, Boccaccio, Petrarch and Pippo Spano (Hungarian general and Masolino's patron) among others, all named in inscriptions, in the Carducci villa around 1447. The works are now in the Uffizi; see Horster 1980, 178–80.

57. For instance the three battles painted by Uccello for that palace around 1456 (now in the Uffizi, the Louvre and the London National Gallery respectively). They were referred to in the inventory, together with paintings of fighting animals, hunting scenes and Pollaiuolo's labours of Hercules; see Wackernagel 1938.

58. The Medici inventory lists portraits of the dukes of Urbino and Milan, as well as a hunting portrait of the duke of Burgundy. Paintings showing scenes in different countries were also to be found; see Chambers 1970, 104–11, which also gives other examples. The Tornabuoni villa, in which Botticelli depicted the liberal arts, also contained portraits. There are fragments of this work in the Louvre.

59. These include Botticelli's *Bacchus*, *Mars*, *Primavera* and the *Birth of Venus*, assumed to have been produced for the villa belonging to Lorenzo di Pierfrancesco de Medici, which was bought in 1477, as well as Signorelli's *Festival of Pan* and Piero di Cosimo's *Hylas and the nymphs*, in the Medici Palace; see Wackernagel 1938 and Chambers 1970, 97–9 and 111, which also has references to smaller panel paintings by Italian masters and Flemish artists such as Van Eyck and Petrus Christus.

60. See Ringbom 1965, 23–57, 72–106, which also gives Venetian examples.

61. That is to say, painters developed the ability to portray a group of figures in one configuration within a dramatic context. Venetian painters such as Giovanni Bellini made an important contribution to this development.

62. Gozzoli was working on this painting in 1459; see below. Commissions for palaces and courts are dealt with in greater detail in Part IV.

63. See Baxandall 1972, 41–3.

64. The theoretical perspective here derives from ideas expounded in Mauss 1950 on relationships based on gifts. As applied here, however, these initial steps towards a theoretical model of this type of relationship also take account of conflicts and change, matters that receive little attention in the work of Mauss.

65. See the foundation established by Jacopo Stefaneschi, dealt with in part 1; Orlandi 1955 I, 418–70, Orlandi 1956, 208–12 and Hatfield 1976, 115–18, 121–3, 124–8 which discusses S. Maria Novella in Florence; see also Davisson 1975, 317 and Höger 1976.

66. See Hueck 1976, 268–9. The document referring to the Bardi chapel in S. Maria Novella (the family also had one in S. Croce) was drawn up after agreement was reached in a chapter meeting attended by notaries, members of the Bardi family and more than 40 monks.

67. See Hueck 1976 and Vroom 1981, 77–80, 189–91 and 272–5.

68. See Orlandi 1955, where various legacies are mentioned in which representatives of the convent act as artistic patrons. In 1325 the prior spent the money that Donna Guardina Tornaquinci had bequeathed in 1303 for a chapel dedicated to St Catherine on the façade because there was already such a chapel (see 425). In 1348 Jacopo Passavanti had the *cappella maggiore* painted at the expense of the Tornaquinci family, after a meeting that involved twenty-five monks held in the S. Nicholas chapel had arrived at the conclusion that the donors were not to be allowed to be buried there but that they

would be permitted to blazon their arms in the chapel (see 434). In 1355 Passavanti, together with his wife and brother, acted as executors of the will of Mico di Lapo Guidalotti, in which money was bequeathed for the painting of the chapter house (see 438–9).

69. The text *pro remedio animae suae et suorum* was frequently added; see von Martin 1932, 23.

70. Cf. the examples given in Trexler 1980.

71. Cf. Jungmann 1952 II, 10–21, 30–31, 53–4, 67, 117–18, 235.

72. This happened on a large scale with popular art; this genre of votive images retained its importance well into the nineteenth century. There were also the wax portraits in SS. Annunziata in Florence, numbering (in 1630) 600 full-length examples and 22,000 smaller ones! See Warburg 1969, 116–19 and Paatz I, 122–3. Another example is the streak of light seen on the memorial painting made by Raphael in around 1512 for Sigismondo Conti, who had narrowly escaped death.

73. Cf. Veblen 1899.

74. The theoretical perspective here derives from Durkheim 1899 and 1902 on *représentations collectives*, though as with the use of Mauss's theory, the application here takes more account of the aspect of change and that of conflict.

75. Cf. Vroom 1981, 121, 129–35, 149–57, 169, 276–80.

76. See Trexler 1971.

77. A case in point is the Scrovegni chapel; see Hueck 1973.

78. See Little 1978, 3–41 and the rubric 'moneylenders' in the index to Little's book.

79. Such observations led Marx to his sharp condemnation of religion as the 'opium of the people'. It may be noted that my analysis suggests that the relations involved in patronage (in the anthropological sense of the word) played a more important role than the relations between the classes, and decidedly more so than did class conflict. Cf. Antal 1948 for a Marxist interpretation, and see Brucker 1977, Kent 1977 and Kent 1978 for arguments against such an interpretation.

80. See Glasser 1977, 62–4.

81. See Glasser 1977, 5–20 on the legal aspects of these contracts, or *allogazione*. They always included reference to the date and place where the agreement had been signed, the names of those involved and of a third party, generally a notary; see especially 21–34 and 53.

82. See Gaye 1839 I, 191–2; translations in Chambers 1970, 95–6 and Gilbert 1980, 8–9.

83. See Gaye 1839 I, 136–7; translations in Chambers 1970, 92–4 and Gilbert 1980, 4–5.

84. See the letter and drawing made by Fra Filippo Lippi concerning a tryptych intended as a gift for King Alfonso of Naples that he was commissioned to

paint by Giovanni di Cosimo de' Medici in 1457. See also the contract
between Ghirlandaio and the prior of the Ospedale degli Innocenti for the
1488 Adoration of the Magi; discussed in Baxandall 1972, 3–8. Glasser 1977,
65–70 remarks on the formula *moda et forma* ('in the manner and style of')
and cites examples of models; see 75; 115–49.

85. See Borsook 1965, 8–14.

86. See Borsook 1980, 38–42. Ghiberti referred to the painter as Maso di Banco;
 the work can been dated 1335–9.

87. See Wood Brown 1902, 139–49; Orlandi 1955 I, 450, 460, 540–43 and
 Borsook 1980, 48.

88. See Giles 1979, 33–41.

89. See Giles 1979, 50–53, 62, 71, 86–139.

90. See Giles 1979, 75–86.

91. See Giles 1979, 50–54, 77–9.

92. See Davisson 1975, 317 for the Strozzi family's older S. Lucia chapel as well as
 agreements on Masses in the years following 1405 and Palla's payments be-
 tween 1419 (a year after his father's death) and 1424. There is insufficient docu-
 mentation to prove exactly the procedure by which commissions were issued.

93. See Davisson 1975, 315–22. Lorenzo Monaco, who painted the first retable,
 died in 1424.

94. See Christiansen 1982, 96–9; a payment of 150 florins was made in 1423.
 From 1420 the painter took a rented house from the Strozzi family in
 Florence. Christiansen suggests that the second portrait depicts Palla's son
 rather than Palla himself.

95. See Vespasiano–Greco II, 139–65 for his biography and this description. He
 was a cultivated merchant and scholar whose circle of acquaintances included
 humanists; see Martines 1963, 12, 166–7, 249, 316–18. He owned a collection
 of unique manuscripts which he was planning to donate to a public library
 being built for S. Trinità, according to Vespasiano; see 146–7.

96. Fra Angelico painted the Deposition, which is now in the Museum of
 S. Marco; see Morante 1970, 99–100.

97. See Sale 1979, 7–83, 101–48.

98. The cardinal is shown kneeling on the rectangular altarpiece; the frescoes
 contain mainly Dominican saints, the emphasis being on their theological
 qualities.

99. See Sale 1979 and Borsook 1980, 122–3. A sum of 250 florins was paid for
 the chapel and 1,000 florins was budgeted for the decorations.

100. Brunelleschi made designs for S. Lorenzo; Donatello made the bronze statues
 that later came to be used as pulpits; the original notion may have been to
 construct a *tramezzo*.

101. Cf. Paatz 1940 I, 560–63; Kennedy 1938, 53–60; Horster 1980, 171, 188,
 190 and Wohl 1980, 71–5.

102. See Goldthwaite 1980, 87.

103. See the survey in Gombrich 1960.

104. See the Introduction; see also De Roover 1963, 1–88; Rubinstein 1966; Hale 1977, 12–13, 20–75 and Kent 1978.

105. See Gombrich 1960 and Hyman 1977, 302–8.

106. See Holmes 1968, 357–64.

107. See Gombrich 1960, 290–91.

108. Sources are given in Hyman 1977. In 1442 a document was drawn up concerning Cosimo's payment into the civic treasury of 40,000 florins for church building on behalf of the prior and chapter.

109. See Herzner 1974, 89–108.

110. This development was continued in the new sacristy, that was built after a design by Michelangelo, and in the *Cappella dei Principi*, both of which had burial monuments and an extensive liturgy of memorial Masses.

111. See Paatz 1940 I, 560–61, 598. The altarpiece was made in around 1442 and is presently in the Uffizi in Florence; two of Pesellino's predella panels are in the Louvre. Michelozzo designed the chapel. Behind it, in about 1456, a fresco was painted showing Cosmas and Damian and Franciscan saints.

112. See Morante 1970, 101–7.

113. See Paatz 1940 I, 560–62; Gombrich 1960, 299; Hale 1977, 31 and Teubner 1979.

114. See Morçay 1913, 16. Indulgences were also granted at Epiphany in 1442 on the occasion of this consecration. After the ceremony had been concluded, Eugenius IV spent his night's rest in Cosimo's cell; see 17.

115. See Morçay 1913, 8–12.

116. See Morçay 1913, 17, 26–8.

117. See Teubner 1979.

118. The main altarpiece that had been painted in 1402, showing saints of the order no longer appropriate in the changed patronage situation, was presented to the Dominicans in Cortona, partly in gratitude for the consecration ceremony performed by the Bishop of Cortona; see Morçay 1913, 16–17.

119. See Morçay 1913. The donations also included candles, wine, salt (see 24) and liturgical manuscripts (22).

120. Cosimo's monastery cell was largely a retreat, though bankers often used convents as places to leave their capital; see Hale 1977, 23–4, 31–2.

121. Vespasiano linked this to Cosimo's feelings of guilt and Eugenius IV's proposal to buy this off for 10,000 florins, less than a quarter of the final costs incurred; see Wackernagel 1938, 229.

122. Orlando de Medici, who died in 1455, founded a burial chapel there; see Paatz 1940 I, 101, 161.

123. See Gaye I, 225–42 and Brown 1981.

124. See Gombrich 1960, 229. The lettering on the marble read '*Costo fior. 4 mila el marmo solo*' and gave the names of both donor and artist. More than 10 years before, around 1448, Piero had commissioned Michelozzo to design a chapel; see Wackernagel 1938, 239. Piero de Medici (1416–69) was responsible for endowing the Medici palace with its rich furnishings and a collection of precious manuscripts; see 238–9.

125. See Gombrich 1960 and Paatz 1940 I, 222–4. These were displayed on the central monument that had been made by Giovanni Gualberto and was renovated in 1448.

126. It was through the mediation of his family that Fra Filippo Lippi was approached and found willing to paint the main chapel, after Fra Angelico had decided to take on work in Orvieto and Rome, including four rooms for Nicholas V in the Vatican Palace of which only the paintings in the pope's private chapel have been preserved. Fra Angelico died in Rome in 1455, and was buried in S. Maria sopra Minerva; see Morante 1970, 84, 109–12. Lippi executed his last work in the Cathedral of Spoleto, where he was buried.

127. See Borsook 1975, xxii, 1–8, 56, 66.

128. St Lawrence was the focus of particular attention shortly after 1447, because of the discussions that arose then concerning the saint's relics; see Borsook 1975 and Van Os 1981b.

129. See Morçay 1913, 14–17.

130. See Kent 1977, 80–99, 241; see also Goldthwaite 1980, 83–8.

131. See Hatfield 1976, 68–110 and figs. 22–50 as well as Langedijk 1981 I for reproductions and identifications of Medici portraits. See also Lightbown 1978 II, 35–7.

132. See Blum 1969, 77–86.

133. See Blum 1969, 151 note 21. In 1473 the ship carrying Memling's altarpiece to Florence was captured by pirates, which caused it to end up in Dantzig – initially in the cathedral, and now in the museum. From 1480 until his death in 1492, Tani lived in Florence. From 1455 until 1465 he had worked in Bruges, and then in London; for these and other Italian clients and later owners of Flemish paintings, see Warburg 1969, 127–59; Blum 1969, 97–103 and Offerhaus 1976, 71–4, 103–7, 114–15.

134. The Vespucci family had a burial chapel installed in the Ognissanti, Ghirlandaio decorating it with portraits of the most important members of the family. Giovanni Rucellai paid for the façade of S. Maria Novella and certain major items of the interior of S. Pancrazio. There were Medici foundations in Fiesole and in various churches in the Mugello. See also Herzner 1974 and Luchs 1977, 36–64.

135. There was a Tornabuoni chapel in the Badia in Fiesole. Giovanni Tornabuoni founded a burial chapel for his late wife, Francesca di Lucca Pitti, in S. Maria sopra Minerva; see Offerhaus 1976, 111–12, 117.

136. Lorenzo Tornabuoni commissioned Ghirlandaio to decorate his chapel; see Luchs 1977, 42–5, 67–8, 86–7, 116, 283.

137. See Luchs 1977.

138. See Horster 1980, 190.

139. See Lightbown 1978 II, 215.

140. In 1482 an estimate was made of the value of this work; see Chambers 1970, 19–22. There continued to be a certain interplay between Florence and Rome in the realm of artistic commissions. Antonio Pollaiuolo made the burial monuments for Sixtus IV (1493) and Innocent VIII (1498) for St Peter's, the patrons being their nephews Giuliano della Rovere and Lorenzo Cibo respectively; see Ettlinger 1978, 148–52. The Pollaiuolo brothers were buried in the wall of S. Pietro in Vincoli, and their portraits were placed there.

141. For the chapel of Francesco Sassetti (1421–90) see Warburg 1969, 127–59; Offerhaus 1976, 71–4, 103–7, 114–15 and Borsook–Offerhaus 1982.

142. See Offerhaus 1976, 229–30; the nature of the 'rights' conferred is not specified, but there is no question of rights of patronage or burial privileges.

143. See Glasser 1977, 53, 112 note 1.

144. Ghirlandaio had already been working on the designs in 1478, and he started painting the chapel, which was situated between the main chapel and the Strozzi chapel-cum-sacristy, in 1483. Some time before this, in 1471, Ghirlandaio's master, Baldovinetti, had started making frescoes and an altar-piece for the *cappella maggiore* (where Vasari says portraits of contemporaries could also be seen) for the Gianfigliazzi family. An estimation of the value of this work in 1497 occasioned a dispute between the painter and the heirs to the Gianfigliazzi estate. In 1461 Baldovinetti had finished the work in the main chapel of S. Egidio that had been begun by Domenico Veneziano; around 1460 he was working in SS. Annunziata; see Chambers 1970, 13–14, 192, 196, 205–6.

145. See Warburg 1969, 142–3 and Offerhaus 1976, 106.

146. See Borsook–Offerhaus 1982, 49–52.

147. See Hale 1977, 83–144 on the Medici popes and subsequent restorations of the authority of the Medici family in Florence.

148. See Hale 1977, 74.

149. See Hale 1977, 74.

150. See Borsook–Offerhaus 1982, 53.

151. See Borsook–Offerhaus 1982, 52–6.

152. See Offerhaus 1976, 117–22 and Borsook–Offerhaus 1982, 19–27.

153. See Borsook–Offerhaus 1982, 45–9.

154. Suggestions are made as to the identity of these figures and their mutual relations in Offerhaus 1976, 119–21.

155. Domenico Ghirlandaio and others – including his brother David – were

responsible for the work. In 1494 Domenico Ghirlandaio was buried in the church; see Orlandi 1955 II, 588.

156. These saints included, besides St Dominic and St Peter of Verona, some whose canonization had been far more recent: Vincent Ferrer, Catharine of Sienna (died in 1380 and canonized in 1461) and Antonino, who had died as recently as 1459.

157. See Vasari–Milanesi III, 260–62.

158. See Offerhaus 1976, 111.

159. See De Roover 1963, 363–9 and Offerhaus 1976 104–6.

160. See Wood Brown 1902, 131–2; see also Wackernagel 1938, 265–72; Offerhaus 1976, 71, 111–15, 229–30; Borsook–Offerhaus 1982, 12–20; Trexler 1980, 92–9 and Cannon 1982, 87–90. This issue was first raised by Warburg 1902 and 1907.

161. See Offerhaus 1976, 227–8, translation in Chambers 1970, 175.

162. See Offerhaus 1976, 227–8, translation in Chambers 1970, 172–5.

163. On humanist literature also cf. Garin 1952; Bec 1967; Baron 1968; Martines 1963, 1968, 1979 and Trinkaus 1970.

164. See Bec 1975, 39–43.

165. See Bec 1975, 43–50.

166. See Bec 1975, 21–31. Ideas resembling those in Alberti's *Della famiglia* were elaborated in his *De iciarchia*. Also, Matteo Palmieri formulated similar ideals in his *La vita civile* and *La città di vita*. For the more emotional side of family life, see the letters of Alessandra Strozzi to Filippo, in Bec 1975, 50–57.

167. See Alberti–Grayson and Alberti–Orlandini.

168. This analysis corresponds to the connection made in Weber 1904–5 between the rise of the capitalist spirit and the development of a Protestant ethic marked by a certain affinity with asceticism. In the light of the material presented here, Elias's 1939 study pays relatively little attention to the role of convents and cities and to the significance, in general, of developments in Italy. There is no extensive discussion, in Elias's study, of the period 1200–1500. Cf. Elias 1939/1969 II, 474–5, note 128.

169. Cf. Goldthwaite 1980 and Kent 1977; the latter tends to stress the continuity guaranteed by the extended family.

170. Cf., for example, Jenkins 1970; see also the commentaries written by bookseller Vespasiano da Bisticci and Filarete's treatise on architecture.

171. See Bec 1975, 59.

172. See Bec 1975, 63–4. Bec quotes a fragment from *Invectiva in Antonium Loschum*; the person to whom this 'invective' was addressed was the chancellor of Milan, with whom Salutati was conducting a polemic.

173. See Baxandall 1971.

174. See Bec 1975, 70. Bec includes a fragment from Bruni's *Ad Petrum Paulum*

Histrum dialogus. In another work, *Laudatio florentine urbis*, Bruni further elaborated his ideas on this subject; see Baron 1968.

175. See Morçay 1913, 8, 12; Jenkins 1970 and Hyman 1977, 90–95.
176. Cf. Pius II's comments as discussed in Mitchell 1962 and the translation by Gabel. See also Vespasiano–Jenkins and Hale 1977, 24–30, 35–42.
177. Aspects of these processes have been described from different angles by De Roover 1963, Rubinstein 1966, Brucker 1977, Kent 1977, Kent 1978, Goldthwaite 1980 and Trexler 1980.

PART IV

1. See Gilbert 1968, 96 and Tommasoli 1978, 229–39.
2. See Poggio Bracciolini, *Historia fiorentina ab origine urbis usgue ad an. 1455*, BAV Urb. lat. 291, with Federico in fol. 2v and Florence in fol. 4v. The portrait is not intended to be a likeness; it is of a standard type. The duke's arms and insignia are worked into the border and appear on the horse's coverings.
3. See Cortesi in Weil-Garris 1980, 87.
4. Baldassare Castiglione (1478–1529) began his career at the court of Mantua, became ambassador to Rome in 1513 and entered the service of the pope in 1524. He started circulating his manuscript in 1518, and finally submitted it to his publisher in Venice in 1527, who brought it out the following year. Castiglione's dialogue was set in four successive evenings during March 1507; Julius had left for Rome, but members of his court stayed in Urbino.
5. Castiglione, 82. There is more praise on 83, 270, 480 and 493.
6. *Inferno* 27, 67; and *Purgatorio* 5, 88.
7. Vespasiano estimated the money spent in building up the library at thirty thousand ducats. In 1467 Federico received approximately sixty thousand ducats in peacetime and eighty thousand during the war. Out of this he paid the court household and his army, as well as taxes to the pope. For the purposes of comparison we may note that a servant earned seven ducats a year, the Doge of Venice three thousand, and wealthy princes and cardinals around twenty thousand. See Clough 1981 I, viii, 130–31 and Tommasoli 1978.
8. In connection with the chronology of Piero della Francesca's work the dates of Federico's patronage are of some importance. On the basis of the latter I conclude that the whole series of commissions given to Piero may be dated approximately 1474.
9. See Tommasoli 1978, 30–55.
10. See de la Sizeranne 1972, 53–141, 223–43 and Tommasoli 1978, 56–200.
11. See Tommasoli 1978, 211–62; Franceschini 1959 and Olsen 1971 deal with the subject within a broader perspective.
12. The depiction of Pius's life (around 1503) has already been briefly described, towards the end of Part II.

13. See Piccolomini–Gabel, 167–8, 331, 504, 656.

14. Piccolomini–Gabel, 505.

15. Piccolomini–Gabel, 654–71, 819–20.

16. See Ricci 1974.

17. The fresco, which measures 2.57 m by 3.45 m bears the inscription: 'SVNCTVS SIGISMVNDVS. SIGISMVNDVS PANDVLFVS MALATESTA. PAN. F. PETRI DE BVRGO OPVS MCCCCLI.' Profile portraits of Sigismondo Malatesta also exist, which have been attributed to Piero della Francesca.

18. See Piccolomini–Gabel, 302, 305, 331, 783, 787.

19. See de la Sizeranne 1972, 232–4 and Tommasoli 1978, 247–8.

20. See de la Sizeranne 1972, 235–56 and Tommasoli 1978, 266–362. The Ubaldini family was the most prominent among the courtiers of Urbino.

21. See Tocci 1965; Lavin 1967; Gilbert 1968, 91–107; Olsen 1971, 19–73 and de la Sizeranne 1972, 259–72, which includes illustrations. Also in attendance at the court, aside from those mentioned in the text, were the writer Matteo Contugi from Volterra, the miniaturists Guglielmo Giraldi and Franco de Russi, sculptors Michele di Giovanni, Ambrogio Barocci and Francesco Laurana and the painter Pedro Berruguete.

22. Paltroni, who died around 1478, wrote the biography after 1471.

23. Texts can be found in the collected volumes BAV Urb. lat. 526, 716, 1023, 1193; see also the odes in 785.

24. See Tommasoli 1978, 17, 24–5, 249, 265, 266, 270–73, 286–8 and 300–301.

25. See Bisticci–Greco, 384–404, 414–16.

26. Burckhardt 1860 suggests a sharper distinction between the Christian and profane or antique traditions than actually existed.

27. See Ligi 1938, 262–424; Lavalleye 1964; Lavin 1967, 1968; Dubois 1971; Ricci 1974 and Burns 1974.

28. See Tocci 1961 and Dubois 1971, 99–102, 116. Some examples of portraits are as follows: Signore Gianfrancesco Oliva, lord of Piandimeleto, is shown wearing his suit of armour in his burial chapel in the monastery of Montefiorentino; members of the Buffi family appear in S. Francesco in Urbino; Pietro Tiranni is shown in S. Domenico at Cagli; Signore Matterozzi in Castel Durante (now called Urbania) and Bishop Arrivabeni is portrayed together with Guidobaldo in a work now in the museum established in the Palazzo Ducale of Urbino.

29. See Lavalleye 1964 and Lavin 1967. Justus received payment for this altarpiece between 12 February 1473 and 25 October 1474; Paolo Uccello had been paid for his work in 1467 by the Corpus Domini confraternity.

30. The payments to Uccello were made from 10 August 1467 to 31 October 1468; this documentation is still extant, in contrast to the court archives, which have perished. See Lavalleye 1964, 31–7.

31. Lavin 1967 identifies this figure as a contemporary of Federico, the Persian envoy Isaac, who was of Jewish descent. The older literature suggests other candidates among contemporaries.

32. Psalm 2:2.

33. St Luke 23:12–25; Acts 4:25–9.

34. An immense variety of names have been put forward. Early suggestions were members of the Montefeltro dynasty and councillors who had plotted the assassination of Oddantonio (depicted in the centre of the image). The identifications proposed in Lavin 1968 are: on the left Ottaviano Ubaldini, on the right Lodovico Gonzaga and in the middle a boy (the son of one of the men and the other man's nephew) who had died in his youth. Ginzburg 1981 (which contains a select bibliography) 133–77 identifies the man on the left as Cardinal Bessarion and the man on the right as Giovanni Bacci, who commissioned Piero's frescoes in the *cappella maggiore* of S. Francesco at Arezzo. Ginzburg proposes that the work be dated 1459, and thus connects it with the Council held in that year.

35. Lavin 1968, 341 note 113 assumes that it was an independent panel in the *Cappella del Perdono*. Clough 1981 ix, 11 considers it together with the portrait in the *studiolo*, dealt with below. Gilbert 1968 suggests that the *Flagellation* was part of a sacristy door.

36. These dimensions are 59 cm by 81.5 cm without the frame. The signature OPVS PETRI DE BURGO S[AN]C[T]I SEPVLCR[I] is indicative of the panel having been part of a commission for a larger whole. Another argument against its having been commissioned separately is that not a single precedent exists; furthermore, Vasari refers to several small panels by Piero in Urbino, and a final piece of evidence is the inventory of the cathedral sacristy in 1774.

37. One piece of evidence pointing in this direction is the presence of the *Flagellation* in the sacristy inventory taken in 1774; see Ginzburg 1981.

38. See Santi–Tocci, 740–43 and Burns 1974, 302–10. Ottaviano Ubaldini was the master in charge of the construction work, which means that of the two hypotheses – that the Brera altarpiece was originally intended for this monastery, or that it was originally intended for the cathedral – the latter is more acceptable. No conclusive verdict can be pronounced, however.

39. See Olsen 1971, 69 and Burns 1974, 303 note 44.

40. This panel ended up (via S. Bernardino monastery) in the Brera in Milan. It has been sawn off all round, and measures – without a frame – 2.48 m by 1.70 m, which is far too small for an altarpiece.

41. The egg, which has occasioned so many speculative remarks, is on the one hand a common Christian symbol, which has been discussed by Durandus among others, and as such also hung before Duccio's *Maestà*, and on the other is a personal emblem of the patron's.

42. BAV Urb. lat. 410 fol. 1r, shortly before August 1474, and 508 fol. 1. Other miniature portraits can be found in Urb. lat. 1, fol. 1v from 1476 and 491 fol. 2v. Compare Stornajolo I 1902, 1–2, 423, 497 and II 1912, 10. See also Gilbert 1968.

43. BAV Urb. lat. 277, with emperors in fol. 2r and Florence in fol. 130v.

44. The Duke's library was not only superior to that of Francesco Sassetti, but also to those of Piero de' Medici, Cardinal Bessarion and Nicholas V, and was on a par with the collections of the kings of France and the dukes of Burgundy.

45. Mottoes sometimes appeared in a linguistic mix: NON MAI, NUMQUAM, HONI SOIT QUI MAL Y PENSE and ICAN VORDAIT EN CROSISEN.

46. BAV Urb. lat. 151.

47. See Rotondi 1950. Like Pienza Cathedral, later restoration work to the ducal palace of Urbino gives rise to numerous interpretative pitfalls when viewing the complex in its present state. On the Muses see Dubois 1971, 126–37 and BAV Urb. lat. 716, which has drawings of the Muses as well as emblems of the liberal arts. It also contains images of classical deities; these, together with classical heroes and the apostles, all figured among the palace decorations.

48. See Rotondi 1950 I, 335–56, Lavalleye 1964 and Clough 1981. Controversy surrounds the reconstruction of both this cycle and that of the liberal arts, completed by Justus of Ghent in 1477, particularly with regard to the original location of the two portraits of the Duke with his son.

49. See de la Sizeranne 1972, 200, 204, 206, 208 and 253–72. Many of the portraits are presently displayed in the palace.

50. Rotondi locates these portraits in the space between the throne hall and the adjacent room. The dating remains controversial; as in the case of the *Flagellation*, each author advances a different date. Cf. Gilbert 1968, 91–5.

51. The panels measure 47 cm by 33 cm. The present frames and free-standing disposition (in the Uffizi) date from much later.

52. In 1459 Federico married the daughter of Alessandro Sforza, Lord of Pesaro and himself an eminent patron of art. She died in 1472 at about twenty-seven years of age, having given birth to nine children.

53. CLARVS INSIGNI VEHITVR TRIVMPHO/QVEM PAREM SVMMIS DVCIBVS PERHENNIS/FAMA VIRTVTVM CELE-BRAT DECENTER/SCEPTRA TENENTEM, and QVE MODVM REBVS TENVIT SECVNDIS/CONIVGIS MAGNI DECORATA RERVM/LAVDE GESTARVM VOLITAT PER ORA/CVNCTA VIRORVM. English translation: Colin Haycraft, quoted in Hendy 1968.

54. In the fourteenth century such elements were incorporated into commissions given by Robert of Anjou, the Visconti family and the Carrara and Lupi families in Naples, Milan and Padua respectively. For the Muses see Schröter 1977.

55. In the fifteenth century there was a great network of rulers related by ties of kinship, including the Trinci family in Foligno, the Malatesta in Rimini and Brescia, the Este in Ferrara, the Gonzaga in Mantua and the Sforza in Milan, whose image repertoires bore great similarity to each other. There are a few examples in Burckhardt 1860; Chambers 1970; Larner 1971, 97–118; Gilbert 1980 and Hope 1981.

56. See Elias 1939.

57. Veblen 1899 clarified this phenomenon in general terms, introducing the concepts of status symbols and conspicuous consumption. Huizinga 1919 commented on these aspects of culture at the court of Burgundy; see 25–124 and 153–84.

58. Cf. Alberti–Orlandini vol. IX; Lomazzo vol. VI; Armenini vol. III and Cortesi's chapter *De Domo Cardinalis*, especially the section entitled *De ornamento domus*, in the Weil-Garris edition, and Vasari's *Ragionamenti*. Vasari lays special emphasis on depictions of *virtù*, *cose illustre*, *richezze* and the ruler's *imprese gloriose*; see Milanesi VIII, 69, 73, 79, 80, 216 and 219–23.

59. See Cortesi–Weil-Garris, 89.

60. See Dubois 1977.

61. See Santi–Tocci, 660–67.

62. Other pictures that appeared in the Gonzaga Palace between 1480 and 1515 included city scenes of Venice, Genoa, Paris, Cairo and Jerusalem by Giovanni Bellini and Carpaccio; the allegories in the *Grotta* or *camerino* of Isabella d'Este were made by Giovanni Bellini, Mantegna, Perugino, Giorgione and perhaps Raphael. See Chambers 1970, 112–50.

63. He began his career with chapel frescoes in Padua and an altarpiece for the high altar of S. Zeno in Verona. For Francesco Gonzaga he made a votive painting, now in the Louvre, and like Piero della Francesca before him, he worked briefly in the Vatican Palace for Innocent VIII.

64. The passage referring to the painters is also discussed in Gilbert 1980, 95–100.

65. See Chambers 1970, 116–18.

66. See Warnke 1985, 217–23, with a survey of painters' rise in social status from 1289 to 1798.

67. See Warnke 1985, 203. In 1499 Mantegna was referred to as *archpictor* (see 225). In 1483 Lorenzo de Medici visited his studio, as recorded in a letter (see 260).

68. See Gilbert 1980, 11–15.

69. See Kempers 1982b, with a survey of painters' tombs and burial monuments.

70. Examples are given in Warnke 1985, 48–51, 55 and 70–98.

71. See Chambers 1970, 125–50.

72. Raphael's pupil Giulio Romano, having worked in Rome, gained a good position in Mantua, as witnessed, among other things, by his palace.

73. See Golzio 1936, 22.

74. See Golzio 1936 on the information after 1510.
75. See Castiglione, 71, 148, 175, 176, 300.
76. See De Grassis–Frati, 50–53.
77. See Olsen 1971, 74–87, which discusses politics, patronage and portraits in Urbino between 1480 and 1530.
78. BAV Vat. lat. 1682 fol. 8v. The title page of fol. no. 9r bore medallions with likenesses of Julius II, Francesco Maria and Giovanni della Rovere as well as Julius and Augustus Caesar. The author, Nagonius, wrote similar odes to other sovereigns, including Louis XII; see Scheller 1985, 34–6.
79. See Scheller 1983, 75.
80. In 1506 or 1507 Michelangelo made a statue for the façade of the church of S. Petronio and another for Ascoli Piceno, which had also been annexed. Illustrations of medallions and miniatures may be found in Weiss 1965.
81. See von Pastor 1924; Partridge 1980; Scheller 1985 and Kempers 1986.
82. I see no contradiction here with the proposition in Elias 1939 concerning the monopoly of the use of force or pacification and the increasing level of violence seen in warfare between larger political entities.
83. This was expressed in the 'pragmatic sanction', which as well as asserting the authority of a General Council over the papacy, regulated the liberties of the Gallic Church. Similar rights were acquired by Henry VIII for the Anglican Church; the Reformation led to complete autonomy in respect of Rome.
84. See Partridge 1980, 44–7 on the *Julius Exclusus*, a dialogue in which St Peter, at the gates of heaven, charges Julius II with being a warrior in priest's clothing.
85. Cf. De Grassis–Dykmans, 292–7, 302–9, 317–69.
86. See De Grassis–Dykmans, 288–92, 303–7, 321–3, 357:11 (page 357, section II), 358.
87. See Partridge 1980, figs. 28 and 38–40. Giuliano della Rovere also ordered the funerary monument for his uncle, Sixtus IV. For an overview of the patronage of Julius II, see Steinmann 1905, von Pastor 1924, 986ff. and Weiss 1965.
88. See Cortesi–Weil-Garris, 71, 87 and the treatises in Kempers 1986, 14–19.
89. See von Pastor 1924, 915–33.
90. See Kempers 1986, 5, with additional references to the architecture under the papacy of Julius II.
91. Documents relating to these commissions may be found in Shearman 1972 and Frommel 1981.
92. Cf. Scheller 1983, 111–15.
93. See von Pastor 1924, 980–86 and Frommel 1977, which also has older examples of funerary monments in the choirs of churches. In passing, it would appear to me implausible that Julius's grave was planned to be directly above that of St Peter.

94. The design combines elements of the free-standing monuments of Sixtus IV – whose effigy, however, was recumbent – rulers like Henry VII in the choir of Pisa Cathedral, Robert of Anjou in the choir of S. Chiara in Naples, and Federico da Montefeltro in the palace gardens at Urbino, with the monument of Innocent VIII, who was also shown seated and making the sign of benediction, but on a wall-tomb. The mausolea of princes such as Louis XII, Francis I, Maximilian I and others of their dynasties could hardly compete with that of Julius II. Their courtiers were likewise overshadowed by Julius's cardinals – men such as Girolamo Basso della Rovere or Asciano Sforza, whose monuments were designed by Sansovino and set in the enlarged choir of S. Maria del Popolo.

95. Such conflicts point to the rise in the artist's status rather than to a lack of appreciation for him; cf. Wittkower 1963 and 1964.

96. See Shearman 1972 and Kempers 1986, 4–7.

97. As described in Paris de Grassis's notes on the dedications of the rooms in his Diarium, BAV Vat. lat. 5636, fol. 71r and Ottob. lat. 2571 fol. 99r–v, 101r–102r, 319v–320r and 467r–468v.

98. See De Grassis, Diarium, BAV Vat. lat. 12268 fol. 391r–4r, 411r–32v and Vat. lat. 12269 fol. 544v–55v.

99. Some of these commissions have been described at the beginning of Part I.

100. See Vasari–Milanesi IV, 326–48 and fragments in Golzio 1936. Kempers 1986, 7–11, argues in favour of the plausibility of Vasari's testimony, and goes into greater detail concerning the Stanza della Segnatura.

101. See De Grassis–Frati, 189–291.

102. See Renaudet 1922, 362, 373, 404; the theme is taken up repeatedly in 366–555.
103. See Renaudet 1922, 185 and 373; see also Klotzner 1948.

104. See Renaudet 1922, 362.

105. The proceedings of this Council are described in De Grassis–Dykmans and Minnich 1982.

106. See Partridge 1980, 43.

107. See Klotzner 1948.

108. See De Grassis–Dykmans, 317–19.

109. Quoted in Partridge 1980, 43, under reference to the source.

110. '*Propter Gallos ab Italia expulsos*'. See De Grassis–Dykmans, 315–17.

111. See De Grassis–Dykmans, 275–92.

112. See De Grassis–Dykmans, 276:7.

113. BAV Vat. lat. 3966 fol. 111r–115v.

114. For the miniatures, see Cassee 1980 and Conti 1981. BAV Vat. lat. 1385 is a manuscript that was used for study by Julius II.

115. For the sketches, see Pfeiffer 1975, 73–97.

116. See Pfeiffer 1975 for a review of the findings of scholarship to date; drawings in Knab 1983.

117. It is my view that none of these changes may be explained purely on the basis of artistic considerations.
118. See De Grassis–Dykmans, 342–4 and Klotzner 1948, 113.
119. Possible identifications of these figures are discussed in Kempers 1986, 25–32.
120. BAV Urb. lat. 151.
121. This is the reverse of the customary interpretation, which takes Gregory IX to be portrayed here with the features of Julius II.
122. See Patrizi–Dykmans, 76, 82, 92, 183, 459, 464, 465, 478, 552.
123. Vasari–Milanesi IV, 337.
124. See De Grassis, Diarium, BAV Vat. lat. 12269 fol. 412r, 428v, 432v.
125. For the present state of scholarship see Dussler 1971, 78–82 and Shearman 1972, 18–22. It is my intention to publish a book entitled *The State as a Work of Art. Political Images in the Age of Raphael*, further elaborating and arguing the hypotheses that follow, concerning the frescoes painted in the Stanze.
126. See De Grassis, *Caeremoniarum opusculum*, BAV Vat. lat. 5634/I fol. 113v–59v, 160r–v, 166v–8r, 170r–73v and Patrizi–Dykmans II, 646–65.
127. See De Grassis–Frati, 33–4.
128. Referred to in De Grassis–Frati *passim* and De Grassis–Dykmans, 294: 16, 303: 3.
129. See Grassis–Frati *passim* and De Grassis–Dykmans, 285:27, 288:14, 290:24, 303:3–4.
130. See De Grassis, Diarium, BAV Vat. lat. 12268 fol. 368r–v; Vat. lat. 12269 fol. 397r–398v and Renaudet 1922, 4, 6, 600–607, 612–14, 625, 644.
131. See Cassee 1980, 41–2 and figs. 30 and 31.
132. See De Grassis–Dykmans, 315:30 and 31, 327:2–3.
133. See De Grassis, Diarium, BAV Vat. lat. 12269 fol. 428v–432v, 435v, 439v and von Pastor 1924, 827–39.
134. See De Grassis, Diarium, BAV Vat. lat. 12269 fol. 428v–431r.
135. See De Grassis, Diarium, BAV Vat. lat. 12269 fol. 459r–464r.
136. See De Grassis–Dykmans, 315–17, 323:26, 335.
137. See De Grassis–Frati, 299–325.
138. Quoted in Roscoe 1805 II, 81 note a.
139. Cf. Knab 1983.
140. The cardinal to the left has been identified as Giovanni de' Medici. See Shearman 1972, 18–22. He was papal legate to Romagna, to whom the generals in the field were accountable. This identification would imply that Leo X was painted over Julius II as it is unlikely that Giovanni de' Medici would have been portrayed twice in the same fresco, once as a cardinal and again as the pope. The available evidence concerning the repainting is not conclusive, and therefore neither the date of the execution of the fresco nor the characters portrayed are certain.

141. See De Grassis, Diarium, BAV Vat. lat. 12269 fol. 463r and von Pastor 1924, 836–7.

142. The figure at the back may be the governor of the palace or of Castel Sant'Angelo; see De Grassis–Dykmans, 136 note 194. In note 230 a cousin of the pope is referred to as *capitaneus generalis custodie sacri palatii.*

143. See De Grassis, Diarium, BAV Vat. lat. 12269 fol. 459–460v.

144. See De Grassis–Frati 314, 319 and von Pastor 1924, 840–45, 853.

145. See De Grassis–Dykmans, 341–7.

146. See Brosch 1878 and Von Pastor 1924, 825–69.

147. See De Grassis, Diarium, BAV Vat. lat. 12269 fol. 544v, 553v–555r, 566v and 12268 fol. 391v–394r, 411r–432v.

148. See De Grassis–Dykmans, 315–17,

 ... ob exterminatos Gallos et profligatos ac expulsos ex Italia, de qua re preter id quod statuit gratias Dei reddi in omnibus terris et locis, non solum Italie sed et Hispanie ac Anglie Alemannieque, et aliorum confederatorum contra Gallos [...] propter victoriam contra Gallos [...] in victoriam et gloriam et triumphum, vitamque et iubilationem, ob Italiam, ob Lombardiam, Flaminiam Liguriamque et urbemque denique recuperatem, servatam, liberatam ...

 These pronouncements can be seen retrospectively as applying to the objectives pursued since 1511.

149. See De Grassis–Dykmans, '... etiam Galli ipsimet victi, qui in urbe erant, – erant enim multi indigene, – de nostra gloria, victoria, laude, pace et quiete contenti esse videbantur, omnes simul Deum benedicentes, qui est benedictus. Amen.'

150. Cf. Scheller 1983, 101–4, 141 and 1985, 36–50 for the ceremonious entries of Louis XII.

151. See the chapter on Cosimo I, p. 275.

152. Quoted in Luzio 1887, 577–82.

153. De Grassis–Dykmans, 335: 'acclamantes inter lacrimas: "Salutem anime sue, qui vere Romanus pontifex Christi vicarius fuerit, iustitiam tenendo, ecclesiam apostolicam ampliando, tirannos et magnates inimicos persequendo et debellando"'.

154. See De Grassis–Dykmans, 335:4.

155. See De Grassis, Diarium, BAV Vat. lat. 5636 fol. 71r–v '... in camera ultima superiori nova idest ea quae est ['inscripta' deleted] picta Signatura sanctae memoriae Julii consecravit ...' See Shearman 1972, 11 for a different transcription and conclusion.

156. See Grassis, Diarium, BAV Ottob. lat. 2571 fol. 319v.

157. I have not been able to verify this hypothesis beyond all doubt on the basis of the available technical data in restoration reports.

158. See Roscoe 1805 II; see also Shearman 1972a and 1972b.

159. See De Grassis–Dykmans, 341–51 and Minnich 1982, 379–81.

160. See De Grassis–Dykmans, 339–69 and Diarium, BAV Vat. lat. 5636 fol. 30r–164v.
161. For the state of scholarship see Dussler 1971, 82–6 and Shearman 1972a, 21–3.
162. See Langedijk 1981 I, 56–60.
163. See Vasari–Milanesi VIII, 122–88.
164. See De Grassis, Diarium, BAV Ottob. lat. 2571 fol. 167r (ceremonious entry into Florence) up to 197r.
165. See Minnich 1982, 383–7.
166. See De Grassis–Dykmans, 341–51.
167. See De Grassis–Dykmans, 359–65.
168. See De Fine, Diarium, BAV Ottob. lat. 2137, 22–4, '*corona et diademate ornata*' (24).
169. See Scheller 1978, 14–20. On the French kings' use of imperial insignia see Scheller 1983, 101–11.
170. See De Grassis, *Caeremoniarum opusculum,* BAV Vat. lat. 5634/I fol. 50r, 54r, 107r, 113r–v, 130r, 161r, 170v–175r, 237v–238r; see also 5634/II fol. 102v–103r, 342r. The descriptions of ceremonies in the Diarium are also illuminating.
171. See De Grassis–Dykmans, 362–9.
172. See Shearman 1972b.
173. Earlier papal commissions have not been discussed here in terms of their line of development; they have been touched on, however, in connection with other types of commissions dealt with in Part II on Sienna, and there are scattered references to them throughout Part III on Florence.
174. Examples are given in Dussler 1971, 18–55.
175. See Dussler 1971, 36–8.
176. See Partridge 1980, 1, 18, 21–5, 75–89.
177. In the Farnese villa at Caprarola, Taddeo Zuccari painted episodes from the pontificate of Paul III, including his struggle with the Lutherans, his meeting with Francis I and Charles V, the granting of Parma to Ottaviano Farnese, the latter's wedding to Margaret of Austria, and the Council of Trent – each accompanied by explanatory inscriptions. There were similar scenes in the Imperial villa at Pesaro, in this case emphasizing the role of the della Rovere family.
178. For papal patronage in the seventeenth century see Haskell 1963.
179. Cf. Roscoe 1805 I; see also Hale 1977, and for portraits see Langedijk 1981.
180. He succeeded Alessandro de' Medici, a descendant of Lorenzo, Duke of Urbino; Cosimo belonged to a lateral branch of the family. The Medici had been driven into exile from Florence in 1494, returning in 1512 only to be exiled again; they established a secure basis for their rule only around the year 1540.

181. Published in d'Addario 1963.
182. See Van Veen 1984. The ceremonies were recorded in pictures; see Langedijk 1981 I, 446–8.
183. See Langedijk 1981 I, 407–530.
184. See Hall 1979.
185. See Allegri 1980.
186. See Langedijk 1981 I, 435; the work was located in the chapel.
187. See Allegri 1980; for the pictures made for the Sala Grande by Bandinelli from 1544 to 1554 see Langedijk 1981 I, 88–91.
188. See Langedijk I 1981, 139–74. Also figuring in the decorations for ceremonious entries into the city were Florentine artists, from Cimabue to Michelangelo, and scenes from the *Disegno*; see Vasari–Milanesi VIII, 528–9.
189. For the historical account see Part III.
190. See Wilde 1944.
191. See Vasari–Milanesi VIII, 220–22.
192. See Vasari–Milanesi VIII, 189.
193. Here the pictorial programme followed the new statutes of Tuscany; see d'Addario 1963.
194. There is a striking similarity here with the iconography of Federico da Montefeltro.
195. Allegri 1980, 243, emphasizes the contrast with the taking of Pisa. Van Veen 1981b, 87–8 qualifies this view by pointing out the fact that neither painting is expressive of anti-republicanism.
196. See Van Veen 1981a.
197. See Van Veen 1981a and 1981b.
198. The victories over Montalcino and Grosseto followed in 1559.
199. The dialogue was largely composed in 1557, with additions made in 1563. It was ready for publication in 1566, printed in 1588 and reprinted in 1619; see Vasari–Milanesi VIII, 7.
200. See also Van Veen 1984, 106–8.
201. See Vasari–Milanesi VIII, 212.
202. There is a striking development in the depiction of generals in the service of the state, mirroring this gradual change: from Guidoriccio, Federico da Montefeltro, Francesco Maria della Rovere and Lorenzo de' Medici to Giacomini and Vitelli.
203. The scenes are illustrative of many of Machiavelli's views on a permanent army, the conduct of the ruler and the history of Florence, but there is not necessarily any question of iconographic details being directly connected with specific passages from Machiavelli's text.
204. In Sienna, too, the imagery was being adapted. The old Siennese emblem of the white-footed mare that had figured on annual reports of the taxation services was replaced by the Medici coat of arms, which also made its

appearance on the city gates and the façade of the town hall, while the annual records of the city became a court chronicle for the Medici. Into the Assumption festivities, too, came a new strain of Medici propaganda.

205. See Vasari–Milanesi VIII, 521–622.
206. See Van Veen 1981, 73–6.
207. See Van Veen 1984, 106–8.
208. See Van Veen 1984. The process of legend-forming started as early as 1566 with the hymn *De Radagasi*; in 1650 *Il Cosmo overo l'Italia Trionfante* appeared.
209. This is similar to the policy pursued – on a smaller scale and with a far simpler administrative apparatus – by Federico da Montefeltro in Urbino around 1450. 210. It is striking how consistently were depicted the features of the state referred to in Weber 1922: 97–102, 122–30, 181–98, 387–495, 727, 857.
211. See Hall 1979, also with references to her articles in 1977 and 1979.
212. See Boschloo 1974 I, 110–63, which discusses Paleotti 1582 at some length.
213. See Hall 1979, 1–32.
214. See Haskell 1963, 3–166; Boschloo 1974 I, 9–37, 49–84, 156–63 (on Annibale Caracci in Rome); see also Dempsey 1980.
215. See Pevsner 1940, 55–139; Boschloo 1974 I, 39–44 deals with the Accademia degli Incamminati in Bologna; see also Dempsey 1980.
216. In his *Ricordanze* Vasari presents a clear picture of his increasing prosperity. This text gives a more practical, less exalted image of his professional activities than the *Vite* or the *Ragionamenti*. The letters shed light on both. Vasari–Milanesi VIII, 360 and following pages has letters about the Academy.
217. See Kempers 1982b.
218. For the relationships between guilds and academies see Doren 1908; Pevsner 1940 and Miedema 1980a for the Netherlands.
219. In this sense one may speak of an organized continuation of the individual expressions of opinion on the art of painting discussed at the beginning of Part III.
220. ACADEMIA LEONARDI VIN[CI] and ACH[ADEMI]A LE[ONARDI] VI[NCI].
221. See Ward 1972, 6–33 and Reynolds 1982, 11–65.
222. See Ward 1972, 6–33 and Reynolds 1982, 11–65.
223. Too little attention is paid in Pevsner 1940 and Dempsey 1980 to the importance of the reorganization of the state (see d'Addario 1963), without which it is hard to explain why the Academy in Florence became a professional association.
224. See Dempsey 1980 and Reynolds 1981, 65–187.
225. See Ward 1972, 61–72 with letters and statutes on 73–114; see also Reynolds 1982, 213–52.
226. See Pevsner 1940, 43–55; see also Ward 1972, 1–4 and Dempsey 1980.
227. See Reynolds 1982, 128.

228. See Reynolds 1982, 83–4, particularly regulations 31 and 32.
229. See Reynolds 1982, 131.
230. See Reynolds 1982, 151–66.
231. See Wittkower 1964, 26–7 and Reynolds 1982, 151–62.
232. See Reynolds 1982, 163. The monument was completed in 1578.
233. See Reynolds 1982, 124–5.
234. See Kempers 1982b.
235. See Reynolds 1982, 174–6. The payments are cited in Ward 1972, 186–94. Over a long period (1570–98) attempts were made to secure a chapel in the Cestello.
236. See Pevsner 1940, 49.
237. See Reynolds 1982, 171–2.
238. See Reynolds 1982, 180–6.
239. See Ward 1972, 114–35.
240. See Reynolds 1982, 180–96.
241. See Reynolds 1982, 176–9.
242. See Ward 1972, 274 and Reynolds 1982, 197–9.
243. See Pevsner 1940, 53–4.
244. See Blunt 1940 and Barocchi 1960–62.
245. Vasari's work is probably the first theory and history of any professional group to have been widely circulated.
246. *Divine Comedy, Purgatorio* XI, 94.
247. For example, Cortesi, Castiglione, Giovio, Bembo, Inghirami, Della Casa and Borghini.
248. Vasari–Milanesi I, 168–77 and III, 8–17. See Miedema 1978–9 on the art history literature on 'mannerism', taken to refer to stylistic development; Miedema proposes that *maniera* be translated as 'working method'.
249. Cf. Blunt 1940, 63–98.
250. Vasari–Milanesi IV, 8–12 and applications of these terms in the *Vite*.
251. See Blunt 1940, 92, 94. This point is also emphasized by Hope 1981.
252. See Vasari–Milanesi I, 97–8, 168, 215–19.
253. See Vasari–Milanesi I, 224–35.
254. See Vasari–Milanesi I, 179–92 and VII, 579–92.
255. See Vasari–Milanesi IV, 7–15, elaborated in the separate *Lives*.
256. See Vasari–Milanesi III, 383–409.
257. See Vasari–Milanesi IV, 13.
258. See Vasari–Milanesi VII, 680: '. . . *ed in particolare, ve n'ha uno che dice quelle pitture essere state tutte condotte in cento giorni.*' It is Milanesi who adds in a note: '*Vuolsi che Michelangiolo, nel veder quest'opera e nell'udire ch'era stata fatta in cento giorni, dicesse: "e' si conosce"* '.

Sources and Literature

MANUSCRIPTS

FLORENCE

Biblioteca Nazionale Centrale
Laudatio ad Robertum regem Napoli, BR 38

LEIDEN

Universiteitsbibliotheek
Clementinae, d'Amblaing 14

LOUVAIN

Theological Institute Library of Niccolò d'Alife
Bible belonging to Robert of Anjou, ms. 1

SIENNA

Archivio di Stato di Siena
Arti, 61
Biccherna, I, 746, 747
Capitoli, 1, 2
Consiglio Generale, 107
Gabella, 1, 3
Mercanzia, 1, 2, 6, 12
Patrimonio Resti, 682
Placito, 1
Statuti, 2, 3, 5, 7, 10, 11, 16, 17, 18, 19–20, 21, 23, 26

Biblioteca Comunale degli Intronati
Odericus, *Ordo officiorum ecclesie Senensis* GV 8
Decretum Gratiani KI 3, KI 8

VATICAN

Biblioteca Apostolica Vaticana
Bracciolini, Poggio, *Storia di Firenze*, Urb. lat. 491
Carmina ad illustrem dominum d. Fedricum Fereticem urbini ducem et comitem, Urb. lat. 716
Corpus iuris civilis, Vat. lat. 1409, 1411, 1430, 1434, 1436
Filelfo, Francesco, *Ciropedia di Senofonte*, Urb. lat. 410
Fine, Cornelius de, *Diarium historicum de rebus in Italia gestis ab anno MDXI ad annum MDXXXII*, Ottob. lat. 2137
Grassis, Paris de, *Caeremoniarum opusculum*. Supplementum et additiones, Vat. lat. 5634, 1/2
Grassis, Paris de, *Diarium Julii et Leonis*, Vat. lat. 5636, 12268, 12269, 12272, Ottob. lat. 2571, Chigi lat. LI 19
Inventarium Bibliotheca secreta Julii, Vat. lat. 3966, fol. 111r–115r
Libri Decretalium, Vat. lat. 1366, 1375–90, 1401, 2492, Pal. lat. 623, 629, 631, 632, 635, 636, Urb. lat. 161
Nagonius, Iohannis Michaelis, *Carminum ad divum Iulium 11 et Franciscum Mariam nepotem libri I–VIII*, Vat. lat. 1682
Novella. Vat. lat. 1456, 2235, 2534
Orationes ad Sixtum IV et Francescum Mariam ducem Urbini, Urb. lat. 1023
Orationes in funere Baptistae Sforza, uxoris Fridirici, Urbini ducis: orationes; epistolae; carmina ad Fridericum ducem, Urb. lat. 1193
Pronosticum: prophetiae: orationes. Urb. lat. 526
Sixtus IV. *De sanguine Christi: De Potentia Dei; De futuris contingentibus*, Urb. lat. 151
Stefaneschi, J., *Exultet*, Archivio Capitolare San Pietro, B 78
Stefaneschi, J., *Liber de Centesimo Jubileo*, Archivio Capitolare San Pietro, G 3
Stefaneschi, J., *Opus Metricum*, Vat. lat. 4932–4933
Stefaneschi, J., *Missale*, Archivio Capitolare San Pietro, C 129

INCUNABULA

Albertini, F., *Opusculum de mirabilibus novae et veteris Urbis Romae*. Rome 1510
Cortesi, P., *De Cardinalatu*. Castro Cortesi 1510
Cortesi, P., *Liber Sententiarum*. Rome 1504/Basel 1513, 1540
Vigerio, M., *Decachordum christianum Julio II Pont. Max. dicatum*. Fano 1507

BIBLIOGRAPHY

Addario, A. d', 'Burocrazia, economia e finanze dello Stato Fiorentino alla metà del Cinquecento.' *Archivio Storico Italiano*, CXXI (1963), 362–456

Alberti, L. B., *Della Pittura* (about 1435), ed. L. Mallé. Florence 1951

Alberti, L. B., *De Re Aedificatoria* (about 1450). ed. G. Orlandi/P. Portoghesi. 2 vols., Milan 1966

Alberti, L. B., *On Painting and on Sculpture. The Latin Texts of De Pictura and De Statua*. C. Grayson London 1950

Allegri, E., und Cecchi, A., *Palazzo Vecchio e i Medici*. Florence 1980

Antal, F., *Florentine Painting and its Social Background*. London 1948

Ariès, P., *L'Homme devant la mort*. Paris 1977

Armenini, G. B., *De veri precetti della pittura libri tre*. Ravenna 1587. Hildesheim/ New York 1971.

Avril, F., *Buchmalerei am Hofe Frankreichs, 1310–1380*. Munich 1978

Bacci, P., *Documenti e commenti per la storia dell'arte*. Florence 1944

Barocchi, P., *Trattati d'arte del Cinquecento*. 3 vols., Bari 1960–62

Baron, H., *The Crisis of the Early Italian Renaissance*. Princeton 1955/1956

Baron, H., *From Petrarch to Leonardo Bruni. Studies in Humanistic and Political Literature*. Chicago 1968

Barraclough, G., *The Medieval Papacy*. London 1968

Battisti, E., *Cimabue*. Milan 1963/London 1967

Bax, M., 'Religieuze regimes en staatsontwikkeling. Notities voor een figuratie-benadering'. *Sociologisch Tijdschrift*, XII (1985), 22–48

Baxandall, M., *Giotto and the Orators*. Oxford 1971

Baxandall, M., *Painting and Experience in Fifteenth-Century Italy*. Oxford 1972/1982

Bec, C., *Les marchands écrivains. Affaires et humanisme à Florence, 1375–1434*. Paris/The Hague 1967

Bec, C., *L'Umanesimo Civile. Alberti, Salutati, Bruni, Bracciolini e altri trattatisti del Quattrocento*. Turin 1975

Becker, H. S., *Art Worlds*. Berkeley 1982

Belting, H., *Die Oberkirche von San Francesco in Assisi. Ihre Dekoration als Aufgabe und die Genese einer neuen Malerei*. Berlin 1977

Belting, H., *Das Bild und sein Publikum im Mittelalter. Form und Funktion früher Bildtafeln der Passion*. Berlin 1981

Bicci, Neri di, *see* Neri di Bicci

Bisticci, Vespasiano da, *Le vite*. ed., A. Greco. 2 vols., Florence 1970–76

Blaauw, S. de, *Cultus et Decor. Liturgie en architectuur in laatantiek en middeleeuws Rome. Basilica Salvatoris Sanctae Mariae Sancti Petri*. Delft 1987

Blum, S. N., *Early Netherlandish Triptychs. A Study in Patronage*. Berkeley 1969

Blume, D., *Wandmalerei als Ordenspropaganda. Bildprogramme im Chorbereich franziskanischer Konvente Italiens bis zur Mitte des 14. Jahrhunderts.* Worms 1983

Blunt, A., *Artistic Theory in Italy, 1450–1600.* London 1940

Bologna, F., *I pittori alla corte Angioina di Napoli, 1266–1414, e un riesame dell'arte nell' età fridiriciana.* Rome 1969

Borghesi, S., and L. Banchi, *Nuovi documenti per la storia dell'arte Senese.* Soest 1898/1970

Borghia, A. (ed.), *Le Biccherne Senesi*, Rome 1984

Borsook, E., and L. Tintori, *La Capella Peruzzi.* Turin 1965

Borsook, E., 'Fra Filippo Lippi and the Murals for Prato Cathedral.' *Mitteilungen des kunsthistorischen Institutes in Florenz*, XIX (1975), 1–145

Borsook, E., *The Mural Painters of Tuscany. From Cimabue to Andrea del Sarto.* Oxford 1960/1980

Borsook, E., and J. Offerhaus, *Francesco Sassetti and Ghirlandaio at Santa Trinità, Florence. History and Legend in a Renaissance Chapel.* Doornspijk 1982

Boschloo, A. W. A., *Annibale Caracci in Bologna. Visible Reality in Art after the Council of Trent.* 2. vols., The Hague 1974

Boskovits, M., *Pittura fiorentina alla vigilia del Rinascimento 1370–1400.* Florence 1975

Bourdieu, P., *La Distinction.* Paris 1975

Bowsky, W. M., *The Finance of the Commune of Siena 1287–1355.* Oxford 1970

Bowsky, W. M., *A Medieval Italian Commune: Siena under the Nine, 1287–1355.* Berkeley 1981

Braunfels, W., *Abendländische Klosterbaukunst.* Cologne 1969

Brinkgreve, C., and A. de Regt, 'Mannen, vrouwen en kinderen.' in: *Samenlevingen. Een verkenning van het terrein van de sociologie.* N. Wilterdink and B. van Heerikhuizen. Groningen 1985

Brosch, M., *Papst Julius II. und die Gründung des Kirchenstaates.* Gotha 1878

Brown, B. L., 'The Patronage and Building History of the Tribuna of SS. Annunziata in Florence. A Reappraisal in Light of New Documentation.' *Mitteilungen des kunsthistorischen Institutes in Florenz*, XXV (1981), 59–142

Brucker, G., *The Civic World of Early Renaissance Florence.* Princeton 1977

Burckhardt, J., *Die Kultur der Renaissance in Italien.* 2 vols., Leipzig 1860/1913

Burke, P., *Tradition and Innovation in Renaissance Italy. A Sociological Approach.* London 1974

Burns, H., 'Progetti di Francesco di Giorgio per i conventi di San Bernardino e Santa Chiara di Urbino.' *Studi Bramanteschi*, 293–311. Rome 1974

Il Caleffo Vecchio del comune di Siena. ed. G. Cecchini. 4 vols., Florence 1932–84

Cannon, J., 'Simone Martini, the Dominicans and the Early Sienese Polyptych.' *Journal of the Warburg and Courtauld Institutes*, XLV (1982), 69–94

Cardile, P. J., *Fra Angelico and his Workshop at San Domenico (1420–1435). The Development of his Style and the Formation of his Workshop.* Dissertation, Yale University. Ann Arbor 1983

Carli, E., *Pienza. La città di Pio II.* Rome 1967

Carli, E., *Il Duomo di Siena.* Genoa 1979.

Carr-Saunders, A. M., and P. A. Wilson, *The Professions.* London/Liverpool 1933

Cassee, E. H., *The Missal of Cardinal Bertrand de Deux. A Study in 14th-Century Bolognese Miniature Painting.* Florence 1980

Castiglione, B., *Il Libro del Cortegiano. Con una scelta delle Opere minore.* B. Maier. Turin 1964

Catalogue of Sienna. *Le sale della Mostra e il museo delle tavolette dipinte.* Rome 1956

Cecchini, G. *Il Palio di Siena.* Sienna 1957

Chambers, D. S., *Patrons and Artists in the Italian Renaissance.* London 1970

Christiansen, K., *Gentile da Fabriano*, London 1982

Ciardi Dupré dal Pogetto, M. G., *Il Maestro del Codice di San Giorgio e il Cardinale Jacopo Stefaneschi.* Florence 1981

Clough, C., *The Duchy of Urbino in the Renaissance. Collected Studies.* London 1981

Conti, A., *La miniatura Bolognese. Scuole e botteghe, 1270–1340.* Bologna 1981

Contini, G., and M. C. Gozzoli, *L'Opera completa di Simone Martini.* Milan 1970

Corpus iuris canonici: I *Decretum Gratiani*: II *Decretalium collectiones.* ed. E. Frieberg. Leipzig 1879–81

Il Costituto del Comune di Siena. ed. A. Lisini. 2 vols., Sienna 1903

Cronache Senesi. ed. I. Fabio and A. Lisini. *Rerum Italiae Scriptores*, New Series XV, vol. VI. Bologna 1931–7

Dante, *The Divine Comedy.* Tr. M. Musa. 3 vols., Harmondsworth 1984

Davisson, D. D., 'The Iconology of the Santa Trinità Sacristy, 1418–1435. A Study of the Private and Public Functions of Religious Art in the Early Quattrocento.' *Art Bulletin*, LVII (1975), 315–35

Degenhart, B., and A. Schmitt, *Corpus der italienischen Zeichnungen*, I. Berlin 1968

Degenhart, B., 'Das Marienwunder von Avignon. Simone Martinis Miniaturen für Kardinal Stefaneschi und Petrarca.' *Pantheon*, XXXIII (1975), 191–203

Dempsey, C., 'Some Observations on the Education of Artists in Florence and Bologna in the Late Sixteenth Century.' *Art Bulletin*, LXII (1980), 552–69

Doren, A., *Das Florentiner Zunftwesen vom vierzehnten bis zum sechszehnten Jahrhundert.* Stuttgart 1908

Dubois, R., *Giovanni Santi, Peintre et chroniqueur à Urbin, au XVᵉ siècle.* Bordeaux 1971

Durkheim, E., *Le suicide: étude de sociologie.* Paris 1897

Durkheim, E., 'De la définition des phénomènes réligieux.' *L'Année Sociologique*, II (1899), 1–28

Durkheim, E., *Les formes élémentaires de la vie religieuse: le système totémique en Australie.* Paris 1912

Dussler, L., *Raphael. A Critical Catalogue of his Pictures, Wall-Paintings and Tapestries.* London 1971

Dykmans, M., *Le cérémonial papal de la fin du Moyen-Âge à la Renaissance,* 2 vols., Institut Historique Belge de Rome. Brussels/Rome 1977, 1981

Dykmans, M. (ed.), *L'Œuvre de Patrizi Piccolomini ou le cérémonial papal de la première Renaissance.* 2 vols., Rome 1980

Dykmans, M., 'Paris de Grassis. I: Sa biographie jusqu'à la mort de Jules II.' *Ephemerides Liturgicae,* XCVI (1982a) 406–82

Dykmans, M., 'Le V^e Concile du Latran d'après le Diaire de Paris de Grassis.' *Annuarium Historiae Conciliorum,* XIV (1982b), 270–370

Eisenberg, M., 'The First Altarpiece for the "Cappella dei Signori" of the Palazzo Pubblico in Siena.' *Burlington Magazine,* CXXIII (1981), 134–48

Elias, N., *Über den Prozeß der Zivilisation. Soziogenetische und psychogenetische Untersuchungen.* 2 vols., Bern/Munich 1939/1969

Elias, N., and J. L. Scotson, *The Established and the Outsiders. A Sociological Enquiry into Community Problems.* London 1965

Elias, N. *Was Ist Sociologie?* Munich 1978

Ettlinger, L. D., *Antonio and Piero Pollaiuolo.* Oxford 1978

Fanti, M., *La fabbrica di S. Petronio in Bologna dal XIV al XX secolo. Storia di una istituzione.* Rome 1980

Feldges-Henning, U., 'The Pictorial Programme of the Sala della Pace. A New Interpretation.' *Journal of the Warburg and Courtauld Institutes,* XXXV (1972), 145–62

Fengler, C. K., *Lorenzo Ghiberti's 'Second Commentary'. The Translation and Interpretation of a Fundamental Renaissance Treatise on Art.* Dissertation, Wisconsin University (1974). Ann Arbor 1980

Filarete, A. A. *Trattato d'architettura* (1465). ed. A. M. Finoli and L. Grassi. Milan 1972

Filarete, A. A. *Filarete's Treatise on Architecture: being the Treatise by Antonio di Piero Averlino, known as Filarete.* Translation, introduction and notes by J. R. Spencer. London/New Haven 1965

Franceschini, G., *I Montefeltro.* Varese 1959

Frati, L., *Le due spedizioni di Guilio II tratte del Diario di Paride de Grassi Bolognese, maestro delle ceremonie della capella papale.* Bologna 1886

Frieburg, *see Corpus iuris canonic.*

Frommel, C. L., 'Die Peterskirche unter Papst Julius II. im Licht neuer Dokumente.' *Römisches Jahrbuch für Kunstgeschichte,* XVI (1976), 57–137

Frommel, C. L., 'Capella Julia. Die Grabkapelle Julius' II. in Neu-St Peter.' *Zeitschrift für Kunstgeschichte*, XL (1977), 26–62

Frommel, C. L., 'Eine Darstellung der Loggien in Raffaels *Disputa*? Beobachtungen zu Bramantes Erneuerung des Vatikanpalastes in den Jahren 1508–1509.' in: *Festschrift für Eduard Trier zum 60. Geburtstag*, 63–103. Berlin 1981

Gardner, J., 'S. Paolo fuori le mura, Nicholas III and Pietro Cavallini.' *Zeitschrift für Kunstgeschichte*, XXXIV (1971), 240–48

Gardner, J., 'Pope Nicholas IV and the Decoration of Santa Maria Maggiore.' *Zeitschrift für Kunstgeschichte*, XXXVI (1973a), 1–50

Gardner, J., 'Nicholas III's Oratory of the Sancta Sanctorum and its Decoration.' *Burlington Magazine*, CXV (1973b), 283–94

Gardner, J., 'The Stefaneschi Altarpiece. A Reconsideration.' *Journal of the Warburg and Courtauld Institutes*, XXXVII (1974), 57–103

Gardner, J., 'Saint Louis of Toulouse, Robert of Anjou and Simone Martini.' *Zeitschrift für Kunstgeschichte*, XXXIX (1976), 12–33

Gardner, J., 'Boniface VIII as a Patron of Sculpture.' in: *Roma anno 1300*, 513–29. ed. A. M. Romanini. Rome 1983

Gardner von Teuffel, C., 'Masaccio and the Pisa Altarpiece. A New Approach.' *Jahrbuch der Berliner Museen*, XIX (1977), 23–68

Gardner von Teuffel, C., 'The Buttressed Altarpiece. A Forgotten Aspect of Tuscan Fourteenth Century Altarpiece Design.' *Jahrbuch der Berliner Museen*, XXI (1979), 21–65

Gardner von Teuffel, C., 'Lorenzo Monaco, Filippo Lippi and Filippo Brunelleschi. Die Erfindung der Renaissancepala.' *Zeitschrift für Kunstgeschichte*, XLV (1982), 1–30

Garin, E., *Prosatori latini del Quattrocento*. Milan/Naples 1952

Garin, E., *La cultura del Rinascimento*. Bari 1967/1976

Gaye, G., *Carteggio enedito d'artisti del secoli XIV, XV, XVI*. 3 vols., Turin 1839-1840/1961

Ghiberti, L., *Commentarii. See* Fengler

Gilbert, C. E., 'The Fresco by Giotto in Milan.' *Arte Lombarda*, XLVII/XLVIII (1977), 31–72

Gilbert, C. E., (ed.), *Italian Art, 1400–1500. Sources and Documents*. Englewood Cliffs 1980

Giles, K. A., *The Strozzi Chapel in Santa Maria Novella. Florentine Painting and Patronage, 1340–1355*. Dissertation, New York University (1977). Ann Arbor 1979

Ginzburg, C., *Erkundungen über Piero. Piero della Francesca, ein Maler der frühen Renaissance*. Berlin 1981

Glasser, H., *Artists' Contracts of the Early Renaissance*. Dissertation, Columbia University (1965). New York/London 1977

Goldthwaite, R. A., *The Building of Renaissance Florence. An Economic and Social History.* Baltimore 1980

Golzio, V., *Raffaello nei documenti, nelle testimonianze dei contemporanei e nella letteratura del suo secolo.* Rome 1936

Gombrich, E. H., 'The Early Medici as Patrons of Art.' *Italian Renaissance Studies. A tribute to the late Cecilia M. Ady,* 279–312. ed. E. F. Jacob. London 1960

Gombrich, E. H., 'Style.' *International Encyclopedia of the Social Sciences,* vol. XV (1968), 352–61

Gombrich, E. H., 'In Search of Cultural History.' Reprinted in: *Ideals and Idols. Essays on Values in History and Art,* 25–59. Oxford 1971/1979

Gombrich, E. H., 'Art History and the Social Sciences.' Reprinted in: *Ideals and Idols,* 131–66. Oxford 1979

Gombrich, E. H., *Symbolic Images: Studies in the Art of the Renaissance.* London/New York 1972

Gordon, D., 'A Perugian Provenance for the Franciscan Double-sided Altarpiece by the Maestro di S. Francesco.' *Burlington Magazine,* CXXIV (1982), 70–77

Il Gotica a Siena. Exhibition catalogue, Palazzo Pubblico, Sienna, 24 July to 30 October 1982. Florence 1982

Goudsblom, J., *Sociology in the Balance.* Oxford 1977

Goudsblom, J., 'Over het onderzoek van civilisatieprocessen.' *De Gids,* CXLV (1982), 69–78

Goudsblom, J., 'De civilisatietheorie in het geding.' *Sociologische Gids,* XXXI (1984a), 138–63

Goudsblom, J., 'Vuur en beschaving. De domesticatie van vuur als beschavingsproces (I).' *De Gids,* CXLVII (1984b), 227–41

Grassis, Paris de, *see* Dykmans and Frati

Grimaldi, G., *Descrizione della Basilica Antica di S. Pietro in Vaticano. Codice Barberini Latino 2733.* ed. R. Niggl. Vatican 1972

Hager, H., *Die Anfänge des italienischen Altarbildes. Untersuchungen zur Entstehungsgeschichte des toskanischen Hochaltarretabels.* Munich 1962

Hale, J. R., *Florence and the Medici. The Pattern of Control.* London 1977

Hall, M. B., *Renovation and Counter-reformation. Vasari and Duke Cosimo in Sta. Maria Novella and Sta. Croce.* Oxford 1979

Haskell, F., *Patrons and Painters. A Study in the Relations between Italian Art and Society in the Age of the Baroque.* London 1963

Haskell, F., 'Fine Arts, Art and Society.' *International Encyclopedia of the Social Sciences,* vol. V (1968), 439–47

Hatfield, R., *Botticelli's Uffizi 'Adoration'. A Study in Pictorial Content.* Princeton 1976

Hauser, A., *The Social History of Art.* 4 vols. New York 1957

Hay, D., *The Italian Renaissance and its Historical Background.* Cambridge 1961

Heck, A. v., *Breviarium urbis Romae antiquae.* Leiden 1977

Heerikhuizen, B. van, *see* Wilterdink 1985a

Hendy, P., *Piero della Francesca and the Early Renaissance.* London 1968

Herde, P., *Cölestin V., 1294.* Stuttgart 1981

Herzner, V., 'Zur Baugeschichte von San Lorenzo in Florenz.' *Zeitschrift für Kunstgeschichte*, XXVII (1974), 89–115.

Hetherington, P., *Pietro Cavallini. A Study in the Art of Late Medieval Rome.* London 1979

Hirschfeld, P., *Mäzene. Die Rolle des Auftraggebers in der Kunst.* o.O. 1968

Höger, A., *Studien zur Entstehung der Familienkapelle und zu Familienkapellen und altären des Trecento in Florentiner Kirchen.* Dissertation, Bonn University (1976). Bonn 1976

Holmes, G., 'How the Medici became the Pope's Bankers.' in: *Florentine Studies. Politics and Society in Renaissance Florence*, 357–80. ed. N. Rubinstein. London 1968

Holmes, G., *The Florentine Enlightenment, 1401–1450.* London 1969

Hoof, J. J. B. M. v., *Het beroep als object van sociologish onderzoek. Een terreinverkenning.* Amsterdam 1969

Hope, C., 'Artists, Patrons and Advisers in the Italian Renaissance.' in: *Patronage in the Renaissance*, 293–344. ed. G. F. Little and S. Orgel. Princeton 1981

Horster, M., *Andrea del Castagno. Complete Edition with a Critical Catalogue.* Oxford 1980

Hueck, I., 'Der Maler der Apostelszenen im Atrium von Alt-St Peter.' *Mitteilungen des kunsthistorischen Institutes in Florenz*, XIV (1969), 115–44

Hueck, I., 'Zu Enrico Scrovegnis Veränderungen der Arenakapelle.' *Mitteilungen des kunsthistorischen Institutes in Florenz*, XVII (1973) 277–94

Hueck, I., 'Stifter und Patronatsrecht. Dokumente zu zwei Kapellen der Bardi.' *Mitteilungen des kunsthistorischen Institutes in Florenz*, XX (1976), 263–70

Hueck, I., 'Das Datum des Nekrologs für Kardinal Jacopo Stefaneschi im Martyrologium der Vatikanischen Basilika.' *Mitteilungen des kunsthistorischen Institutes in Florenz*, XXI (1977), 219–20

Hueck, I., 'Cimabue und das Bildprogramm der Oberkirche von San Francesco in Assisi.' *Mitteilungen des kunsthistorischen Institutes in Florenz*, XXV (1981), 279–324

Hueck, I., 'Il cardinale Napoleone Orsini e la capella di S. Nicola nella basilica francescana ad Assisi.' in: *Roma anno 1300*, 187–99. ed. A. M. Romanini. Rome 1983

Hueck, I., 'Der Lettner der Unterkirche von San Francesco in Assisi.' *Mitteilungen des kunsthistorischen Institutes in Florenz*, XXVIII (1984), 173–202

Huizinga, J., *Herfsttij der Middeleeuwen. Studie over levens- en gedachtenvormen der veertiende en vijftiende eeuw in Frankrijk en de Nederlanden.* Groningen 1919

Huyskens, A., 'Das Kapitel von St Peter in Rom unter dem Einfluß der Orsini (1276–1341).' *Historisches Jahrbuch der Görres-Gesellschaft*, XXVII (1906), 266–90

Hyde, J. K., *Society and Politics in Medieval Italy.* London 1973

Hyman, I., *Fifteenth Century Florentine Studies. The Palazzo Medici and a Ledger for the Church of San Lorenzo.* Dissertation, New York University (1968). New York/London 1977

Inventory of Sienna: *Guida-Inventario dell'Archivio di Stato.* Rome 1951

Jenkins, A. D. Fraser, 'Cosimo de Medici's Patronage of Architecture and the Theory of Magnificence.' *Journal of the Warburg and Courtauld Institutes*, XXXIII (1970), 162–70

Johnson, T. J., *Professions and Power.* London 1972

Jong, M. de. 'Monniken, ridders en geweld in elfde-eeuws Vlaanderen.' *Sociologische Gids*, XXIX (1982), 279–95

Jungmann, J. A., *Missarum Solemnia.* 2. vols, Vienna 1952

Kaemmerling, E. (ed.), *Ikonographie und Ikonologie. Theorien, Entwicklung, Probleme. Bildende Kunst als Zeichensystem*, I. Cologne 1979

Kantorowicz, E. H., *The King's Two Bodies. A Study in Medieval Political Theology.* Princeton 1957

Kempers, B., 'De civilisatietheorie van Elias en civilisatieprocessen in Italië, 1300–1550.' *Amsterdams Sociologisch Tijdschrift*, VIII (1982a), 591–612

Kempers, B., 'Dood en professie. Grafcultuur en beroepsprestige van Renaissanceschilders.' *Sociologische Gids*, XXIX (1982b), 468–84

Kempers, B., 'Problemen en beloften van kunstsociologie in Nederland.' *Sociale Wetenschappen*, XXVII (1985), 99–118

Kempers, B., 'Staatssymboliek in Rafaëls Stanza della Segnatura.' *Incontri*, II (1986a), 3–48

Kempers, B., *750 jaarverslagen. Schilderkunst in Siena, vormgeving in Amsterdam.* Eindhoven 1986b

Kempers, B., and S. de Blaauw, 'Jacopo Stefaneschi. Patron and Liturgist. A New Hypothesis on the Date, Iconography and Function of his Altarpiece for Old Saint Peter's.' *Mededelingen van het Nederlands Instituut te Rome*, XLVIII (1987), New Series 12 XLVII, 83–113

Kennedy, R. W., *Alesso Baldovinetti. A Critical and Historical Study.* New Haven 1938

Kent, D., *The Rise of the Medici Faction in Florence, 1426–1434.* Oxford 1978

Kent, F. W., *Household and Lineage in Renaissance Florence. The Family Life of the Capponi, Ginori and Rucellai.* Princeton 1977

Klotzner, J., *Kardinal Dominikus Jacobazzi und sein Konzilswerk.* Analecta Gregoriana XLV. Rome 1948

Knab, E., E. Mitsch and K. Oberhuber, *Raphael Die Zeichnungen.* Stuttgart 1983

Kollwitz, J., 'Bild und Bildertheologie im Mittelalter.' in: *Das Gottesbild im Abendland,* 109–22. ed. W. Schöne, J. Kollwitz, H. v. Campenhausen. Berlin 1957

Krautheimer, R., *Rome, Profile of a City (312–1308).* Princeton 1980

Kristeller, P. O., *Studies in Renaissance Thought and Letters.* Rome 1956

Ladner, G. B., *Die Papstbildnisse des Altertums und des Mittelalters.* 3 vols., Vatican 1941, 1970, 1984

Langedijk, K., *The Portraits of the Medici, 15th–18th Centuries.* 2 vols., Florence 1981

Langlois, M. E., *Les registres de Nicolas IV. Recueil des bulles de ce pape.* 2 vols., Paris 1886–90

Larner, J., *Culture and Society in Italy, 1290–1420.* London 1971

Lavalleye, J., *Le Palais Ducal d'Urbin.* Brussels 1964

Lavin, M. A., 'The Altar of Corpus Domini in Urbino. Paolo Uccello, Joos van Ghent, Piero della Francesca.' *Art Bulletin,* XLIX (1967), 1–25

Lavin, M. A., 'Piero della Francesca's Flagellation. The Triumph of Christian Glory.' *Art Bulletin,* L (1968), 321–4

Lavin, M. A., 'Piero della Francesca's Montefeltro Altarpiece. A Pledge of Fidelity.' *Art Bulletin,* LI (1969), 367–71

Lightbown, R. A., *Sandro Botticelli.* 2 vols., London 1978

Ligi, D. B., *Memorie ecclesiastiche di Urbino.* Urbino 1938

Lisini, *see Costituto* and *Cronache Senesi*

Little, L. K., *Religious Poverty and the Profit Economy in Medieval Europe.* Ithaca 1978

Lomazzo, G. P., *Trattato dell'arte della pittura, scultura e architettura* (1584). Rome 1844

Luchs, A., *Cestello. A Cistercian Church of the Florentine Renaissance.* Dissertation, Baltimore (1975). New York 1977

Lusini, V., *Il Duomo di Siena.* 2 vols., Sienna 1911 and 1939

Luzio, A., 'Federico Gonzaga ostaggio alla corte di Giulio II.' *Archivio della R. Società Romana di Storia Patria,* IX (1887), 1–582

Malmstrom, R. E., *Santa Maria in Aracoeli at Rome.* Dissertation, New York University. Ann Arbor 1973

Martin, A. von, *Soziologie der Renaissance. Zur Physiognomik und Rhythmik bürgerlicher Kultur.* Stuttgart 1932

Martindale, A., *The Rise of the Artist in the Middle Ages and Early Renaissance.* London 1972

Martines, L., *The Social World of the Florentine Humanists.* Princeton 1963

Martines, L., *Lawyers and Statecraft in Renaissance Florence.* Princeton 1968

Martines, L., *Power and Imagination. City-states in Renaissance Italy.* New York 1979

Marx, K., *Marx/Engels, Werke.* 29 vols., Berlin 1965–72

Maso, B., 'Riddereer en riddermoed. Ontwikkelingen van de aanvalslust in de late middeleeuwen.' Sociologische Gids, XXIX (1982), 296–325

Mauss, M., 'Essai sur le Don', *Année Sociologique*, new series I, 31–186. Paris 1950

Meiss, M., *Painting in Florence and Siena after the Black Death*. Princeton 1951

Melnikas, A., *The Corpus of the Miniatures in the Manuscripts of Decretum Gratiani*. 3 vols., Vatican 1975

Middeldorf-Kosegarten, A., 'Zur Bedeutung der Sieneser Domkuppel.' *Münchner Jahrbuch der bildenden Kunst,* XXI (1970), 73–97

Miedema, H., 'On Mannerism and Maniera.' *Simiolus,* X (1978–9), 19–46

Miedema, H., *De archiefbescheiden van het St Lukasgilde te Haarlem, 1497–1798*. 2 vols., Alphen aan den Rijn 1980a

Miedema, H., 'Over de waardering van architect en beeldende kunstenaar in de zestiende eeuw.' *Oud Holland*, XCIV (1980b), 71–87

Milanesi, G., *Documenti per la storia dell'arte senese*. 3 vols., Sienna 1854–6

Minnich, N. H., 'Paride de Grassi's Diary of the Fifth Lateran Council.' *Annuarium Historiae Conciliorum*, XIV (1982), 370–460

Mitchell, R. J., *The Laurels and the Tiara. Pope Pius II., 1458–1464*. London 1962

Mok, A. L., *Beroepen in actie. Bijdragen tot de beroepensociologie*. Meppel 1973

Moore, Barrington Jun., *Social Origins of Dictatorship and Democracy: Lord and Peasant in the Making of the Modern World*. Boston 1967

Moorman, J. R. H., *A History of the Franciscan Order from its Origins to the Year 1517*. Oxford 1968

Moran, G., 'An Investigation Regarding the Equestrian Portrait of Guidoriccio da Fogliano in the Siena Palazzo Pubblico.' *Paragone,* XXVIII (1977), 81–8

Morante, E., and U. Baldini, *L'Opera completa dell'Angelico*. Milan 1970

Morçay, R., 'La Cronaca del convento Fiorentino di San Marco.' *Archivio Storico Italiano* (1913), 1–29

Neri di Bicci, *Le Ricordanze*. ed. B. Santi. Pisa 1976

Nessi, S., *La Basilica di S. Francesco in Assisi e la sua documentazione storica*. Assisi 1982

Odericus, *Ordo officiorum ecclesiae Senensis*. ed. G. C. Trombelli. Bologna 1766

Offerhaus, J., *Motief en achtergrond. Studies over het gebruik van architectuur in de Florentijnse schilderkunst*. Dissertation, Utrecht 1976

Olsen, H., *Urbino*. Copenhagen 1971

O'Malley, J. W., 'The Vatican Library and the School of Athens. A Text of Battista Casali, 1508.' *Journal of Medieval and Renaissance Studies*, VII (1977), 271–89

O'Malley, J. W., *Praise and Blame in Renaissance Rome. Rhetoric, Doctrine and Reform in the Sacred Orators of the Papal Court, c. 1450–1521*. Durham 1979

Oosterbaan Martinius, W., *Schoonheid, welzijn, kwaliteit. Over legitimerings- en toewijzingsproblemen in het kunstbeleid*. Amsterdam 1985

Orlandi, S. (O P), *Necrologio di Santa Maria Novella*. 2 vols., Florence 1955

Orlandi, S. (O P), 'La Madonna di Duccio di Buoninsegna e il suo culto in S. Maria Novella.' *Memorie Dominicane*, LXXIII (1956), 205–18

Os, H. W. van, *Marias Demut und Verherrlichung in der sienesischen Malerei, 1300–1450*. The Hague 1969

Os, H. W. van, *Vecchietta and the Sacristy of the Siena Hospital Church. A Study in Renaissance Religious Symbolism*. The Hague 1974

Os, H. W. van, 'The Black Death and Sienese Painting. A Problem of Interpretation.' *Art History*, IV (1981a), 237–50

Os, H. W. van, 'From Rome to Siena. The Altarpiece of San Stefano alle Liza.' *Mededelingen van het Nederlands Instituut te Rome*, XLIII (1981b), 119–28

Os, H. W. van, *Sienese Altarpieces, 1215–1460. Form, Content, Function*. Vol. I: 1215–1344, with a contribution by K. van der Ploeg. Groningen 1984

Osheim, D. J., *An Italian Lordship. The Bishopric of Lucca in the late Middle Ages*. Berkeley 1977

Otto, H., 'Der Altar von St Peter und die Wiederherstellungsarbeiten an der alten Basilika unter Johannes XXII und Benedikt XII.' *Mitteilungen des österreichischen Instituts für Geschichtsforschung*, LI (1937), 470–90

Paatz, W. and E., *Die Kirchen von Florenz*. 6 vols., Frankfurt 1940–54

Paleotti, G., *Discorso intorno alle imagini sacre e profane*. Bologna 1582/1599

Paltroni, P., *Commentari della vita e gesti dell'illustrissimo Federico Duca d'Urbino*. ed. W. Tommasoli. Urbino 1966

Partridge, L., and R. Starn, *A Renaissance Likeness. Art and Culture in Raphael's Julius II*. Berkeley 1980

Pastor, L. v., *Geschichte der Päpste im Zeitalter der Renaissance. Von der Wahl Innozenz' VIII. bis zum Tode Julius' II*. Freiburg 1924

Pevsner, N., *Academies of Art. Past and Present*. New York 1940/1973

Pfeiffer, H., *Zur Ikonographie von Raphaels Disputa*. Miscellanea Historiae Pontificiae, XXXVII. Rome 1975

Piccolomini, *see* Dykmans and Pius II

Pietramellara, C., *Il Duomo di Siena. Evoluzione della forma dalle origini alla fine del Trecento*. Florence 1980

Pius II (Eneo Silvio Piccolomini), 'Commentarii. Commentaries.' eds. F. A. Gragg and L. C. Gabel. *Smith College Studies in History*, XXII, XXV, XXX, XXXV, XLIII (1937–57)

Ploeg, K. v. d., *see* Van Os 1984

Pope-Hennesy, J., *Sassetta*. London 1939

Previtali, G., *Giotto e la sua bottega*. Milan 1967

Quednau, R., *Die Sala di Costantino im Vatikanischen Palast. Zur Dekoration der beiden Medici-Päpste Leo X und Clemens VII*. Hildesheim/New York 1979

Renaudet, A., *Le Concile Gallican de Pise-Milan. Documents Florentins 1510–1512.* Paris 1922

Reynolds, T., *The Accademia del Disegno in Florence. Its Formation and Early Years.* Dissertation, Columbia University (1974). Ann Arbor 1982

Ricci, C., *Il Tempio Malatestiano.* Rimini 1974

Riedl, A., and M. Seidel, *Die Kirchen von Siena.* 3 vols., Munich 1985

Ringbom, S., *Icon to Narrative. The Rise of the Dramatic Close-up in Fifteenth-century Devotional Painting.* Abo 1965

Roma anno 1300. Atti della IV Settimana di Studi di Storia dell' Arte medievale dell' Univerità di Roma 'La Sapienza'. 19–24 May 1980. ed. A. M. Romanini. Rome 1983

Roover, R. de, *The Rise and Decline of the Medici Bank, 1397–1497.* Cambridge (Mass.) 1963

Roscoe, W., *The life and Pontificate of Leo* X. 4 vols., Liverpool 1805

Rotondi, P., *Il Palazzo Ducale di Urbino.* 2 vols. Urbino 1950

Rubinstein, N., 'Political Ideas in Sienese Art: the Frescoes of Ambrogio Lorenzetti and Taddeo di Bartolo in the Palazzo Pubblico.' *Journal of the Warburg and Courtauld Institutes,* XXI (1958), 179–207

Rubinstein, N., *The Government of Florence under the Medici, 1434 to 1494.* Oxford 1966

Sale, J. R., *Filippino Lippi's Strozzi Chapel in Santa Maria Novella.* Dissertation University of Pennsylvania (1976). New York/London 1979

Santi, G., *La vita e le gesta di Federico di Montefeltro.* ed. L. M .Tocci. Vatican 1985

Santi, *see also* Neridi Bicci

Scheller, R. W., 'Ensigns of Authority: French Royal Symbolism in the Age of Louis XII.' *Simiolus,* XIII (1983), 75–141

Scheller, R. W., 'Gallia Cisalpina: Louis XII and Italy, 1499–1508.' *Simiolus,* XV (1985), 5–60

Scheller, R. W., 'Imperiales Königtum in Kunst und Staatsdenken der französischen Frührenaissance', *Kritische Berichte* VI (1978), 5–24

Schneider, L. (ed.), *Giotto in Perspective.* Englewood Cliffs 1974

Schröter, E., *Die Ikonographie des Themas Parnaß vor Raffael.* Hildesheim/New York 1977

Seidel, M., 'Die Verkündigungsgruppe der Sieneser Domkanzel.' *Münchner Jahrbuch der bildenden Kunst,* XXI (1970), 18–72

Seidel, M., '"Castrum pingatur in palatio." Ricerche storiche e iconografiche sui castelli dipinti nel Palazzo Pubblico di Siena.' *Prospettiva* (1982), 17–41

Shearman. J., 'The Vatican Stanze. Functions and Decoration.' *Proceedings of the British Academy,* LVII (1972a), 3–58

Shearman. J., *Raphael's Cartoons in the Collection of Her Majesty the Queen and the Tapestries for the Sistine Chapel.* London 1972b

Sizeranne, R. de la, *Federico di Montefeltro capitano, principe, mecenate, 1422–1482.* ed. C. Zeppieri. Urbino 1972

Smart, A., *The Assisi Problem and the Art of Giotto.* Oxford 1971

Sombart, W., *Der moderne Kapitalismus.* 2 vols., Leipzig 1902

Southard, E. C., *The Frescoes in Siena's Palazzo Pubblico 1289–1359.* Dissertation, Indiana University (1979). New York/London 1979

Steinmann, E., *Die Sixtinische Kapelle.* 2 vols., Munich 1905

Stornajolo, C., *Codices Urbinates latini.* 2 vols., Rome 1902–12

Stubblebine, J. H., *Guido da Siena.* Princeton 1964

Stubblebine, J. H., *Duccio di Buoninsegna and his School.* 2 vols., Princeton 1979

Swaan, A. de, 'De mens is de mens een zorg. Over verstatelijking van verzorgingsarrangementen.' *De Gids,* CXXXIX (1976), 35–98

Swaan, A. de, *Kwaliteit is klasse. De sociale wording een werking van het cultureel smaakverschil.* Amsterdam 1985

Teubner, H., 'San Marco in Florenz. Umbauten vor 1500. Ein Beitrag zum Werk des Michelozzo.' *Mitteilungen des kunsthistorischen Institutes in Florenz,* XXIII (1979), 239–72

Tocci, L. M., *Il Padre di Raffaello. Giovanni Santi e alcune delle sue opere più rappresentative nella regione di Urbino e quella di Pesaro.* Pesaro 1961

Tocci, L. M. (ed.), *Il Dante Urbinate della Biblioteca Vaticana,* 2 vols., Vatican 1965

Tommasoli, W., *La vita di Federico da Montefeltro, 1422–1482.* Urbino 1978

Torriti, P., *La Pinacoteca Nazionale di Siena.* 2 vols., Genoa 1979

Toynbee, M., *St Louis of Toulouse and the Process of Canonization in the Fourteenth Century.* Manchester 1929

Trexler, R. C., 'Death and Testament in the Episcopal Constitutions of Florence 1327.' in: *Renaissance Studies in Honour of Hans Baron,* 31–74. ed. A. Molho and J. A. Tedeschi. Dekalb (Ill.) 1971

Trexler, R. C., *Public Life in Renaissance Florence.* New York 1980

Trinkaus, C., *In Our Image and Likeness. Humanity and Divinity in Italian Humanist Thought.* 2 vols., Chicago 1970

Ullmann, W., *Medieval Papacy. The Political Theories of the Medieval Canonists.* London 1949

Vasari, G., *Le Vite de' più eccelenti pittori, scultori e architettori* (Florence 1568). ed. G. Milanesi. 'Le Opere di Giorgio Vasari.' 9 vols., Florence 1878–85

Vasari, G., *Le Vite de' più eccelenti pittori, scultori e architettori,* in the editions of 1550 and 1568. Text edited by R. Bettarini and Paolo Barocchi. 7 vols., Florence 1966

Vauchez, A., 'La commune de Sienne, les ordres mendiants et le culte des saints: histoire et enseignements d'une crise, novembre 1328–avril 1329.' *Mélanges de l'école française de Rome. Moyen-Âge – temps modernes,* LXXXIX (1977), 757–67

Veblen, T., *The Theory of the Leisure Class. An Economic Study of Institutions.* New York 1899

Veen, H. T. van, 'Cosimo I e il suo messagio militare nel Salone dei Cinquecento.' *Prospettiva,* XXVII (1981a), 86–90

Veen, H. T. van, 'Antonio Giacomini, un commissario repubblicano nel Salone dei Cinquecento.' *Prospettiva,* XXV (1981b), 50–56

Veen, H. T. van, 'Art and Propaganda in Late Renaissance and Baroque Florence. The Defeat of Radagasius, King of the Goths.' *Journal of the Warburg and Courtauld Institutes,* XLVII (1984), 106–18

Villani, G., *Cronica di Giovanni Villani.* Florence 1815

Vroom, W. H., *Het kunstenaarscontract in de 15e und 16e eeuw in de Nederlanden.* Universiteit van Amsterdam 1959

Vroom, W. H., *De financiering van de kathedraalbouw in de middeleeuwen.* Maarssen 1981

Wackernagel, M., *Der Lebensraum des Künstlers in der florentinischen Renaissance. Aufgaben und Auftraggeber, Werkstatt und Kunstmarkt.* Leipzig 1938

Wallerstein, I., *The Modern Worldsystem. Capitalist Agriculture and the Origins of the European World-economy in the Sixteenth Century.* New York 1974

Warburg, A., *Gesammelte Schriften.* ed. G. Bing. Neudeln/Liechtenstein 1969

Ward, M. A. J., *The Accademia del Disegno in Sixteenth Century Florence. A Study of an Artistic Institution.* Dissertation, Chicago 1972

Warnke, M., *Hofkünstler. Zur Vorgeschichte des modernen Künstlers.* Cologne 1985

Weber, M., 'Die protestantische Ethik und der Geist des Kapitalismus.' *Archiv für Sozialwissenschaft und Sozialpolitik,* XX/XXI (1904–5). Reprinted in: *Gesammelte Aufsätze zur Religionssoziologie,* 1. Tübingen 1920

Weber, M., *Wirtschaft und Gesellschaft. Grundriß der verstehenden Soziologie.* Tübingen 1922/1956

Weil-Garris, K., and J. F. d'Amico, 'The Renaissance Cardinal's Ideal Palace. A Chapter from Cortesi's "De Cardinalatu".' *Studies in Italian Art and Architecture, 15th through 18th Centuries.* ed. H. A. Millon. Memoirs of the American Academy in Rome, XXXV. Rome 1980

Weiss, R., 'The Medals of Pope Julius II (1503–1513).' *Journal of the Warburg and Courtauld Institutes,* XXVII (1965), 163–82

White, J., *Duccio. Tuscan Art and the Medieval Workshop.* London 1979

Wilde, J., 'The Wall of the Great Council of Florence.' *Journal of the Warburg and Courtauld Institutes,* VII (1944), 65–81

Wilterdink, N., and B. van Heerikhuizen, *Samenlevingen. Een verkenning van het terrein van de sociologie.* Groningen 1985a

Wilterdink, N., 'Comparative Historical Sociology in the Seventies.' *Netherlands' Journal of Sociology,* XXI (1985b), 4–20

Wittkower, R. and M., *Born under Saturn. The Character and Conduct of Artists. A Documented History from Antiquity to the French Revolution.* London 1963

Wittkower, R. and M., *The Divine Michelangelo. The Florentine Academy's Homage on his Death in 1564. A Facsimile Edition of Esequie del divino Michelangelo Buonarotti* (Florence 1564). London 1964

Wohl, H., *The Paintings of Domenico Veneziano, 1410–1461. A Study in Florentine Art of the Early Renaissance.* Oxford 1980

Wollesen, J. T., *Die Fresken von San Piero a Grado bei Pisa.* Dissertation, Heidelberg 1975/1977

Wollesen, J. T., 'Die Fresken in Sancta Sanctorum. Studien zur römischen Malerei zur Zeit Papst Nicolaus' III. (1277–1280).' *Römisches Jahrbuch für Kunstgeschichte*, XIX (1981), 35–83

Wood Brown, J., *The Dominican Church of Santa Maria Novella at Florence. A Historical, Architectural and Artistic History.* Edinburgh 1902

Zdekauer, L., *Il constituto del Comune di Siena dell'anno 1262.* Milan 1897/1974

Zwaan, T., 'Historische maatschappijwetenschap, staatsvorming en kapitalisme.' *Amsterdams Sociologisch Tijdschrift*, VII (1980), 117–70

INDEX

*Page numbers of illustrations
are in italic.*

DATE DUE

NOV 1 3 2004			
GAYLORD			PRINTED IN U.S.A.

and-death struggle at an abandoned airstrip. He complicates matters during courtroom litigation by accusing an attorney of murder. Caught in a maelstrom of complicity, his major adversary makes a final, fatal decision. The gripping story ends with an opening to future confrontations, beginning with *The Dryline*.

"Fast-paced and fascinating. Grubbs takes you into a world where complex events have to be broken down into something easily understood.

The book is most engrossing in the courtroom scenes, when Seiler is testifying. He breaks complex issues . . . into language that a layperson can easily understand.

The jury understands it. The reader understands it—and is fascinated by the testimony.

—Galveston County Daily News

"A suspenseful, well-written, solidly plotted novel that visits the world of good and bad lawyers and public officials, and a couple of spectacularly evil characters."

"My only negative comment has to do with how late I stayed awake to finish it . . ."

—The Angleton Facts

www.GrubbsBooks.com

Don't miss *Bad Intentions,*
the first novel of the Tom Seiler series!

Autographed copies:
www.GrubbsBooks.com

Tom Seiler has vices and virtues. He drinks, swears, and often struggles with his perception of revenge and justice; but the former NASA design engineer also sees life in simple terms—right is right and wrong is wrong. An expert at all things mechanical, he and his family are drawn into a conspiracy involving a tractor-trailer collision killing four siblings in the small town of Alvin, Texas. A powerful Houston attorney, in a pre-tort reform strike at the trucking industry, planned and orchestrated the murders. The stakes in *Bad Intentions* are immense—an upside of a quarter of a billion dollars and a downside of lethal injection at The Walls prison in downtown Huntsville, Texas. Geographically stretching from Houston to the beaches of Indianola, Seadrift, and Port Aransas, Texas, *Bad Intentions* weaves a tale of terror and carries Tom into a life-